BUILDING
THE
ESCORIAL

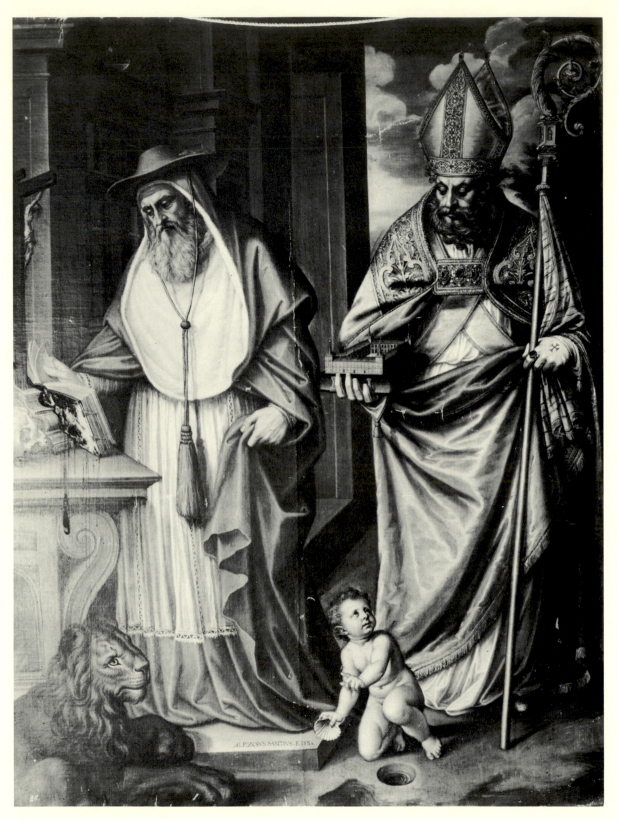

Alonso Sanchez Coello, *Saint Jerome and Saint Augustine*, 1580, Escorial, basilica (photo Mas).

GEORGE KUBLER

BUILDING THE ESCORIAL

PRINCETON UNIVERSITY PRESS

PRINCETON, NEW JERSEY

*To all who did and will
build and restore the Escorial
and its libraries*

CONTENTS

LIST OF ILLUSTRATIONS xi

PREFACE xv

PART ONE THE HUMAN FABRIC

CHAPTER ONE THE CHANGING FAME OF THE ESCORIAL 3

The Panegyric Tradition 3

Spanish Panegyrists 4

Nineteenth-Century Guidebooks 6

Derogatory Writings 7

Classical French Architectural Criticisms 8

Romantic Critics 10

Critical Studies since 1880 10

CHAPTER TWO THE CHAIN OF COMMAND 12

The King's Wishes 12

The King and Architecture 15

Madrid and the Court 17

The King's Architects 19

Juan Bautista de Toledo 20

Juan de Herrera 22

CHAPTER THREE LABOR AND ITS GOVERNANCE 29

The Jeronymites 29

The Priors 30

The Congregación 32

The Council on Architecture 33

The Master Workman 33

The Master Builders 35

The Contractors 37

The Foremen 38

The Labor Force 39

CHAPTER FOUR THE ESCORIAL DESIGN: ORIGINS AND ANTECEDENTS 42

The Temple of Solomon 42

Spalato 43

The Monastic Origin of the Program 44

Hospitals of Cruciform Plan 44

Italian Participation in the Escorial Designs 45

 Villalpando's Translation of Serlio, 1552 45

 Michelangelo, 1475-1564 46

 Francesco Paciotto, 1521-1591 47

 Galeazzo Alessi, 1512-1572 51

 The Opinions of the Florentine Academy 52

 Trace Elements of Palladio 53

PART TWO THE TISSUE OF MATERIALS

CHAPTER FIVE THE VOW FULFILLED, 1557-1571 59

San Lorenzo: Electing the Site 60

Toledo's "Universal Plan," 1559-1563 62

The Rule of the Priors, 1563-1572 64

The Completion of the Rehearsal Compound, 1567-1571 71

CHAPTER SIX ASSEMBLING THE BASILICA 77

Preparations Before 1574 77

The Basilica Partitioned in Ten Contracts 81

Architectural Drawings for the Basilica 84

CHAPTER SEVEN COMPLETING THE BLOCK 87

"The King of Spaine's House" 87

The Palace Courtyards 89

Architectural Drawings of the Palace 91

The College and Seminary Buildings 92

The Library Portico and Forecourt 95

CHAPTER EIGHT THE SURROUNDING STONESCAPE 98

The Hospital Buildings 98

The Compaña 100

The Northern Service Buildings (*Casas de Oficios*) 101

The Plaza Promenades (*Lonjas*) 103

Roofings of Slate and Lead 103

Fenestration 105

Stairways 109

Basements and Cisterns 110

Ducts and Drains 111

CHAPTER NINE EVENTS AFTER 1600 114

Valladolid, Lerma, and the Buen Retiro 114

The Panteón 115

The Sacristy 117

Juan de Villanueva as Royal Architect 117

Nineteenth-Century Expropriation and Renewal 118

Natural Destruction 119

 The Great Fires 119

 The Plague of Termites 122

Ramón Andrada's Restoration and Rebuilding 123

EPILOGUE A SIXTEENTH-CENTURY MEANING OF THE ESCORIAL 125

Mannerist Style as Psychohistorical Analysis 125

Estilo Desornamentado and Plain Style as Labels 126

Renaissance Magic? 128

Sigüenza and the Aesthetics of Saint Augustine 131

APPENDIXES

 1: Coello's *Saint Jerome and Saint Augustine* 135

 2: The King's Decree of a Tax Exemption 136

 3: Moneys for the Fabric of San Lorenzo 138

 4: Herrera and the King on Alchemy 140

 5: The Cost of the Work, 1562-1601 141

 6: A Satire against the Site of the Escorial 155

 7: La Fresneda 158

 8: Catalogue of Drawings from the Office of
 Juan de Villanueva, 1785 159

 9: Types of Construction Contracts, by Years 162

x CONTENTS

List of Abbreviations 169
Archival References 171
Bibliography 173
Index 181
Illustrations 189

LIST OF ILLUSTRATIONS

Frontispiece. Alonso Sanchez Coello, *Saint Jerome and Saint Augustine*, 1580, Escorial, basilica (photo Mas).

1. Ground plan between 5- and 15-foot levels (HS, plan 1).
2. Upper plan between 15- and 30-foot levels (HS, plan 2).
3. Section through westernmost cloisters (HS, plan 3).
4. Section (north-south) through palace court, basilica, and main cloister (HS, plan 4).
5. Section (east-west) through King's house, basilica, forecourt, and portico (HS, plan 5).
6. Elevation, south façade (HS, plan 6).
7. Perspective rendering from west by north (HS, plan 7).
8. Map of environs (after Jürgens, *Spanische Städte*, Map 25).
9. View from southeast (Meunier, ca. 1665, in EEC, 1:666).
10. Main cloister, from west (Meunier, ca. 1665, in EEC, 1:670).
11. Main altar, from choir balcony (HS, *perspectiva*).
12. Jacome da Trezzo, commemorative medal (MAN).
13. Karel de Mallery, *Hannah* (courtesy Colin Campbell).
14. Jacome da Trezzo, medal commemorating Herrera, the basilica, and the birth of Philip III, 1578 (MAN).
15. Tabernacle in main altar (HS, plan 9).
16. Valsain, oil painting (photo EK, 1979, by permission of IVDJ).
17. Yuste and Escorial, royal bedroom in relation to altar (after Zuazo, in EEC, 2:141).
18. Pedro Perret, *Allegory* (after Cervera, in EEC, 2:94).
19. Drawings of spires (lower left) and details of main cloister (LS, pl. 19).
20. Entrance façade of basilica (LS, pl. 1).
21. Entrance façade of basilica with statues (photo EK).
22. Temple of Solomon (after Prado and Villalpando, *Ezechielem* 2: pl. 12, courtesy Columbia University Libraries).
23. Drawings of Spalato (after Zorzi, *Disegni*, figs. 266, 267).
24. Filarete, *Ospedale maggiore*, Milan, plan and façade (after Spencer, *Filarete's Treatise* 2:ff. 82ᵛ, 84ᵛ).
25. G. V. Casale (A) plan of S. Maria del Carignano, Genoa (BNM); (B) view from west (photo Sagep spa).
26. Section of basilica, preliminary design (LS, pl. 2).
27. Flat vault in forechurch (photo EK).
28. S. Sebastiano, Mantua (after Mancini, *Vita di Alberti*, p. 396).
29. S. Maria, Montepulciano (photo Alinari).
30. Escorial, reconstructions of early design (A) Zuazo, in EEC, 2:110; (B) L. Perez Bes, 1970 (after copy in AME).
31. Monastery cloisters, plan before 1567 (LS, pl. 21).
32. Elevation (rejected) adding fourth story to monastery cloisters (LS, pl. 20).
33. Sketch plan of the state of construction in 1568 (based on Rubio, in CD 161 (1949): opp. p. 182).
34. Perspective view of construction in 1568 (Rubio, in CD 161 (1949): opp. p. 182).
35. Luca Giordano, mural in main stairway (before 1702), at right the King, Toledo, Herrera, and Villacastín (photo Mas).
36. Views of basement talus (A) southwest tower; (B) adjoining central "tower"; (C) southeast corner at prior's tower (photos author, 1952).
37. Refectory (A) to north (photo author, 1952); (B) to south (photo EK).
38. (A) Plan (after Zuazo, in EEC, 2:147); and (B) view of "sun-corridors" (photo EK).
39. Plan at ground level of southwest tower and cloister supports with comments in handwriting of Juan Bautista de Toledo (LS, pl. 18).
40. Provisional church (A) showing crypt beneath altar (AME); (B) looking north (photo author, 1964); (C) to south (photo EK).

41. View of the King's dwelling at La Fresneda (A) façade; (B) monastery cloister; (C) monastery façade (photos EK).

42. Elevation of ground floor, main cloister, northeast corner (LS, pl. 22).

43. Serlio, façade, theater of Marcellus, Rome (after Serlio, *Libro Tercero*, 1552, fol. 27).

44. Plan of crypt (A) after Andrada, in EEC, 2:839; (B) after LS, pl. 24; (C) after LS, pl. 23.

45. Plan of basilica, with discarded sanctuary, before 1575 (LS, pl. 5).

46. Plan of basilica at sanctuary foundation level, changed after 1575 in palace court and spiral stairs to choir (LS, pl. 7).

47. (A) Rejected plan for sanctuary at level of royal tombs flanking main altar (LS, pl. 6); (B) nearly final plan of basilica, with quadrate sanctuary, *camarín*, lateral tombs. Palace court and spiral stairs to choir altered in final design 1576 (LS, pl. 8).

48. Main cloister, "imperial" stairway (A) stair tower, from east (photo author, 1964); (B) view looking east (after Brambilla, *Coleccion*, 1832, p. 7).

49. (A) Main cloister, fountain of the Evangelists (photo EK); (B) elevation of fountain edicule; and (C) plan of basins (after Ruiz de Arcaute, *Juan de Herrera*, pp. 121, 122).

50. (A) Elevation of kitchen portico, west front, built after 1568 (LS, pl. 25); (B) kitchen vault (photo EK); (C) kitchen to west (photo EK).

51. Monastery cloister, southwest court (photo EK).

52. Plan of foundations under dome supports of basilica, begun 1573 (LS, pl. 9.1).

53. Variant designs for dome supports: the smallest corresponds to pillars as built (LS, pl. 10).

54. Plan of the partitioning of the basilica in contracts.

55. G. V. Casale, drawing on site of crane used at Escorial (BNM).

56. Dome of basilica (photo EK).

57. Preliminary plan (rejected) of forechurch beneath choir balcony (LS, pl. 9.2).

58. Plan of sanctuary and King's apartment marked with sightlines from bed to windows and altar (LS, pl. 14).

59. Plan of south tower, basilica façade, at thirty-foot level (LS, pl. 15.2).

60. Plans of south tower showing lower and upper shaft above monastery roof, (A) working draft with corrections, (B) finished tracing (LS, pl. 16).

61. Tower face, suitable for any of the eight identical faces of both towers (LS, pl. 17).

62. Working interior elevation looking west at north-south cross section (LS, pl. 3).

63. Working elevation in basilica, looking south, from tower at right to entrance to sacristy at left (LS, pl. 4).

64. Airshafts flanking forechurch, behind basilica towers (A) north airshaft (photo author, 1964); (B) detail of fig. 63 showing south face of south airshaft as designed before changes (LS, pl. 4, detail); (C) south airshaft as built (photo author, 1964).

65. Fabricio Castello? Drawing of the Escorial in construction, c. 1576. Hatfield House, collection of Lord Salisbury (after Skelton and Summerson, *Description of Maps*, permission of Lord Salisbury).

66. Hatfield drawing, detail lower center, showing cranes raising stone for basilica walls.

67. Courtyard, King's house (A) east range corner before removal of ground-floor windows (photo Eloy, 1963); (B) west range (photo EK); (C) west range fenestration (photo EK); (D) upper sanctuary wall (photo EK); (E) east range (photo EK).

68. Main reception rooms, King's house (A) upper winter room; (B) lower summer room (after Zuazo, in EEC, 2:348).

69. King's apartment: dining room and bedroom (PAN).

70. Sanctuary, altar, and tomb of Philip II above doorways to King's bedroom, left and center (PAN).

71. Window illuminating north reliquary chapel (A) exterior position (PAN); (B) detail, south side, exterior (photo author, 1964); (C) interior position relative to chapel of relics (photo author, 1964).

72. Plan of upper floor palace attic chambers on palace court (LS, pl. 31).

73. Plans of six levels in east building of palace court (LS, pl. 30).

74. Hatfield drawing, lower right, east building of palace during construction, 1576.

75. Plan of hall and reception room in east building of palace (after Andrada, in EEC, 2:345).

76. Plan of service buildings at ground level in palace court, working drawings (LS, pl. 26).

77. Views of service buildings from palace (A) looking southwest (photo author, 1978); (B) looking northeast (photo EK).

78. Hatfield drawing, upper right, college quadrant in 1576.

79. North façade and college tower (A) north and west façades; (B) northwest tower from south (photos EK).

80. Plans and section of college crossing tower (drawing EK).

81. View of college assembly room (after Zuazo, in EEC, 2:119).

82. Main entrance façade (A) from west (after Cervera, in EEC, 2:54); (B) from forecourt (photo EK).

83. Projects attributed to Juan Bautista de Toledo for main entrance (A) "Palladian"; (B) "Alessian" (after Ruiz de Arcaute, *Juan de Herrera*, opp. pp. 17, 32).

84. Hatfield drawing, top center, showing entrance area and forecourt.

85. Passage between infirmary and Compaña (A) "warped" door to street; (B) south façade (photos EK, 1979); (C) drawing c. 1785, south elevation (after Caturla, *Pinturas*, opp. p. 20).

86. Flour mill with water-driven turbine in Compaña outbuildings (A) plan; (B) section (LS, pls. 33, 37).

87. Plans of upper floor, "second" *casa de oficios* (A) indexed as to use; (B) plan of chapel at northwest corner as built (LS, pls. 46, 45); (C) view of both *casas de oficios* from southwest (photo author, 1978); (D) court of present post office (photo EK).

88. Plans, elevations, and sections of "second" *casa de oficios* (A) final working plan, including chapel (LS, pl. 47); (B) plan at lower level (LS, pl. 48); (C) east section of north building in palace (LS, pl. 40); (D) north elevation, upper street (LS, pl. 39); (E) section through court and south rooms (LS, p. 41).

89. Working sketch and plan for ground floor, "second" *casa de oficios* (LS, pl. 42).

90. Final plan, upper floor, "second" *casa de oficios* (LS, pl. 49).

91. (A) Plan of paving on west and north plazas (after Jürgens, *Spanische Städte*, pl. 12); (B) view of north plaza (photo EK).

92. Meeting of low palace lead roof and steep monastery slate roof between basilica and monastery (photo author, 1964).

93. Lower attic chamber (*camaranchón*) between main stair tower and south basilica-façade tower (photo author, 1964).

94. Gabriel Joli (1700-1777), oil painting before 1771 (photo M. Soria collection, Yale University).

95. Serlio, diagrams of relieving arches over flat-arch lintels (after Serlio, *Libro Quarto*, 1552, fol. 17ᵛ).

96. (A) Interior, southwest-tower stair (photo EK, 1979); (B) iron bands in ceiling reinforcing archive stairway (photo author, 1964).

97. Monastery-crossing tower (A) elevation, as originally built (Andrada, in EEC, 2:333); (B) as restored after 1671 (drawing EK); (C) view of interior (photo EK); (D) view from southwest (photo EK).

98. Library (A) from south (PAN); (B) northern window on east side, drawing by P. Tibaldi with comments by Herrera (BM).

99. Garden stairs (A) Hatfield drawing, lower left, building the prior's garden stairs; (B) section and elevation (HS, plans 1, 4); (C) plan; (D) view of grotto and its entrance at southwest corner, lower garden level (photo EK, 1979).

100. Hatfield drawing, upper left, showing curved spire profiles and main-stair roof, 1576.

101. Basements, cisterns, and toilet tanks as indicated by Herrera in HS, LS, Salcedo, and archival sources (drawing EK).

102. North façade in summer (photo EK, 1979).

103. East building, palace, basements (now Museum of Architecture) (photo Eloy).

104. Lithographed plan by F. Salcedo (1876) (photo courtesy BNM).

105. Water ducts and drains, diagram based on manual of maintenance written in 1645 (after G. de Andrés, "Relaciónes").

106. Lerma, ducal palace, river façade (after Cervera, *El Conjunto palacial*, fig. 45).

107. Madrid, Buen Retiro palace (after Caturla, *Pinturas*, opp. 34).

108. Crypt under basilica, remodeled as Panteón (engraved by Pedro de Villafranca, 1654, after Ximenez (A) entrance axis (southwest to northeast); (B) cross-axis (southeast to northwest); (C) plan; (D) stairway.

109. Sacristy (A) altar and *camarín* of the *Sagrada Forma* (after Ximenez); (B) view of sacristy from south (PAN).

110. Juan de Villanueva, plans of palace quadrant in 1785 before remodeling palace entrance and north façade (A) ground plan and basement under northeast tower; (B) plans of college apartments on entresol, upper floor and cloisters at north forecourt façade, including part of college assembly room (AGP, photos permission PAN).

111. Juan de Villanueva (A) plans; (B) elevations of the Herreran *casas de oficios* showing crowded additions in 1785, and Villanueva's designs for further enlargement (AGP, photos permission PAN).

112. Oil painting attributed to Fray Francisco de los Santos of the conflagration of 1671 (in Facultad de Arquitectura, Madrid, courtesy G. de Andrés).

113. College-crossing tower (A) as rebuilt in 1673 on Zúmbigo's design, about to come down in 1963 (photo Eloy, courtesy Ramón Andrada); (B) college-crossing steel spire, seen from cloister-crossing spire being rebuilt in 1963 to Herrera's design (photo Eloy, courtesy Ramón Andrada).

114. New roofs and attics, at the southern cloisters,

looking east to main-stairway housing, 1967 (photo Eloy, courtesy Ramón Andrada).

115. King's house, eastern gallery, lower floor at terrace level, after removal of nineteenth-century partitioning in 1962 (photo Eloy, courtesy Ramón Andrada).

116. Reception room, ground floor, east range of palace, during restoration in 1963 (photo Eloy, courtesy Ramón Andrada).

117. Ground plan at level of basilica floor, 1972 and *pudridero* (courtesy Ramón Andrada).

118. Ground plan at 15-foot level with dimensions, 1964 (courtesy Ramón Andrada).

119. Plan with partitions at 15-foot level, 1972 (courtesy Ramón Andrada).

120. Plan with partitions at 30-foot level, 1972 (courtesy Ramón Andrada).

121. Plan below 55-foot cornice, 1972 (courtesy Ramón Andrada).

122. Plan of attic chambers and dormitories, 1972 (courtesy Ramón Andrada).

123. Plan of the roofs and vaults, 1967 (courtesy Ramón Andrada).

PREFACE

WHAT ORIGINALLY attracted me to consider writing an architectural history of the Escorial in 1937 was the tight direction, swift pace, and short duration of work on this major Renaissance building. It was then already apparent that the design was divided, the plan being by Juan Bautista de Toledo and the elevations by his successor Juan de Herrera. Since then the participation, both direct and indirect, of other architects in Italy has become known (Chapter Four). In addition, archival collections previously unavailable were gradually opened for study. It became possible after 1963 to assemble materials from many archives and to write the history of the fabric in its temporal setting, with almost daily reports and accounts. The record is filled with delays, setbacks, new designs, confusion, and far from perfect decisions, as in every major architectural work past and present.

Yet no building ever had a better opportunity for approaching perfection, as its learned chronicler, Fray José de Sigüenza, first wrote about the building of the Escorial, both as an eyewitness and participant soon after its beginning. In the *Prólogo* he wrote these words:

the grandeur and majesty exceeding all earlier efforts [was] achieved by avoiding every superfluity in materials and forms. These were so well assembled and sought out for their needs and ends, that any others would be either superfluous or pretentious. The completeness of each part is so finished and related to every other part that no one can complain or worry that any is slighted.

From this a great beauty arises in the entire body. We who today see and enjoy it are freed from the desire for all that was celebrated in antiquity. We contemplate it and learn from beholding it an infinity of delights that cannot be known from ancient accounts or from the vestiges that have been discovered in the provinces of Asia and Europe by those worshippers of antiquity anxious to possess them. (FME, p. 5. See Chapter Ten on the relation of these remarks to Augustinian aesthetics.)

As with other buildings in sixteenth-century Spain (and elsewhere), the construction of the Escorial was beset by vacillation, indecision, and compromise. Remarkable is the persistence of pristine intention through four centuries of changing taste and the virtually intact preservation of the monument as if embalmed in an inviolable identity, resisting without major losses the attacks of modish change, like a sacred and funereal enclave of eternity inside the storms of history.

Still another appeal was in the relation of the Escorial to an architecture of minimal ornament—like that of the period between the two world wars. This affinity or resemblance between periods nearly four centuries apart—or as Augustine would say, of correspondence—requires explanation along unexpected lines, which converge in an aesthetic system identified with the early-Christian architecture of the ancient world and the thought of Saint Augustine.

The method of this book is to connect building history with architectural criticism. It is assumed that critical precision requires a historical documentation directly proportional to the required degree of precision. It is possible at the Escorial to relive its entire gestation and construction in a wealth of detail that is rarely if ever available for more rapidly executed forms of art, such as drawing, painting, and sculpture.

In selecting the relevant documents it was necessary to separate permanent structure from movable furnishings. The purpose throughout was to discover the motives and strategies of the many authorities and persons engaged in building the Escorial. Few edifices exist on which the record is long and complete enough for this task. Before the sixteenth century full records are rare: after it they are more dispersed and fragmentary. For the Escorial Philip II was said to have written papers enough about the building in his own hand to "burden several mules," and this is nearly the measure of such documents at Simancas, at the Escorial, and in Madrid and London.

At the beginning of the last stage of archival study it seemed possible that nearly every stone, brick, and timber could be dated and assigned to a contractor, given the wealth and redundancy of the archives. That possibility, however, is perhaps fortunately eliminated by the appearance of archival gaps owing to the political disturbances of the nineteenth and twentieth centuries, when many papers at Simancas and the Escorial were scattered or destroyed. The amount of this loss has not been exactly determined, but recently published inventories at both archives, by Amalia Prieto and Gregorio de Andrés, make their use easier. Fortunately, the contract specifications and the records of payment supplement each other, and the gaps do not often coincide, although both series are incomplete. The municipal archive in the lower town at El Escorial (the Villa) has many sixteenth-century copies of contracts that are also preserved in the monastery archive, but it was not possible either in 1964 or in 1978 to correlate the two collections.

At San Lorenzo I am indebted to Fray Luciano Rubio for many hours of discussion while visiting the monastery with him in 1978 and 1979, and to Gregorio de Andrés, who was most helpful both at the Escorial in 1963-1964 and at Madrid in 1978-1979. Fray Teodoro Alonso Turienzo, librarian in the royal archive and in the Augustinian library, was perennially helpful, beginning in 1972. The administrator for the Patrimonio Nacional at the Escorial, Don Jesus Luque Recio, made possible my visit to the upper palace floors and roofs in 1979 with my son Edward.

In Madrid, both Gregorio de Andrés at the library of the Instituto de Valencia de Don Juan and in the rare book and manuscript division of the Biblioteca Nacional, and Luis Manuel Auberson, who is dedicated to furthering knowledge of the Escorial, gave much assistance in many ways. At the royal palace in Madrid, Fernando Fuertes de Villavicencio and Ramón Andrada Pfeiffer extended many courtesies. For permission to examine the *Sumario* engravings of 1589, I thank Doña Justa Romero in the palace library and Maria Teresa Ruiz Alcón of the Inventarios office in the palace for help with photographs from the Patrimonio archive. At San Lorenzo del Escorial, Eloy Fernández de la Peña supplied photographic prints from the negatives he made during the work of rebuilding the roofs. Ramón Andrada, finally, whom I regard as the successor in this century to Toledo, Herrera, and Villanueva as among the architects of the Escorial, has my enduring gratitude for making available his measured drawings of the fabric, as well as his copious photographic files.

For great help with typing, I thank my friend Clement Kerley, of C. P. Kerley and Associates, who made possible the use of word-processing equipment, operated admirably by Mrs. Eugenia Bakes.

Early periods of research on sabbatical leaves in Spain, England, France, Italy, Belgium, and Portugal were assisted by occasional Guggenheim and Fulbright fellowships between 1952 and 1969. The sabbatical leave during 1978-1979 was made possible by a research grant from the National Endowment for the Humanities, supplemented by Yale University.

My beloved wife, Elizabeth, was the urgent cause for writing the book, and has been a participant in it from the beginning, when I was a student at the Institute of Fine Arts, New York University, in 1937. Our son, Edward, generously took time from his architectural practice to be the photographer in 1979, to make the drawings, and to be the tactful critic of the book.

New Haven, August 1, 1979

ONE

THE HUMAN
FABRIC

1

THE CHANGING FAME OF
THE ESCORIAL

THE BUILDING of the Escorial has provoked much architectural writing during its four centuries of existence.[1] The fabric began in the mind of Prince Philip II during the 1550s. Made visible in stone, it engendered among writers on architecture a wide variety of opinions exceeding the usual range of disagreement. This process too was one of building the fame of the Escorial, and it was also building the history of the criticism of art, as well as the history of ideas.

THE PANEGYRIC TRADITION

From the first generation of those who chronicled its construction and decoration, and through four centennial publications, the panegyrists have almost never adversely criticized the design of the Escorial. Its admirers have always treated it as a unique marvel of the world. Such praise has an analogy today in the lavish annual report of an industrial corporation to its stockholders. The report calls attention to new developments, and it looks confidently to the future without questioning the company's policies.

Miguel de Unamuno first remarked that almost no one in its history had been able to think about the Escorial without searching for the meaning of Philip II, and inventing it where it cannot be found.[2] Half a century later, Wido Hempel expanded on Unamuno's remarks by saying that whoever judged Philip unfavorably also disliked his building, while those who inclined to a monarchic and Counter-Reformatory ideology would reverently marvel at it. His observation holds true for the Italian poets praising the Escorial late in Philip's life, when the extravagant exaltation of Philip served also as a critique of Venetian policy

[1] The accepted usage in Spain today is not "at El Escorial," but "at the Escorial." G. del Estal, "El Escoríal en la transición," p. 561n.

[2] "En El Escorial," in *Andancas y visiones españolas*, pp. 48-49.

favoring the Turks. Their idea of the Escorial was formed on Herrera's prints (figs. 1–7) published in 1589.[3]

Spanish writers before the present century were nearly unanimous in a tradition of unrelieved praise for the marvelous character of the Escorial as the eighth wonder of the world. The expression first appeared in Spain in 1594, when Juan Alonso de Almela, a physician from Murcia, described the eighth wonder in great detail eleven years before the publication in 1605 of Fray José de Sigüenza's masterpiece.[4] This long tradition of the Escorial as a wonderment still continues in Spanish and Italian literature, where it has been surveyed and charted in some of its meanders by anthologists and historians.[5]

Padre Luciano Rubio analyzes the twelve Spanish authors whom he regards as direct sources of information. Seven contemporary witnesses of the building operations were Antonio de Villacastín, Juan de San Jerónimo, José de Sigüenza, Jerónimo de Sepúlveda, Juan de Arfe y Villafañe, Juan de Almela, and Jehan Lhermite. The other five are Francisco de los Santos (1657), Andrés Ximenez (1764), Damián Bermejo (1820), José Quevedo (1848), and Antonio Rotondo (1863). In addition, Hempel has discussed the cult of Philip II in Italian writings on the Escorial, and Theodor Henermann has used European writings other than Spanish on the Escorial as a topic in the history of criticism.[6] These valuable studies, however, do not exhaust the bibliography. Still lacking are an account of Italian writings since 1600 and the complete bibliography of the building, although the works by Teeuwen and Turienzo have advanced in that direction.[7]

Thus a division among panegyrists, critics, and scholars seems in order. The panegyrists are usually but not always Spanish. The critics who find fault are mostly non-Spanish, and usually French. The few modern scholars are mostly Spanish: Julián Zarco Cuevas, Gregorio de Andrés, Luciano Rubio, and Teodoro Alonso Turienzo as archivists and historians at the monastery. Others are historians of art: Carl Justi, José Camón Aznar, Francisco Iñiguez, René Taylor, Luis Manuel Auberson; or architects, Fernando Chueca, Secundino Zuazo, Luis Cervera. And there are many others whose studies have been more occasional.

SPANISH PANEGYRISTS

The major chroniclers were three Jeronymite friars who were eyewitnesses and participants closely involved with every aspect of construction: Juan de San Jerónimo, Antonio de Villacastín, and José de Sigüenza. They were among those who shaped the Escorial, and their writings are primary sources on most points. Juan de San Jerónimo was present from 1562 to 1591 as chief accountant for the monastery and *arquero* (treasurer), as well as a scholar in the library, who was the earliest and most authoritative of its chroniclers.[8] Both Sigüenza and Villacastín often gleaned from his account, and Sigüenza also frequently cited Villacastín,[9] who was from beginning to end the *obrero mayor* (chief workman) without whose approval no work could begin. Sigüenza

[3] HS; W. Hempel (*Philipp II, und der Escorial*, pp. 62, 103) on the "Poemi . . . in lode . . . de lo Escuriale," published at Udine in 1592 and gathered by Giovanni di Strasoldo.

[4] Sigüenza, FME; J. Almela, "Descripción de la octava maravilla del mundo," pp. 5-98. Almela's work ends with a discourse on the superiority of the eighth wonder to all those before it. Only Book 3 is published. As Gregorio de Andrés points out (p. 8) it contains little that was not said by Sigüenza, excepting the parts about the *Botica*, the Compaña, the basements, and the hospice. Almela was preceded by Paolo Morigia in using the phrase *Octava maravilla*. The two works are otherwise independent of each other. Hempel, *Phi-*

lipp II pp. 15-18; P. Morigia, *Historia brieve* . . . , 1593.

[5] S. Alvarez Turienzo, *El Escorial en las letras españolas*; L. Rubio, "Los Historiadores del Real Monasterio de San Lorenzo de El Escorial," pp. 499-521.

[6] Hempel, *Philipp II*; Henermann, "El Escorial en la crítica estético-literaria del extranjero," pp. 319-341 (reprinted in *Monasterio*, pp. 757-775).

[7] N. Teeuwen, "Bibliographie non espagnole de l'Escorial," pp. 777-805; T. A. Turienzo, "La Ciudad de Dios, archivo de documentos escurialenses," pp. 807-907.

[8] JSJ, pp. 5-6.

[9] Rubio, "Historiadores," pp. 507, 520.

called him the keystone of the enterprise[10] and his day-to-day written orders, never separately studied, would fill a large volume.

These friars were most concerned with recording the progress of design and construction, together with the constant discouragement and frustration during the work, which are part of building history rather than of criticism and evaluation, as practiced by late observers. Hence the discussion of these chronicles is part and parcel of the history of construction, and not part of the fame of the Escorial, however much the friars' words are in praise of it.

Sigüenza's history of the building supplied many pages to his successors at the monastery, Francisco de los Santos and Andrés Ximenez.[11] Santos added a new description with engravings of the redecoration of the crypt (1617-1654) on designs by G. B. Crescenzi, and Ximenez supplied a catalogue of some of the painters and craftsmen who had worked at the Escorial. Both authors, unlike Sigüenza, whose "plain" style suits the architecture, were generous with superlatives, which often reappear in nineteenth- and twentieth-century handbooks and guides.[12]

The purpose explained by Ximenez in the *Prólogo* was to safeguard the commemorative panegyric tradition, which Santos established, by continuing it without change, enriching it only with new figures of speech and the description of new additions to structure and decoration—the altarpiece of the Santa Forma in the sacristy, and the jeweled treasures or paintings which had been added to the Escorial since its description by Santos in 1657.

Antonio Ponz, whose career was closely bound to the reform of taste in eighteenth-century Spain, spent enough years at the Escorial (1760-1765) as a copyist, using the skill he learned in Rome (1751-1759),[13] to speak with authority on the building and its art collections. This he did at astonishing length in the eighteen volumes of the

Viaje de España (1772-1794), where references to the Escorial are more abundant than to any other place in Spain excepting Madrid.[14] According to his nephew and biographer, José Ponz,[15] Don Antonio had read in Italy Norberto Caimo's travel books about Spain with such excitement and disagreement that he resolved to travel at length in Spain, to correct Caimo's mistakes.

Padre Caimo (fl. 1715-1777) spent three weeks at the Escorial (8-29 August 1755) writing long letters about his impressions.[16] They reflect the views of a cultivated cleric familiar with the theoretical writings of his time. He began by saying that he could not accept the Escorial as the "unique marvel of the world," in Santos's words. He preferred to call it only the eighth, rather than to follow the Spaniards in their inflated praise, on the strength of several criticisms of his own. He disapproved of the orientation that caused the building to turn its back on Madrid, and to thrust the principal west façade so close to the mountain slope only 100 paces away (fig. 9), that in August a full hour of daylight was lost on this exposure. Ponz never answered this point.

Caimo's second criticism was that the church suffered because the huge choir balcony cut off its light, by requiring the people to enter under the oppressively low, flat *sotacoro* (under-choir) vault, as through a dark grotto (figs. 1, 5). Ponz at first replied by calling attention to the remarkable feat of building a flat vault over a square area sixty feet on each side, and he accused Caimo of exaggerating its darkness.[17] Ponz then exonerated the architect for building it as ordered (*el arquitecto siguió lo que se le ordenaba*), which may indirectly blame the King. But later on in 1792[18] Ponz adopted Caimo's own position, saying that "those choirs, built over doors and entrances, seem invented only to make the churches cavernous and dark, at least for a third, if not one-half their length. Would not the church of the Escorial appear in greater majesty at the first entrance if this

[10] FME, p. 454.

[11] Sigüenza, *Fundacion del Monasterio de San Lorenço el Real*, 1605; F. de los Santos, *Descripción del Real Monasterio de San Lorenzo del Escorial,* 1657; A. Ximenez, *Descripción del Real Monasterio de San Lorenzo del Escorial,* 1764.

[12] Alvarez Turienzo (*El Escorial en las letras españolas*) has listed some (pp. 76-77) of these commonplaces.

[13] J. Ponz, "Vida de Don Antonio Ponz," pp. 5-15.

[14] Madrid has twenty-one lines of entries, and the Escorial seventeen, Toledo eleven, and Rome twenty-nine in the 1947 index of the *Viaje.*

[15] "Vida," p. 10.

[16] N. Caimo, *Lettere d'un vago italiano ad un suo amico,* 1759-1767.

[17] *Viaje,* 2: 159 (written 1773).

[18] *Viaje,* 16: 1432-33, par. 51.

huge choir was not there? It makes the distance to the nave seem like passing through a cellar." Actually, neither Caimo nor Ponz mentions the important fact that the program for the basilica, as a mausoleum and palace chapel, required from the beginning that it be separated from the lesser area where people from town and countryside could worship as in a parish church beneath the choir. Sigüenza makes this clear: "The basilica is a square . . . where as in a royal chapel not all may enter," while "for the common people and ordinary services . . . the area beneath the choir provides abundant space, being like the body of the church." Elsewhere Sigüenza holds that "His Majesty wished to use [the basilica] with his children undisturbed by commoners [*gente común*]."[19]

Ponz also thought the steps to the main altar were too many, and that this was because the friars in the balcony had to be able to see the altar from the lofty choir (fig. 10). As to the main cloister, he cites Sigüenza's opinion that the fountain building was too large, diminishing the majesty of the surrounding cloister façades, by being thirty feet wide and fifty-five feet high, as shown in the engraving accompanying his comment (fig. 11).[20]

Caimo's other criticisms are of the stairways in the small cloisters, as uncomfortably dark and low, and of the refectory, a vaulted chamber which he thought was also too low (fig. 37), noting that its height was constrained by an effort to avoid differences of floor level in first and second stories of the south range. He likewise criticized the King's chambers (fig. 1, *102*) as too small and confined, so much so that they were hardly worth comment. At the library he noted that its south

entrance was off center and too close to the corner of the room (fig. 2, *R*). In general, Caimo's negative criticisms of the Escorial were few and his praises abundant. He was unaware of the program, both as to functions and as to ritual, and his comments are more normative than investigatory, being concerned with how the building might be improved, instead of why it is as it is.

Caimo's letters at the beginning of the *Viaje* affected Ponz more than those at the end. Ponz borrowed their format as well as their scholarly concern for correct attributions, and the comparative method for assessing the relative values of similar works. These procedures were present, not only in Caimo's writings, but also in the ideas Ponz absorbed in Italy from many other sources. Yet the *Vago Italiano* is the only writer Caimo cites with frequency (eighty-six times), more often than Vasari (eighteen), Vignola (twenty-six), or Palladio (six). Caimo attracted Ponz as an opponent early in the Spaniard's career, but twenty years later Ponz came to agree with Caimo on the question of the *sotacoro*, on which they both were inadequately informed.

In review, Ponz appears mostly in the role of a panegyrist for the Escorial, leaving it only at the end of his life, in order to defend his ideas about a better seating for prebendaries than in choir balconies. His firm belief always remained that "if a Spaniard abroad finds his country attacked on account of its famous buildings, he may defend himself in good reason with the magnificent edifice of the Escorial."[21] The Escorial and the style of Herrera were his touchstones of quality in the arts.

NINETEENTH-CENTURY GUIDEBOOKS

The friar Damián Bermejo published his *Descripción artística* in 1820 to make known the restoration of the edifice under Ferdinand VII and the damages inflicted by occupying French troops (pp. iii-iv). This small pocket-book owes its entire organization to the panegyric tradition. Its literary style is less opulent than that of its predecessors, being more a forerunner of the later guidebooks in its octavo format than the large quartos of the publications of 1657 and 1764. Ber-

[19] FME, pp. 591, 468.
[20] *Viaje*, 2: 163, 183. As Ponz copied Meunier's etching of

about 1665, it seems appropriate to reproduce his source.
[21] *Viaje*, vol. 7, prologo, 584 (first published 1778).

mejo himself says (p. v) that "every day Spaniards and foreigners come" to examine and admire the Escorial and the treasures in it.

The guidebooks issued in great profusion during the expansion of nineteenth-century travel have been studied by Alvarez Turienzo.[22] They are as lacking in architectural criticism as were the more costly books of panegyric purpose, although they inherited from Bermejo the factual assertion and the concise description. Like the panegyric, the guidebook starts from the assumption that the importance of the subject matter needs no justification.

Bermejo claimed to have taken measurements and to have searched for the most "authentic and certain notices" in its archives (pp. vi-vii). Bermejo's book is an exact description, but Quevedo's supplies history and biography, as well as sections enumerating losses and restorations, all in the panegyric mode, and claiming that the Escorial is "the prime monument of Spain, and even

of Europe; the most beautiful and complete edifice the arts have produced; the most august temple of Christianity; the most incontestable and eloquent testimonial of the knowledge and power of the Spanish nation; the most eloquent page in its sixteenth-century history."[23]

If Bermejo's small octavo was the first guidebook written for lay visitors coming to the site by diligence, Rotondo's large folio volumes were his first abundantly illustrated accounts of the Escorial and its collections, printed not long after steam trains began bringing daily visitors, as Rotondo explained in that year, "erasing distances among peoples and making one family of them all . . . the locomotives trailing their lovely manes of vapor and spreading enlightenment."[24] Thus the illustrated guidebooks, large and small, were written for tourists and summer visitors at a time with an uncertain future, when the buildings and their endowments were falling into decay.

DEROGATORY WRITINGS

Stories and legends hostile to Philip II are the continuing source of a long tradition of animosity about the Escorial.[25] Many older travel accounts appear in the anthology edited by J. Garcia Mercadal. Non-Spanish publications bearing on the Escorial are reviewed and classified by T. Henermann. Paul Guinard, finally, when invited to write on French travelers by a centennial commission unfriendly to criticism of the Escorial, resolved the difficulty with grace by concentrating on illustrations and the panegyrical aspects of the abundant literature in French. Derogation is disparagement with an overtone of misrepresentation, as of incomprehending detraction, and it continues today along traditional lines in writings about the buildings. This tradition of derogation began soon after the decision was made to build a burial place for Charles V in memory of the victory at San Quintín (1557). The Treaty of Ca-

teau-Cambrésis in 1559 sealed a French defeat that was the first military triumph of Philip's reign, when the Escorial was still an unknown village.

From the beginning in 1557 such derogations surround the vow at San Quintín. An example is in the travel notes of Jacob Sobieski of Poland, who visited Spain in 1611. He had heard it said that during the siege of St. Quentin in Flanders, the church dedicated to San Lorenzo was converted into a fort, and that the vow was made by Philip to recompense the saint for the profanation of his temple by building a monastery of such magnificence that it would be known across the ocean as a miracle of the world.[26]

Scholars agree, however, that no document supports this account of profanation and vow of reparation, and that Philip's only vow was to erect a burial place for his father and to give thanks for innumerable blessings by the construc-

[22] "El Siglo de las guías escurialenses," in *El Escorial en las letras españolas*, pp. 115-136.

[23] J. de Quevedo, *Historia*, p. vii.

[24] A. Rotondo, *Historia descriptiva*, p. 5.

[25] J. Garcia Mercadal, *Viajes de extranjeros por España y Por-*

tugal; Henermann, "El Escorial"; P. Guinard, "El Escorial visto por los escritores franceses," pp. 661-682.

[26] Garcia Mercadal, *Viajes*, 2: 333. This story was repeated by Théophile Gautier, *Voyage en Espagne*, p. 139.

tion of a monastery[27] called San Lorenzo de la Victoria, a name still in use as late as 1562,[28] although early documents from the building site are usually stated as from "la Fabrica del Monasterio de Sant Lorencio" (1562), later becoming "San Lorencio el Real" (1564). This last designation stayed in use all through the period of construction (1584).

The acrimony of most older criticisms of the Escorial, especially in northern Europe, is prefigured in 1563 in a remark by the first prior, and again about 1587 in an anonymous satire (Appendix 6), of a hostility matched only in the comments of French travelers in the Romantic period. The first prior, Fray Juan de Huete, was ordered to move to the Escorial from the comfort of Guisando as an ill old man. He arrived on 1 March 1563 to live with five other friars in a house bought for them by the King in the lower town, where several small chambers served as cells. As Sigüenza says, "the place had poor lodging for them."[29] No house in the town had either a window or a chimney, "with light, smoke, animals, and men all having but one door." Huete was still too exhausted on 12 April to attend the laying of the first stone at the site of the future monastery, but on 20 August he was able to be

at the foundation-stone ceremony for the church. On 11 November, his patience was already at an end, and he wrote angrily to the King's secretary, Pedro de Hoyo, blaming the architect, Juan Bautista de Toledo, for neglecting the work: "I hold it a shame that he who is in charge never sees it from one millennium to the next, except for a day or two, so that there is no church being built in this worst place in the world [el mas ruin lugar del mundo], because he who is to build it does not live there."[30]

More public is a sharply critical anonymous satire of about 1587-1590, which ridicules the site[31] as barbarous (descortés) and abominable (aborrecible), and the building thrust into the mountains as lacking good climate, too hot in summer, too cold in winter, in a barren setting without wine or bread, where the King, forgetting his rank, sleeps on coarse bedding. The church is closed to the people, the figures of the Saints in it are too distant to be seen, the painters seem to have forgotten their art, and even the books are invisible in the library. The author was certainly a wit, and he knew without love both the town and the royal site above it, at a time when the edifice was nearing completion and far from looking its best.

CLASSICAL FRENCH ARCHITECTURAL CRITICISMS

Other disparagements of the building itself began to appear among French travelers' accounts in the seventeenth century. These remarks are usually set among expressions of polite approval. With others yet to come from the Romantics, there formed a stock of commonplaces that were shared among the literary travelers to Spain in Europe.

Antoine de Brunel in 1665, after restating the mythical vow of reparation promised for the des-

ecration at San Quintín, described the Escorial as the "ugliest place in nature," because of its towering mountain and wretched village. He saw the north entrance as "unclear and unimpressive," and the main façade as crunched against the foot of the mountain to the west. The building was good for friars, but inadequate for a great monarch, whose dwelling was far from royal, being of small, low, and bare chambers with furniture

[27] L. Rubio, "La Victoria de San Quintín." L. M. Auberson, "San Lorenzo," p. 354, argues that the vow was to build a church at the saint's Spanish birthplace at Loret, and that this vow had nothing to do with the Escorial.

[28] L. Cabrera de Cordoba, Felipe II, 1: 370 (first published 1619).

[29] FME, p. 24.

[30] PA, pp. viii-ix (AGS, legajo 258, f. 295, 8 pp.)

[31] Alvarez Turienzo, El Escorial en las letras españolas, pp. 186-187. The termini ante and ad quem are suggested by a reference to the Prince (born in 1577, King in 1598 as Philip III) as "not learning his grammar." His father began grammar aged 10 (J. March, Niñez, 1: 68-69).

made to be moved whenever and wherever the King moved. The paintings were unimportant, and the library had an insignificant, hidden entrance. What magnificence could be seen was lugubrious and overpriced. The exterior lacked small gardens owing to the bad climate.[32]

François Bertault (1659)[33] was another French traveler read widely throughout Europe. He found the Escorial unimpressive and lacking in liveliness, set as it was in a rocky and barren countryside. The building had no esplanade for the view to Madrid, and the west façade was as though blinded by the mountain rising above it. He liked the granite (as being between marble and limestone), but the corner spires drew no praise. The inner courts gave a crowded effect, the Patio de Reyes was airless because of the high buildings enclosing it, and the many courts behind them were dark as prisons. His remarks are incisive and welcome after the blandness of the panegyrists. They offer a repertory of French academic judgments, but without the historical interest in knowing why taste differs from country to country.

Madame d'Aulnoy, who was in Spain from 1679 to 1681, admired the granite, but found the little cloisters monotonous ("who has seen one has seen the others"). The building had no surprises for her, but she liked the massing. The expense struck her as excessive and out of proportion to the beauty it produced, with the exception of the newly decorated mausoleum, which she appreciated for the richness of its materials. She found the King's house inadequate ("not sumptuous"), more a place of retreat and prayer.[34] She thought Bramante was the architect. Both Madame d'Aulnoy and her compatriot A. Jouvin[35] expressed high approval only of the richness of the materials in the sanctuary and crypt, following the taste of the French court in the 1670s.

Norberto Caimo (1755) needs mention again, to place him in relation to his predecessors. He confused the architect with Juan Bautista Monegro, the sculptor. The vow was made to assure victory at San Quintín, and the Escorial was Spain's only benefit of that victory. But Caimo's architectural criticisms are more vivid than his history: the northern windows are fewer than the southern ones because of the terrible winds, which carry away men and animals like leaves, eroding even the granite in flaky sheets. The church, he says, is a small copy of St. Peter's in Rome. A poorly designed choir balcony reduces light in the nave, being supported by a flat vault in a dark vestibule, and the choir might well be moved elsewhere.[36]

Jean-François Peyron (1772-1773) borrowed freely from other travelers, adding some acute observations of his own. Though arid and barren, the site struck him as *pittoresque* and suitable for a monastic retreat, in the semblance of a city, with its palace, several churches, a college, libraries, artisans' workshops, a park, gardens, factories, and promenades. The crypt, however, failed to inspire reverence, even though it had been "designed by Charles V himself."[37]

Jean-François de Bourgoing (1777-1795) was in Spain for many years as an anticlerical diplomat. He saw the corner towers as the inverted feet of the gridiron of San Lorenzo's martyrdom. During the residences of the court, the friars' cells accommodated courtiers of both sexes. He thought that the main supports of the dome in the basilica were too massive and that the passageways among the many cloisters were so narrow and dark that the finest designs, which were the main stairway and the entrance portico of the basilica, were discovered by surprise and without adequate preparation. In the library the colossal frescoes dwarfed the bookshelving. Without the court in residence, the Escorial was only an enormous monastery, imposing by mass and solidity more than by magnificent decoration.[38] Both Peyron and Bourgoing, who expressed their feelings as visitors more openly than had those before, anticipated the sensibility of the Romantic travelers.

[32] Garcia Mercadal, *Viajes*, 2: 435. This work has wrongly been assigned to F. van Aerssen.

[33] Ibid., p. 617.

[34] Ibid., pp. 1096-1097.

[35] Ibid., pp. 773-775.

[36] Ibid., 3: 423-430. French, German and Polish editions of

this work exist.

[37] Ibid., pp. 859-870. Peyron's work was first published in 1780, with a second edition in 1782, followed by English and German translations.

[38] Ibid., p. 966.

ROMANTIC CRITICS

Paul Guinard and Theodor Henermann both discussed the new attitude toward the Escorial, emerging in France and Germany after the Revolution, as under the influence of Schiller's play *Don Carlos*, wherein the retardate first-born son of Philip II and Maria of Portugal (twice his first cousin) was transfigured as a symbol of insurgent youth seeking freedom.[39] The play was a deforming substitution for the biological reality of Don Carlos's sad life;[40] in it, the figure of Philip the Prudent became a demoniacal tyrant, and the Escorial was his horrid, monk-ridden charnel house.

Instead of criticizing architecture, travelers began to express their feelings, as did Wilhelm von Humboldt in 1799. Being struck by the number and narrowness of the windows, he found a Gothic aspect for the building.[41] Chateaubriand saw the Escorial as funereal buildings invented by Philip, and others viewed the Escorial as an expression of the tyrant, satanic in his conventual prison, guarding the fortress of God.[42]

Théophile Gautier's visit in 1840 found the Escorial deserted after the exclaustration of 1837,[43] and his harsh phrases, "architectural nightmare, desert of granite," describe abandonment and desolation. Gautier's remarks are otherwise lacking in architectural insight except for his observation that the alleged resemblance of the plan to the gridiron of the martyrdom was a "symbolic puerility."[44] Edgar Quinet in 1843 likewise saw only death and desolation, but as expressing the union of church and tyranny in a place where the *pudridero* (rotting-place) is the least sad relic of a dead society.

From 1850 to 1900 over sixty travel books on Spain appeared in France, each containing a chapter or at least a few paragraphs on the Escorial, but nearly all authors, whether Catholic or Protestant, indulge more in funereal feelings than in architectural observation.[45] Like Unamuno, Guinard would say the collective inability of the age to appreciate the Escorial is owing to a bourgeois dislike of *desornamentado* simplicity.[46] The rise everywhere in Europe of a renewed taste for the Gothic may also be to blame.

CRITICAL STUDIES SINCE 1880

In Germany, finally, a few appeared at the end of the century who found the Escorial marvelous for its architecture. One of the earliest was Ludwig Passarge, who could admire anew the luminosity of the basilica, based like a Greek temple on clear and simple forms, writing unashamedly about the sublime, and ridiculing the labyrinthine anxiety of his European contemporaries, noting their stereotyped opinions.[47] His redemption of the Escorial eventually found followers, but it was not until 1935 that Georg Weise attempted to absorb the chronicles by Sigüenza and Villacastín, as references for Passarge's perceptions of majesty, grandeur, and sublimity.[48] Yet the German concern about Counter-Reformation grandeur and sublimity in Spain lacked historical depth, much as the panegyrists' unquestioning view of the Escorial as a flawless building was also unhistorical.

Exact archival knowledge of the Escorial began in 1916 with the first publication of Villacastín's

[39] Guinard, "El Escorial," 2: 667; Henermann, "El Escorial," p. 329.

[40] L. Pfandl, *Philipp II*, pp. 372, 386.

[41] *Gesammelte Schriften*, 15: 321f., cited by Henermann "El Escorial," pp. 329-330.

[42] F.-R. de Chateaubriand, *Mémoires d' Outre-tombe*, ed. Levaillant, 3: 7; A. de Custine, *L'Espagne sous Ferdinand VII*, 1838, 2: s.v. Escorial.

[43] Quevedo, *Historia*, pp. 241-247.

[44] T. Gautier, *Voyage en Espagne*, pp. 126-131.

[45] E. Quinet, *Mes Vacances en Espagne*; Guinard, "El Escorial," p. 671.

[46] Unamuno, *Andanzas*; Guinard, "El Escorial," p. 673.

[47] *Aus dem heutigen Spanien und Portugal*.

[48] A. Haupt, *Geschichte der Renaissance in Spanien und Portugal*; L. Bertrand, *Philippe II à l'Escorial*; T. Davies, *The Golden Century of Spain*; Weise, "Der Escorial . . . ," *Spanische Forschungen der Görresgesellschaft*, ser. 1, vol. 5 (1935): 337-360 (republished in Spanish with an epilogue in EEC, 2: 273-295).

memoirs of the construction, in a series of scholarly editions still in progress. Catalogues of the relevant papers at Simancas and in the monastery now make it possible to find exact documentation on almost every recorded aspect of the building's history.[49] Portabales had used the archives to support his thesis that the architects knew and did little, while the *aparejadores* (or master builders) did almost everything.[50] Padre Luciano Rubio found contrary evidence in the same archives and prepared the chronology of the building operations; Cervera discovered new information on the life of Herrera and his family; Zuazo investi-

gated the origins and antecedents of the designs; and Chueca rediscovered the old royal tradition of the monastery-palaces of Spain before the Escorial.[51]

In 1936 most of the sixteenth-century architectural drawings related to the Escorial were first published as tracings with a biography of Herrera based on the documents known to Llaguno.[52] The catalogue of these drawings in the palace library at Madrid[53] is fundamental to any study of the Escorial today, as is the book by Iñiguez relating them to the archival sources.[54]

[49] DHM, 1 (1916); A. Prieto Cantero, "Inventario razonado de los documentos," pp. 7-127; G. de Andrés, *Inventario.*

[50] PA and PM.

[51] Rubio, CD 160 (1948): 52-108, 419-474, and "Cronologia," pp. 11-70; L. Cervera Vera, "Semblanza de Juan de Herrera," pp. 7-103, and *Las Estampas y el Sumario*; S. Zuazo Ugalde, *Orígenes*, and "Antecedentes," pp. 105-154; and

F. Chueca Goitia, *Casas reales.*

[52] A. Ruiz de Arcaute, *Juan de Herrera*; E. Llaguno, *Noticias.*

[53] LS.

[54] F. Iñiguez, *Trazas*, less tendentious than Portabales, but reflecting the archival confusion that faced scholars before the appearance of the Simancas and Monastery catalogues by Amalia Prieto Cantero and Gregorio de Andrés.

2

THE CHAIN OF COMMAND

THE KING'S WISHES

The daily custom of Philip II was to make his wishes clear even when he was changing his mind, as seen in the innumerable comments he scrawled in the margins and between the lines of every paper reaching his desk for decisions. Only time and unauthorized interpretations by others blurred them in frequent and necessary changes. His own writings are mostly fragmentary orders revealing the emergent and pragmatic character of his thought. The solutions are provisional pieces, in a stable system of purpose, pieces adapted to changing needs during a quarter-century of construction. Two major documents from him set forth his intentions in building the Escorial, once in 1567, four years after the official beginning of work, and again, after its completion, in his testament of 1594.

The letter of foundation and endowment for San Lorenzo el Real summarizes ten years of Philip's thought about the burial place for his parents and family:[1] in brief, that the purpose of the Escorial was to place there the body of his father, the Emperor, inappropriately left at Yuste, where he died. Nothing is said about any vow to replace a church allegedly destroyed at San Quintín on the feast day of San Lorenzo (10 August 1557). The Spanish occupation of the French town occurred after 27 August, and the dedication of the Escorial to San Lorenzo, an early Spanish martyr, was part of Philip's Hispanic policy, corresponding to his lifelong desire to be King in Spain rather than Emperor in Europe.[2]

The letter of 1567, however, enlarges the scope of the King's plans: the purpose of building the Escorial now was to fulfill the wish of Charles V, the Emperor, to be buried with his wife. The Emperor imposed only one condition in a codicil to his will, that the burial should not be in Granada with his grandparents, Ferdinand and Isabella. To this effect, Philip says, he founded San Lorenzo el Real near the Villa del Escorial,[3] dedicating it to San Lorenzo in memory of the favor

[1] "Carta de fundacion y dotacion," DHM, 2 (1917), 63-138 (22 April 1567). In 1566 he wrote to his Ambassador at Rome that the building would serve to "posar alli el cuerpo del Emperador, mi padre (que haya gloria), que esta indecentemente en Yuste, donde murio." Iñiguez, *Trazas*, p. 73, citing IVDJ, envío 61, #11 (16 May 1566).

[2] L. Rubio, "La Victoria de San Quintín," p. 411. Auberson, *Monasterio*, pp. 333-362, found evidence that Philip offered a church to Loret in Spain in 1585 to honor the Spanish martyr at his birthplace.

[3] Raised to status as Villa in 1565 (Zarco, DHM, 2: 191).

and victories that Philip began to receive on the Saint's feast day, and founding it among the Jeronymites because of the affection and devotion of Philip and the Emperor for that order.[4]

The King's building was often called by its martial title, San Lorenzo de la Victoria, and if the "expiatory vow" is an unfounded and derogatory legend, there is some authority for the belief in the sixteenth century that the Escorial was a monument commemorating the victory at San Quintín.[5] No mention of the battle by name appears in the letter of 1567, and in 1562 the Venetian ambassador in Madrid wrote the Doge that the church being built by Philip was "dedicated to San Lorenzo della Vittoria."[6] The name was rejected in Spain, however, when the prior at San Lorenzo told the King that the community preferred in ordinary speech to call the monastery "San Lorenzo el Real," not "de la Victoria" or "de la Herreria," as it was too small.[7] Philip's wish in the matter followed, as it did so often, the friar's own. But the idea if not the name persisted through the sixteenth century, finding expression in two widely circulated medals of 1563 and 1578.

The early medal (fig. 12) with rim of laurel leaves portrays a profile bust of Philip in armor and bareheaded. The reverse shows a round, domed temple and the legend PIETAS PHILIPPI 1563.[8] The armor, legend, and laurel all allude to San Quintín, the battle that destroyed French military ambitions and gave Spain uncontested power in Europe for over a century. The legend, however, speaks more of Philip's vow to bury his parents as they desired, and it refers implicitly to San Lorenzo el Real alone.

The meaning of the round temple is ambiguous in sixteenth-century usage. On Roman coins round and domed buildings are temples of victory,[9] but in the Renaissance they may also signify the "temple of the Lord," as in an engraving by Karel de Mallery, *The Prophetess Hanna*,[10] where she is shown night and day *in templo Dominum*, seated before a round temple like that of the *Pietas Philippi* medal (fig. 13).

Philip's wishes cannot be understood without knowing his needs. These are stated in the motto of the medal of 1563, where his need to fulfill his father's wish for burial was expressed in a symbolic round structure,[11] which prefigures the originally circular crypt under the sanctuary at the Escorial, and the huge colonnaded monstrance on the altar above it.

Sigüenza made much of the resemblance between father and son in their preference to live like friars among friars. During his residence at Yuste, Charles V attended daily sermons and lessons with a friar's punctuality, and four masses daily for his father, mother, wife, and for his own health. Other masses he heard and saw from his bedchamber through a window viewing the main altar. At compline he accompanied the friars to the choir balcony in the church for prayers after nightfall. After a year the master of novices jokingly asked the Emperor's chamberlain to tell him that he might be considered as having passed his novitiate. Charles replied in the same tone that if the community was pleased with him, he would like to be considered a *profeso*, whereupon he was duly inscribed and the customary outdoor collation for newly professed friars was held in his honor. As death approached, he requested his confessor to celebrate the masses for his parents and his wife, whereupon his funeral was re-

[4] DHM, 2: 72-73.

[5] The early sources are enumerated by Rubio (CD 170 [1957]: 481).

[6] ASV (Spagna, filza 4, #109 [27 April 1562], from Paolo Tiepolo), repeated 5 June 1563 by Giovanni Soranzo (filza 5, #20).

[7] IVDJ, envío 61, #40 (February 1563). The Herreria was the large meadowland south of the monastery, where some friars would have preferred it to be built, away from the winter winds. But the Herreria was probably malarial, like La Fresneda. Vicuña, *Anécdotas*, pp. 62-68.

[8] Alvarez-Ossorio, *Medallas*, p. 153, #296B. The bust copies the medal of 1555 by Jacopo Trezzo (Babelon, "Jacopo da Trezzo," pl. 3, 1-2, p. 200), portraying Philip as Prince and

Regent. The reverse shows the Sun with quadriga and legend IAM ILLUSTRABIT OMNIA (mentioned by Porreño, *Dichos*, pp. 10v, 140).

[9] On coins (Alessandro Donato, *Roma vetus ac recens*). The legend is MARTI VLTORI.

[10] C. Tümpel, "Ikonographische Beiträge zu Rembrandt," p. 32 (Hollstein, *Dutch and Flemish Etchings*, vol. 15, no. 286, p. 165).

[11] Modino, "Priores," p. 196, and "Fidelidad de Hijo," believes that the idea of building a monastery was in Philip's mind as early as when his father was near death at Augsburg in 1547, expressing then his wish in a codicil, and confirming it in 1554.

hearsed in his presence, with a tumulus, his household in mourning clothes, and Charles himself offering a taper as the passage of his soul from the body.[12]

The second Escorial medal honors its second architect Juan de Herrera in 1578 (fig. 14). The reverse shows a *templum Domini* as in the Karel de Mallery engraving, with San Lorenzo and his attribute, the grill of his martyrdom, in the doorway. Two friars are in prayer outside the Doric temple. At the top the sun's rays break through a cloud. The allegorical female figure of *Architectura* sits in the foreground holding compass and square with an armillary sphere at her feet, in an unfinished vaulted church of Tuscan order, clearly an allusion to the basilica of the Escorial, where the vaults and dome were in construction in 1578.[13] On the exergue a dedication, DEO ET OPT[IMO] PRINC[IPI], honors the birth of the future Philip III. The *templum Domini* in the background is an early design for the monstrance as finally executed in jasper, enamel, gold and jewels.[14] The early form on the medal indicates a shallow dome rather than the tall one of the final form made by Jacome Trezzo of Milan in 1578-1585 on designs by Herrera for a round *Sagrario* (ciborium, shrine) with eight columns bearing apostles, and niches for the Evangelists, fifteen feet high on the main altarpiece in the sanctuary of the basilica, and nine and one half feet in diameter (fig. 15).[15]

Thus the two medals are like an emphatic correction of an early misinterpretation, rumored in Europe as the King's intention to found a martial temple of victory. This expiatory interpretation of the Escorial, part of the propaganda against Philip, would "prove" him guilty of destroying a church in Flanders in 1557. That propaganda eventually matured in the myth of Philip as the despotic murderer of his son Don Carlos and his half-brother Don Juan of Austria, a myth promulgated by William of Orange, Friedrich von Schiller, André Chenier, Victor Alfieri, and Nuñez

de Arce throughout Europe. But the King intended only a *templum Domini* in gratitude for many great benefits both past and present ("muchos y grandes beneficios que de Dios Nuestro Señor hemos rescebido y cada dia rescebimos").

The testament and the letter of foundation and endowment give the King's frame of mind both after the end and near the beginning of the Escorial. The letter of 1567 is mostly about endowments (paragraphs 1-14), burials of royal persons (18-22), and commemorative masses for all of them (23-39), as well as about the priests needed among the friars to say all the masses, and about the rules of their community (41-46). The economic life of the friars is defined (47-66), and the closing paragraphs (67-86) deal with the college, seminary, and hospital. The major topic therefore is economic (thirty-two paragraphs), clearly divided as income and expense. Little is said about any accommodation for the court. Philip's entire concern in 1567 was for the burials and the monastery.

The testament of 1594 has little to say about San Lorenzo el Real, but the palace is more prominent (*la Casa y Monesterio*, paragraph 14) than in 1567. This part of the will charges Philip III with the care of the Escorial, founded for the service of the Lord and for the burial of royal persons and the care of their souls with many masses. Purpose and principal function were thus essentially unchanged from beginning to end of Philip's reign.

The codicils to the will in 1597 and 1598 are more expansive.[16] The King was already much concerned in 1567 with the problems of endowment (15-17), and he wrote then that the heavy costs of the first four years' work made it necessary to use income from endowments both past and future, for *labor y fabrica* henceforth.[17] The new endowments were later enumerated in 1592, as being sufficient for the maintenance of 150 friars and the college with its seminary, but even these were soon found to be inadequate, when the

[12] Sigüenza's account (*Historia*, 2: 150-162) has been dismissed as credulous. Stirling-Maxwell (*Cloister-Life*, p. xx) nevertheless calls it "contemporary narrative." Sigüenza himself professed only in 1567, having been thirteen when the Emperor died in 1558.

[13] *AME*, VI-15 (May-October, 1578), payments for cranes and scaffolding at the dome; FME, p. 83.

[14] HS, pl. 11, *Custodia* inside *Sagrario*, and pp. 31-32.

[15] Herrera is portrayed contemplating its plan in the engraving by Maea (L. Cervera, *Retrato*).

[16] The testament and both codicils are available in the scholarly edition by Zarco, DHM, 2: 7-62.

[17] Ibid., p. 94, par. 17.

King was considering a new letter of foundation.[18] The report by a Jeronymite adviser opens with a paragraph on the need for repair and renewal in an already decaying fabric ("reparando y renovando lo que padeciere flaqueza y diminucion," p. 185). The Escorial must spend one-third of its income on cult alone, unlike episcopal establishments, with much greater incomes, and unlike the knightly orders, whose separate incomes are also larger. At the Escorial the character of the endowment is one of petty properties and interrupted revenues ("menudencias y rentas tan quebradas, odiosas y de tantos pleitos, riesgos y costas en cobrarlas y beneficiarlas . . . ," p. 187). The codicils of 1597 and 1598 reflect such worries by the King as well, who ordered in 1597 that after his death the monastery shall receive a monthly grant of 8,000 ducados.[19]

In 1598 the second codicil endowed the monastery with another eight substantial properties[20] and increased the monthly cash allowance of 8,-000 ducados with a deposit of 50,000 more against which loans could be taken (par. 21) as needed, so that the monastery might "save its income, relieve its debtors, and avoid further debt."[21] The expense of the sacristy, furthermore, was to be relieved by the proceeds from papal bulls printed at Toledo. The upkeep of the gardens was to come from the income of the property at Vaciamadrid, as well as from a grant of 500 ducados to be administered by the *Congregación* (the executive committee, also called "oficiales de pluma y cuenta") and the prior. Francisco de Mora, finally, was instructed as royal architect to preserve the royal rooms and the *casas de oficios* (service buildings) by visiting the buildings from time to time and providing workmen as needed.

Since the letter of endowment in 1567, the income-producing properties belonging to the Escorial had been exempted from all taxes.[22] Thus the King's provision supported the buildings, the friars, and the schools for nearly three centuries in the manner to which they were accustomed, until abrogation after 1835.[23] That manner is described by Fray Juan de Benavente, ca. 1595: "The Order of St. Jerome is not an order of mendicants, nor of barefoot friars, nor was it founded to beg alms on the streets, nor to travel on foot, nor to live without servants. . . . If their expenses of old as to hospitality and almsgiving and the manner of life are to be curtailed, a different order would be the result."[24]

THE KING AND ARCHITECTURE

Philip's early interest in architecture is not mentioned by his many biographers, because there is no sure record of it before the great tour of Europe at his father's command (1548-1551),[25] except in a remark published by Francisco de Villalpando in 1552. In the dedication to the Prince of his translation of Serlio's Books Three and Four (*Tercero y quarto libro de architectura*), Villalpando says that the Prince's travels in Europe had delayed its publication. In the Prince's permission to publish (dated 9 November 1552) Villalpando is praised for his translations, which were of "much advantage in the edifices to be built in Spain." The phrasing implies that the Prince had known of them for an unstated time.[26] His known letters to Villalpando (who was Gaspar de

[18] Ibid., pp. 165-184, 185-187, "Advertencias del P. Fr. Juan de Benavente," written for the King in the last years of the reign.

[19] B. Porreño (*Dichos*, p. 148) reported Philip as saying that if he were not King, he would have liked to be a gentleman with an income between 6,000 and 8,000 ducados. Thus his dying gift of 96,000 ducados annually would have supported only twelve such caballeros. Porreño wrote about 1626, being informed about the King by his maternal uncle, Francisco de Mora, the successor to Juan de Herrera as royal architect (p. 109ᵛ).

[20] DHM, 2: par. 19: Campillo, Monesterio, Piul, Pajares,

Palomarejo, la Rinconada, El Berrueco, Madres Viejas.

[21] Ibid., p. 58: "traer holgadas sus rentas y sobrellevar los que las pagan, y excusar necesidades de empeñarse."

[22] Zarco, "Carta de fundación," pp. 87-88.

[23] G. del Estal, "Transición," pp. 578-584.

[24] DHM 2: par. 8, p. 116.

[25] J. C. Calvete de Estrella, *El felicísimo viaje*. J. M. March (*Niñez y juventud de Felipe II*, pp. 221-222) says of Philip that he received in his early education "no notion of art, nor of any science" until the tour began in November 1548.

[26] S. Serlio, *Tercero y quarto libro de architectura*, facs. ed., 1977 M. Menendez Pelayo wrote in 1853 that Villalpando pre-

Vega's brother-in-law) about the work at the Alcazar in Toledo do not begin until 15 October 1553.[27]

After his return to Spain in 1551, Philip began a campaign, using the services of the court architects, to renovate the many royal seats that had fallen into disrepair.[28] At Valsain near Segovia in 1552 Luis and Gaspar de Vega began to build towers and verandas overlooking the gardens (fig. 16) which recall Flemish country houses in their use of slate-roofed spires, chimneys, finials, dormers, all novelties in Spain at that date, and anticipating the steep roofs and towers of the Escorial in the 1560s.

The King's letters to Gaspar de Vega from Brussels reveal a professional interest in building matters. In 1557 he specifies precisely how he wishes a colonnaded gallery to be closed off from the weather and finished inside. He wishes to know in 1559 about the number, weight, dimension, and the cost of freight for lead roofing sheets to be sent from England to Spain, as well as an estimate for roofing the Alcazar at Madrid in lead. But he disagrees with Vega about lead roofs at Valsain, not only because of the cost, but also the weight, and the heat in summer, as he knows in Brussels. He prefers steep slate-covered roofs in the manner of Flanders, which sparkle in the light. Eight roofers were engaged there, including two quarrymen, four to cut, trim, and set the slates, and two carpenters for the framing, who all were to arrive in Spain in the spring. Before then, Vega was to order timber to be cut and to locate a slate quarry that the King had seen near Valsain, and he is cautioned that slates split dangerously when overheated in fires. Philip was also sending to Genoa at this time for five *stuccatori* to decorate walls and vaults at Valsain. In 1562 the slates and spires of Valsain were repeated at the Pardo in the fashion of Flanders.[29]

As for the Alcazar of Toledo, the King observed that on the main façade the existing towers cut off the best views, thus expressing his interest in landscape for its own sake as a source of visual

pleasure.[30] This interest reappeared strongly in his siting of the Escorial with the drawing room at the east façade, from which he could see to Madrid. At Toledo he requested estimates and a proposal for improving the design. He suggested that a curtain wall be built flush from tower to tower to allow larger rooms within, weighing also the advantage of better rooms against reducing the light below the ground floor in dwellings, offices, and stables.

Gaspar de Vega accompanied the King to England for the marriage to Queen Mary in July 1554. It was the King's wish that Vega study foreign buildings and practices of construction that might be useful in Spain. Vega returned overland and wrote a report (16 May 1556) on French royal seats. At the Louvre he judged the stairway inadequate for the finest building in France. Only the roof-terraces pleased him at St. Germain-en-Laye, of white stone over vaulting in brick. Fontainebleau struck him as more boastful (*fanfarron*) than meritorious, lacking any good stairway and looking ruinous. All told, France had nothing so good as in Flanders, where the cleanliness greatly impressed him. In Brussels the King commented, on reading this, that Gaspar would have done better to look at them in more detail (*mas particularmente*), and to have gone to Chambord, which is the best, according to Martín Cortés, who had seen it.[31]

The report continues on about the state of the royal works in Spain, enriched with many marginal glosses by the King. Vega's comments on the gallery at Valsain are reprimanded: "Be it done as ordered and not as he and his uncle [Luis de Vega] opine, regardless of what they say here," and later, "make haste," a phrase recurring obsessionally in the royal glosses on the correspondence about the Escorial.[32] The other buildings mentioned in Gaspar's report are the Pardo, the Alcazar in Madrid (where the King was eager to live on returning to Spain and urged haste), Aranjuez, Aceca, the Alcazar in Toledo, the castle in Segovia, and the Casa de Campo near Madrid.

sented the manuscript "many years before it was printed" to the Prince (*Historia de las ideas estéticas en España*, II, 370).

[27] Llaguno, *Noticias*, 2: 213-214.

[28] F. Iñiguez, *Casas reales*; Llaguno, *Noticias*, 2: 42, 196-197.

[29] Llaguno, *Noticias*, 2: 208.

[30] Llaguno, *Noticias*, 2: 199 (15 February 1559).

[31] F. Iñiguez, *Casas reales*, pp. 165-195. Cortés, Marquis of Oaxaca in New Spain and son of the conquistador, was among fourteen grandees accompanying Philip to England (J. Vandernesse, in L. Gachard and P. Piot, *Collection*, 4 [1882], 442.)

[32] Iñiguez, *Casas reales*, p. 167.

These documents show that Philip in 1556 was much occupied in Flanders with the question of renovating the royal residences, not with the rich ornamentation known today as "Plateresque style" in Spain, and "style François I" in France, but in a modern, "plain style," more common in Italy and Portugal,[33] that was based on ancient Roman models and the writings of Vitruvius. This plain architecture is known as *estilo desornamentado*, and the Escorial is its major example, reflecting Philip's taste in countless matters of choice and decision.

MADRID AND THE COURT

The program to renovate the royal residences was but one piece of a larger design in Philip's mind during the 1550s, in which the Escorial became all-absorbing only after his father's death in 1558. In that greater design the Escorial became a vital part, but it too depended on another piece of the plan, which was to move the center of power from the feudal nobles at Toledo, to Madrid where a less constrictive political setting of ancient privileges would favor Philip's new government.

The King's affection for Madrid probably owes much to his having been reared there during the 1530s by Portuguese nurses (his mother was Portuguese) and the family of his Castilian *ayo* (tutor), Juan de Zuñiga and his Catalan wife, who both wrote copious letters about his studies and the children among whom Philip spent his childhood.[34]

After the *felicísimo viaje*, when he learned that his reign would be only as King in Spain and not Emperor, he was frequently in Madrid[35] before leaving for England in 1554, and when he returned in 1559, he was never again to leave the Peninsula. From the beginning, Madrid was his choice as *Corte*, as his residence with the government in attendance. He never decreed at any time that Madrid was to be "the capital" by an official transfer of government. It simply happened, when the King chose to bring the court from Toledo to Madrid in June 1561.[36] The royal council met on the sixth; a royal magistrate (the *corregidor*) took charge on the eleventh; the King himself was in residence on the twelfth or before; and the town council ruled that the court was in Madrid from the sixteenth on,[37] where it remained for forty years until after Philip's death and its removal to Valladolid by his son.

In fact, Madrid had been the seat of his court three times before, when he was Regent during his father's absences, in 1539, in 1543, and 1551, and 1552. During Charles's second regency in 1516, Cardinal Cisneros also governed from Madrid after the death of Ferdinand.[38] In the larger frame of Philip's policy after the Treaty of Cateau-Cambrésis in 1559, when France yielded to Spain after the defeat at San Quintín, Philip was free to reorganize the Spanish monarchy from a nomadic government to a sedentary one, from an alliance of bellicose feudal nobles to a prematurely modern state of scribes and bookkeepers, or in Philip's own words, "clerks of pen and account book" (*oficiales de pluma y cuenta*).[39] Fernando Chueca Goitia notes the fundamental reasons for the existence of Madrid, (1) as the strategic location for the Visigoths during the Reconquest, and (2) the abundance of its forests and subterranean waters, relative to those of Toledo on its bleak plateau high above a bend of the Tagus.[40]

Much has been written in the twentieth century

[33] J. Camón Aznar, *Arquitectura plateresca*; G. Kubler, *Portuguese Plain Architecture*. Chueca, "El estilo herreriano," pp. 215-253.

[34] J. M. March, *Niñez* vol. 2: letters from Estefania de Requesens to her mother, 1533-1540, pp. 93-353. Zuñiga was *ayo* from 1535, and *mayordomo mayor* until his death in 1546.

[35] According to Vandernesse, "Journal des voyages," p. 4f., he resided in Madrid during Oct.–Nov. 1551; May–June 1552; and in March and April of 1554.

[36] BM, Addison, 10236: *Nuevas de corte estando la corte en*

Madrid, f. 74ʳ. "His Majesty ordered the court to leave Toledo against the will of everyone . . . the King our lord left for Aranjuez and thence for Madrid on Monday 19 May in 1561."

[37] M. Fernandez Alvarez, *Economía, Sociedad y Corona*, pp. 255-280.

[38] Ibid., pp. 240-242.

[39] In the second testamentary codicil, referring to the Congregación, treasurer, overseer, and paymaster, who were governing the fabric. DHM, 2: 60, par. 25, 1598.

[40] *Madrid, Ciudad con vocación de capital*, pp. 136-137. On

about *capitalidad* (or "capitalhood") at Madrid,[41] although there is no evidence that sixteenth-century people thought of any city as a "capital" in the sense that we have inherited from eighteenth-century political science. Milton spoke of Satan's "capital city," Pandaemonium, in 1667, but not until Samuel Johnson's *Rambler* in 1750 did Rome become "capital city of the world." In English, "capitalhood" first appeared in 1865.[42]

The question is therefore less one of "capitalhood" than of how the saying *solo Madrid es Corte* came into being. It is likely that sixteenth-century Spaniards, including Philip II, understood *Corte* only as the *casa real*, the royal household and government that accompanied the King to whatever place he chose as residence. But the *casa real* underwent a deep change when Charles V abandoned the simpler Castilian usage of his grandparents for the elaborate Burgundian royal household of his father, which was established on Charles's order at enormous expense in 1547 for the European journey of Prince Philip. Soon after, the Castilian parliament complained in 1555, 1558, and 1559 and later that the costs of the new court would have sufficed to conquer kingdoms.[43]

Prince Philip's household in 1547 was the turning point in Spain, when the Duke of Alba was ordered by Charles V to arrange the *casa real* of the Prince on the Burgundian model of the Emperor's own household. The Duke was angered,[44] but he complied speedily, in deference to the future King's Flemish subjects, and in preparation for the impending journey. The party leaving Spain was guided by seven chamberlains who arranged the travel of a company numbering fifteen hundred courtiers and musicians, and a complete kitchen staff with table servants, under the escort of fifteen hundred infantry,[45] all paid, fed, and lodged from royal funds. In the Alcazar at Madrid in the years after 1561, the Burgundian ceremonial was centered on the King's apartment of

study, bedroom, dressing chamber, closet, and toilet. These rooms were approached through a series of guarded antechambers where visitors were ushered according to their rank. The household was directed by a grandee, the *mayordomo mayor*, who ranked second in the government after the president of the council of Castile. Four more mayordomos assisted him in the administration of every kind of service—the bodyguards, the medical advisers, the church officials, as well as cooks, butlers and footmen, the stablemen, palace servants, and the clerks and pages. In addition, the gentlemen of the table, of the palace, and of the chamber gave services more of bodily presence than of personal duties. These were performed by aides of lower rank yet noble birth, like the *aposentadores* (billeting officers) in the palace, or the *camareros* (chamberlains). The feeding of the court was provided by a grandee, the *sumiller de corps*, and five lesser *sumilleres* (butlers) directing scores of kitchen workers. The safety of the court was protected by three hundred guardsmen, Flemish, Spanish, and German, and a nightwatch of several dozen sentinels.[46]

From the beginning of this life under Burgundian court ritual, Philip accepted its duties—receptions of royal visitors, participation in religious festivals, official meetings of the five knightly orders, council meetings, and family ceremonials and funerals—as part of the kingly role intended for him by Charles V. But it was a rule he arranged to play intermittently and only at Madrid, by using the various residences he had inherited as places of release from courtly life. At the Escorial, however, he returned to an ancient mode of royal residence among friars.[47]

The Prince's view of the situation had appeared in his letters to the Emperor in 1545-1546.[48] The letters express concern and indignation. In the first place, Philip calls attention to the inadequacy of future revenues into 1550, both as to annual

Toledo in 1566 see the panoramic print by Georg Hofnagel. Subterranean water in Madrid: Fernandez Alvarez, *Economía, Sociedad y Corona*, p. 262, on the Moslem *viajes de agua* devised to conduct rainwater to the area of Madrid (as studied by Oliver Asin).

[41] Bibliography in Fernandez Alvarez, *Economía, Sociedad, Corona* parte IV.

[42] *Oxford English Dictionary*. In Spanish, *capital*, used of a city, appeared in the late eighteenth century (Jovellanos, Vil-

larroel) but it is not in the *Tesoro* of 1611 by S. de Covarrubias.

[43] J. March, Niñez, 2: 392.

[44] March, *Niñez*, 2: 391: "se revolvio airado."

[45] Calvete de Estrella, *Viaje*.

[46] L. Pfandl, *Philipp II*, Chap. 8.

[47] F. Chueca, *Casas reales*.

[48] March, *Niñez*, 1: 182-183, 207-208.

sources of income ("rentas vendidas y dadas de los ordenes y lo del subsidio y cruzada"), and as to fixed charges for defense of the realm ("guardas y fronteras"). He mentioned the difficulty of borrowing monies needed by the Emperor, such as a loan of 30,000 ducados that left all concerned in Spain both surly and desperate ("desabridos y desesperados"). He ventured also to correct his father's belief that Spain should be as generous as France to its king, noting that France is more fertile than barren Spain, where one bad year keeps the poor from lifting their heads again for many more. In addition, raising the past year's revenues of 450 million maravedis (125,000 ducados) brought such poverty that many, both among the people and nobles, went unclothed and the prisons were filled with delinquents unable to pay their taxes. These opinions probably were supplied by advisers hoping to reach the Emperor, but they also suggest Philip's readiness to hear and act on unpleasant truths.

THE KING'S ARCHITECTS

When Prince Philip described Francisco de Villalpando in 1552 as "geometer and architect,"[49] it was the first official use of this title by a Spanish royal patron. Villalpando was originally a bronze worker, and his translation of Serlio qualified him, in Philip's opinion, as a humanist and theorist, deserving recognition in the liberal art of architecture.

When writing his wishes in 1556 about the remodeling of the Alcazar in Toledo, Philip referred to both Alonso de Covarrubias and Villalpando as *maestros de obras*, thus avoiding the conflict between the practitioners and the theorists of building that still persists in Spain, as in the works by Portabales, who, as a modern *maestro de obras* himself, sought to prove that the *arquitectos* of the Escorial were ineffective courtiers remote from the day-to-day conduct of building.[50] This conflict proved unmanageable in the 1550s and 1560s at the Alcazar in Toledo, where professional builders delayed the work, flouted royal authority, and profiteered from rigged bids.[51]

As a result of these and similar troubles in the royal works, the King probably decided to consider for the Escorial an organization of the fabric that would protect the project from venal contractors and master builders, by introducing the architect as a technically competent scholar, humanist, and theorist from outside the builders' guilds. Thus he would be a direct representative of the royal authority, at the rank of the members of the Congregación (equivalent to an executive committee), and empowered to intervene as directed by the King.

The financial structure at the Escorial was diagrammed in 1963[52] in a nonhistorical scheme to show the architect as subordinate to the Congregación, although the architect's authority emanated directly from the King and was never channeled through that committee, whose main function was to exercise control over the contractors. The architect was never controlled by the Congregación, which consisted at the Escorial only of the overseer (*veedor*), the accountant (*contador*), and the paymaster (*pagador*). They met with the prior of the monastery or his vicar. The prior represented the needs of the religious community as well as the King's interests. The architect and the prior both had direct access to the King, and both were independent from the authority of the Congregación.

Chueca has noted that such an executive building committee was used under Charles V in the mid-1530s for the royal works in Spain, with the same trio of overseer, accountant, and paymaster, who were not builders but financial officers, assisted by the master builders. These in turn wrote the specifications, provided drawings and models, and advised the committee on costs. When a contract was auctioned (in *subasta*), the bidders met

[49] Serlio, *Tercero y quarto libro* (1552), fol. 1ᵛ. Llaguno (*Noticias*, 2: 220-221): active at Toledo in 1540 on gilding the Cathedral metalwork.

[50] Llaguno, *Noticias*, 2: 216; Portabales, *Artífices; Maestros.*

[51] J. J. Martín Gonzalez, "Nuevos datos," shows Herrera resolving the impasse after 1570.

[52] M. A. Garcia Lomas, "Organización laboral," 2: 300.

with the master builders at appointed times and places, and the committee awarded the work to the bidder they preferred. The contractor then was bonded (*fianzas*) and he began work at his own risk, under the supervision of the master builders on salary at the site.[53]

Prince Philip first began to consider building a burial place for his father when thoughts of death were in the Emperor's mind, before his abdication and the renunciation of the monarchy to his son in 1555. When he learned of his father's plans to retire to the Jeronymite monastery at Yuste near Plasencia, Philip went there incognito on his way to England on 24 May 1554,[54] in order to examine the construction being done in anticipation of the Emperor's arrival.

Sigüenza states that Charles had chosen Yuste before 1542 for his retirement, on advice from counselors who recommended the site, the climate, and the character of the monastery there, and that funds and a model of the work to be done were sent from Brussels in 1544. Gaspar de Vega was also sent to Yuste to plan the Emperor's dwelling and to prepare a drawing of the monastery for him to see in Flanders in 1554. The chief foreman appointed at Yuste in 1554 was Fray Antonio de Villacastín, a lay brother who later supervised all construction as *obrero mayor* at the Escorial.[55] Hence the work at Yuste prefigured the idea of the Escorial and even its design in part (fig. 17).[56] The patron was Charles V, and Prince Philip was his agent.

JUAN BAUTISTA DE TOLEDO

Not until 1559 did the King name his own architect, when he sent a letter of appointment on 15 July from Ghent to Juan Bautista de Toledo in Naples, calling him to Madrid as royal architect (*nuestro arquitecto*) with a small annual salary of 220 ducados.[57] His wife and two daughters and all his books and papers came later by sea with the household possessions, but the ship sank and everyone drowned, a tragedy from which Toledo seems never to have recovered.[58]

At first the King entrusted him with directing all royal works, and specific tasks at Aceca near Toledo, Aranjuez, the Pardo, and making the first plans for the Escorial, where he was appointed *maestro mayor* of the fabric on 10 August 1563, in addition to building reservoirs for the Casa de Campo and leveling a street in Madrid. The combination of overwork with the loss of his family and all his professional papers produced in him an inability to keep appointments or to meet work schedules, which soon undermined everyone's confidence. In January 1562 the plans for the Escorial were still undecided in many details after a whole year. The King was dissatisfied with his drawings for the basilica to the point of inviting an opinion and new drawings from a visiting Italian architect, Francesco Paciotto, which infuriated Toledo.[59] In the meanwhile, a "council of architecture" was appointed, including the Marqués de Cortés and the Conde de Chinchón, who gave their opinions. The Marqués wanted to keep Paciotto's squared design for the church, with Toledo's main cloister and *sotacoro* entrance, and the friars' cloister like one by Gaspar de Vega.[60]

Before long the King was angered by Toledo's forgetfulness, complaining on 15 January 1563 that he marveled how Toledo did not appear when he said he would come.[61] On 18 January the King decided that Toledo should have two assistants to help with drawings and models. A month later Herrera was appointed together with Juan de Valencia (the stepson of Luis de Vega), each at an annual salary of 100 ducados, and Toledo was raised to 500 ducados annually for life, which Philip may have assumed was not for long.[62] On 2 May 1563 the prior complained that Toledo did little and spent much, although on the thirteenth he praised Toledo as the most "conversable" man in the world, who had offered the

[53] F. Chueca (*Arquitectura del siglo XVI*, p. 165) also called attention to the persistence of this system in Spanish building today.

[54] Vandernesse, "Journal des voyages," p. 14; Sigüenza, *Historia*, 2: 148.

[55] *Historia*, 2: 147, 148.

[56] Martín ("Yuste," pp. 27-51) disagrees with Sigüenza on the role of Villacastín.

[57] Llaguno, *Noticias*, 2: 81.

[58] C. Vicuña, "Juan Bautista de Toledo," *Monasterio*, p. 133. This biography is complete but adulatory.

[59] Z, 146-4 on Toledo's anger, and Cervera, *Estampas*, p. 20, on this disagreement between the King and his architect.

[60] PM, p. 107; PA, p. 70.

[61] BM, Addison, 28350, f. 34.

[62] AGP, *Cédulas*, 2, f. 272ᵛ (published in PA, pp. 21-22).

friars his tools and designs if he should remain alive along enough.[63]

Crisis upon crisis occurred soon after. On 15 November 1563 a great quarrel arose at Aranjuez between Toledo and Andrés de Ribera in which Toledo was characterized as "incurable."[64] He also quarreled with the master builder Pedro de Tolosa at the Escorial, alarming people by his fantastic talk (*bizarrias*). The King declared it as mere laziness (*pura pereza*), saying he wished to see if Herrera could be more useful.[65] Even the prior turned against Toledo now, saying the buildings would be finished before Toledo would get around to preparing the contracts for them, because of his indolence (*flema*).[66] On another occasion in November 1563, all the master builders were sick, and Toledo never appeared at the site.[67]

More incidents of dissatisfaction multiplied during 1564, and on 30 May, the King requested opinion on his work from the leading Spanish master builders, Rodrigo Gil de Hontañón, Hernando Gonzalez de Lara, Enrique de Egas, and others. Two came to the Escorial in July and they expressed unfavorable judgments on the talus wall of the south façade, on the columns projected for the basilica, and on the refectory.[68] Toledo was also requested by the prior to put his orders in writing, as his speech was so confusing that it would be better if he said nothing. The King agreed, saying that Toledo's work could be made to look well only at great cost.[69] In November the prior criticized Toledo's drawings as small and incomplete, and as sources of error, particularly those for the King's house (*aposento*).[70] In February 1565 matters had gone so far that the King ordered work to proceed without telling Toledo because he was ill.[71] The Congregación was ordered to schedule working plans if Toledo failed to do so. Gaspar de Vega, furthermore, was summoned to review Toledo's drawings for errors in February 1566, and the King said that to

discuss a contract with Toledo was endless.[72] On May 12, 1567, Herrera was a witness to the testament of Toledo, who died one week later. The King ordered that the executors receive the current third part of his salary, and he offered further relief in case of need. A codicil left small sums to two manservants and one friend for services during his illness.[73]

The King's judgment in bringing Toledo back to Spain in 1559 cannot be questioned: his qualifications then in Italy were certainly superior. His reputation as Michelangelo's assistant at St. Peter's from 1546 to 1548 has been confirmed by repeated archival discoveries.[74] Saalman showed that Michelangelo regarded Giovanni Battista de Alfonsis as his choice to succeed Antonio Labacco. Alfonsis was known as the Spaniard in Michelangelo's entourage, and he represented Michelangelo in a stormy confrontation early in 1547 with the deputies of the *fabbrica* over the queston of authority to dismiss the assistants of Antonio de Sangallo, Michelangelo's predecessor at St. Peter's. The deputies complained that they were kept in ignorance of Michelangelo's plans. During charges and countercharges, Toledo investigated alleged irregularities in the accounts of the *fabbrica*. His salary was 50 scudi monthly from 23 December 1546 to 20 September 1548, and on 7 April 1547 he was paid 37 scudi for work and materials used on the *modello novo* that was being made in Michelangelo's house by two joiners (*falignami*) under Toledo's direction. Many lists of workers paid by the day, which include names of Spaniards, were signed by Toledo and another employee. He also wrote on Michelangelo's behalf to the deputies, requesting payments to artisans such as stoneworkers, sculptors, and joiners, and signing himself *Jo. Baptista de Alfonsis, architectus*.[75] The handwriting of these is identical with Toledo's in Spain after 1559. Vicuña supposed that Toledo left Rome in October 1548 to work

[63] PM, pp. 161, 163.
[64] BM, Addison, 28350, f. 101ᵛ; IVDJ, envío 61, #68, f. 2.
[65] IVDJ, envío 61, #386.
[66] PM, p. 166.
[67] IVDJ, envío 61, #385.
[68] AGS, 260, f. 481.
[69] PM, p. 184 (AGS, 258, f. 297, 15 July 1564).
[70] PM, pp. 192-193 (AGS, 258, f. 313, 6 October 1564).
[71] Z, 146-62.

[72] IVDJ, envío 61, #105; Cervera, *Estampas*, p. 23.
[73] Llaguno, *Noticias*, 2: 242 (19 May 1567).
[74] Howard Hibbard (letter to author, 1963); Luciano Rubio (letter to author, 1963; and in C. Vicuña, "Juan Bautista de Toledo," AEA 39); S. Giner Guerri, "Juan Bautista de Toledo," *Analecta Calasactiana* 19; H. Saalman; "Arberino Correspondence."
[75] Also *Giovan Battista Spagniolo*, and *Jo. Batista de li Alfonsi*.

for the Viceroy of Naples, Pedro de Toledo, where he may have taken the name of his protector, perhaps being also related to him on the maternal side in a branch named Alfonso.[76] Vicuña thinks that he was Basque, on the strength of an unspecified reference by the prior (10 July 1563) that he showed partiality to "those of his nation," which Vicuña argues to mean only Basques (*vascos*).

Of Toledo's early years nothing is known except that in 1564 he said he had been an *aparejador* (builder) as a youth (*mancebo*).[77] In Naples he was appointed director of royal works on an annual salary of 220 ducados. He owned a windmill on the dock in the harbor, and his wife, Ursula Javarria, who was a daughter of the lawyer of the Treasury in Naples, bore him two girls. In Naples he was engaged on a building at the viceregal palace,[78] and in 1549 on a rampart of the Castelnuovo, as well as on the church of the San Giacomo degli Spagnuoli, and on the opening of the Via di Toledo through the old city. In 1559 when he left for Spain, he was still *ingegniero* and *architecto del Castelnuovo* from June to September.[79]

Philip's design in appointing him was to bring in an outsider who was also a Spaniard of high reputation—but not too high—in Italy, a builder who could break the traditional mold of the Spanish master builders and do it as one of them, as well as being a literate humanist familiar with theoretical writings and close to the major architects of the day in Rome. Fray José de Sigüenza, who admired Toledo, may as a novice have known him in person. Sigüenza called him "a man of many parts, a sculptor and one who drew well, knowing Latin and Greek, much read in philosophy and mathematics, and having the knowledge that Vitruvius, prince of architects, requires of those who desire to practice the art and be called masters of it."[80] Toledo had other defenders: Juan de Quiñones, a learned antiquarian and

mayor of the Villa del Escorial, wrote that Toledo came from Madrid and that he was called *El Valiente Español* in Rome.[81]

An informed opinion of his contribution to the Escorial cannot stand alone on the evidence of the King's dissatisfaction and his conflicts with others at the site. It must emerge from the work that is surely his in the building. It is clear from the documents, however, that Toledo's authority and prestige deteriorated steadily from before the beginning of construction, as early as 1561-1562, with Paciotto's criticisms. He was bypassed in 1563, subjected to appraisal by outsiders in 1564, and ignored by the King in 1565.

JUAN DE HERRERA

When the King named Juan de Herrera as one of two assistants to Juan Bautista de Toledo, on an annual salary of 100 ducados, he was to be paid by Toledo, whose pay on the same date was "raised" from 500 to 700 ducados. The other assistant was Juan de Valencia, who was usually called *el clérigo*, being an ordained priest. He had worked with Gaspar de Vega on other royal residences.[82] Both assistants were described in the royal appointments by the King as men of whom he had "received notice that they were skilled in matters of architecture." They were to serve him in every way as ordered in relation to that profession, under the orders of the architect, Juan Bautista de Toledo, assisting at the works and in preparing drawings and models. Valencia was assigned to the Alcazar in Madrid and the Pardo, as well as to others in Madrid and environs, but Herrera's place of duty was not specified.[83]

At this time everyone concerned with the design of the Escorial had been agitated by Paciotto's radical criticisms of Toledo's plans. Various other opinions were solicited from experts, like the prior of Zamora.[84] The King was infuri-

[76] Vicuña, "Juan Bautista de Toledo," AEA, 39: 7. Vicuña also surmises (pp. 4-5) that Michelangelo brought Toledo from Florence to Rome.

[77] Vicuña, "Juan Bautista de Toledo," *Monasterio*, p. 132.

[78] R. Filangieri, *Castel Nuovo*, p. 285, and the "Rassegna," p. 257.

[79] PM, p. 19.

[80] FME, p. x. Born in 1544, Sigüenza took orders in 1567. His chronicle mirrors that of Fray Juan de San Jerónimo, JSJ, p. 19 (L. Rubio, "Historiadores," p. 506), the primary source

for the building history of the Escorial.

[81] *Explicación*; F. Iñiguez, *Trazas*, p. 127.

[82] IVDJ, envío 61, #11 (2 December 1561).

[83] The three royal cedulas in AGP are published entire in PA, pp. 21-22 (18 January 1563).

[84] BM, Addison, 28350, f. 43, January 1563, in the King's hand: "See if it will be well for him to see here the drawings of the church and monastery . . . and tell Juan Bautista to hurry to have them ready for them" (f. 35-36).

ated when Toledo failed to appear in Madrid as summoned, and the assistants were appointed about this time. Toledo's raise was really an abrogation, because of the checks on his authority in the appointment of two young and unknown assistants who would be his overseers and rivals, carefully phrased as "disciples skillful and competent enough to help him make drawings and models," and the final wounding provision required him to pay them from his salary. In effect, he had lost authority and would never again be in sole command, but always under the watchful eye of the young guardsman, who was also known as "el soldado de la guarda Alemana."[85] Herrera himself later referred to this appointment as "a royal favor, in order to accompany Juan Baptista de Toledo," ending his ten years of service in the guard of the Emperor and that of the King.[86]

Herrera's Early Career. From the King's point of view again, the events leading to and from Herrera's appointment as *discípulo* (disciple) should be examined. First, the *cédulas* (decrees) in 1563 reveal a double purpose. The master builders would interpret Valencia's appointment as the King's choice to replace the late Luis de Vega, his stepfather, in the royal works. Herrera's, on the other hand, continued Philip's intention (as in Toledo's appointment) to have a Spaniard, but also an outsider who would be a humanist and theorist of the fine art of architecture rather than a builder from the ranks of the artisans and contractors.

But what was in Herrera's career before 1563 to justify the King's confidence in a thirty-three-year-old guardsman? Herrera's service with Philip began in 1547 when he left his family at seventeen to seek his fortune with the court in Valladolid near the twenty-year-old Prince, whom he accompanied to Flanders in 1548,[87] staying with the court at Brussels, and returning to Spain with the heir apparent in 1551. Two years later, the young courtier became a soldier in the service of the Emperor in Italy. He was an arquebusier in the cavalry guard of Fernando de Gonzaga, campaigning in northern Italy and Flanders. He remained in Brussels until 1556, returning to Spain with the Emperor's household, in order to accompany him in retirement to Yuste, remaining there until the Emperor's death in 1558. He was possibly one of the King's "observers"[88] at the scene. Herrera is then recorded as present at the obsequies in Brussels, where a "Juan de Herrera" led the horse of Aragon in the funeral procession of December 1558.[89]

During 1559-1560 Herrera was in Madrid, where he prepared and presented a petition to the King for a license on a metallurgical process using a special furnace for the purification of copper from sulfurous ores in the Indies (Antilles, New Spain, and Ocean mainlands). The license was granted as a royal privilege (6 October 1560) for fifteen years, to work such deposits and to market the metal without taxation up to one-quarter of production. The process itself was one familiar to Herrera at his birthplace of Mobellán in Santander, where his father owned an iron foundry.[90] Herrera was also at Alcalá de Henares in 1561-1562, studying with Honorato Juan, the preceptor of Prince Carlos, then age seventeen, where he was engaged in copying and illustrating for the Prince a manuscript on astronomy, the *Libro de las Armellas*, which had belonged to Alfonso the Wise.[91] Don Juan of Austria and Alessandro Farnese were here as well. Herrera's interest in instruments for astronomy and navigation may be related to his association at Yuste with Juanelo Turriano, the Italian engineer and clock- and instrument-maker of Charles V, who later gave advice at the Escorial.[92] Herrera might again have

[85] PM, p. 43, letter of 23 September 1563, by the contador of the Congregación, Andrés de Almaguer.

[86] Llaguno, *Noticias*, 2: 333, "Memoria . . . a Mateo Vazquez" (1584). Herrera refers here to thirty-one years of service from 1553.

[87] Ceán-Bermudez, *Ocios*, p. 10; L. Cervera, "Semblanza," p. 8. It is supposed he was born about 1530.

[88] The published lists of the companions of Charles V at Yuste do not mention Herrera, but Luis Cervera, a foremost scholar of Herreran studies, affirms his presence ("Semblanza," p. 9). Any suggestion that Herrera was a "spy" for Philip is unnecessarily modern.

[89] Gachard and Piot, *Collection*, 4: 45; L. P. Gachard, ed., *Relations*, 1856, p. 267. The name is also given as "Jehan de Herrera," among the *gentilzhommes de la maison*, and among the *coustillers* (cutlers), p. 269.

[90] A. Ruiz de Arcaute, *Juan de Herrera*, pp. 16-17.

[91] Now in the Escorial Library. Van der Essen puts the period of these studies from October to July (*Alexandre Farnèse*, 1: 56f.).

[92] AGS, 261, f. 170-171 (1578?); Prieto, "Inventario," p. 23.

been the King's observer during the unruly be-
havior and illness of the Prince.[93]

Herrera certainly knew Philip as well as any
young courtier about his age, but it is more dif-
ficult to establish his architectural attainments.
There is no record that he either designed or built
anything before being appointed as Toledo's as-
sistant in 1563. He may have read and conversed
widely about building during his long travels, and
have seen the architectures of Italy, France, and
Flanders.

An image of his life as courtier, soldier, and
scholar appears in an allegorical engraving by
Otto van Veen, about 1594/5 (fig. 18). It is based
on a painting in Stockholm entitled *Telemachus
Pursued by Venus, Protected by Athena*.[94] The en-
graving by Pedro Perret[95] is dedicated to Juan de
Herrera, with an explanation in ungainly Latin,
referring to Herrera's licentious youth and pen-
ury, redeemed by his moral reform and search for
wisdom. The engraving shows a youth (Herrera)
lying on the ground among blandishments of-
fered by Cupid, Venus, Bacchus, and Ceres,
while the aged hag Egesta (poverty) tears the
clothes from his body. Athena and Chronos come
to his rescue and putti above bring wreaths of vic-
tory down the steep path from the Temple of
Fame. This allegory was a sixteenth-century com-
monplace of the hero's career, of the types known
as the Temptations of Youth, and Hercules at the
Cross-roads.

Herrera at the Escorial until 1567. His decree of
appointment on 18 February 1563 coincided with
the arrival of the drawings requested by the King
from Francesco Paciotto, and may have been
prompted by the approaching need for more as-
sistance to the ailing Juan Bautista de Toledo. On
23 April a foundation stone was inscribed and laid
in the basement beneath the future seat of the
prior in the still unbuilt refectory.[96] Herrera him-
self composed the inscription, naming Toledo as
architectus,[97] in his first recorded action as *discípulo*.

Herrera's name appears rarely in the records
until after Toledo's death in 1567, but as Cervera
has noted, he is often mentioned informally in
daily notes (*billetes*) exchanged by Philip with his
secretary Pedro de Hoyo at the end of 1564 and
in 1565, when Herrera was "continually in the
company of the King."[98] There were other infor-
mal *discípulos* as well: Toledo "appointed" Lucas
de Escalante as of 8 March 1565, and on 19 July
1565, Toledo referred to Geronimo Gili as "mi
discípulo viejo," as if to put Herrera in his
place.[99]

On 23 September 1563, Herrera provided a
new tripod type of stone hoist, of which Toledo
said that his own would be more useful than the
one by the "soldado de la guarda Alemana."[100]
But in 1566 the King urged that Herrera, instead
of Toledo, attend to suitable tackle.[101] A refer-
ence to drafting by the real *discípulos* appears
when Herrera and Juan de Valencia were engaged
on plans in duplicate for the upper floor of the
main cloister (fig. 19).[102] The King approved the
drawings, but he noted the lack of the stairway
and sacristy designs, which had still to be decided
on the ground-floor plans.

Early in 1566 the King wanted Gaspar de Vega
to review Toledo's drawings for errors,[103] which
suggests that Herrera was not first in the King's
mind to correct Toledo, being still a *discípulo*.
This view reappears with the drawings for the
wall of niches supporting the terraced garden on
the south façade: the King ordered that Herrera
make a copy of Toledo's design for his use,[104]
and later, that Herrera explain a memorandum
submitted by the prior.[105] This matter concerned

[93] Walsh, *Philip II*, Chap. 17, "The Illness of Don Carlos."

[94] Illustrated in the catalogue of the National Museum,
Äldre utländska målningar och skulpturer, p. 205.

[95] J. Müller-Hofstede, "Zum Werke des Otto Van Veen
1590-1600," pp. 157-159.

[96] Andrada, "Primera piedra," pp. 73-76.

[97] Letter to Mateo Vazquez (1584), Llaguno, *Noticias*, 2: 333:
"la cual yo escrebi de mi mano."

[98] Cervera, "Semblanza," p. 14; Llaguno, *Noticias*, 2: 333:
"Desde el año de 1565 comence a andar continuamente con S.
M. adonde quiera que iba."

[99] PM, p. 23: the King inquired whether Escalante was get-

ting two salaries; PA, pp. XL-XLI.

[100] PA, p. VII (AGS, 260, f. 347).

[101] PM, p. 224 (AGS, 260, f. 383, 22 February 1566).
Iñiguez, "Ingenios," discusses these hoists at length (pp. 192-
197).

[102] IVDJ, envío 61, #385, n.d., and BM 338-9, probably
1564 (Rubio, "Cronología," p. 39). LS, pl. 19 shows details
of the moldings (fig. 19).

[103] Cervera, *Estampas*, p. 23; IVDJ, envío 61, #105.

[104] PM, pp. 46, 228 (19 Mar. 1566).

[105] Z, 146-92, 6 June 1566: "podra venir herrera pa hazer

doubts about errors of construction for which Toledo was to blame. The King's note on this mentions another paper on the matter by Herrera, which seemed correct.[106]

One month before the onset of Toledo's fatal illness, Herrera received a salary increase to 250 ducados,[107] at a time when he was praised for his diligence in devising machines (*ingenios*) for cutting stones and a crane for raising them.[108] Herrera's manuscript on pulleys of April 1567 also helped to establish him.[109] Three *discípulos*, Herrera among them, witnessed Toledo's testament in Madrid a month later.[110] Juan de Valencia and Gerónimo de Gili were the other two. Neither of them appeared again at the Escorial.

There is no evidence that Herrera had more important things to do at the Escorial after Toledo died than before. The Congregación and the master builders continued to be in conflicting authority, with the King resolving their disputes and making the decision as he wished. Toledo's death strengthened the hand of the master builders and reduced Herrera to the position of a designer, most of his work having been projected by his predecessor, leaving him with some technical contributions, such as cranes and pulleys, to offer to the common enterprise, in addition to supplying architectural drawings based on Toledo's.

For reasons he never made clear, the King appointed Herrera, not to Toledo's post, but as aide to the Master of the Horse in 1569-1577, and as court chamberlain in 1579.[111] Both were important places at court, in keeping with Herrera's status as *criado* in Philip's household. This title can mean an intimate of the King's since youth, or a member of the household. Herrera was probably both. As *criado de nuestra casa*, he continued to have medical services and a dwelling supplied by the King after he left the *furriera*.[112] Only in 1582, writing from Lisbon, did Philip himself call Herrera "nuestro arquitecto."[113] But the income thereof (1,000 ducados annually) did not come to him until 1587,[114] with the title "Architecto General de su Mgestad, y Aposentador de su Real Palacio," which he used in 1589 on the *Sumario* of the Escorial prints that he wrote to accompany Pedro Perret's engravings.[115]

After Toledo's death, no one else at the Escorial could have framed the thirty-five brief questions sent with Toledo's drawings to the Florentine Academy.[116] Herrera's name also appears in July 1567 in a consultation requested by the King on a model for the main stairway of the large cloister, prepared by G. B. Castello of Bergamo,[117] who had come to Spain in 1562 and found work as an architect-decorator and painter at the Alcazar in Madrid in 1563-1564.[118] The King did not want the Italian to be present, but Herrera and Lucas de Escalante were convoked. In September, Castello was appointed as *criado del Rey* on a small annual salary of 3,000 reales (8 ducados) to make drawings, models, and painted designs. He would reside in Madrid and serve at the Escorial, the Pardo, Valsain, Aranjuez, and the Alcazar at Toledo as a decorator.[119] His salary was raised to 400 ducados (29 December 1568), but he died the following year in June with his assistants still unpaid.[120] His appointment by the King was not threatening to Herrera, and it marks the King's rising interest in the painted decoration of the Escorial.

In 1568 a model was needed for the construc-

rr[az]on de la q scribe el prior." At that moment Herrera was in Madrid (IVDJ, #13, 6 June 1566).

[106] Z, 146-11, n.d.: "q me truxo ayer Herrera y parece me q tiene razon en ello."

[107] Cervera, *Estampas*, p. 24 (14 March 1567), and AGP, 3: 50: as of 1 Jan., and again to 300 ducados on 14 September 1577 (marginal note).

[108] DM, 43, April 1567, letter from Almaguer, who usually named Herrera only as "el vizcaino." In this letter to the King he adds, "no me descontenta su diligencia y cuidado que pone."

[109] AGS, 258, f. 488.

[110] Llaguno, *Noticias*, 2: 246, 12 May 1567.

[111] *Ayuda de furriera*, salary 150 ducados, and *aposentador de palacio*, with duties both as to court protocol and as to paying for services furnished to the royal household (C. Perez-Pastor, "Noticias," pp. 25, 27; Cervera, "Semblanza," p. 96; Llaguno, *Noticias*, 2: 333, 366-368).

[112] Llaguno, *Noticias*, 2: 274 (14 September 1577).

[113] Ibid., p. 213 (20 January 1582 and again on 4 June 1584, ibid., p. 278).

[114] Ruiz de Arcaute, *Juan de Herrera*, p. 126: as "arquitecto de las obras reales y aposentador mayor de palacio."

[115] HS, facs. ed., 1954, 1978.

[116] V. Daddi-Giovannozzi, "L'Accademia fiorentina e l'Escuriale," pp. 423-427; G. Kubler, "Paciotto."

[117] BM, Addison, 28350, f. 249.

[118] Llaguno, *Noticias*, 3: 7.

[119] PM, p. 66 (5 September 1567).

[120] AGP, 3: 67ᵛ, 97ᵛ, 136ᵛ, 137.

tion of the monastery roofs, which were to have been designed by Gaspar de Vega, but the King asked Herrera in Vega's absence for a small model of his own.[121] Herrera wrote in 1584 that Vega's plans would have been most costly to make and maintain, and that his own scheme for the roofing saved over 200,000 ducados.[122] Gaspar de Vega had also been preparing to import iron roof nails for the slates of the prior's tower from Flanders, but Herrera devised a machine for their manufacture.[123] The King's note urges that Herrera discuss it with Vega.

As a designer Herrera made an appearance (8 December 1569) with a wrought-iron grille for the provisional church then being completed. Two designs were submitted, one with wrought-iron leafage, the other plain. The prior disliked the plain one but the King preferred it.[124] In 1570 Herrera designed two fountains for the cloisters, after consulting with the pipelayer (*fontanero*).[125] At this time he was also sent to Toledo to verify faults in construction that had been reported at the Alcazar and at Aranjuez.[126] In 1571 he was granted a house to be built at the King's expense in the lower town (the *Villa*), where he could live and keep all the drawings and papers related to his duties[127] for the duration of his work at the monastery.

Herrera in Charge. By 1572 Herrera's position and influence were such that he was at the center of the effort to reorganize the *fábrica*, preparing a preliminary study before 30 January 1572.[128] It guided the final text of the royal instruction dated 22 October 1572,[129] which began to circulate in July. When the treasurer, Andrés de Almaguer, read it, he found himself separated from the Es-

corial after ten years' service. His guarded views of the new dispensation appear, unsigned and undated,[130] in forty-three brief comments on its fifty-two sections, addressed to the King. But the final drafting was done without him,[131] and his successor, Gonzalo Ramírez, replaced him in wording it.

When the influential chief mason, Pedro de Tolosa, sent a protest to the prior, Herrera answered it, and the King asked the prior to discuss it with Tolosa and Villacastín, thus bringing Herrera into a colloquy with the traditional representatives of master builders and workmen at the Escorial. In fact, Herrera was planning to replace Tolosa with a master mason of his own choice: Diego de Alcántara, engaged to work at first in Madrid (20 December 1573) on drawings for the Escorial and later to assist Herrera as an *aparejador* on the basilica in 1574,[132] who would be friendly to Herrera's novel procedure of rough-dressing the stone at the quarry.

The controlling new factor in all these changes was the beginning of the basilica on a greatly increased scale of effort and expense imposed by the King's urgency to finish the entire work. It began, "a toda furia" in Sigüenza's words, in the spring of 1575, continuing until 1586. Sigüenza calls Herrera the principal designer ("traçador principal") and constructor ("hombre de gran ingenio"),[133] and in 1576, Juan de San Jerónimo characterized him as "arquitecto, matematico e ingeniero de las obras de S.M."[134] With the basilica rising, Herrera took over the fabric and its administration in ways that his predecessor never established. The council on architecture asked his advice about wage increases.[135] In another instance, a new model maker was to be instructed

[121] PM, pp. 82, 146 (19 March 1586).

[122] Llaguno, *Noticias*, 2: 335.

[123] PA, p. LXXXVIII (AGS, 260, f. 103, 10 June 1568); PM, p. 83.

[124] PA, p. CVIII. Camón ("Arquitectura trentina," p. 409) regards this as Herrera's first design at the Escorial, but Iñiguez, *Las Trazas*, p. 67, assumes that Herrera's were the ornate designs.

[125] AHN, 15188, #18-19 (18 March 1570). This is the earliest mention of Francisco de Montalban from Cordova, who later came to supervise the waterworks of the building in 1576 (AME, v-14).

[126] AHN, 15188, #42-3; #48 (28 June 1570).

[127] Llaguno, *Noticias*, 2: 174; Cervera, "Juan de Herrera," pp. 527-555.

[128] AGS, 260, f. 133 (Almaguer to Gaztelu): "Y porque Juº

de Herrera es el portador que a visto en el estado que anda la obra deste monestº me remito a su relacion."

[129] Zarco, DHM, 3: 33-62; PM, pp. 269-270 (30 July 1572).

[130] PM, pp. 272-274.

[131] Modino, "Priores," pp. 272-273 and n. 223.

[132] PA, p. CXXXV (2 June 1574); PM, p. 86, 11 December 1575.

[133] *Historia*, 2: 438. As engineer, Iñiguez, "Ingenios," pp. 181-214, and RA, p. 71.

[134] "Memorias," p. 160.

[135] AHN, 15189 (14 February 1575), on a request for regular pay on feast days. Today it would be called overtime, as the request came from a plumber who had been at the Escorial for many years, repairing sudden breaks in an innovative system.

by Herrera; or Herrera approved the use of cranes in the main cloister; or the master mason, Lucas de Escalante, went to Madrid to learn from Herrera about the plans of the church in order to decide how much stone to quarry under the new instructions.[136]

Herrera's rise to power was tested on the issue of "thick-skin" dressing of stone at the quarry, by leaving a layer to resist the shocks of transport in ox-carts. Recently appointed to office as royal architect, on 9 January 1576 he conferred in the prior's quarters with the contractors from the quarries and the Conde de Chinchón, for the council on architecture, about the merits of cutting to shape and roughing out (*labrar y desbastar*) at the quarry, as against carting stone before shaping it. The arguments opposing were the high breakage, untrained workers, departure from Spanish custom, and higher cost. The King's belief that it would be quicker was tested empirically when he came in person to the quarry (8 March 1576) to resolve the conflict, and to witness the use of a new derrick (*cabrilla*) that Herrera had devised.[137] In April 1576 the resistance of the master builders was administratively broken by the appointment of Juan de Mijares as "aparejador unico de la iglesia," instead of the usual number for each craft, and work proceeded as planned with improved efficiency.[138]

While the church walls were rising, Herrera designed the main altarpiece and monstrance as well as the lateral tomb groups of the families of the Emperor and the King (figs. 11, 15, and 70), to be built on contract with Pompeo Leoni and Jacome da Trezzo and others in four years.[139] The project was slowed by financial difficulties, with the King away in Portugal from 1580 to 1583, and in 1581 Trezzo wrote out of desperation to Herrera in Lisbon, "come bon amigo y capo desta obra," asking his aid in getting enough money for

his stonecutters.[140] Their friendship is commemorated in the medal (fig. 14) cut by Trezzo in 1578,[141] designating Herrera as IOAN.HERRERA. PHIL.II.REG.HISPP.ARCHITEC.

In 1579, when the King was planning the Portuguese succession and his governing in Lisbon, Herrera began to put his own affairs in order, making his second testament, which returned to the King the architectural drawings in his possession since 1573, sent from Italy for the basilica.[142] He also made arrangements to continue the discipleship he and Juan de Valencia had been granted in 1563. Two young men, Francisco de Mora and Pedro del Yermo, who had professed in architecture and mathematics, were appointed at salaries of 100 ducados each to serve under Herrera in His Majesty's service.[143] These arrangements prepared Herrera to accompany the King to Portugal from 1580 to 1583 during the annexation. Herrera's activity there was intense,[144] beginning in the King's company with a study of the Roman remains at Mérida in the spring of 1580 before the march into Portugal, where, as *aposentador*, Herrera had to review and prepare the places of Philip's residence.

Herrera returned to Madrid to attend to royal works in the autumn of 1581. He designed parts of the palace and gardens at Aranjuez, and the Guadarrama bridge (built in 1582) near Galapagar on the road to the Escorial, going back to Lisbon in the summer of 1582.[145] Later his chief interests were in supervising and publishing the engravings of the Escorial; overseeing the construction of the Exchange in Seville, which was begun on his plans in 1572; initiating in Madrid an academy of mathematical studies in 1582; designing the mint at Segovia; beginning a school of architectural studies in Madrid in 1584 for builders and artisans; and helping to plan the cathedral of Valladolid and the water supply of the city (1585).[146]

[136] Saltillo, "El Rey Don Felipe II," p. 8 (12 October 1575) on the model maker, Jusepe de Frecha); PM, p. 284, on L. de Escalante.

[137] JSJ, pp. 160, 163; Sigüenza, *Historia*, 2: 440; Llaguno, *Noticias*, 2: 124-125.

[138] Llaguno, *Noticias*, 2: 123; Sigüenza, *Historia*, 2: 443.

[139] J. Babelon, "Jacopo da Trezzo," p. 294 (Contract 3 January 1579).

[140] Babelon, "Jacopo da Trezzo," p. 78; Cervera, "Semblanza," p. 36. Trezzo lived in Madrid in a house designed for him by Herrera.

[141] Alvarez-Ossorio, *Catálogo* #275, pp. 172-173, diam. 50 mm.

[142] Cervera, *Estampas*, p. 28.

[143] AGP, 5: 242; 6: 284; PM, p. 287 (17 August 1579). Yermo was his nephew and *criado de su Majestad*, inheriting the proceeds from the engraved publication of 1589 (Llaguno, *Noticias*, 2: 350-351).

[144] Chueca, "El estilo herreriano y la arquitectura portuguesa," pp. 215-253.

[145] Cervera, "Semblanza," pp. 46-55.

[146] Ruiz de Arcaute, *Juan de Herrera*; Cervera, "Semblanza."

Herrera's lifelong relation to the King remains enigmatic. He thought of himself as architect, mathematician, and engineer, but Philip always treated him as a courtier, *criado del rey*, and chamberlain. Herrera accepted these roles, saying that he was in royal service from the age of seventeen until his death.[147] It is possible that he was consulted by the Prince on matters of architecture long before their close association after 1565, and that Herrera may even have brought Toledo to Philip's attention after 1547 during their travels. Indeed Herrera may have awakened the Prince's interest in architecture of which no trace appears before the journey to Flanders. Herrera was too young still for any responsible post, but he may have praised the work in Rome of an older compatriot who was second in command at St. Peter's in 1546-1547 under Michelangelo. In this way Philip may have been aware of Toledo long before appointing him in 1559, under Herrera's guidance at court in Madrid. Toledo's tragic return to Spain, and his uneven performance were distressing to Philip and redeemed only by Herrera's rising brilliance, without which the Escorial might never have been completed as we know it. The Escorial is unthinkable without Philip, but without Herrera, Philip could not have thought it to the end so quickly.

[147] Llaguno, *Noticias*, 2: 333.

3

LABOR AND ITS
GOVERNANCE

THE JERONYMITES

Both Charles V at Yuste and Philip II showered the Jeronymite Order with benefits of which the burdens were heavy and the motives unclear. Left to themselves, the Spanish Jeronymites were noted for their charities to the poor, pilgrims, and travelers, and for their austere devotion to splendid divine services that kept them in choir at least eight hours each day. Royal demands upon them began under Enrique II and continued until Enrique IV, when friars Gonzalo de Illescas and Alonso de Oropesa were drawn into public life. Later on Queen Isabella named Fray Hernando de Talavera as first archbishop of Granada, and Cardinal Cisneros sent two Jeronymites to America as governors of the Indies.

The retirement of Charles V at Yuste may be taken as the model for Philip's conception of the Escorial, in being the kingly retreat to prayer and devotion in a monastic setting that could be adapted to royal needs, with the aid of friars committed in principle to royal service. For example,

from the beginning of accountancy at the Escorial in 1562, Fray Juan de San Jerónimo began his duties as a bookkeeper under the treasurer, Andrés de Almaguer, but during his long life he had performed a hundred different duties, among others as cashier, librarian, archivist, chaplain to the King, and skilled botanical draftsman.[1] Some of the most responsible friars at the Escorial came to the new foundation from Yuste, such as Fray Francisco de Villalba, the preacher, and Fray Juan de Regla, confessor to Charles V. Both took part in revising the Instructions of 1572.[2]

The King's wishes were bindingly recorded in eighteen royal instructions dealing with many aspects of the fabric's governance, which were issued between 2 April 1562 and 1 October 1578.[3] The most comprehensive ones, signed on 15 August 1563, 12 September 1569, and 22 October 1572, show the King gradually investing the prior of the monastery with total authority as head of the fabric in 1572,[4] and later of the town govern-

[1] JSJ, pp. 5-6; burial notice, 1590.
[2] Modino, "Priores," p. 72. Portabales, however, wrongly thought the revisions were the work of the prior, inspired by

Philip (PA, p. 55).
[3] Zarco, DHM, vol. 3.
[4] DHM, 3: 33, 192.

ment, to which the King gave the rank of *Villa* in 1565. But the town council could not appoint either mayors or councilmen without the prior's approval. The prior and the treasurer, moreover, were empowered to judge civil cases of disorders among the laborers living in the town.[5]

In a recent study the organization of the labor is diagrammed as six separate "ministries" answering to the King, but such a scheme emerges from modern industrial organization more than from the royal document on governance.[6] The diagram shows the "treasury" as not responsible to the prior, and the Congregación as superior to the prior. It also fixes the architect under the Con-

gregación's orders instead of responsible only to the King as an officer appointed by royal decree. The keeper of materials and equipment is also shown as superior to the master builders (*aparejadores*), instead of being at the same rank. The main error, however, is in not separating the authority of the prior from the executive committee (Congregación), and in isolating him from the lower "levels" of the organization, whereas the prior actually had authority over every rank as *superior y cabeza* (1572), even over the executive committee, but not over the architect, who was responsible only to the King.

THE PRIORS

The governance of the fabric was therefore totally delegated by the King in 1572, when he gave control of all building in progress to the Jeronymite prior, who henceforth bore every administrative responsibility, assisted by the Congregación, of which he was a member, and the friars of the Escorial. At the beginning of governance in 1563, the Congregación was never named as such, but existed as a continual association in an executive committee, of prior, accountant-treasurer, overseer, and paymaster, meeting to keep the accounts of income and expense in order.[7] Their name as the Congregación did not appear until 1569, when its members were specifically charged with supervising the fulfillment of all contracts with the preparators.[8]

Thus the key post at all times was the prior's. From the beginning of the Jeronymite Order in 1374 each house of friars was independent from the others, and each house elected its own prior every three years. But at the Escorial the right to elect the prior was withheld until forty friars were in residence, and even then the King chose the priors until 1636,[9] exempting the priors from all other duties in the Order to relieve them for the

tasks of governance. The prior of the Escorial in effect exercised feudal privileges over towns and estates that were endowments in the letter of foundation of 1567,[10] and these endowments burdened the religious community with troubles not of their own choice.

Such overwhelming royal favor during the history of the order was owing to its peninsular character. The fact that no major houses existed in the rest of Europe was of value to royalty seeking privacy and immunity from spies. The tradition of sumptuous cult in splendid monasteries and churches was also attractive to monarchs, whose constant travels required comfortable quarters they could commandeer by gifts and favors, in the absence of all adequate hostelry for the entertainment of King and court.[11] In these ways the Jeronymites became a source of devoted service to royal needs and at the Escorial, the nearly absolute local power of the priors brought the entire community into some form of royal service during the laborious years of construction.

The priors from the beginning in 1561 were the chief intermediaries between the King's wishes in Madrid and the daily problems at the building

[5] Modino, "Priores," p. 214.

[6] Garcia Lomas, "La Organización laboral," p. 300.

[7] DHM, 3: *Instrucción*, 1563, paras. 1-7.

[8] Ibid., teniendo los aparejadores . . . y tambien la Congregacion muy particular cuidado de mirar siempre que las tales obras que se dieren a destajo se hagan y cumplan conforme a

los condiciones, contratos, y asientos en que se dieren." DHM, 3: 29.

[9] Modino, "Priores," pp. 21-23, 24.

[10] DHM, vol. 2; Modino, "Priores," p. 26.

[11] Chueca, *Casas reales*; E. Tormo, *Los Jerónimos*, pp. 30-32.

site. In addition the vicar in the prior's absence was always empowered to act on his principal's behalf. In the prior's dwelling all the administrative lines came together from above and below the head of the monastery. The prior and his staff were explicitly charged with the weekly review of the effectiveness of the entire laboring force, and the prior held the right to hire or dismiss at any rank, excluding the royal architects and the lifetime appointments of Pedro de Tolosa and Luis de Escalante as master builders. His own friars, like Antonio de Villacastín, the *obrero mayor*, were also excepted.[12]

Five priors were in office between the laying of the first and last stones (1563-1584). Fray Juan de Huete was in charge for only two years (1 March 1563-25 June 1565), and they were the hardest. He had been prior at Zamora, building the fine monastery there, and general inspector of the order. He was sickly and old, and his vicar, Juan del Colmenar, directed the heavy work of assembling materials for raising the walls in the excavated foundations, with short funds and a shortage of laborers. Huete himself attended to the payrolls, complaining that much was spent but little was built.[13] He was the constant critic of Juan Bautista de Toledo, whose absences and conflicts with the master builders disturbed his sense of orderly conduct. Huete also insisted, with Villacastín,[14] on enlarging the monastery from fifty to one hundred friars. Huete could make architectural drawings, which were approved as such in 1564 by the outside masters who had been convoked to consider the problems of the four monastery cloisters and the doubling of the number of friars.[15] Modino notes that peace returned to the fabric when Toledo was instructed to work with the builders on the King's dwelling, while the prior and vicar named other builders to work under their orders on the monastery,[16] a division of responsibility suggested by the King.

The aged vicar, Juan del Colmenar, was prior from 26 June 1565 until 30 December 1570. His first task at the Escorial had been to clear the brush from the building site (28 March 1562), but

when he became prior, the accountant Almaguer overshadowed him in correspondence with the King, incurring the mistrust of the friars. Like Huete, Colmenar sought every possible economy in building operations, and he centered his efforts on reforming the ungoverned profiteering of the master builders, as implied in the additions of 1569[17] to the Instructions of 1563.

The third prior, Hernando de Ciudad Real (late 1570 to 23 February 1575), began his term with the arrival of new friars who brought the population to forty,[18] the number needed for them to elect their prior rather than accepting the royal appointments (which continued unchanged). His struggles were rightly concerned more with regulating the disparate customs brought by new friars to the community than with the building itself, and he also had to supervise the beginning of monastic life at the Escorial when the friars moved up the hill from the Villa to the new cloisters in June 1571.[19] His attempts to implant the customs of his former house at Guadalupe brought dissension. Another of his unpopular actions as *superior y cabeza* was the exclusion of Villacastín from the meetings of the Congregación,[20] improper for any prior during construction, when the prior's obligation was to see to its best conduct.

Fray Julián de Tricio (prior from 20 May 1575 to sometime in 1582) governed the community when the court was often in residence at the monastery itself, with all the inconveniences of conjoining court and cloister. The college was also living in the monastery, pending the construction of its own quarters, and the library was housed in the same cloister of the hospice as the college and seminary. The confusion in the monastery was extreme. Heavy building operations began on the basilica and in the main cloister, filling the air with noise and dust. In all these and other matters Tricio benefited from a tradition of governance that was now tried and tested, having firm statutes in the Instruction of 1572.

Fray Miguel de Alaejos (prior from 1582 to 1589) had been prior at Yuste and elsewhere,

[12] Modino, "Priores," p. 37. (The characterization of Villacastín is by Portabales, PA, p. 41.)
[13] AGS, 258, f. 40, cited from Modino, "Priores," p. 232.
[14] Modino, "Priores," p. 238; FME, p. 61.
[15] Modino, "Priores," p. 240.

[16] AGS, 260 (8 May 1565); Modino, "Priores," p. 253.
[17] DHM, 3: 25-32.
[18] Modino, "Priores," p. 262.
[19] JSJ, pp. 67-71.
[20] DHM, 3: 73.

coming to San Lorenzo when all building was nearing completion and at a time when the monastery was at last occupied only by the friars. As the Escorial reached completion, in 1587 the King was able to influence the order's governing body to name the priors rather than having the friars themselves elect the office.[21] Actually, the *definidores* of the order had acted before according to

the King's wishes in the case of this monastery, which was a royal foundation in every sense. The building of the Compaña and other services on the periphery of the Escorial finally brought the friars a calm that had never been theirs among the distractions of constant building for three decades.

THE CONGREGACIÓN

The name has the meanings both of "office" in the sense of a place where bookkeepers and secretaries work on records of all kinds, and of a board of overseers who govern the financial affairs of an enterprise. The Congregación of the Escorial was both of these, as well as an executive committee, and it employed many scribes to keep multiple sets of identical records. All the financial records of income and expense, all the specifications, estimates of cost, contracts, appraisals and payments were in the keeping of the Congregación. But apart from its employees, the Congregación itself comprised only five functions: accounts, justice, inspection, banking, and payments, which were directed by two or three officers in addition to the general director, who was the prior of the monastery.[22] The accountant (*contador*) was also a civil judge. The inspector (*veedor*) examined all work and materials to verify their good quality. The meetings were attended by the *obrero mayor*, Fray Antonio de Villacastín, as consultant. The prior or the vicar, as second in command, presided. The paymaster (*pagador*) was responsible for issuing cash on paydays in the lower town where the laborers lived at the building site. In an emergency the accountant was authorized to distribute pay without the presence of inspector or scribe. In 1569 the burdens of the *pagador* were lightened by more assistants among the foremen (*sobrestantes*) to distribute weekly payrolls.[23]

In 1572 the new Instruction separated the paymaster's office from the Congregación, which now included only the prior or his vicar, and the inspector and accountant, who were not to act separately but only as a body, keeping record of all deliberations. The *veedor* now became an inspector at all ranks in the *fábrica*. In 1573 his designated duties were to inspect building in progress, to evaluate the workmanship, and to stop payment on bad work. His rounds were to inspect the conduct of the master builders and their foremen, and to assist as needed in the provision of materials; to help the contractors, and to arrest thieves and arsonists at the building site, delivering them to the mayor in the lower town.[24] He was also placed in charge of the account books, with a paid assistant, so that he might attend to his many supervisory duties.

The *contador* kept record of all income and expense as well as all contracts and estimates for ongoing work. Thus the accountant and the paymaster exchanged roles. The *contador* was now a treasurer, more than an accountant, but both treasurer and inspector remained responsible for the accounts, relieving the prior of this duty, while the paymaster assumed charge of a separate office, no longer sitting with the Congregación, and becoming an employee rather than a director.

[21] Sepúlveda, "Historia," p. 44.

[22] DHM, 2: 73, as of 1573.

[23] Portabales's partisan view gives the Congregación no other function than to oppose the *aparejadores*, whom they

wished as an administrative body to dominate, including the architect and the chief workman (PA, pp. 45-49).

[24] DHM, 3: 71-72, 75-76.

THE COUNCIL ON ARCHITECTURE

The only other body directly responsible to the King was the *Consejo de architectura*, first mentioned in 1564,[25] in connection with the replanning of the monastery to house more friars. Its members were the Conde de Chinchón, the Marqués de Cortés, and Pedro de Hoyo, the King's secretary.[26]

Diego de Chinchón (ob. 1608) had accompanied Philip to England in 1554 as a member of the household, later becoming Spanish ambassador to Rome and Vienna. He was known at court in Madrid as favorite (*privado*) and *mayordomo mayor*, and was at Philip's deathbed in 1598.

Martín Cortés (1533-1589) was the son of the conquistador, inheriting the title of Marqués del Valle de Oaxaca. He too accompanied the King to England in 1554, and remained close to court until his return to Mexico in 1562. He was back in Spain in 1567. The presence of these two nobles of new families and great wealth suggests that one of their functions was to channel funds into the coffers of the Escorial. Martín Cortés may have intervened in bringing, as of 18 April 1565, an annual income from America, collected as tribute among those Indian communities given to Spanish colonists under the institution of *encomienda* (the grant of labor by Indians in return for religious education).[27]

The American grants, exceeding 100,000 ducados in five years, require some comment as to the entire expense of the Escorial. Sigüenza's estimates for the thirty-year period of outlays was over 5 million ducados or about 166,000 ducados as an annual average.[28] The American contribution would then have been about 13 percent annually in the period 1565-1570. The place of the Escorial in the whole economy of Spain can also be estimated. The total expense of the country was divided under two headings: *casas reales* and defense.[29] In 1549 the royal expenses were 343,-000, and defense 402,000 ducados. In 1598 they were 371,556 and 1,313,700. As a portion of the 1598 expense for royal dwellings, the averaged cost of the Escorial was 43 percent, and it was 10 percent of the total national expense. The averaged annual cost of the Escorial, moreover, was less than 8 percent of annual royal income,[30] and under 39 percent of the annual costs of the court. As an economic historian has remarked, the Escorial was a venture designed to produce employment and, as such, was economically indispensable during the inflationary spiral of Philip's reign.[31] It should also be noted that during construction in 1563 the King had exempted about 1,000 persons (master builders, contractors, artisans, and laborers) from taxes while they worked on the Escorial.[32] This policy, however, added to the hidden overall expense of the building, confirms another economist's conclusion that the increased costs of Philip's government were borne by laboring people and town dwellers.[33]

THE MASTER WORKMAN

As we have seen, Fray Antonio de Villacastín was the unique *obrero mayor*, regarded by the master builders as the "*aparejador* of everything."[34] As a humble lay brother he was adviser to the Con-

[25] PM, p. 61.

[26] Vicuña ("Juan Bautista de Toledo," p. 147) adds Doctor Velasco, an adviser to the King, and he defines the function of the Consejo as giving opinions on technical problems.

[27] L. B. Simpson, *Encomienda*. In 1565, 55,000 ducados arrived from this source (Z, 146-51, February 1565), and in 1567, 10,000 ducados. In 1570, 30,000 were promised on a yearly basis (AGS, 259, f. 59); IVDJ, #147 (June 1567); AGP, 3: 197 (10 September 1570). See Appendix 5.

[28] FME, p. 418: 5,260,560 ducados were received and expended.

[29] M. Ulloa, *La Hacienda real de Castilla*, pp. 60-61.

[30] Sigüenza, FME, p. 418, gave total royal income for the Escorial as 5,260,560 ducados between 1562 and 1598, from a total royal income of 12,245,000 ducados.

[31] J. M. Bringas, "Notas de economia," pp. 57-58.

[32] Rotondo, *Historia*, p. 22 (cédula real, 18 January 1563); also AGP, Patronato, legajo 1, copy 1633, 1ʳ (original 15 January 1563).

[33] Ulloa, *La Hacienda*, p. 555.

[34] The phrase is Portabales's (PA, p. 41).

gregación without being a member of it, although he was required at every meeting[35] about building matters. Without his approval no work might go forward.

His career is like that of the mendicant building friars of New Spain, who in the same period were prodigious builders throughout Mexico and Yucatan, erecting hundreds of churches and monasteries throughout the Indian world, guided by the skills they learned in monastic life, and working with a medley of tribes and languages.[36] José de Sigüenza chose to finish his account of the Escorial with a life of "Fray Anton," as he preferred to be called.[37] Born about 1512, he was apprenticed in Toledo to a layer of brick and tile, and entered the Jeronymite Order in 1539 at the Sigla monastery, receiving the habit as a chorister, although remaining a lay brother in building trades and performing every other service, from kneading and baking bread to being doorkeeper. After 1554 he was employed for the Emperor and placed in charge of the remodeling at Yuste.[38] In July of 1562 the King placed him as *obrero mayor* at the Escorial, where he remained until his death in 1603. He absented himself from the laying of the foundation stone (23 April 1563), saying that he would lay the last stone instead, as he did on 13 September 1584.[39] Though neither learned nor a priest, his authority at the Escorial was such that all there from the King to the apprentices relied on his skill and judgment, both in construction and in smoothing conflicts. Another contemporary chronicler[40] said that the King wanted Fray Antonio as foreman to have "joint command and true power in order to do and undo as he saw fit."

His title as *obrero mayor* was by common consent and he used it himself in his duties as the foreman of all the laborers, who sometimes numbered 3,000.[41] He was also paymaster when needed, and keeper of materials (*tenedor*), or a stand-in for absent *aparejadores*, and in attendance at the Congregación, resolving every kind of problem as needed. For at least fifteen years (1570–1585) he gave written approval for every part of the work, summarizing its conditions and specifications, contracts and estimates.[42]

Especially notable are his views on the office of the keeper of materials and equipment, as defined in the Instruction of 1572.[43] He wanted to reduce unnecessary paperwork, as in the case of the six scribes needed to obtain any material from the stockpiles, and to simplify the books, as with the costing of lost equipment, or the issue of metals to be built into the fabric. He approved of reusing scrap metal from the wagons, cranes, and other heavy gear by sale to the smiths against their wages.

Yet the bookkeeping was beyond the capacities of the keeper and Fray Antonio without further assistance, as in the accounting of 30,000 *fanegas*[44] of lime needed for mortar each year, done by only one foreman and Fray Antonio. Granite was receipted at the quarries by an *aparejador* and a friar, while brick and tile were booked at the kilns by a foreman. Cartage was accounted to the respective *aparejadores*. In effect, one of many results of the reform in 1572 was the introduction of friars from the monastery, delegated by Villacastín as associates with the foreman who assisted the master builders. Finally, when the authority of Herrera began to be marked in the 1570s, the King said that "the architect should do nothing without communicating first with Fray Antonio."[45]

[35] DHM, 3: 73.

[36] Kubler, *Mexican Architecture*.

[37] FME, pp. 454–465.

[38] Gachard, *Yuste*, 1: 46, as foreman (*sobrestante*).

[39] "Memorias," DHM, 1: 12, 27.

[40] Sepúlveda, "Historia," p. 14: "con mando mixto y mero imperio, para que hiciese y deshiciese como a el le pareciese."

[41] Villacastín, letter to Jehan Lhermite (4 March 1600), *Le Passetemps*, 2: 87: 1,500 artisans (*oficiales*) and 1,500 laborers (*peones*), every day in some years.

[42] Rubio, "Historiadores," p. 509. G. de Andrés, *Inventario*,

p. 19. Fourteen previously unpublished letters by him appear in Anonymous, *Fray Antonio de Villacastín*.

[43] AGS, 260, 610; text published by Anon., *Villacastín*, pp. 126–135. The keeper of materials and equipment was an office begun in 1562. In 1573 it was charged that he made money beyond his salary amounting to over 1,500 ducados. The Congregación exonerated him after finding that he had saved his salary and served faithfully, never giving reason for suspicion.

[44] A *fanega* is 1.58 bushels.

[45] FME, p. 461.

THE MASTER BUILDERS

No exact equivalent for *aparejador* exists in English architectural usage, although it is close to, yet different from, *appareilleur* in French. The term "preparator" in English has been preempted by laboratory assistants who prepare biological specimens for scientific use. In Spain the persistence of this medieval term has been because of the official status enjoyed by the *aparejadores* in nineteenth-century Spanish architectural education during the 1850s. Since 1871 the craft has been open to all by royal decree, and its adherents are valued only for the skill and knowledge they demonstrate.[46]

Sigüenza defined the sixteenth-century functions of the *aparejador*, distinguishing him from the architect by placing him between the designer and the contractor as the "intermediary who assembles the building materials, decides how they shall be cut, and divides pieces for good fit throughout the building with evenness and beauty, as well as drawing the details for the guidance of the contractors."[47]

At the beginning in 1563, Juan Bautista de Toledo appointed three *aparejadores*, one each in stonework, bricklaying, and carpentry, with the power of dismissing any of them who were found unsatisfactory. But if Toledo were to neglect this duty, the prior and the treasurer were empowered to order him to replace any *aparejador* found wanting.[48] Each preparator was entitled to one assistant paid by the King. By 1569 it was necessary to forbid preparators to employ other assistants on their own initiative, or to place assistants in the employ of any one contractor. This measure suggests collusion and profiteering among *aparejadores* and contractors. Finally, the King's secretary wrote a sharp rebuke to the *aparejadores* (25 August 1569), complaining of their delays in giving drawings for work to the contractors (in violation of orders from the Congregación).[49]

In 1572 the new Instruction[50] called for four *aparejadores*: two for stonework and one each for

bricklaying and carpentry, but they were to be chosen and appointed by the prior (not by the architect) and dismissed by him if and when necessary. The pay remained the same, with the previous restriction on additional assistants and their employment by contractors. Their work orders, however, were to come from the Congregación and the master workman, Villacastín, and they were required not to meddle in each other's business to prevent collusion.

Other restrictions on unnecessary expense came in 1573-1574. The masons had been hiring carpenters to make wooden patterns for stonecutting, but the Congregación ruled that they should be made in the building set aside for drafting and model making (the *casa mayor de traza*), where the patterns could be available to other masters and foremen.[51] In 1574 the Congregación had to renew its regulation that the master masons (Tolosa and Escalante) submit dated and signed specifications for the sizes and quantities of stone they were requisitioning from the quarrymen.[52] This precaution also is clearly directed against fraud among masons, quarrymen, and carters, who were extracting more stone than needed from distant, rather than nearby, quarries. The presence of at least one mason and one friar to take delivery at the quarry was also required once weekly, and the masons were forbidden to break up stones that were not cut to required measure. Teamsters and drivers were to receive daily orders every evening from the masons for the next day's needs, and to cart no more than written in the order. The foremen were also empowered to issue work orders for the master masons when the latter had been unable to file their own orders. In brief, the masons had been dilatory and unreliable, at the expense of the crown and to the detriment of the contractors.

The master masons were further ordered not to divert masons in their employ from tasks assigned by the Congregación, under penalty of fines

[46] *Enciclopedia universal ilustrada*, Barcelona, 5: 931.
[47] FME, p. 23.
[48] DHM, 3: 8, 27.
[49] PA, p. 47.
[50] DHM, 3: 33-62.
[51] DHM, 3: 71.
[52] DHM, 3: (7 July 1574).

against their salaries. They had also been in the habit of making the work drawings at home, and were ordered to prepare these instead at the main drafting rooms on the site. Conflict between master builders and contractors was possibly more common than their collusion to defraud. An example is the beating of a contractor by a nephew of Pedro de Tolosa. The *aparejador* himself, Tolosa, was found guilty by the Congregación and was ordered to be jailed, just when there was great haste for him to finish roofing the makeshift church. Tolosa was fined and denied access to the fabric,[53] but he eventually returned to work.

Another suit arose between a master builder and the Congregación, when Lucas de Escalante, the other master mason, who was raising the walls of the main cloister in the winter of 1568, ordered granite architraves sixteen feet long. The prior and Congregación demurred, appealing to the contractors, who advised that such monoliths cost more than when cut in four parts. A test was made, and the great stone could not be brought across frozen rivers even by fourteen oxen without being mired beyond recovery. At the King's order, Escalante was obliged to forego the monoliths[54] in favor of three-piece flat arches. The prior judged that the fault was the master builder's, as the one responsible for tests and appraisals (*tanteos y tasas*).

Sometimes the master mason Pedro de Tolosa, when backed by the King, could stand against even Villacastín, the *obrero mayor*, as when in 1571 it was decided to rebuild the main staircase walls, with the masonry (*obra*) by contract and the cut-stone facings (*asiento*) by piecework. This went against the grain with Villacastín, who thought piecework (*a jornal*) would raise the cost by 2,000 ducados and be done no better.[55] Another source of conflict between the Congregación and the master builders was at the expense of the contractors, because the *aparejadores* would delay the de-

livery of estimates in order to favor those whom they preferred. When the Instruction of 1572 was made public on 8 December by the prior, only the *aparejadores* dissented, and further instructions became necessary in 1574 that limited their powers even more.[56]

Herrera's cranes and lifts and the division of the work at the basilica into ten crews, each with its own master mason, eventually made speedy building possible, but these changes also made new difficulties that were not resolved until 1576. The masters wanted more pay; the drawings were not ready; it was uncertain who would draft the specifications; the contractors wanted guarantees that they would be paid; and throughout Spain people began to murmur about the cost of the Escorial, which was rising with the new procedures to speed construction, because of heavier costs, for more masons at higher wages[57] and for living quarters at the quarries. To top it all, Herrera decided to appoint Juan de Mijares as the only master builder of the basilica (*aparejador unico de la iglesia*) in April 1576. Tolosa and Escalante, the original master builders at the site, went or were sent away to other posts.[58] Mijares remained at the Escorial until 1583.[59]

With Mijares's appointment, the authority of the master builders was broken, and the era of the contractors began. Troubles at the fabric nevertheless worsened as the pace of building quickened. There was an unprecedented riot by a majority of the stonemasons at the site on 20 May 1577. Irritated that some of their Biscayan compatriots had been imprisoned by the mayor in the lower town, stonemasons stormed the jail to save the prisoners from being beaten. The rioters and the prisoners were all from the north and considered themselves of noble birth. The riot subsided when the prisoners were released by order of the prior, but discontent remained widespread among the general population because of recent new tax

[53] Modino, "Priores," p. 251: the sentence was "voluntary exile."

[54] Modino, "Priores," pp. 254-255. In 1571 Escalante married the sister of Tolosa, with some dowry from the King via the prior (ibid., p. 270).

[55] Modino, "Priores," p. 265.

[56] DHM, 3: 79-84; Modino, "Priores," pp. 274-277.

[57] PM, p. 88; PA, p. cxxx, vi-viii (25 March 1576). The King had ordered paying masons at the quarry one-fourth more

than originally contracted.

[58] AGP, 4: 318ᵛ: Tolosa went as *maestro mayor* to Uclés (9 April 1576). Escalante died in 1579 at Aranjuez; Tolosa in 1583.

[59] Llaguno, *Noticias*, 2: 123; C. Wilkinson ("Juan de Mijares," and "The Career of Juan de Mijares," p. 122) gives Mijares's appointment as 11 August 1576, although he prepared orders as *aparejador* for the fifty-five-foot cornice in the palace court on 14 April 1576 (AME, v-27).

levies. The leaders were punished and left the fabric, but those remaining were not affected because of their exemption from taxation on their pay at the Escorial. Yet the usual hostilities between them and the town government had worsened in the rising economic distress of the farmers and townspeople in the region. It is also likely that the departures of Tolosa and Escalante were part of the grievance, as was the men's being worked harder than before and under worse conditions at the quarries than at the building.[60]

THE CONTRACTORS

Not the least of the many disagreements between the King and Juan Bautista de Toledo concerned obtaining the best work for the least money. Toledo believed that it was by piecework, but the King thought that each piece of work should be contracted to the lowest bidder on exact specifications. Toledo was accustomed to work together with his artisans, and the King expected every job to be completely thought out and described in minute detail before giving it to competitive bidding (a destajo). Toledo was the outsider, and the King had much experience with the royal master builders in Spain who were accustomed to the competitive system. Their disagreement is clearly recorded in December 1564.[61]

After 1569 the destajo would be normal all through the fabric, in quarrying and masonry, as well as in carpentry and bricklaying and every other building craft, to the exclusion of all piecework, except on small tasks, and foundations up to ground level. The specifications for contracts were to be written and drawn by the aparejadores, who were not in any way to deter or molest the contractors, before or after the awards in open bidding.[62] The Instruction of 1572 laid out further extensions of the principle, especially to the provision of burnt lime for mortar, the cost of which had become excessive on piecework. The preparators were expected to monitor work awarded on contract, and contractors were forbidden to take another contract until the current one was finished, unless the prior ordered otherwise. The preparators in turn were forbidden to make known on their own the terms and estimates of any work coming up for bids, or to abuse the bidders in any way.[63]

The prior was also authorized, in the furtherance of the contract system, to employ on daily wages as many as ten good artisans from different crafts, who had the means and credit to become contractors. By this device the King in effect diminished the number of outsiders being introduced to the fabric. To ensure the prior's control over the quality of work, the Congregación could withhold one-third to one-fourth of the agreed price until inspection of it by their agent and the responsible preparator.[64]

In 1575, it was announced in major cities of Spain that the construction of the basilica would proceed by destajo. Some sixty builders appeared for the bidding at the Escorial, of whom twenty were chosen in January 1576 for the ten sections. Each had two master masons and at least forty artisans, and each section received 250 ducados monthly. The unsuccessful bidders were paid for their travel to and fro at 2 ducados daily, calculating eight leagues distance each day.

The first decision after forming the ten sections was whether to shape each stone, ready for laying, at the quarry or on the site. In a general meeting the Congregación, the council on architecture, Herrera as architect, and the contractors all agreed to adopt shaping at the quarry.[65] The King was at the Escorial for the meeting, and the

[60] JSJ, pp. 187-188; FME, 73-74. C. Vicuña, "El Motín," *Anécdotas*, pp. 56-61.

[61] Z, 146-24. Pedro de Hoyo discussed work to be given on contract with Toledo, who was awarding work based on his own estimates (a tasacion). The King comments that bidding (a destajo) is preferable, and that he wants the friars' opinion.

[62] PA, p. 47. The aparejadores were reprimanded (25 August 1569) about issuing drawings for destajo without prior consent

from the Congregación.

[63] DHM, 3: 37-39.

[64] DHM, 3: 63 (19 October 1573). Congregación to the King.

[65] JSJ, pp. 159-160 (8/9 January 1576), PA, p. cxxxiii (19 January 1576). For a possible precedent in Mexico, Kubler, "Ucareo."

Congregación finally agreed to pay for shaping at the quarry one-fourth more than originally contracted for, as well as an annual bonus of 200 ducados to each contractor as of 9 January 1576.

The appraisals (*tasaciones*) by the preparators, on which the bids were based, were on three kinds of wall: up to the thirty-three-foot level; from thirty-three feet to crest; and finally the dressing of the completed wall. Lucas de Escalante, who had been among the first *aparejadores*,

was hostile to the new idea, saying that he could not participate without Herrera's drawings for the work, which he still had not received from the architect.[66] Other objections arose, which were resolved when the King visited a quarry in March 1576 to observe the method in practice. Herrera's stone lifter, with geared pulleys, was demonstrated to the satisfaction of the King, who then ordered work to proceed as decided in January.[67]

THE FOREMEN

These men were the lowest rank of the governing officers appointed in the administration. To make sure that these important links with the laborers were reinforced by the central authority of the prior, a friar-delegate accompanied each foreman in his daily rounds. The Instruction of 1563 stresses the friar-delegate as the principal member of the pair, chosen by the prior or his vicar to prepare with a foreman of proven ability and literacy a weekly list of all laborers and their hours of daily work. This was signed by friar and foreman for use in making up the payroll. The list also distinguished between productive and unproductive workmen, and it reported efforts to defraud the paymaster.[68] All ranks in the fabric, from the prior to the foremen, were enjoined to make certain that every laborer was useful and punctual in winter and summer, working with the same care as he would on his own account. Dismissals were in the power not of the foreman but of the prior, the accountant, and the architect.

The foremen were appointed by the prior and accountant, and they were paid the highest laboring wage (3 reales per day), but they took their working orders from the architect.[69] No one at any official rank—whether *aparejador* or foreman—was allowed servants, houses, or carts at royal expense. Nor could the foremen, together with the artisans and laborers, be required by any

friar or officer of the fabric to perform any other services than those for which they were paid. In 1572 the new Instruction[70] required the prior to take oaths from the foremen to serve well and faithfully. The Congregación also decided to move the foremen about from crew to crew, and to dismiss them without prejudice when the contract was completed. The implication here is that the number of foremen had been increasing unduly and that many were idle.

Their principal duty was still to supply worklists specifying the craftsmen, hours worked, and wages due. These lists were delivered to the master workman, Fray Antonio, or his representatives, who were friars entrusted with the Saturday night payroll. This shift from the accountant's office to the friars as delegates is part of a general effort by the Congregación to reduce the salaries paid to civilian assistants.

In 1573 the Congregación urged further provisions to the preceding Instructions. These had stated it as the foremen's duty to receive from the preparator (*aparejador*) each evening the orders for the assignment or task of the crews for the next day. But the foremen complained that the master builders (*aparejadores*) were often inaccessible at their dwellings because they were making drawings. From this arose the Congregación's ruling that the masters should draw in the drafting

[66] Modino, "Priores," p. 298, citing AGS, 261 (1 December, 1575).

[67] JSJ, p. 163. PA, pp. iii-iv, is an order by Toledo (10 April 1562, fourteen years earlier) that the stones for door and window frames be "debastadas en la cantera," but here *debastar* means only rough-shaping, for which Toledo would supply

dimensions. No document mentions the process again until 1575.

[68] DHM, 3: 6. The term *fraile delegado* was coined by Garcia Lomas, "Organización laboral," p. 300.

[69] Always called *maestro mayor* in this Instruction.

[70] DHM, 3: 59.

rooms at the building site.[71] Another proposal was to appoint a master foreman who would visit all works to inspect the performances of masters and laborers, as well as the condition of their equipment, and to report to the overseer (*veedor*) and to Villacastín, the *obrero mayor*, who were both overworked. This master foreman would be their representative (*fiel executor*), salaried at 4 reales daily, and empowered as a justice at the building site, where he would also guard materials and equipment. The King's marginal note to this proposal says, "for the present what is provided is good, and let it be kept."[72] No later document mentions any master foreman other than Villacastín.

But the Congregación had second thoughts about foremen and the keeper of supplies at the end of 1573.[73] They now proposed that these officers should not be natives of the Villa at the lower town or of the province surrounding it, because of their venality and propensity to favor each other. They also thought that the overseer should perform the tasks of apprehending thieves in the fabric and delivering them for justice to the mayor of the Villa. Thus the "idle" foremen were not after all to be trusted, and the "overworked" *veedor* was further to be burdened.

The authority of the prior was once questioned over the choice of a foreman.[74] The overseer wished his candidate to be appointed, but the prior insisted on his own authority, being un-

willing to commit his successor to a surrender on foremen, whom he regarded as the prior's responsibility. The King supported him by affirming that no appointment of foremen should be controlled by any other officer of the fabric than the prior.

The duties of foremen were specifically enumerated in special orders and Instructions after 1573.[75] For example, a foreman at the tile works was charged with packing for transport, recording production and quantities transported, and in all matters to "take care of the King's property."[76] At the slate quarries of Bernaldós a foreman was to inventory all tools left by his predecessor, to mark them with an R as royal property, and to separate new from used tools. He was to supervise the daily working hours in person, according to the seasons, and to reduce the wages of absentees: a workman was not to bring his wife or relatives to the quarry without express permission from the Congregación, and in case of illness he had to find a substitute. The foreman was also to provide muleteers with loading orders to present at the fabric. At the end of the month he was to prepare the payroll lists and assist the paymaster in delivery of payments to the workmen. Similar orders were prepared for other crafts, recognizing and regulating the importance of the foremen in the discipline of production, under conditions where the foreman was in sole charge for long periods as a manager.

THE LABOR FORCE

These included skilled artisans (*oficiales*) in many crafts as well as laborers (*peones*).[77] Both were hired by the architect with approval from the prior (or vicar) and treasurer. The only requirements were competence and reliability as workmen. They could be dismissed by the architect at the will of the prior and treasurer, for inadequate work, or for rebelliousness, or other defects. There was never any difficulty in finding enough laborers, because the crews assembled to build the

Escorial quickly acquired the characteristics of a protected and envied class. All who worked at the Escorial were exempted from taxes on their wages, which continued even during idle periods when the flow of design or materials was interrupted. Even sales of food in the lower town to the Escorial workmen were tax-exempt, beginning in 1563 and continuing under Philip III, who renewed the exemption in 1645.[78]

In 1562 a bailiff was appointed by the prior and

[71] DHM. 3: 63-68 (19 October 1573) [72] Ibid., p. 66.

[73] DHM, 3: 69-78 (21 December 1573), "Relacion."

[74] Modino, "Priores," pp. 304-305 (23 February 1576).

[75] DHM, 3: 99-104.

[76] DHM, 3: 106.

[77] DHM, 3: 8-9 (2 April 1562), *Instrucción*.

[78] AGP, legajo 14, ff. 96ᵛ-99. I thank M. C. Volk for communicating her find.

treasurer to keep order at the fabric. He received a daily wage of 5 reales, including Sundays and holidays, and was under the supervision of the treasurer, who also administered justice for the entire community and provisioned everyone at the site with supplies at just and moderate prices. The treasurer alone was responsible for such provisioning, which was not unprofitable to him, since all other officers of the fabric were forbidden to resell food to laborers.[79] Cartage and the care of the hundreds of draft oxen required a separate Instruction.[80] The service was another responsibility of the prior, who appointed a friar as superintendent of the teamsters, carters, ox-drivers, and tenders of the carts and their harnesses. The lawyer of the fabric procured winter fodder for the two hundred oxen, which needed thirty-four pastures in summer.

The working hours for most laborers were from 6 a.m. to 11 a.m. and 1 p.m. to sunset with a half-hour rest at 4 p.m. Winter hours were 7 a.m. to 12 p.m. and from 1 p.m. to sunset for all hands, Spanish and foreign. A hospital in the Villa was available for the sick and injured, and in winter at the monastery kitchen a heated room for laborers existed in 1573. Many who lived in the Villa below the monastery were often abused by the mayor, who, as an officer subject to the prior, could be restrained when necessary, although the mayor's interests lay with the townspeople rather than the transient laborers.

With the completion of the monastic buildings approaching in 1571-1572, the problem of finding work for the idle laborers first arose,[81] and it was not resolved until after work began on the basilica in 1575. The King and the administration were aware of the irreplaceable value of a trained and stable working force, which they could not disperse, having no choice but to keep them on part-time projects. The difficulty was not resolved until the work began on the basilica in 1575. The new contracts dropped from twenty-three in 1574 to only two in 1577 (Appendix 9). Of course many old contracts were still in force, making employment for many, but they too reached their end, and enforced idleness became general. New contracts for the basilica were fewer than under

the old arrangement, and the new ones concentrated fewer workmen in more efficient ways than before. The net result was a diminution in the size of the active labor force until the basilica was well enough along to allow the diversion of many crews to other tasks in the palace and college, which had been delayed by the new work schedules for the basilica.

The beginning of the new work prompted Villacastín to stage a surprise for everyone. On 7 March 1575, when the first stones were to arrive,

he secretly ordered, although he was himself little given to jokes and parties, a delightful invention to which everyone came—contractors, masters, foremen, artisans and laborers—about a thousand persons disguised as dancers in a showy procession. In the vanguard were the laborers, carrying instead of lances and pikes, tools of their crafts, pickaxes, hammers, shovels, hoes, mattocks, all in strange disguises. In the middle, as in a battle force, came a squadron of splendid infantry with pikes, lances, and crossbows. In the rearguard were four quadrilles of draft oxen, each team with its driver. The first one pulled the largest stone in a triumphal chariot garlanded in ivy and flowers which were never lacking here even in winter, and with a figure of St. Peter in front, key in hand. The second chariot bore San Lorenzo . . . and in the third came the four Cardinal Virtues, signifying the person of the Founder, prudent, temperate, strong, and just, and this last virtue preceded the others bearing a naked sword in hand, and all singing in harmony the praises of Our Lady and the glorious martyr San Lorenzo. On the fourth chariot were the three Marys coming to the sepulcher of our Lord. When asked, the inventor of the procession [Villacastín] explained that they were the emblem of the priors and holy friars searching night and day in the temple for Our Lord. After the four pillar-foundation stones were unloaded in their proper places . . . the dancing began and then the processions and parades. Finally a lively young bull, stumbling into some and trampling others, without hurting anyone, ended the party to the delight of all.[82]

Fray Juan de San Jerónimo added further details: the people in disguise wore garments of priests and gentlemen, escorting two others impersonating bishops, one slapping people instead of blessing them, and the other picking a fight with

[79] DHM, 3: 10-11.
[80] DHM, 3: 15-23 (1568).

[81] Modino, "Priores," p. 270; PM, p. 268.
[82] FME, pp. 55-56.

some costumed horsemen to the joy of the crowd. At the end everyone fell upon the food, which Fray Antonio had provided.[83]

We are not told exactly what happened during the long idle period, but many laborers and artisans may have drifted away to other jobs or back to their fields, and the *fiesta de Fray Antonio*, which celebrated a return to work at the Escorial, reflected the wishes of the employers more than those of the laborers. The Hatfield drawing of the basilica in construction (fig. 65) shows the setting of the festival, among unfinished façades almost enclosed by the rising walls of the monastery, the King's house, and the palace.

There were many benefits both in remaining and in returning to the Escorial: exemption from taxes; half-pay during illness; pay on holidays; hospital and medical services; foodstuffs at fixed prices from the *fábrica* stores and in the Villa during periods of price inflation; pay supplements according to work done.[84] The provisioning of workmen by the Congregación at the King's expense was foreseen in the Instruction of 1563, when the treasurer was ordered to take special care that the people were provided with food.

Using Quevedo's notes on food prices at the Escorial in 1571,[85] Portabales concluded that a *peón* earning 2 reales (= 68 maravedís) daily could buy an adequate supply of food for his family at the *fábrica* stores and have 20 maravedís left over:

1 lb. goatmeat	10 maravedís
2½ lbs. bread	9

1 flask oil	8
1 measure wine	5
1 lb. peas or lentils	16
	48

Quevedo also noted that wheat, which had risen in Castile from 7½ reales per bushel to 11, never exceeded 9 reales 4 maravedís at the Escorial, and that the price of bread did not rise between 1564 and 1571. Such fixed prices were part of the Instruction of 1572, when the Congregación was authorized to purchase and store supplies of wheat against shortages at the fabric and in the Villa, and to regulate production at the bakeries as needed.[86] These practices actually began in 1571, when 5,000 bushels of wheat were purchased at the Villa for storage. Milling was to be done as near as possible to reduce costs of transport, and the prior was to appoint the sellers of bread and fix the quantities to be baked. Sales were for cash.[87]

The ancient tradition of a monastic hospice for travelers and beggars continued at the Escorial, but it was enlarged by the King's wish to have the facility also serve the ill and injured of the fabric. A hospital was accordingly built in 1575-1576 by Fray Antonio with fifty beds in the original dwelling of the friars in the lower town. If need arose, it could take as many as seventy beds. In 1599, the hospital was abandoned and the service was moved to the Compaña, which had been added to the monastery.[88]

[83] JSJ, pp. 121-123.

[84] J. M. Bringas, "Consideraciones," p. 58.

[85] J. Quevedo, *Historia*, pp. 96-98, reprinted in PM, pp. 119-121.

[86] DHM, 3: 77-78 (royal approval 30 April 1574).

[87] Modino, "Priores," pp. 268-269, compares these measures to those of a modern labor cooperative.

[88] Modino, "Priores," pp. 293-295; J. Donato Martinez, "Fuentes," pp. 310-311.

4

THE ESCORIAL DESIGN: ORIGINS AND ANTECEDENTS

IN ENGLISH, the word *design* combines many meanings. These relate mainly to purpose actions of all kinds, such as a political design or an economic plan, as well as to making a model, a drawing or a picture. But in modern Spanish (as well as French and Italian), the artistic sense is predominant and exclusive, as to draw sketches for figures or plans for buildings. Thus the English usage permits a distinction between remote and immediate acts of design, as in the difference between overall strategy and limited tactical actions, and it relates design to the political, social, and economic conditions of any work of art. When considering remote acts of design, however, the special case of a design's origin, or its coming into being, requires separate treatment from its antecedents, which only convey what preceded the forms being studied. Thus the design of the Escorial is both one and many. The King's wishes endowed the building with a variety of purpose, but his architects, each according to his nature, gave it different kinds of unity by designs related to ancient Mediterranean, Italian, northern European, and medieval Spanish sources.

THE TEMPLE OF SOLOMON

Wherever a King builds, Solomon comes to mind. At the Escorial, the statue by J. B. Monegro of King Solomon, among six Old Testament builder-kings on the basilica façade, was an afterthought before 1580, not included in Herrera's early drawing of the façade (fig. 20), showing six sphere-crowded obelisks,[1] but no kings.

For Sigüenza in 1605 the statue of Solomon was only a simile in the *Prologo*[2] when he compared the Escorial to another Temple of Solomon, whose ceremonial the King was imitating in his Escorial. But the idea of the six Biblical Kings

[1] LS, p. 17 and pl. 1. The contract with Monegro for the six statues was granted on 21 December 1580 (AME, VII-13, ff. 12ᵛ-15).

[2] FME, p. 6. The legends by Sigüenza were not carved until after 1605 (p. 216) and were not put in place until the 1660s (Andrés, "Nueve Cartas," pp. 116-127).

found no expression until Monegro was engaged to carve them. Also after the fact of the Escorial was the lavish publication[3] (1598-1604) of a study imaginatively restoring the Temple in Jerusalem, by the Jesuits J. B. Villalpando (1552-1608) and Jerónimo Prado. Villalpando was Herrera's pupil, and the restoration (fig. 22) shows the influence of the Escorial designs in many ways. It is not likely that the King saw Villalpando's work until the Jesuit left for Rome in 1592.[4] Grandiose as they are, Villalpando's apocalyptic elevations and plans of the Temple are as far from the Escorial as William Blake's visions are from engineering drawings.

SPALATO

The palace of Diocletian in Dalmatia appears in two sixteenth-century drawings with legends in Italian. The drawings show the mausoleum in plan and its doorway in elevation.[5] Zeiller was struck by the resemblances of the plans at Spalato and in Spain. He illustrated them at the same scale, noting a near identity of overall dimensions (205m x 165m). Other similarities, of royal retreat and burial place, can be added. The doorway drawing shows a width-height ratio of 3:5, as at the Escorial façade portals (fig. 23).[6] The use of a pediment interrupted by an arched aperture is common to both basilica and mausoleum: it has been called the Syrian pediment.[7] Courtyard arcades lining the forecourt approaching the basilica were planned by Toledo[8] but never executed. The plan (fig. 31) shows twenty coupled columns on the south forecourt wall, which were to have formed sheltered walks. Had they supported arcades, the effect would have been like the peristyle and prothyron courts at Spalato.[9]

It is well known that Italian military architects knew Spalato in person or by drawings because of its economic and strategic importance: Spalato sold Turkish wheat to Venice (1570), the Vene-tians in turn bought horses from its back country (1582),[10] and at the end of the century, Spalato was refurbished as a commercial port by Venice.

Toledo's initial design (fig. 30) for the Escorial had fourteen towers, of which ten marked the corners and the midpoints of the rectangular enclosure. The effect was castellated and defensive as at Spalato, where sixteen towers defended corners, gates, and walls. Later changes at the Escorial, required by the doubling of the monastic community in 1564, not only raised and leveled the terraced silhouette of Toledo's first design, but also eliminated the covered walks flanking the basilica's forecourt.

To compare the programs shows greater differences than do the plans of Spalato and the Escorial. Both have royal residence, circular tombs, and temple, but Spalato was a fortified garrison, of which half the area was given to housing the imperial guard and the stables. At the Escorial Philip finally refused to have animals stabled in the building, preferring to reserve it for human use only, and all animals were kept in outbuildings beyond the Compaña.[11]

[3] Villalpando, *In Ezechielem Explanationes*, vol. 2. René Taylor ("Villalpando," in *Academia*) suggests (p. 7) that Villalpando studied with Herrera before 1580.

[4] Taylor, "Villalpando," pp. 5-7. Taylor prefers 1580, for which proof is lacking. A. Rodriguez Gutierrez de Ceballos also favors 1580, as the beginning of Salomonic "emulation" by Philip II ("Juan de Herrera y los jesuitas," p. 8). But by then all major decisions about the Escorial had already been made. Villalpando's esthetic ideas gave Taylor a confirmation of his interpretation of the Escorial as a Mannerist monument ("Villalpando," p. 8).

[5] They were published in 1912 as by Palladio and again in 1958 as of unknown authorship: E. Hébrard and J. Zeiller, *Spalato*, pp. 4, 5, 7. The drawings in the collection of the Royal Institute of British Architects may have been brought to England by Inigo Jones after his journey of 1614-1615 in the Veneto (J. C. Palmes, *Architectural Drawings*, p. 13). G. Zorzi (*Disegni*, p. 106, figs. 266, 267) transcribed the Italian notations.

[6] *Sumario*, p. 22.

[7] F. Bulič, *Kaiser Diokletians Palast*, p. 109.

[8] *Sumario*, pp. 21-22.

[9] F. Bulič, *Kaiser Diokletians Palast*, figs. 11 (R. Adam, 1764), 28.

[10] F. Braudel, *La Méditerranée*, pp. 241, 327.

[11] Sigüenza (FME, p. 400) as usual turns the necessity into a virtue of the King's: "the founder . . . wished no beast or animal inside or near the walls, but only rational human beings."

THE MONASTIC ORIGIN OF THE PROGRAM

The final program was attained gradually and by accretion rather than by instantaneous foresight of all needs: (1) The initial and constant requirement was for a dynastic burial place and temple, properly called the basilica. (2) Both crypt and temple were to be served by daily rituals of commemoration for dead and living royalty, performed by a large monastic community housed in five cloisters. (3) The King's house was to surround the sanctuary and face toward Madrid. (4) Courtiers and their servants of both sexes were to be housed according to their rank and suitably close to the person and family of the monarch, whose service was the reason for the court's presence. (5) A library of world importance was to be accessible to all principal groups in the complex, with adequate protection for manuscript treasures. (6) The college and seminary with its professors was to replenish the monastic community and share in the rituals of commemoration. (7) Adequate hospital services were to be provided, together with a pharmacy where medical research could be performed. (8) Outbuildings would house the overflow from court and schools (the *casas de oficios*). (9) A separate compound, the Compāna, would be for workshops, stables, mills, storage, bakery, and other industrial activities, as well as guesthouses, a hospice, and offices.

Only the first five of these functions were considered in the earliest planning of the Escorial. The last four were later additions. Originally the kitchens and stables were to be housed in the quarters later occupied by the college and seminary. The hospital, however, was conceived from an early date as protruding beyond the block. The outbuildings (*casas de oficios* and Compaña) were afterthoughts, made necessary by the change of plans regarding college and seminary, and by unforeseen increases in the services and their staffing.

F. Chueca first showed in 1966 that palace-monasteries of multiple functions in early medieval Spain were the original stock from which the builders of the Escorial drew most of their solutions.[12] In these medieval prototypes the monasteries housed royal tombs, together with palace chapels, royal collections, and church schools. Chueca rightly considers the Escorial as the last of the palace-monasteries in Spain, where the friars were exempted from episcopal taxation and subjected to the monarch,[13] and where the royal family and court might lodge amid their travels to attend the needs of government throughout the country from region to region.

Chueca also sees the palace of Diocletian as an origin for the series of similar edifices at Constantinople, Ravenna, Aix-la-Chapelle, the Westminster Abbey of Edward the Confessor (1042-1066), and the Abbey of St.-Denis (Paris), where monastic houses became permanent cult places at the tombs of kings. The Spanish series began at Oviedo in Asturias after A.D. 768: royal tombs adjoined the King's palace in a monastic compound, continuing in Benedictine, Cistercian, Mendicant, Carthusian, and Jeronymite houses under royal protection, and coming to an end at the Escorial.[14]

HOSPITALS OF CRUCIFORM PLAN

The western half of the Escorial owes its plan—as two cruciform courts of eight cloisters flanking an open court—to the design by Antonio Averlino Filarete for the Ospedale Maggiore of Milan

[12] *Casas reales en monasterios y conventos españoles.* Dieter Jetter ("Klosterhospitäler") extended the analysis to include St. Gallen, Cluny, and Poblet for the antecedents of the hospital at the Escorial. For earlier royal burial churches, K. H. Krüger, *Königsgrabkirchen der Franken, Angelsächsen und Langobarden.*

[13] Chueca, *Casas reales,* p. 22, citing J. F. Lemarignier, *L'Exemption monastique,* Dijon, 1960, pp. 300-301, and

G. Constable, *Monastic Tithes.*

[14] Chueca, *Casas reales,* pp. 31-49, 51-59, 76. He rejects the suggestion of F. Iñiguez (*Trazas,* p. 20) that the Benedictine monastery at Catania in Sicily, begun 1558, bears any relation to the Escorial. The plan by Valeriano de Franchis is also by paired and symmetrical cloisters flanking a church, but no other evidence now connects it with the Escorial.

begun in 1546 (fig. 24).[15] These cruciform courts were widely copied in Italian and Spanish hospital designs, as at Santo Spirito in Sassia at Rome, and in Spain in an important series of related hospital buildings at Valencia, Zaragoza, Toledo (Santa Cruz), Santiago de Compostela, and Granada. Three were built by Enrique Egas (Santiago, 1499; Santa Cruz in Toledo, 1501; Granada, 1504). The source of them all is Filarete's design in Milan, which he provided with a sewage system and water supply described at length in the treatise and imitated at the Escorial. The *Trattato* (c. 1464) was copied for Alfonso of Aragon in a version available at Valencia by 1546.[16]

The Hospital de Tavera in Toledo, begun in 1541, is the main precursor in Spain for the severe architecture of Italian precedents, as used at the Escorial. The designer and architect, Bartolomé de Bustamante (1501-1570), repeatedly said that the hospital was his design, and scholars have long accepted his claim. Bustamante was in Italy in 1536 and again in 1565-1567 as a member of the Jesuit commission on buildings.[17] His knowl-

edge of architecture was more theoretical than practical, and his relation to the master builder parallels Herrera's at the Escorial. Both Bustamante and Herrera were in command until they retired: both were apostles in Spain preaching correspondence and unity of design released from ornament. Philip II requested Bustamante's advice on the "errors" (*yerros*) at the Escorial in 1570,[18] but Bustamante declined because of age and illness, saying he thought he could have said many important things to the King on this subject. These *yerros* probably concerned the main stairway (fig. 31) as begun on designs by Toledo. The walls were taken down and rebuilt (to Herrera's design) early in 1571.[19]

All authorities accept Bustamante as designer in 1547 of the church, built over a round crypt like that of the Escorial. The crypt was begun in 1542 and completed in 1545. Bustamante determined the form of the church and crypt from beginning to end.[20] His Italian models were possibly works by Antonio de Sangallo and Baldassare Peruzzi, reinforced by Serlio's *Tercero y quarto libro*.[21]

ITALIAN PARTICIPATION IN THE ESCORIAL DESIGNS

This theme is as old as the Escorial itself, but it has been unwelcome to many Spaniards in recent decades, among whom the *Hispanidad* of the building has been augmented by exaggerating the exclusivity of the contributions by Juan Bautista de Toledo and Juan de Herrera, and by ignoring or undervaluing the documented participation in Spain of Francesco Paciotto. The roles of Michelangelo, Galeazzo Alessi, Vincenzo Danti, Andrea Palladio, and Vignola are likewise not much discussed in Spain, but of course these Italians pre-

pared projects only at the King's request, without themselves coming to Spain. In addition their drawings for the Escorial have either not survived or been lost.

Villalpando's Translation of Serlio, 1552

Sebastiano Serlio (1475-1554/5?) began publishing the *Regole generali di architettura* in 1537. Book Four appeared first in 1537, and Book Three fol-

[15] J. Spencer, *Filarete's Treatise*, 1: 137-146, 2: 79r-84v. S. Zuazo first published the derivation in *Los Orígenes*, p. 19.

[16] C. Wilkinson (*Tavera*, p. 248, v. 50, and p. 256, v. 66) believes it was borrowed for use at the Escorial.

[17] A. Rodriguez Gutierrez de Ceballos, *Bartolomé de Bustamante*, published the principal documents. C. Wilkinson, *Tavera*, believes that Alonso de Covarrubias was the architect, although he is mentioned in the documents only as *maestro mayor*. In 1546 he received 15,000 mvs. of salary, and Bustamante 70,000 (Rodriguez Gutierrez de Ceballos, *Bartolomé de Bustamante*, p. 331). The plan of 1541 does not bear Covarrubias' handwriting (as claimed by Wilkinson, *Tavera*, pp.

272-273, notes 1, 4. It seems to be Bustamante's (Rodriguez Gutierrez de Ceballos, *Bartolomé de Bustamante*, fig. 1).

[18] M. Pereda de la Reguera, *Bustamante*, p. cix (25 May 1570), letter to S. Francisco Borja.

[19] L. Rubio, "Cronología," p. 46, citing AGS, 258, f. 105, published by Portabales (PA, pp. cxvii-xviii). Also Modino, "Priores," p. 265, on cost and method.

[20] Rodriguez Gutierrez de Ceballos, *Bartolomé de Bustamante*, p. 34; P. Salazar de Mendoza, *Cronica*; Wilkinson, *Tavera*, Doc. iii.

[21] Wilkinson, *Tavera*, sees the Tavera Hospital as "an extension of the principles of the Plateresque style to a new mon-

lowed in 1540. He wrote for architects and laymen, but was criticized by younger contemporaries such as Benvenuto Cellini in 1568 as an empiric carpenter, and Gianpaolo Lomazzo in 1584 as lacking invention.[22] His translator in Spain was Francisco Villalpando (b. Palencia?-ob. 1561),[23] who dedicated his work to Prince Philip in 1552. It may have molded the architectural taste of the future monarch. Villalpando implies that he had begun the translation before the Prince's departure for Flanders in 1548, hoping to inspire him to build "many great and royal edifices."[24] Whether Villalpando directly influenced Prince Philip is unknown. His architectural work is known only at Toledo, when he and Gaspar de Vega began to build the imperial stairway design in the Alcazar on a royal appointment of 15 October 1553; the Prince said that it should be built "with upper landings at the upper corridor ends (testeros)."[25] Only the first flight was built when Villalpando died, and Herrera finished the rest in 1574 and later.[26]

Villalpando's errors in translating Italian indicate a lack of humanistic schooling and associations.[27] They reflect the artisan's status as a bronze worker trained in late-medieval traditions of craftsmanship. Coming into the new stream of Renaissance learning he lacked the fluency in modern and ancient languages that were customary among his Italian contemporaries. His translation nevertheless supplied Spain with a working text for Vitruvian design as Serlio understood it. Serlio was already old-fashioned among Italian architects when he died near eighty, fifty years older than the King. Juan Bautista de Toledo probably relied more on Villalpando's translation than on his memories of working under Michelangelo in 1546-1547, having lost his library and papers at sea. Like Serlio, he favored the Tuscan Order above all others, which Serlio regarded as being the more rustic, least subtle or graceful, and strongest style, composed of the "roughness and delicacy that please architects,"[28] and of which Juan Bautista de Toledo was a master in the sun-corridors (fig. 38) and the niched retaining-wall grottoes at the Escorial (figs. 99, 101).

MICHELANGELO, 1475-1564

In 1560 Cardinal Granvelle of Arras, who had been councilor to both Charles V and Philip II, wrote from Rome to Madrid saying for the King's benefit that Michelangelo, who was then eighty-five, would be willing if asked to design a sumptuous tomb for the Emperor and other works as needed, "especially if his Majesty would address him a few lines."[29]

There is no record of the King's answer. But a detailed description of work by Michelangelo appears in the account at Simancas of a tabernacle made on Michelangelo's design and executed by the Sicilian sculptor Giacomo del Duca before 1574. The price was 2,500 ducados, for an octagonal pedestal of marble ten palmos ("handspans") high, containing stairs and surmounted by a metal tabernacle, also octagonal, with eight standing figures of bronze three palmos tall. Another element rose another four palmos, surmounted by a dome, then another pedestal five palmos high, supporting a sphere two palmos in diameter, and

umental style of abstract and geometric order," a conclusion that requires more participation by Alonso de Covarrubias than Bustamante's claims permit.

[22] J. Schlosser, *Letteratura artistica*, pp. 407-408; G. C. Argan, *L'Arte*, pp. 183-189; L. H. Heydenreich in Thieme-Becker, *Künstlerlexikon* 30, 1936, pp. 513-515. On domestic prototypes for the King's house, see Rosenfeld, *Serlio*, 1978.

[23] Villalpando's birth date has not been determined, but the commission for the iron grille of the cathedral at Toledo in 1540 suggests an established master in bronze, making him perhaps twenty years younger than Serlio, i.e., born about 1495.

[24] Serlio, Book 3, 1552, f. II. M. Menendez Pelayo goes farther (*Historia de las ideas estéticas en España*, 2: 370), saying in 1883 that Villalpando presented Philip with the translation "many years before printing it with illustrations brought from Italy." M. Gomez-Moreno (*El Libro español de arquitectura*, p. 10) believes that the manuscript was known to the sculptor Diego Morlanes before 1545, and that Pedro Machuca at Toledo "awakened in Villalpando the intention to translate it."

[25] Llaguno, *Noticias*, 2: 215-220; A. Gonzalez Palencia, "Documentos," pp. 11-14; Martín Gonzalez, "Nuevos datos," pp. 271-290.

[26] Martín Gonzalez, "Nuevos datos," pp. 278-279; C. Wilkinson, "The Escorial," pp. 69-76.

[27] Discussed in G. Kubler's introduction to the facsimile edition of the 1522 translation, Valencia, 1977, pp. 11-15.

[28] Book Four, v: "aquella rustiqueza y delicadeza que a los arquitectos mas les a contentado" (Villalpando's translation). See Rosenfeld, *Serlio*, on Serlio's domestic architecture.

[29] Gachard, *Correspondence*, 1: 191 (28 July 1560), addressed to G. Perez, the King's secretary.

a Christ in Ascension four palmos tall. The aggregate height would have been twenty-eight palmos (fig. 10).

It is clear that Giacomo del Duca and possibly Michelangelo himself had made a project for the tabernacle at the basilica, on which work from Herrera's designs was begun only after 10 January 1579, by Jacome Trezzo, Pompeo Leoni, and J. B. Comane.[30] Meanwhile the Spanish ambassador in Rome had learned that art merchants there were assembling these parts, and Cardinal Granvelle sent the King two drawings showing actual conditions and the projected completion.[31] Advised by Villacastín and Herrera, the King rejected this work in 1578, after studying the drawings, as lacking the necessary qualities for the Escorial.[32] In this way Michelangelo was twice passed over by the King, once before and once after the sculptor's death. In both cases Michelangelo's foreknowledge of Philip's needs is documented, as well as his eagerness to be considered. The offer of his services in 1560 is related, not only to his association with Juan Bautista de Toledo at St. Peter's in 1546-1547, but also to the abundant Italian literature glorifying Philip's journeys in Italy from 1548 to 1559, and to his leadership in resisting Turkish control of the Mediterranean.[33]

FRANCESCO PACIOTTO, 1521-1591

In 1561 this famous military engineer, nearly forgotten today, was asked by Philip II for his advice. Paciotto himself claimed that he made the design of the basilica as executed, on order from the King in 1562.[34] Sigüenza, furthermore, who knew the people, the documents, the drawings, and the models as chronicler and librarian in 1600, always referred to the church as Paciotto's.[35]

Paciotto, who was called Pachote in Spain, came to Philip's attention through the Farnese

family, for whom he had designed the Cittadella in Piacenza during 1558 (later continued by Vignola). At their request he also altered Vignola's designs for the pentagonal palace at Caprarola. Eventually, when Vignola made drawings in 1572 for the basilica at the Escorial, he conformed (as at the Cittadella in Piacenza) to conditions already established by Paciotto ten years earlier. In this way Vignola encountered again and again the prior presence and criticism of Paciotto.

In 1558 Philip asked Paciotto to accompany him to the Low Countries, where he remained until late in 1559 as "ingegner maggiore di tutta la Fiandra," receiving royal gifts and title as cavaliere.[36] Under Spanish government in Brussels there was much discussion of a suitable palace for the monarchy and court, which would be like Chambord,[37] but when Paciotto arrived he was entrusted with making designs for the palace on the pattern of his still-unbuilt scheme for the Cittadella in Piacenza. Thus Paciotto wrote to Ottavio Farnese (4 August 1559) that the King had been pleased by the designs to the point of wishing Paciotto to accompany him to Spain in the spring.[38] Paciotto's journey to Spain was delayed until 1561 by his duties as a military engineer attached to the service of Emmanuel Philibert of Savoy, who took him to Nice for two years, where he built fortifications, as he did during the rest of his life in Europe after the Spanish journey in 1561-1562. In Spain he described the purpose of his visit as to "review the fortifications of that kingdom and to prepare a design for the church and monastery at the Escorial, which was later built."[39] Thus Paciotto missed the first stages in the planning of the Escorial during 1561, but he was on hand in time to criticize the second designs by Juan Bautista de Toledo in the spring of 1562. In July the King ordered Paciotto to prepare corrections as well as new drawings of his own, which Philip saw in February 1563 together with

[30] L. Rubio, "Cronología," p. 62, citing CD, vol. 162, p. 546.

[31] J. Babelon, "Jacopo da Trezzo," pp. 134-139, and 313-316 (texts).

[32] Jahrbuch der kunsthistorischen Sammlungen, p. 198, no. 8743 (14 August 1578).

[33] Hempel, Philipp II, pp. 23-49; Braudel, La Méditerranée. Babelon mentions a bronze tabernacle in the Museo Nazionale at Naples, attributed there to Michelangelo. It corresponds in composition to the design offered to Philip, being in shape an

octagonal, domed edifice ("Jacopo de Trezzo," p. 138; illustrated by F. Iñiguez, Trazas, fig. 33). No trace of it is apparent in Herrera's designs.

[34] F. Paciotto, "Memorie," pp. 437-438.

[35] FME, pp. 55, 97, 219.

[36] Paciotto, "Memorie," pp. 378ff., 441.

[37] P. Saintenoy, "Les Arts et les artistes à la cour de Bruxelles," pp. 114f. Copies of the plans were paid for in 1556.

[38] A. Ronchini, Atti e memorie, p. 306.

[39] Paciotto, "Memorie," pp. 437-438.

Paciotto's merciless critique in Italian on the church project.

Paciotto left Madrid on 7 September 1562, returning to military architecture in Naples and at Antwerp, where the pentagonal citadel, begun in 1564, was his chief work. He was asked by the Farnese family in November 1563 to see the continuation design by Vignola of the Cittadella at Piacenza, which Paciotto had begun in 1558, and he declared that since the Goths, no greater barbarism had been committed than Vignola's *machinaccia* ("huge contraption").[40]

Paciotto's criticisms of the Escorial merit review. In July 1562 the King's secretary, Pedro de Hoyo, wrote a memorandum to the King on an interview with Paciotto about Toledo's design:

Paciotto was with me today and saw the plan for the monastery. He noted many faults in the church, and said that in any case its design should be changed. The darkness of the passages around the kitchen also displeased him. He says that this would be a great fault, since in the open country no room or part should be dark. He also would wish the entrance passage to Your Majesty's dwelling to be shorter, and not to have that turning. He said other things too of which I shall give an account to Your Majesty. They are not very important, and I believe that he will tell of them himself. I send Your Majesty the design [of the church(?)].[41]

The King's comments on this memorandum, written perhaps on the same day, are scrawled as usual on the margin of the sheet.

Paciotto was here tonight, and he told me that he had seen the design, and that when you would be present he had many things to tell me about it. I told him that as he has criticisms to make, it would be well for him to try to correct the errors when he can. Tell him tomorrow to do so and to make some drafts of his idea at the present scale, from which I do not wish now to change. I see indeed that the entrance to my apartment is not good, but I don't care. As to the other things, seek the remedy, especially as regards the [crossing] supports, and the lighting around the kitchens. If it can be done, very good; but if not, no. As to the supports, this alone will ruin everything else. If he should come here I will learn more from him, but don't cease your efforts to note everything and to ask him for the remedies which his criticisms require.

One of Pedro de Hoyo's next *villetes* reports to the King upon his having carried out these orders:

I said to Paciotto that he should prepare some design for the church. On the lighting of the kitchen passages he is at work. At the house of the Conde de Chinchon he asked me to excuse him, although he took measurements and made a rough sketch. I suspect that he will attempt it, and if he succeeds in it, he will show it, and if not, he won't. He told me that Your Majesty should order the church sent to Italy. Your Majesty may wish to receive an account of all this.[42]

The "account of all this" was the following document by Paciotto in Italian, showing hasty composition without careful revision.

Report by Pachote on the Monastery Church. The reason for my changing the plan of the church which Juan Bautista de Toledo made on the drawing of the monastery which Your Majesty ordered to be built was that I found it in poor style, composed without order and lacking in good architecture, as related below. I would have made it square rather than another shape for many reasons, such as its meeting the straight lines of the monastery with agreeable consequences, arising from the enlarged capacity, which this shape affords more than all others composed of straight lines, and for its beauty, of which we see many examples both ancient and modern, where gracious appearance unites with the commodity of altars and tombs capable of being arranged therein with beautiful order. Now to return to the cause that moved me to change the plan: I say that however infinite in number were the errors to be found in it, which would impede its construction, I shall nevertheless here write alone of those faults which suffice to show that the church could not be built without deformity and ugliness, lacking the reason and measure of noble, good, and beautiful architecture. I will begin then with the pilasters added to the square supports, and the pilasters of the lesser arches. The supports as shown in the plan are five feet wide, and the imposts or pilasters of the lesser arches are each two feet wide, making nine feet in all. The nave vault being fifty feet across, as shown in plan, I say that the pilasters and the supports are wrong, and cannot perform their duty without deformity and ugliness, lacking architectural order by deficient size as shown by this explanation. Such supports may be built either with bases or without. Of the profile which Juan Bautista de Toledo drew without bases to show me in Your Majesty's presence

[40] Ronchini, *Atti e memorie*, p. 309.
[41] IVDJ, envío 61, #27.
[42] IVDJ, envío 61, #29, f. 4, n.d.

at Aranjuez, I say either that the height of such supports will exceed their due measure, or that the nave of the church will not attain the height it should have at this size. The height should equal two squares, to wit, twice its width, because the supports, as stated, are five feet wide. Being multiplied by nine, the greatest height which can be assigned in this position, is forty-five feet. The architrave, frieze and cornice add two column widths, or another ten feet to the [springing of the] vault. Half the width of the nave, or twenty-five feet, plus five feet for the apparent increase of straight lines and for the projections of the cornices and other smaller members, such as those which cause the eye to diminish the size. Altogether these total only eight-five feet. This is less than the one hundred feet, which should be the nave height, as a double square, rather than as a dwarfed elevation, which is visibly lacking fifteen feet of its [proper] height.

Aside from this, the lesser arches are thirty feet wide as shown on the plan, and the supports rise forty-five feet, as said before. Not only do these arches fall short of the two squares which the require, being no less important than the nave arches and in the same viewing range, but they do not even reach one and one-half squares, subtracting the arch thickness of one foot as seen on the plan. Thus, as we see, this arch is thirty feet wide and forty-three feet high, or less than one and one-half squares, in a most imperfect ratio, and truly of mean and bad effect. I say again that without a pedestal the church cannot exist.

Now let us examine this pedestal. As we said, the pilasters which bear the secondary arches at the sides of the [main] supports, are each two feet thick. This width is insufficient for the projections of the base of the support or for the base of the pedestal, because the supports being of the aforesaid height and thickness, and having flat faces, the bases should not project less than half the thickness of the support, or two and one-half feet. The pedestal being fifteen feet high, cannot have less projection for its base than one and one-half feet on each side, and if so, it were better to avoid having the work appear *seua* [fat]. These three feet, added to the two and one-half of the pier bases, plus five for the pier, total nine and one-half feet, without, however, the one-quarter foot which should be added at least to benefit each part between the pedestal and the pilaster of the secondary arches, in order to make the work firmer and more stable and more sightly. In all, ten and one-half feet, although the plan shows only nine feet, whence it appears that the work cannot succeed even with the pedestal, since the pilaster is too thin by one and one-half feet, without possibility of correction. Let us suppose that the work be successful in this portion, which cannot be, I say, because if the little pilasters in

the choir be united so simply with the main supports, then the projections of the large ones will hide the small pilasters so that they cannot be seen, and the entrance will be false, and contrary to plan, with very great deformity, so that in this portion, the work cannot be brought forward, nor can it be brought to a good end in either way [with or without a pedestal].

Let us go now to the dome and the other parts of the church. As to the dome, I say, that in order to be as it shows on the plan, as having a diameter the same [as the width] of the large nave, and having to be built to a height above the nave with architrave, frieze, straight cornice, and spherical closure, as required, that it departs but little, in respect to its span, from the quadruple proportion, to wit, of four squares, or four nave spans, as much as to say that it is more like a belfry than a dome, and truly a ridiculous thing, of a measure never seen among the ancients nor among moderns, unless perhaps among Germans or Goths, of whose architecture I do not speak, for knowing its rule or measure, being entirely contrary to my practice.

On the plan it likewise seems that on the right and left sides of the crossing there are to be oval vaults, which cannot be done [in good proportion] because either the greater or the smaller side departs from rational [measure]. The device was never used, either by the ancients or by good moderns, although they devised an infinite variety of vaults. I will say no more about this, save that it is unreasonable and bad.

The walled sides of the little domes over the secondary aisles lack the usual projection, which they have on three boundaries, from the walled side, [with the result that] the structure lacks a shoulder, so to speak, losing grace badly by its absence. Hence the five-foot pilasters should project from the wall, of which one finds only a token on the plan, as well as the projection of the altars with their platforms protrude so far from the wall, that aside from their ugliness, they would impede traffic and would seem like unforseen intrusions more than like parts of the intended design. There are still other errors in these little domes, as in the main dome and its crossing, both of projections and of relief, as well as of other measures, about which I will be silent, as they are tedious and difficult things to describe, and obscure to the understanding. Even though half of what has been said should suffice to know the wrongness of this plan, I still do not wish to fail to say something about the choir-[balcony] and the entrance to the Church underneath it. This is composed with a number of pilasters which appear to interrupt doors and windows in the plan. These are out of line with the pilasters, which occupy the free and open passages at the middle of each entrance bay. Likewise in the choir: its vault is in the same plane as the church, and of the

same width. Its height is thirty feet less, without any intersection of the projections (moldings) between choir and church, and a pilaster divides the width of this choir [at the façade] where a window opens above the solids in the lower walls although the solids below do not continue those above. Similarly, in the choir the pilasters are cut in two by the floor of the choir, with the base beneath the pavement or floor, and the capital at the impost of the vault descending from above, where the [upper] nave is so dwarfed that it would better be called a grotto than a choir.

I shall therefore conclude that the church is wrong in manner to be termed neither good nor bad, being too much outside every normal precept of good architecture. It will suffice as to an opinion of this plan, to conclude that it is more a nightmare than a plan for such a royal church, and with this I make an end.[43]

Thus Paciotto's participation in the designs of the Escorial is attested not only by his criticisms of Toledo's designs but also by the King's request for Paciotto's own drawings in 1562, as well as by Sigüenza's repeated assertions that the designs for the church as built were Paciotto's. Sigüenza, however, esteemed them little, characterizing them as mere squared versions of the plans for St. Peter's in Rome: "in my opinion there is little to thank him for, because it is no more than the chapel and temple of the Vatican, without the nave, and having squared façades where half-circles appear there."[44] Sigüenza did not know of Paciotto's debts to Galeazzo Alessi, whose church in Genoa, S. Maria del Carignano (fig. 25), is a closer prototype for the plan and dome than Michelangelo's.

Paciotto's report explains several points about his position. He preferred the *forma cuadrada* for the church because of its coherence with the monastery design, and because it allowed more room for altars and tombs. Yet the curved-wall foundations for an apse were actually laid, and their straightening to conform to Paciotto's design did not occur until after 1564.[45] His preference for rectilinear compositions is forcefully expressed. He disapproved of the deep choir-balcony, saying

that it was more like a grotto than a choir, and he thought the dome rose too high, like a Gothic belfry. He did not understand the King's requirement that the forechurch be for the common people, and that all else was to be the court chapel.

The clear inner height of the nave, on the other hand, was too low, being fifteen feet less than his prescription that the nave should be twice as high as its width. He thought the pilaster projections were too shallow in the nave, and he disapproved of Toledo's oval vaults flanking the crossing, thereby opposing Vignola, whose oval church of S. Andrea on the Via Flaminia in Rome (1550-1553) was surely familiar to him.

Four of Paciotto's recommendations were adopted. The apsidal towers projected by Toledo were canceled, and transferred to the church façade in 1562.[46] Only their foundations and lower stories were built according to Toledo's designs (fig. 1, nos. 97, 102). A rectilinear sanctuary (fig. 46) replaced the earlier curved foundations; the oval vaults were suppressed; and the nave elevations were raised to double the width. But the height of the dome as built disregarded his criticism, rising to four times the nave width, and the choir-balcony remained grottolike as planned by Toledo.

Why Paciotto was invited to participate in the design of the Escorial is not adequately answered by the family connections of Philip II and Alessandro Farnese, who had been Paciotto's pupil from 1553 to 1556 in arithmetic and military design.[47] The affinity of minds between the King and Paciotto is more important, as when the King admired the plans by Paciotto for the Cittadella in Piacenza enough to bring him to Brussels and Madrid, as a proponent of "sober commodity"[48] in architecture, compared with Vignola's exterior richness and pomp. Paciotto was recognized in Italy (in Bosello's words) for "unity and correspondence among exterior and interior façades." Thus Paciotto's "bare style" (*estilo desornamentado*) attracted the King as early as 1558, well before Toledo was appointed.

[43] The original at Simancas (258, f. 274-286) is in Paciotto's handwriting. The title is Pedro de Hoyo's. (Spanish translation in Ruiz de Arcaute, *Herrera*, pp. 147-149.)

[44] FME, p. 55.

[45] PM, p. 196 (AGS, 158, f. 131, 11 October 1564).

[46] Sigüenza, FME, p. 219, disapproved this change, prefer-

ring the *singular majestad y grandeza* of Toledo's canceled towers, which he admired in the model.

[47] Ronchini, *Atti e memorie*, p. 300.

[48] Giovanni Bosello (in A. Terzaghi, *Arte antica e moderna*, pp. 376-377) thus compared them, as commissioner to Margaret of Austria for the building in Piacenza, in 1561.

In the history of Italian architecture the contrast between Vignola and Paciotto marks a cleavage in sixteenth-century taste. This cleavage separated the aims of rich ornament and bareness of surface, and it separated the formal language of mannerism in Europe from the bare style of the Escorial. In the process Paciotto played an important part, justifying the King's confidence and guiding him away from Toledo's dependence on the tradition from Bramante to Michelangelo, toward the greater simplicity, unity, and correspondence of all parts that characterized the military engineering of the mid-century.

Galeazzo Alessi, 1512-1572

The earliest explicit written comparison between the Carignano church in Genoa and the Escorial is on a plan of Alessi's church, drawn in ink and watercolor before 1586 by Giovanni Vincenzo Casale, who described it as being "of a temple or church in the city of Genoa, which resembles that of the Escorial, although I do not know which is older."[49] Alessi began the Carignano church in 1552, eleven years before the Escorial was begun, and he left Genoa in 1569. A sketch plan of the Genoese church drawn by Alessi in 1562 resembles Bramante's church of Ss. Celso e Giuliano in Rome (1509).[50] It shows a projecting semicircular apse flanked by parallel sacristies, whereas Casale's plan (fig. 25) records a flat sanctuary masking both the apse and the sacristies. It is like the *iglesia cuadrada* credited to Paciotto for the Escorial.

That Alessi prepared projects for the basilica of the Escorial was claimed by Filippo Alberti soon after 1572 and Egnatio Danti writing in 1583.[51] Danti says the date was after Michelangelo died in 1564 and before Alessi's death in 1572. The accounts by Alberti and Danti are substantially similar, without one being a copy of the other. Both

draw on the same evidence. Both accounts revolve around the presence at the Spanish court of Barone Martirano, who discussed with Philip II the defects of the designs that had been prepared for the Escorial. Alberti mentions models: Danti, who was a mathematician, stresses the architectural and mathematical knowledge of Barone Martirano.

In both sources the Barone was commissioned by the King to solicit architectural drawings from the leading Italian architects, and Alessi was among these in both accounts. Alberti says that Alessi would have accepted the invitation to Spain had he not died. Danti says that Vignola was invited to combine the best features of all twenty-two Italian projects for the Escorial, and that Vignola was invited to Spain, but refused because of age and illness. The two accounts are not inconsistent: Alberti's is part of his life of Alessi, and Danti's comes from his life of Vignola.[52] In 1583 Danti enumerated the projects solicited from Italian architects by Martirano. The Barone went first to Vignola in Rome "to get from him a most suitable design," and returned to Madrid. On a second trip to Italy he visited Alessi in Genoa, Tibaldi in Milan, Palladio in Venice, the Accademia dell'Arte del Disegno in Florence for a corporate design, as well as Vincenzo Danti for an oval church that had been ordered by the Grand Duke Cosimo,[53] and many others in various cities, representing twenty-two projects.

Because both sources agree that Martirano was the King's agent, his historical existence needs to be confirmed separately from them. Danti spoke of him as a mathematician. There is record of a Calabrian Scholar, Gian Tomasso Martirano, who not only wrote mathematical works but assumed as heir the title and name of his uncle after 1541.[54] This uncle, Barone Bernardino Martirano, had served Charles V as secretary in Naples, maintaining a celebrated villa near Portici where he en-

[49] The plan is now in the Biblioteca Nacional at Madrid, as part of Casale's large architectural portfolio (BNM, *Bellas Artes*, #16-49, f. 170), and its date is given by Casale's leaving Italy in 1586 for Portugal, never to return. G. Kubler, "Alessi," p. 599.

[50] Santo Varni, *Spigolature*, pl. 2; E. de Negri, *Galeazzo Alessi*, p. 38.

[51] F. Alberti, *Elogio*, p. 26; E. Danti, "Vita di . . . Vignola."

[52] L. Pascoli added in 1730 that Alessi received in Spain an

annual salary of 1,000 ducats (*Le Vite*, pp. 283-284). F. Milizia (*Memorie* 2: 17) stays closer to Alberti. W. Suida, in Thieme-Becker, *Künstlerlexikon*, 1 (1907): 259, has Vignola being invited, but passing it to Alessi. No evidence supports this.

[53] This title of Cosimo's was assumed in 1569, and it may fix a date post quem for the oval project.

[54] F. Pometti, *Memoria . . . Lincei*, 1897, p. 106; L. Aliquo-Lenzi, *Gli Scrittori calabresi*, p. 263; A. Zavarrone, *Biblioteca calabra*, p. 92.

tertained the Emperor in 1553.[55] His nephew in 1570 was also active as an *ingegnere*, designing fountains for Capua.[56] Thus Barone Martirano must be Gian Tomasso, who like his uncle served the Spanish King in Italy, and whose correspondence with Philip II surely existed but has still to be discovered.[57]

THE OPINIONS OF THE FLORENTINE ACADEMY

In 1567, the year Juan Bautista de Toledo died, the Accademia dell'Arte del Disegno in Florence was requested by the Spanish court at Madrid to render its opinion on twenty-nine drawings for the Escorial. The questions and the answers of the Accademia, as well as some of the drawings, have been published repeatedly with extensive commentaries.[58] The queries were submitted in Italian, and it is possible but not provable that they were composed by G. B. Castello, who had come to Madrid from Genoa in 1562[59] being appointed *pintor y architeto* employed on models, drawings, and other matters of painting, as required at the Escorial,[60] such as the model submitted in 1567 for the main stairway in the monastery (probably of the projected paintings).

F. Iñiguez supposes that all twenty-nine drawings sent to Florence for criticism were by Toledo and that none was of Italian origin. Only one of the twenty-nine drawings discussed can be attributed to Toledo: it is the longitudinal section now in the Palace library in Madrid (fig. 26), showing the basilica with an apse and two low façade towers. This drawing, labeled *C*, is attributed by Rubio to Paciotto, because of its quadrate form as a square plan of nine divisions (*iglesia cuadrada*). Iñiguez's reason for giving it to Toledo is the four-story elevation in the forecourt, which was not decided until 1564.[61]

But the drawing marked *C* does not corre-

spond to the questions asked of the Accademia. Question 12, concerning triglyphs and metopes in the Doric order, is not relevant to figure 2, where no entablature has these features. Question 15 describes pilasters without bases in the apse, which the Accademia criticized as *zoppe* or defective, whereas the Madrid drawing shows complete bases.

The lost designs sent to Florence included: three different projects, classified as A, B, and C, for a central-plan church with one dome; another without any dome (D); a church with a false-dome sanctuary (E); a rotunda (F); a church with several false domes (V); and another with three axial nave cupolas (Z). Four façade designs were submitted (J to accompany C, and K to go with B); and there were thirteen other undescribed plans.

If we assume that the twenty-nine drawings were the ones solicited in Italy by Barone Martirano, a hypothetical calendar can be arranged to fit the available evidence. Paciotto's harsh criticism of Toledo's plans for the church in July 1562 was followed by his suggestion to the King that the plans be sent to Italy. Returning to Italy in September, Paciotto sent the King new plans for a quadrate church in February 1563.[62] This period in 1562-1563, when the King solicited criticisms of Toledo's plans, seems the most likely time for the beginning of Barone Martirano's commission to assemble new plans from the best architects in Italy.

By 1567 several would have been collected for the Accademia. In Florence a jury of six members met on 8 June 1572 "to examine sections, plans, and designs for a building of King Philip's . . . as to their quality." The jurors were Bartolomeo Ammanatti, Angelo Bronzino, Vincenzo de Rossi, Francisco da Sangallo, Vincenzo Danti, and Zenobio Lastricati.[63] Finally the twenty-two projects Martirano had assembled were submitted to Vi-

[55] B. Croce, "I fratelli Martírano," pp. 65-76.

[56] G. A. Manna, *Cancelleria . . . di Capua*, f. 104-105. S. Spiriti, *Memorie . . . Cosentini*, p. 77.

[57] The relevant archives at Naples were destroyed in World War II.

[58] V. Daddi-Giovannozzi, "L'Accademia fiorentina," pp. 423-427; L. Rubio, in CD 171 (1959); 194-200; F. Iñiguez, *Trazas*, pp. 74-77, 133-135. Many errors and omissions in the transcription by V. Daddi-Giovannozzi are repeated by Rubio and Iñiguez, who did not see the original.

[59] Llaguno, *Noticias*, 3: 7.

[60] AGP, 3: 67ᵛ; also PM, p. 66; BM, Addison, 28350, f. 249.

[61] Iñiguez, *Trazas*, pp. 74-77; LS, 2: 17 (attributed to Diego de Alcántara); Rubio, CD 161 (1949): 202.

[62] Kubler, "Paciotto," pp. 176-189. The document on sending the plans to Italy is in IVDJ, envío 61, #29, p. 4. On Paciotto's new quadrate plan in 1562, ibid., #40, and Cervera, *Estampas*, p. 21.

[63] ASF, *Arti, Accademia del Disegno, Giornale e ricordi*, 5: 25, f. 20ᵛ.

gnola in Rome for him to make a synthesis. The resulting designs were shown at the Vatican to Pope Gregory XIII on 7 July 1572.[64] The witness was the Ferrarese envoy, Gurone Bertano, who wrote that he was invited by the Pope in Vignola's presence to view "certain designs by Vignola of a church which the King of Spain wants to build."[65]

The King wrote to the prior of the Escorial on 22 February 1573, that the awaited drawings for the church had arrived, and that he thought there was little to be taken from them.[66] Were these drawings the entire Martirano collection or only those put together by Vignola? If the calendar proposed here is correct, the King knew the drawings sent to the Accademia in 1567, and this notice would refer to Vignola's "synthetic" church project. Juan de Herrera, in his second testament (20 February 1579), mentions some drawings as "plans and elevations sent from Italy for the church of San Lorenzo el Real de El Escorial, which are also to be given to His Majesty because they are his," together with the collection he had acquired from Juan Bautista de Toledo.[67]

It is certain that both in Rome and Florence during early June in 1572, projects for the Escorial were being viewed and that these were the result of Barone Martirano's longstanding royal orders to secure designs from the leading Italian architects. Among them were designs by Galeazzo Alessi. In 1572 only some foundations had been laid for the basilica, and in 1574 the King still wavered between the old design by Toledo and the one substituted by Paciotto. The King finally decided in favor of Paciotto's flat-walled sanctuary and transepts, which in plan so strikingly resemble those of Alessi's basilica in Genoa.

The names of the Italian designers recruited by Martirano are rarely mentioned in the building records of the Escorial. But the work as it proceeded showed increasing resemblances to Italian models. Alessi's plan for the basilica in Genoa, as well as the membering of the dome are among these convergences. The King's preference for Paciotto's *iglesia cuadrada* in 1574, and the resem-

blance of plan and dome to Genoa, lead to the belief not only that Paciotto had the Genoese church in mind in 1562 but also that Alessi's lost plans as solicited by Martirano, had adapted the Carignano church in Genoa to Spanish needs. On receiving the drawings from Italy in 1573, the King might have added as an afterthought, not only that the best had already been taken, but that the basilica, as it was going to be built, already owed as much to Alessi as to any other Italian.

TRACE ELEMENTS OF PALLADIO

Both the basilica and the texts about it allow the reconstruction of fragments of a lost design by Andrea Palladio, who became a member of the Florentine Accademia del Disegno in 1566,[68] where Martirano could reach him both an an architect and as a corporate member. Traces of his participation would have been filtered through Spanish minds, and it is unclear whether the traces were mediated through Palladio's *Quattro libri* after 1570, or through a specific design for the purpose in Palladio's hand. The traces needing verification at the Escorial are these:

1. As in several Palladian houses, the church façade has an arcaded narthex enclosed beneath an upper chamber, which is the choir-balcony. At the Escorial this grouping of narthex and choir above it forms the *sotacoro* narthex scheme, the narthex being the entrance portico, and the *sotacoro* the fore-church, both supporting the choir-balcony above them (figs. 1-*43*; 5-*S*; 27).
2. The *sotacoro* has the form of a Palladian *sala tetrastila* in plan and structure.
3. The upper nave and sanctuary imitate Roman-bath (thermal) architecture, with tripartite clerestory windows beneath round arches, spanned by entablatures at or below the impost level (fig. 5), as in Palladio's studies of ancient Roman buildings.
4. The practice introduced at the Escorial in 1576 of rough-finishing the stone at the

[64] M. Walcher Casotti, *Il Vignola*, 1: 216.

[65] G. Canevazzi, *Memorie e Studi*, p. 345, citing a letter in the Archivio di Stato in Modena. Bertano was also a Spanish agent in Rome (L. Serrano, *Correspondencia diplomática*, 1: 459, citing AGS, *estado* 900, n, 11, 19, 22, 1565).

[66] Rubio, "Cronología," p. 51, citing Llaguno, *Noticias*, 2: 310.

[67] Cervera, *Estampas*, p. 55, n. 6.

[68] R. Pane, *Palladio*, p. 29.

quarry, in imitation of what was thought to be Roman and Biblical practice, is suggested in *Quattro libri* by Palladio as of 1570, but in an unrelated context.

Sotacoro Narthex. The solution of combining a portico underneath a weatherproof chamber, as an entrance defined by a pediment spanning its width, seems first to have occurred to Palladio early in his career at the Villa Godi of Lonedo, begun in 1540. The idea perhaps came to Palladio from Alberti's design for S. Sebastiano in Mantua (1460), where the narthex façade opens as a loggia underneath a closed, choirlike upper chamber crowned by a pediment (fig. 28). The present appearance of this façade does not correspond to Alberti's original design, as seen in a plan by Labacco, where only three doorways appear instead of the five built at the end of the century, and long after Alberti's death.

As Palladio used this scheme in other villas, he thereby disregarded the sacred character of the pediment (*fastigium*) that was repeatedly asserted by ancient authors and was known to Alberti, who restricted the use of the pediment to churches. Without the pediment, the narthex occurs underneath an enclosed upper chamber about 1536 in such designs by Palladio as the Villa Trissino at Cricoli. This derives from Falconetto's Loggia Cornaro and eventually from Rafael's design for Villa Madama near Monte Maria. These designs prior to Palladio's lack the pediment, and they are like sections of porticoed street façades, as seen in early sixteenth-century stage designs and drawings of urban settings by Bramante or Peruzzi. But the pedimented villa was Palladio's recurring preference. He surely knew that Cicero, Plutarch, and Suetonius all relate how the Senate decreed that Caesar might have a pediment on his house, a form previously reserved for temples alone.

After the Villa Godi, the pedimented narthex entrance reappears at the Villa Cerato in Montecchio Precalcino, the Villa Repeta in Campiglia, and the Villa Thiene (Vicenza) in 1556. It now presents the possibilities of a façade that includes both open and closed forms within the same vertical plane, like the Palazzo Chiericati, incorporating as many kinds of activity as possible within

the same envelope. Palladio wrote in 1570 of the loggia beneath a *sala* as a place "where those may wait for the owner to come forth to greet and deal with them." It appears in none of Palladio's churches, and it is always connected with villas or palaces.

Whether Palladio would have used the scheme in a putative design for the Escorial is not known. But the formula of the pedimented narthex beneath an upper room is among the most distinctive features of the Escorial. No earlier prototype for it is known in Spanish architecture. It later became a standard treatment of Spanish church façades throughout the world in the seventeenth and eighteenth centuries. Italian examples are very rare: Ippolito Scalza's S. Maria in Montepulciano (fig. 29) picks up the line of Alberti's S. Sebastiano about 1563. In addition the façades of S. Alessio (*c.* 1582) and Flaminio Ponzio's S. Sebastiano (1612), both in Rome, are early examples.

The Spanish need for this scheme is explained by the habit of housing the choir of smaller churches in a balcony spanning the nave entrance. The choir loft rarely appears outside Spain: Venetian examples are S. M. dei Miracoli by Pietro Lombardo in 1481-1489, and at S. Giorgio dei Greci in 1538. But in Spain the choir-loft balcony was a normal feature of smaller churches as early as 1474, in the foundations of the Catholic Kings after the battle of Toro, at S. Juan de los Reyes in Toledo, Santo Tomás in Avila, S. Jerónimo in Madrid, S. Cruz in Segovia, or the Cartuja de Miraflores near Burgos. It provided a desired separation between the lay congregation and the monastic community.

At the Escorial, a balcony spanning the nave was planned for the friars from the beginning, and it remained in the final execution, much as originally planned by Juan Bautista de Toledo. Hence the façade of the basilica presents a new solution, combining the Spanish tradition of the choir balcony with an Italian domestic loggia of the type described by Palladio.[69] Soon after the Escorial, the formula was used again at S. Vicente de Fora in Lisbon (1579) and in Madrid at the church of the Encarnación by Juan Gomez de Mora in 1611. In the smaller version, the façade

[69] *Quattro libri*, 1570, 1: Chap. 21, "Delle loggie, dell' entrate, delle sale."

became a favorite form among the Carmelites, spread through the Hispanic world by them and other orders as well. S. Teresa at Avila is an example.

Sala Tetrastila. The narthex of the Escorial leads into a square forechurch, which is like an entrance vestibule. According to Sigüenza, it was meant to serve the common people as a nave, while the great nine-part square beyond it was the royal chapel, reserved for the monarch, his family, and the court.[70] In this *sotacoro*, the flat vault (figs. 1-40; 27) is carried on four supports near the corners, an arrangement that Palladio called the *sala tetrastila*, having "columns to proportion the width to the height and to support the upper chamber safely."[71] He used it as a vestibule in many country houses, like the Villa Mocenigo or the Villa Cornaro, where it is entered by a loggia at the entrance. It serves as an inner hall giving access to the rooms leading out from it. Palladio describes the form as though it were an ancient type of atrium, by listing it among the five kinds enumerated in Vitruvius' chapter on the *cavaedium*.[72] Actually nothing like Palladio's *sala* is known in ancient architecture. The Roman atrium was open to the sky. No example was roofed in the manner proposed by Palladio. The atrium in the Pompeiian "House of the Silver Wedding" is arranged with broad, covered walks surrounding a small impluvium. In the same house the *oecus corinthia* is the only known example of an ancient tetrastyle room, but its four columns stand too close to the walls for easy circulation, and the effect is more that of a shrinelike enclosure in a cul-de-sac than of a center of circulation. Palladio's intervals between wall and column, on the contrary, are large enough to serve as walks.[73]

At the Escorial an early drawing (fig. 57) shows square supports and niched walls for the *sotacoro*, and it may reflect knowledge of Palladio's book of 1570. Another plan shows the curved sanctuary wall (fig. 45) straightened after 1564. This drawing still retains the niched walls in the *sotacoro* with supports repeating those of the main cross-

ing at a smaller scale. The final form was fixed before 1575, without wall niches, and having L-shaped supports in plan (figs. 1-40; 5-L, M). It is difficult to explain this design without either some intervention by Palladio, or some imitation of his manner of thought.

Thermal Windows. Ten large clerestory windows perforate the upper nave walls of the basilica (figs. 4, 5). They are semicircular, with vertical divisions marking three lights in each window, resembling the upper fenestration of vaulted Roman imperial baths after Trajan. An ample passage in the thickness of the wall at the clerestory sill, as in thirteenth-century Gothic churches, permits circulation throughout the building at this level, for maintenance and fire protection. The cross-section (fig. 4) resembles those of Romanesque and Byzantine churches, with circulation both on the tribune story and at clerestory level.

The aisle elevations show the same system (figs. 62, 71). The semicircular vault lunettes are divided in three vertical fields simulating windows below a tribune which is a balcony surrounding the entire church. The façades of these tribunes have arches flanked by paired pilasters. The design here too evokes the porticoed bays of Roman bath architecture via Palladio's works. He used the tripartite thermal window theme repeatedly, beginning with early villa designs (1541-1545).[74] He valued it as an expression of structure, to mark large chambers having groin vaults, which would otherwise lack any exterior statement of their presence. Prior to 1560 other architects were reluctant to adopt his non-Vitruvian theme, but it was almost a signature for Palladio, who learned its use in his detailed studies of the ruins of Roman baths,[75] applying it to religious architecture after 1558.

Stone Finished at the Quarry. In October 1575, when work had been begun on the church walls, it became apparent that the fabric was rising about one course of masonry per year. The crews were accordingly reorganized, as ten units of

[70] FME, p. 312, "Para la gente vulgar . . . sirve abundantemente el sotacoro, que es como cuerpo de iglesia."

[71] *Quattro libri*, 2: 36.

[72] *De Architectura*, Book 6, Chap. 3, pp. 79-82 (facs. ed., Urrea translation).

[73] *Quattro libri*, 2: viii: the distance from the wall of the columns is one-sixth of the distance from wall to wall.

[74] Zorzi, *Palladio* 4 (1954): figs. 2, 4.

[75] Zorzi, *Disegni*.

forty workmen each under their own foremen and master builders on a contractual system, ordered to shape and trim the stone at the quarry on extra pay. The results were dramatic: by February 1577, the entire church had risen to the thirty-foot level.

A question arises as to the source for the practice of quarry-finishing. A. Ceán-Bermudez thought Herrera had drawn the idea from Palladio,[76] who was alleged to have said that the ancients carved stone at the quarry.[77] But Palladio's chapter discusses only rustication and finishing the stone at the building site. The only possible remark by Palladio in the sense suggested by

Ceán, occurs in Chapter Three, where he recommends that marbles be worked at the quarry because they are softer there than after long exposure.[78] Herrera never said that the reorganization followed ancient practice, but ancient precedents were invoked during the controversy, as when Sigüenza compared the practice of Solomon in building the temple of Jerusalem.[79]

Whether or not a design by Palladio for the Escorial reached Spain, elements of his practice were incorporated by Herrera after the death of Toledo, and they are noticeable in the church façade and narthex scheme, in the *sotacoro*, and in the clerestory windows.

[76] Llaguno, *Noticias*, 2: 124.

[77] *Quattro libri*, 1: Chap. 10.

[78] *Quattro libri*, 1: Chap. 3; ". . . sara piu facile il lavorarle

all' hora, che se per alcun tempo fussero state all' aere."

[79] FME, pp. 66-67.

TWO

THE TISSUE OF MATERIALS

5

THE VOW FULFILLED,
1557-1571

CABRILLANA claims that the King's creation of an abbatial lordship over the Villa was a regression to the worst of feudatory institutions; that the city of Segovia was deprived of these revenues and lands; and that whole villages disappeared as their fields were converted into pastures serving the royal hunting park. Thus the apocalyptic environmentalists of today, to whom every human use of the natural setting is suspect, sharply criticize the purpose, the method, and the results of building the Escorial, thinking in much the same way as the mayor of nearby Galapagar in 1561. According to Cabrera, the magistrate of the royal woodlands approached the mayor during a tour of inquiry for his opinion on the future monastery, and the mayor said, "Put it down that I am ninety years old, twenty times mayor, and alderman as many more, and that the King will be making here a nest of caterpillars which will devour everything in this land. But the service of the Lord must come first."[1]

Actually, the present-day cattle raisers at Cam-pillo and La Granjilla say the land is too wet and the soil too shallow for agriculture. The malarial conditions there until this century were unfavorable to settlement.[2] These very conditions, however, favored the development by the monastery of large transhumant flocks of sheep, with pastures from Avila province to Estremadura, the wool being sent for processing in Segovia and Toledo.[3] Yet in 1599, a profitable year, the monastery took a profit of only 5,000 ducados, or less than one modest gentleman's yearly income. The main source of the monastery's income was from grain sales, as in 1596, when the production was worth 26,000 ducados. Wool and grain together, however, were an annual income amounting to less than one-fifth of the averaged annual cost of building the Escorial, and it probably was enough to feed the 150 friars living there.[4]

The large enclosure of the Escorial's lands surrounded some twenty square miles. It was made up of 254 parcels, all immured by a stone wall twelve feet high, from Campillo to Fresneda. The

[1] Porreño, *Dichos*, pp. 1, 28ᵛ. A modern critic is N. Cabrillana, "Repercusiones," pp. 378-379, writing as an economic and social historian, who draws attention to the worst possible effects of the King's decision to build the Escorial.

[2] C. Vicuña, "Los estragos del paludismo . . . ," *Anécdotas*, pp. 62-68.

[3] Cabrillana, "Repercusiones," pp. 387-389 (wool); p. 390 (grain).

[4] Based on the daily food cost for a laborer as 48 reales, and assuming that a friar's would cost three times more.

land cost only 11,000 ducados, and the Crown converted it into a hunting preserve under strict control, which was an accepted way of saving the countryside from depopulation.[5]

SAN LORENZO: ELECTING THE SITE

The battle of San Quintín (Saint-Quentin in northeastern France) occurred on 10 August 1557, the day of San Lorenzo, an early Christian martyr born in Spain. From this originated the name of the votive building that Philip had been considering for some time, first conceiving of it during the journey with his father through northern Europe in 1548-1551.

The search for a site began in 1558-1559.[6] The King first enlisted the aid of the Jeronymites. In the spring of 1561 he wrote to their general, announcing his intention to found the monastery of San Lorenzo de la Victoria.[7] But as the site had not yet been chosen, he asked for advice. The general appointed three priors, who were experienced in building monasteries and financing them, to serve the King in choosing the site according to the custom of the order. A prior to supervise the new foundation was offered subject to the King's approval.

The Jeronymites also engaged to receive building funds and to authorize the prior at the Escorial to pay these out to laborers and artisans, with assistance from a vicar and one other friar. In effect, the general instituted the friars' governance of the building of the Escorial through their representatives in the executive committee, the Congregación,[8] which would continue in authority until the dissolution of monastic properties in the nineteenth century. The general was guided by longstanding custom, which the King saw no reason to contest. In the same week he wrote the general (15 June 1561) to appoint friars to advise

on the choice of a building site and on its planning and distribution. The general answered at once (17 June), appointing two priors and one vicar, the latter being asked by the King to bring him (20 June) some drawings of their best monasteries for use in planning San Lorenzo.[9] Only after these arrangements did the King appoint Juan Bautista de Toledo (on 12 July 1561) as *arquitecto real* for San Lorenzo.[10]

On 14 November of that year, the King called the decisive meeting to determine the site. Only the chroniclers mention the "commission of scholars, philosophers, doctors, architects, and masons" that was appointed.[11] The known correspondence suggests that these were none other than the priors and vicars appointed earlier in the year to look for a site answering the conditions of Vitruvius as healthy, with good air and water—friars such as Juan de Huete, prior of Zamora; Juan del Colmenar, vicar of Guisando; Gutierre de León of Madrid; and others of the Jeronymite Order, who met with the King late in 1561 to learn his wishes in the selection.

From the King's point of view, his correspondence in 1561 shows that although he had decided to begin the monastery for his parents' graves, he wished the friars to advise on the site and planning. The third week in April was the period of decision. On the sixteenth he decreed the foundation and endowment of a monastery to say masses and prayers for the souls of the Emperor and Empress.[12] On the same day he also wrote to the general of the Jeronymite Order, requesting

[5] Cabrillana, "Repercusiones," pp. 404-407, reconstructs the sixteenth-century history of the *cerca*.

[6] JSJ, p. 10: "mas de tres años se experimento."

[7] AGP, *Cédulas*, 2, f. 99 (16 June 1561).

[8] Fray Francisco de Pozuelo, General O.S.J. to the King, 17 June 1561, in PM, pp. 155-156 (AGS, 258, f. 7). The minute-book for meetings of the Congregación is in AGP (*Patrimonio*, legajo 1793, covering 1573-1834).

[9] AGP, *Cédulas*, 2, f. 12ᵛ (15 June 1561) and 125ᵛ (20 June 1561).

[10] AGP, *Cédulas*, 2, 142ᵛ-143 (12 July 1561), confirming the earlier *cédula* of 15 July 1559 fixing his salary as 220 ducados annually.

[11] JSJ, pp. 9-10; FME, p. 14. Neither source gives a date or reference. AGP, *Cédulas*, 2, f. 156ᵛ, gives 14 November 1561 (the King to the vicar of Guisando and the prior of Zamora).

[12] AGP, *Cédulas*, 2, f. 99; Cervera, *Estampas*, p. 17.

that selected friars advise on the choice of the site and on the plan. On 20 April he ordered the friars to bring plans of their best houses for the improvement of San Lorenzo. The friars were later asked to meet at Guadarrama to decide on the site and plan. Thus they were invited to fix the program of the new house, although the general warned the King that even if they were experienced in monastic design, he could not vouch for their knowledge of building (*arte de labrar*).[13]

The searchers in November first visited and rejected the region around Manzanares, and then La Fresneda, which was discarded as being malarial and depopulated. La Alberquilla was passed over as having no water. The commission finally agreed on the base of the mountain above the village named El Escorial. Abundant water was available in springs and mountain streams. Another resource was forests. Stone, gypsum, and sand were nearby, and deposits of fine-grained granite, both white and blue (cardena). The King, however, preferred the Jeronymite house at Guisando, where he frequently visited "as a place of great devotion, and to be alone."[14] Sigüenza adds that the King wanted San Lorenzo far enough from Madrid to serve as a contemplative retreat for him and the friars. But after spending Holy Week at Guisando, he decided that it was too mountainous and lacking a level place for his designs, as well as being too distant from Madrid. Manzanares was closer, but too much uphill (*a repecho*) from Madrid.[15]

On 14 November 1561 the King finally announced his decision in favor of the location near El Escorial,[16] convoking the priors, the architect, and a mason to meet there to lay out the plan. Juan Bautista de Toledo was delayed as usual.[17] Although the priors mentioned their fear that the site was too windy and cold, and that the Herreria and La Fresneda might be better choices, they began to lay out a plan 500 feet long and 350-400 feet wide. Toledo arrived after they finished.

When urged to draw what they had done, he said he had already prepared his own plans and sent them to the King.[18] The friars' plan was smaller than the Jeronymite house at Zamora and half the size of the plan Toledo would finally stake out in April and May of 1562,[19] in the King's presence. The block, called the *cuadro*, was 740 feet long and 570 feet wide (east-west), turned clockwise twelve degrees off the cardinal points to the northeast. Vicuña points out that the eastern declination gave a better view south from the King's apartment to the Herreria and Las Machotas, as well as protecting the southern rooms from northerly winds, and admitting more sun to the King's quarters than if they were in the shadow of the prior's tower.[20] Other preparations at the end of 1561 were to clear the thickets, which grew so densely on the site that the local people sheltered their animals in them during tempests and snows. Huts for the workmen, water conduits, kilns for lime and brick, slaking pits, a large workshop, wagons, forges, stone and tools to cut it, all were ordered early in April 1562.[21] Excavations for the foundations began under the southern range soon after, with funds of 25,000-30,000 ducados in hand for the current year.

In sum, the King has made sure the Jeronymite Order would be the key instrument for the achievement of his wishes. The site he chose was suitable only for a monastery of retreat, but it had a view of Madrid, more than a day's journey away to the east. The friars reluctantly accepted his decision, but they did not learn the magnitude of his plans until Toledo staked out a block in April 1562 and began work on a monastery covering twice as much area as the one they tried to lay out themselves with Pedro de Hoyo late in 1561. The friars were therefore not fully informed, although they had provided traditional models for the monastery, without being allowed to intervene in the design. The King chose the exact site, and the first working drawings were

[13] PM, p. 155. [14] JSJ, pp. 9-10.

[15] FME, Discurso 2, 13-19.

[16] JSJ, p. 11.

[17] BM, Addison, 28350, f. 14-15.

[18] G. de Andrés, "Toponimia," pp. 10-12 (3 December 1561).

[19] JSJ, pp. 18-19. Gregorio de Robles assisted him.

[20] C. Vicuña, "Juan Bautista de Toledo," *Monasterio*, p. 146. According to JSJ, p. 18, the King's secretary, Pedro de Hoyo, took great pains with the laying of the staked lines, and "made much of his part in it." See Hoyo's letter of 3 December 1561 (Andrés, "Toponimia," pp. 10, 12).

[21] PM, pp. 159-160: royal order (2 April 1562) copied at the Escorial 10 April 1562.

by Juan Bautista de Toledo (fig. 30).[22] The King's decision became public on 26 December 1561 when the court and government were told in the presence of Toledo and several friars, of his Majesty's choice of the site.[23]

TOLEDO'S "UNIVERSAL PLAN," 1559-1563

The expression *traza universal* is Toledo's for the drawings he prepared in three copies for the King, the friars, and himself, backed with cloth linings.[24] In his will, Toledo directed that ten bundles of his papers be delivered to the King,[25] together with a signed recommendation of the persons he deemed worthy of serving the King on his works and buildings in 1567. Thirty years later, two stacks of drawings by Toledo and Diego de Alcántara were inventoried among the belongings of Juan de Herrera. These were all then the property of Herrera, and it is unlikely that they would have been claimed by the crown. Any surviving drawings now attributed to Toledo and Herrera for the Escorial are probably from this collection.

All the drawings in the King's collection, kept at the Alcazar in Madrid, disappeared in the conflagration on Christmas eve in 1734, although some perhaps were salvaged from the ruins, coming into private hands.[26] In 1765 it was rumored in Madrid that original drawings by Herrera were being sold, but nothing could be done to acquire them for the Real Academia de San Fernando. In 1912, finally, the drawings of the Escorial now in the royal palace library came to light in an album purchased by Alfonso XIII. Today architectural drawings of the Escorial, prepared for use in construction, exist only at the Biblioteca Nacional and Biblioteca de Palacio. Fifty-five have been published. Of these, seventeen pertain to outbuildings and other properties, and thirty-eight to

the Escorial itself.[27] Of these last, twenty-one are assigned to Herrera by Lopez Serrano. Only one is mentioned as being related to Toledo (fig. 72). The longitudinal section of the church (fig. 26) was accepted by Iñiguez as by Toledo.[28] But the drawing of Toledo's criticized by Paciotto in 1562 was not this one, marked C (fig. 26). The table shows the variance between the dimensions of C (LS, pl. II) and those of the drawing Paciotto was studying:

	LS, II (fig. 26)	Paciotto
Nave height	75	85
Aisle width	20	30
Dome supports, height	50	45
Aisle width: height	22:41	30:43
Pedestal height	—	15
Dome diameter: height from floor	50:170	50:200
Aisle vaults	barrel	oval
Choir balcony	plain wall	pilasters

For our purposes, Juan Bautista de Toledo can be associated with only three drawings, and none of them is necessarily by his own hand:

1. Plan of the four small cloisters (fig. 31)
2. Elevation of small cloister (fig. 32)
3. Section marked C[29] (fig. 26)

[22] Cervera (*Estampas*, p. 16, citing IVDJ, envío 61, #11) says that Toledo gave his first designs to the King before 30 November 1561. Iñiguez (*Trazas*, p. 13, citing IVDJ, envío 61, #3, 16) discusses the new second project briefly.

[23] L. Megnie, *El Escorial*, p. 15.

[24] PA, p. xxxiv (AGS, 261, f. 2, 9 October 1564).

[25] Llaguno, *Noticias*, 2: 90, 242 (12 May 1567).

[26] Vicente Carducho (*Diálogos*, pp. 153-154) described the semicircular room in the west tower (*Torre Dorada*), which was the King's architectural study containing drawings of all royal seats in Spain and Portugal.

[27] M. Lopez Serrano, *Trazas*. Two drawings vanished while the album was kept at the Escorial from 1913 until 1931: a post-Herreran plan of the manuscript library and a plan and elevation of the Campillo residence (ibid., p. 7).

[28] Iñiguez, *Trazas*, p. 45. Portabales accepted five of the thirty-eight as Toledo's: figs. 59, 39, 19, 31, 42, and 50, presumably because those parts of the building were begun before Toledo's death (PA, p. cxcv).

[29] Drawing 3 lacks the doubled forecourt columns shown in plan (fig. 31). Lopez Serrano believed drawing 1 was a tracing of a plan by Toledo modified by Herrera (*Trazas*, pp. 21-

Fortunately the written record is ample enough to give detailed information about his activity at the Escorial in these years, although there is no sure evidence for any drawing known today being by him. He presented his first designs to the friars on 13 January 1562 together with a written account. They studied them until late at night, continuing the next morning, and agreeing about the general plan. After listening to him at length, they had few changes to suggest.[30]

The King still was thinking of room for only fifty friars. Toledo's design (fig. 30) accordingly showed a low, western two-storied building. The eastern half rose three stories, being separated from the low building by towers on north and south façades dividing the west and east halves. Two domed towers marked the west library façade at the main entrance, and two domed towers flanked the church sanctuary, making fourteen in all instead of the present eight towers.[31]

When excavation began that winter at the site, houses were built in the lower village for the eight resident friars and their servants, as well as for the architect, accountant, and paymaster. An enclosure was needed for thirty teams of oxen. Arrangements to feed and equip the workmen were planned by Toledo and the friars.[32] By early July 1562, when Toledo was ready to build the foundation walls, Fray Antonio de Villacastín arrived as *obrero mayor*, serving until 1594 as supervisor of all building activities. During Toledo's life he steadied the erratic conflicts that grew between the architect and the master builders.

Villacastín's arrival in July coincided with the first disagreement between the King and Toledo over Paciotto's criticisms. Sigüenza's explanation is that Philip thought Toledo's design for the church was "ordinary" (*comun*) and discordant with his own wishes. Toledo was greatly upset[33] and urged the King to send his drawings for the

church to Italy for evaluation. Later on he complied with the King's request for new designs of the church.[34] The decision against him was irreversible, because Cortés and Chinchón, for the council on architecture, ruled that the church was to be built on the squared plan of Paciotto's design (based on Alessi's plan [fig. 25A] in Genoa for the Carignano Church). Yet Toledo's plan for the King's dwelling and services were to remain unchanged.[35] Finally all services of the monastery were to be kept within Toledo's block, but not without taking advantage of the plans supplied by Gaspar de Vega. Iñiguez sees another rivalry here, but nothing is known of the designs.[36] Actually Paciotto's designs were still under consideration.[37] At the fabric, these winter months were spent building deep, large foundation basements, for which all hands prepared lime, shaped stone, and worked other materials in anticipation of laying the foundation stone of the monastery in the spring.[38]

Thus Toledo had lost to Paciotto the main body of the church, although his designs of the forechurch and of the main block were retained in part. His physical and professional decline were becoming noticeable in his irascibility and unpunctuality. To improve the internal morale of the fabric, another foundation-stone ceremony (20 August 1563) was held. It marked the beginning of the basilica's foundations at the future entrance from the sacristy (fig. 1, *O-P*), with a cornerstone laid by Toledo as *arquitecto mayor* of the King and *maestro mayor* of the fabric,[39] assisted by two master builders. Nearly everyone of rank, at court, monastery, and fabric, was present in an act of continuity during an uncertain period.

The complaints about Toledo's behavior led to the formulation of a new Instruction defining various responsibilities.[40] With his increasing disabilities, the handful of friars then at the monastery

22). Iñiguez (*Trazas*, p. 34) gave it to Toledo, and he believed that drawing 2 was like the work of Rodrigo Gil de Hontañón (ibid., p. 40).

[30] IVDJ, envío 61, #3, f. 1. Sigüenza described this first design as existing also in a wooden model (FME, pp. 30-31), which he described. The King mentioned having seen a model in January 1562 (BM, Addison, 28350, f. 16), which is probably this one.

[31] Zuazo, *Orígenes*, p. 12. Nine towers, if the main staircase housing is included.

[32] DHM, 3: *Instrucción* 1 (2 April 1562), 1-2, and PM, pp.

156-158.

[33] FME, p. 55; Z, 146-4 (July 1562).

[34] IVDJ, envío 61, #29, f. 4; #40 (February 1563).

[35] PA, p. 70; PM, p. 107 (AGS, 258, f. 205, January 1563).

[36] Iñiguez, *Trazas*, p. 15.

[37] BM, Addison, 28355, f. 35-36 (January 1563).

[38] Z, 146, 3, f. 7; Andrada, "Primera piedra," pp. 73-76.

[39] JSJ, pp. 25-29. Toledo's stone was set above a smaller one laid by the Bishop of Cuenca, a confessor of the King.

[40] DHM, 3 (10/15 August 1563); BM, Addison, 28355, f. 89v-90v (4 August 1563).

assumed many new supervisory duties. An ex-
ample was the need for reorganizing the transport
of building materials to the site. A memorandum
about the one hundred yokes of oxen and carts
owned by the fabric accompanies the Instruction
of 1563.[41] The oxen and their drivers were placed
under the direction of a friar chosen by the prior,
who thereby also became a director of transport,

responsible for the well-being of the animals, pro-
viding their food, seeing to their care under four
crews of attendants, building suitable stables and
forges, disciplining the drivers and their helpers,
enforcing the working hours to avoid the exhaus-
tion of the animals, and supervising the weight of
their loads.

THE RULE OF THE PRIORS, 1563-1572

In 1564 Prior Juan de Huete noted in a report to
the King the slowing down of the work caused
by Toledo's absences.[42] Figure 33 illustrates the
parts under construction. The inner walls of the
south and east ranges (2) had risen to ground-
floor level, while the outer walls were lower,
reaching only to the basement transom sills, al-
though in the sections corresponding to the clois-
ters (9) and refectory (8), the stone window
frames were partly in place. Every sentence is
loaded with reproach; the stairways were not all
ready; in the basilica the foundation was not yet
excavated. The retaining wall of niches had foun-
dations only at the southeast corner (1).

Another account by Fray Juan de San Jerónimo
also described the state of the same works at the
time of the death of Prior Huete nearly two years
later (25 June 1565).[43] The earliest walls began to
rise at the prior's tower (1) on the southeast cor-
ner, as well as extending west under the projected
chapter-rooms (2) to the infirmary tower (3),
which was finished first. Of the projected four
small cloisters, the two southern ones (4, 5) were
built as of this date, as well as a provisional dwell-
ing for the King (6), under the choir balcony of
the temporary church (7). It included a monastic
cell, a small toilet, and a very small tribune from
which the mass at the north end could be viewed.[44]

The stairway fresco (1692-1702) by Luca Gior-
dano may be based on lost designs by G. B. Cas-
tello (il Bergamasco).[45] The tower left of center
(fig. 35) has scaffolding, and a wall of four arches

at its left. The land rises to the right, suggesting
that right is west and left is east. The tower is
possibly the base of the southwest (infirmary)
tower, and the arcade a part of the south range of
the infirmary cloister. The King stands with Juan
Bautista de Toledo kneeling before him, Juan de
Herrera at Toledo's left, and Fray Antonio de Vi-
llacastín gesturing toward a construction at the
left, which may be the kitchen building. At the
King's left stands Miguel de Antona, the dwarf
and court jester (ob. 1570), and behind him are a
dog, a horn, and two attendants. Left of center
are two groups of workmen. The presumed date
would be after the decision in 1564 to increase the
height of the cloisters.[46] The King may be stand-
ing near the kitchen doorway.

The priors soon learned as Toledo's vitality
waned that he could easily be bypassed after the
King lost confidence in him, and that when the
prior and the master builders could agree, they
could reverse the architect's decisions. This hap-
pened at the end of April 1564, when Prior Huete
(who disliked the torus molding of the south
façade talus, as designed by Toledo) consulted
with Pedro de Tolosa, the master mason, on the
cost of changing it to a larger module of more
traditional appearance. Tolosa thought it would
cost 133 ducados, and the change was made with-
out consulting Toledo,[47] probably before too
many pieces of the offending torus had been set
in place (fig. 36). Prior Huete could therefore
write on August 18 that the entire south façade

[41] DHM, 3: 15-23; AME, I-9 [1563].

[42] PM, p. 169 (AGS, 258, f. 287, 7 April 1564).

[43] JSJ, p. 32.

[44] Sigüenza (FME, p. 32), describes this compound. Plans
and elevations were reconstructed by L. Cervera (fig. 34).

[45] Rubio (CD 162 [1950]: 528-529).

[46] PM, pp. 260-261.

[47] Modino, "Priores," pp. 235-236; PM, p. 174: if the talus
were to be altered, the cost would be 300 ducados.

molding had been completed to his liking with the large molding, which is reminiscent to our own eyes of late Gothic ornament, or even of Manueline moldings in Portugal. There is no doubt that the King supported the prior: a marginal note in his hand says, "as to the molding, try to get it into [Toledo's] head by whatever means you think best."[48]

In the summer of 1564, Huete submitted his own sketch-plans for enlarging the monastery, and others were requested from Pedro de Tolosa.[49] These included enlarging the refectory by extending it northward into the crossing-tower corridor (fig. 1-*00*); the novice's dormitory above the provisional church (fig. 2-*M*), and the number of friars' cells. The new sketches were at the scale of Toledo's "universal plan."[50]

But the paucity of cells for the friars, and their smallness, still disturbed Huete,[51] whereupon the Congregación requested a commission of five Spanish master builders to give their opinions on eight topics.[52] Their answer was signed by Rodrigo Gil and Hernán Gonzalez.[53] The response amounted to a critique by the profession:

1. The "weak" torus molding (fig. 36) on the south façade below the talus (or batter) is left to the judgment of Toledo (but Huete soon after had his way). Iñiguez suggests that this issue divided the Gothic taste of R. Gil from Toledo's Roman manner.[54]

2. The sloping talus, though disapproved, may continue as designed rather than *a plomo* (perpendicular). This feature reveals Toledo's training as a military architect, and it is the only openly defensive aspect on south and east, excepting the King's house, where it is omitted.

3. Vaulted chambers should be groined rather than barrel vaulted, and of brick above the imposts, both in basement and upper levels.

This recommendation was probably intended to reduce building costs.

4. Wall thicknesses and mortars throughout are to be proportioned to projected heights and loads.

5. The church pillars are too large for the altar to be seen from the aisles.

6. The retaining wall of niches is of a thickness adequate to its height.

7. The refectory (fig. 37) can be enlarged at its north end (Tolosa's proposal).

8. The number of cells and apartments can be doubled by adding another floor to the monastery (fig. 32) without exceeding the present boundary of the plan.

The eighth opinion required the greatest alterations because the infirmary tower at the southwest corner had already been begun as a smaller and shorter element. The addition of more height in the smaller cloisters not only diminished their light, but it also required the redesigning and unification of the south façade, formerly a double composition with major east portion, and a minor west wing, to a single façade with two instead of three towers, which for symmetry and correspondence would have to repeat on the north façade in the general distribution.

Yet Toledo's original design is still visible today. All six canceled towers in the universal plan still show in the ground plan (fig. 1, *HH, 102, 97, 75,* and the stair-shafts flanking the library façade at *49*). The sanctuary towers can be seen in the plans of the royal apartments. Both library towers are visible in the pilasters of the west-façade elevation, as well as in the massing of the library unit as a wide, extended central tower. But Toledo surely felt diminished by the prospect of these alterations.

Prior Huete disliked the seventh refectory solution, because it restricted service from the

[48] BM, Addison, 28355, 304ᵛ; 308ᵛ-309 (n.d.).

[49] PA, p. x; PM, p. 54 (5 June 1564).

[50] PM, p. 175 (AGS, 258, f. 301, 15 June 1564). A thumbnail sketch of the two cloisters is on the blank sheet. Huete writes to Hoyo that the new plans will not "change or extend the area of the block (*cuadro*) of the whole house, as defined since the beginning."

[51] PA, p. cxliv; PM, pp. 53, 171 (AGS, 258, f. 288, 30 May 1564).

[52] Iñiguez, *Trazas*, pp. 20-25: Rodrigo Gil de Hontañón (designer of the cathedrals at Salamanca and Segovia); Zumárraga from Talavera; Hernán Gonzalez de Lara (Tavera Hospital, Toledo); Enrique Egas (Almagro); Gaspar de Vega (Toledo).

[53] The King's questions: PA, pp. xii-xvi (AGS, 258, f. 207-210, July 1564). The answer: PA, pp. xvi-xix (AGS 260, f. 481, 5 July 1564).

[54] Iñiguez, *Trazas*, p. 22.

kitchen, and it deprived one cloister of its walk. He disapproved also of adding another floor for more cells, because they were too small and as dark as dungeons ("serian como una mazmorra"). As to the niched wall, Huete denounced it as too expensive (50,000-60,000 ducados), and its great stairways (*escalerones*) as prejudicial to the terrace gardens (fig. 99).[55]

In the monastery ground plan (fig. 33), the prior wanted an exit from the refectory (*8*) to the infirmary cloister (*5*), but the King preferred the actual solution, where the refectory is entered from the crossing tower by three doorways, for the reason that food could most easily be passed from kitchen (*8*) to tables. On the upper monastery plan the King wanted the barbershop to be above the north end of the garment room (fig. 1, *MM*). This floor plan comprised a novices' dormitory (fig. 2, *M*) using the main cloister stairs (fig. 2, *L*) and having south light. He rejected one other dormitory above the refectory (fig. 2, *Q*), because he thought this space would be better used for friars' cells. In the *Sumario* it nevertheless remains as a dormitory. He also urged further study of the doorways connecting the two dormitories (fig. 2, *QQ, M*) with the toilets (fig. 2, *N*). Over the barbershop (fig. 2, *Q*) the King writes about two floors (attics?). Both could be used for storing bedclothes. The King's second memoir was about Tolosa's plans. He regretted the lack of chapels in the main library (fig. 2, *R*) and chapter-room (fig. 1, *Q, & R_x*), suggesting that two, or even four, be arranged in the garment-room *roperia* at fig. 1,-*MM*, or in the portico (fig. 1, *49*).

This crisis of authority and the ensuing rivalry among Toledo's critics drew two long comments from the King, sent to Huete on 19 July 1564, and written in his own hand, after he had prepared a plan (now lost) of his own for the four cloisters.[56] His comments tell much about the rival projects and his own grasp of the problems they raised. The first memoir discusses Prior Huete's plans for the monastery. As he wrote, the plans of four cloister levels were before him. Of the basement chambers (fig. 33), he wished the large storerooms beneath the refectory (*8*) and

kitchen (*11*) to make a continuous circuit with those under the south (*9W*) and west ranges (*13*), as well as under the crossing tower (*14*) in a series of communicating chambers. About the college ground plan the King wrote that the two northernmost courts needed more thought as to the placing of kitchen, students' refectory, and the lecture room. He preferred to keep kitchen and refectory near the north range and to put the lecture room overlooking the forecourt (fig. 1, *52-53*), whereas the Prior's plan put the kitchen there.

In the "second" cloister (fig. 1, *RR*), so named because it was built after the infirmary cloister, only twelve cells were provided on three levels, and the King proposed four more on the lower attic level. He noted that the refectory had more ample room for the dormitory above it than the garment room. The scriptorium, originally planned by Toledo for the discarded center south tower, would have to be moved next to the chapter-room (fig. 1, *R_x*) on the ground floor. Twelve friar's cells with water line and sewer drains (*servicio y vaciadero*) for hospital patients were planned in the south range (fig. 33, *9W*) on three floors. The southwest *botica* (infirmary) tower was to house the dispensary, with its dining room and fireplace, and a chapel above it (fig. 1, *V, VV*). The kitchen wing seemed low and dark, and he suggested that it rise three stories for better lighting from the adjoining cloisters (fig. 1, *RR*). The kitchen vestibule (fig. 1, *SS*) would give access also to the basement woodpiles and dishwashing troughs, as well as to the area for feeding the poor, although he was uncertain whether the college kitchen might not be a better place for this service. The small courts (fig. 1, *41, 42, patinejos*) flanking the forechurch (fig. 1, *40, sotacoro*), had already been designed by Toledo and would remain his responsibility; actually Herrera redesigned them in 1576.

The implications of these comments by the King are clear: they show him turning away from Toledo to the prior and the master builder. They are the longest writings in his hand on the building of the Escorial, and there is no mention of Herrera. The royal lodging (*aposento real*), under-

[55] PM, p. 176 (AGS, 258, f. 301, 6 July 1574).

[56] PA, pp. CXLVII-CLIII; PM, pp. 179-183 (AGS, 258, f. 207-210; also 260, f. 299-300). Iñiguez (*Trazas*, pp. 26-28) under-

estimated the architectural knowledge of the King and did not separate Huete's drawings from Tolosa's.

neath the choir balcony of the provisional church, is not discussed. He was more intent on the needs of the ill and poor, and of the friars and students, than of the court and royal household, because the drawings at hand by Huete and Tolosa were only for the monastery and college. Without having been there, Sigüenza described the appearance of the fabric as of 1564, probably using plans and drawings now lost: the visible exterior above the basements consisted of the refectory and the kitchen buildings.[57]

The infirmary-garden building extends beyond the block at the southwest corner (fig. 38), and it too was on the King's mind in 1564, when he wrote another memorandum. It leaves no doubt that this delightful sun-corner garden was part of a design by Toledo, who called it the sun-corridors (corredores del sol) for the friars who were convalescent.[58] But the original need was for a buttressing substructure that would support the enlarged southwest tower. Such a substructure had been foreseen for the southeast tower but not for the small southwestern one planned for the small community before its enlargement and redesign. In effect, the terrace gardens are the top of a wall buttress holding up the southern and eastern flanks of the monastery, as well as its southern towers.

A drawing of the ground plan of the southwest tower (fig. 39) bears a comment in Toledo's handwriting, saying that "according to this plan, the towers can be made to appear square from the outside."[59] Toledo is referring here only to the western towers, because the eastern ones are square to the top floor under the spires, while at the west façade, they are L-shaped in plan above the abutting slate roofs. Until contrary evidence appears, this aspect of the west towers[60] may be assigned to Toledo's redesign of this period, together with the niched retaining wall, the sotacoro vault, and the main cloister.

In October 1564 Prior Huete renewed his attack on Toledo's manner of working, with complaints that major errors had appeared in the south façade, and that his working drawings, which had illegible scale marks, were only small sketches covered with calculations, and lacked dimensions as well as partitions.[61] Three days later Toledo defended his work, securing a copy of the offending design, and saying that the elimination of the central southern tower had obliged him to remedy the south façade design as best he could. The other excuse he made was to say that someone had changed the dimensions on the friars' copy of the "universal plan." This was a set of all his drawings mounted on cloth, one of the three made for the King, himself, and the friars.[62] The King at this time still referred to the future basilica as having an apsidal sanctuary,[63] of which figure 26 is a variant version.

Toledo defended himself again on many topics in a memoir written as a diary (15-22 November 1564).[64] He reports having remeasured the foundations of the main cloister and the south range (cuarto) without finding errors, but that the kitchen building was half-a-foot out of alignment. The error was corrected by taking it from the adjoining cloisters (fig. 1, PP, RR) and adding an extra foot to the width of the kitchen. The rainwater cisterns in the two small southern cloisters were staked out to have their boundary walls support the cloister walks. Two stairways were also laid out, one at the southwest tower and the other on the east side of the refectory. As to basement heights, he urges, contrary to the King's wish for deeper cellars, that they all be eighteen feet high, whether big or small, for economy in laying drains and conduits. Turning to the basilica, he

[57] FME, p. 32: "Estava ya a este punto hecha la casa del refitorio y la cozina." Large flooring beams for them were being sought from Quexigal. PM, pp. 202-203 (8 January 1565). The beams for the upper dormitory floors were also being sought, so that they might have seasoned when needed.

[58] PA, p. xxii (AGS, 258, f. 210), September-October 1564; Iñiguez, Trazas, p. 29; S. Zuazo, "Antecedentes," p. 149. The term corredorcillos del sol, is in Toledo's own hand (PA, p. xxxi; PM, p. 199; AGS, 258, f. 218).

[59] Lopez Serrano (Trazas, p. 20) mistakenly calls it a plan of the prior's tower, and attributes both the written comment and the drawing to Herrera.

[60] He says that he paced out and staked both corner towers of the south front on 18 November 1564 (PA, p. xxx).

[61] PM, p. 192 (AGS, 258, f. 313, 6 October 1564). Huete was defending Tolosa from charges by Toledo.

[62] PA, p. xxiii-xxv; PM, pp. 194-196 (AGS, 261, f. 2, 9 October 1564).

[63] PM, p. 196 (11 October 1564). The King orders that "se engruesen las paredes del medio circulo de la cabecera de la yglesia" (copies to prior and Toledo).

[64] PA, pp. xxix-xxxii; PM, pp. 198-201 (AGS, 258, f. 218-219).

mentions the underground burial vault and the need there for a ventilating duct (fig. 44 C) there rather than a slot window (*saetera*). As to the southeast corner, Toledo urges extending the buttressing platform eastward, especially at the declivity underneath the southeast corner of the King's house.

For this critical year, when the Congregación and the friars took charge, and the work was moving ahead more rapidly than under Toledo's sole direction, the King's winter orders are known.[65] The agenda included these tasks:

1. Raise the walls of the royal dwelling four courses.
2. Thicken the semicircular wall of the apse and the walls south and north of it (presumably for the tomb figures of the royal families?) to the level of the King's apartment.
3. Toledo to finish the new design of the south façade talus and fenestration with evenly spaced window axes for security in the talus level, using false windows as necessary.
4. Rebuild the southwest tower foundations (fig. 33, *3*) to communicate with the west façade basements (fig. 33, *13*).
5. Finish vaulting the two southern cloister cisterns (fig. 33, *4, 5*).
6. Excavate for the foundations of the main stair (fig. 33, *15*), toilets (fig. 33, *10*), and crossing tower of the four small cloisters (fig. 33, *14*).
7. Continue building the niched retaining wall at the sun corridors west of the infirmary tower.

On 7 December he asked Toledo to return to Madrid where he could finish his drawings at the King's side, but Toledo replied almost angrily two days later that he could not be absent from the building site, where he was helping manually, among windstorms and cloudbursts, like the *aparejador* he had been in his youth.[66] Actually, Toledo's violent disagreements with some master builders (Andrés de Ribera and Pedro de Tolosa) had already begun in the summer. In December his differences with the King, over whether to

employ people on piecework (*jornales, a tasacion*) or on contract (*a destajo*), were becoming acute, Toledo preferring to control with jobs based on his own estimates, and the King insisting on contracts awarded in public competition.[67]

The slow tempo among idle builders[68] during the winter at the fabric in early 1565 quickened with the King's eagerness to move ahead on his own design for living at the Escorial, even if only in temporary quarters. On 8 March the first Mass was celebrated at the monastery in the provisional church (figs. 1, *GG*, and 40),[69] and it marked also the proclamation at the fabric on that day of the King's new orders for its governance.[70] Portabales, who first published the orders, claimed that they "definitely approved Toledo's plan without permitting alterations." Actually the orders are less final. They authorize Toledo's plan, but specify it as incomplete. They bind both Toledo and the friars to follow the "universal plan" as it then existed, with recourse to the King in case of conflict. More concretely, these orders were intended to define priorities among building schedules and to delimit the responsibilities of architect, friars, and master builders. The prior and the vicar were charged with the main cloister, although work on that project was to be delayed for the present. Their most urgent matter now was to hasten construction of the four small cloisters, including the kitchen, toilets, and other services. Toledo was given the basilica and the temporary church, as well as the royal dwelling and the niched wall. The "sun-corridors" of the infirmary were to be built jointly under the direction of the prior and Toledo, on a special drawing (*traza particular*) still to be made by the architect.

The prior and vicar were authorized to name two masters, a mason and a bricklayer, and to direct their work. A new requirement was that such *aparejadores* be provided with suitable dwellings so that they might reside with their families near the site, instead of traveling long daily distances to and from work. Toledo was enjoined to be clearer in giving his orders. The friars should treat him courteously. The masters were to show respect and obedience to the friars, the plan, and

[65] PM, pp. 196-198 (11 October 1564) covering until spring.

[66] PM, pp. 57, 59 (7 and 9 December 1564). This is Toledo's only reference to having been a master builder in the Spanish sense of an *aparejador*.

[67] Z, 146-24, f. 25.

[68] PM, p. 207 (23 January 1565); p. 208 (31 January 1565).

[69] Villacastín, DHM, 1: 12.

[70] PM, p. 209 (AGS, 260, f. 491, 8 March 1565).

Toledo. Nor was Toledo to resent decisions taken in his absences by the Congregación. Toledo's feelings were bruised by these limitations on his authority, and he complained to the King that his designs for the main cloister were being taken from him and that he was deprived of recourse.[71]

The emerging regime of competitive bids for contracts (destajos) now required master builders to write specifications in full detail. Called condiciones, these were written by the master builders themselves, and they usually signal the beginning of construction. Drafts of specifications for the brick basement vaults of the two southernmost small cloisters are dated 30 April 1565. The quality of the materials was carefully specified, and all tools and scaffolding were to be supplied at the King's expense.[72]

At the southwest tower foundations, masons were paid in 1565 for a large basement vault beneath the infirmary. This would have extended westward, outside the block, and under the sun-corridor terrace, behind the niched retaining wall.[73] Another important basement chamber was finished in 1566, the flat-vaulted room under the choir of the provisional church where the King wanted to live. The circular vault is still visible, and it is the prototype at the Escorial for the forechurch (sotacoro) vault (fig. 27) built in the basilica after 1576, of concentric circular voussoirs.[74] Further paperwork was needed in 1566, when estimates were solicited for the little cloisters from three experts: Toledo himself, and the master mason Pedro de Tolosa, as well as Gaspar de Vega,

whom the King suggested. Toledo's estimate is preserved:[75] each cloister would cost over 4,000 ducados excluding doors and the salary of the master builder.[76] The estimates by Rodrigo Gil and Gaspar de Vega were more than double (8,-500 ducados), and in November the contract was still without a taker,[77] for reasons unknown, but during 1566-1567 until Toledo's death few contracts were awarded, and the only significant ones were for basement drains and conduits, for masonry in the little cloisters, for the outside corbelled passage from the southwest tower to the sun-corridors (fig. 36), for frames and closures of doors and windows, and for continuing the thirty-foot cornice on the west façade to the kitchen portal.[78]

Toledo himself was busied with making scale models of the small cloisters. These showed alternate solutions, using either vaults or trabeation in the walks. He also worked on the water-supply system, planning to have the rainwater cisterns of the small cloisters (fig. 1, II, LL) supply the sewer between them underneath the toilet building (fig. 1, EE). This gravity system was fed from springs under the building, and mainly by mountain streams from the west.[79] The bearing walls of the toilet building[80] were rising by November 1565 when building activity increased, and 3,000 ducados were being spent monthly. Yet the work was advancing slowly: in January 1566 the foundations of the kitchen and toilet hall were still being excavated, in a way suggesting that the drain designs had not been anticipated. The pro-

[71] PA, p. xliv (AGS, 261, f. 4, 1565).

[72] PA, pp. xxxiv-xxxv (AGS, 260, f. 495; 261, f. 5, 30 April 1565, emended 21 June 1565).

[73] AME, I-44, f. 1ʳ, 18 November 1565. The linear measures of masonry paid for, indicate a chamber either 30 by 45 or 10 by 65 feet, according to the maximum and minimum widths of the basements under the monastery itself.

[74] AME, I-44, 1ʳ, v., 3 March 1566. Sebastian de Llama was paid 84 reales "porq reboco y retundio la bobeda debaxo del coro de la capilla del sepulcro." The vault is about ten feet in diameter. On its mode of construction and that of the sotacoro, L. M. Auberson ("El Misterio de la boveda," p. 3 v.) supposes that the voussoir ringstones were flanged and tracked together, and he writes (letter to author, 19 December 1978) that a replica in wood (60 by 60 cm.) sustained without deformation the weight of a man.

[75] PM, pp. 21-22 (AGS, 258, f. 342-343, 19 January 1566).

[76] PA, pp. xlvi-lv (AGS, 258, f. 7):

quarrying and rough trimming stone	15,081 reales
finishing stone	21,792
laying stone	8,326
Total	45,199 (fractions omitted)

[77] PA, p. lvi (AGS, 258, f. 3, 19 April 1566); IVDJ, envío 61, f. 92.

[78] AME: basement drains, I-64 (1566); stone for kitchen, provisional church and two small cloisters, I-65 (December 1566); water mains from toilet hall to west exit at kitchen portal, I-66 (19 April 1566); masonry for exterior gallery on southwest tower, I-68 (n.d.); doors and windows for south building, stairs, and cells, I-68 (28 April 1566); thirty-foot cornice, I-90, 94 (6 June and 6 December 1567).

[79] Rubio, "Cronologia," p. 26. Springs were under the college and the north aisle of the basilica. Also G. de Andrés, ed., "Libro de la fontaneria," pp. 219-318 ("Libro de la fontaneria . . . 1645," attributed to fray Nicolás de Madrid).

[80] PA, pp. xlv-xlvi (18 November 1565).

visional church was only then being scaffolded for the choir-balcony vault that would shelter the King's apartment.[81] By April 1566, twenty to twenty-four yokes of oxen were hauling timbers for the floor beams,[82] and the floor was laid in anticipation of the King's coming to stay there for Lent, in which case the newly plastered rooms could be "dried with heat and hung with tapestries."

When the King considered leaving Spain to attend to the revolution in Flanders at the beginning of 1567, he drew up an agenda for the fabric,[83] in case of an absence of unknown length.

1. The specifications for the two small cloisters were to be reviewed with Toledo's elevation drawing at hand (presumably similar to figure 32, dated by Lopez Serrano as 1568 or 1569).
2. A model for the main stairway was to be inspected, and orders given for its execution under Pedro de Tolosa's direction, although Lucas de Escalante was to build the arcade responding to the cloister at its eastern entrance.
3. Orders were also to be prepared for the royal dwelling under Escalante's direction, and for its grills (*rejas*) separating it from the church and monastery.
4. Orders were provided for the governance of the master builders (these probably were preliminary to the decree of 12 September 1569, DHM, III, 25-32).
5. Juan Bautista de Toledo was to prepare plans, elevations, and sections for the entire basilica. This order suggests that these were then not ready.
6. "Foundations of the main cloister" also appeared on the reminder, but without further explanation.

The King's "letter of foundation and endowment," dated 11 April 1567,[84] arose from the same anxiety about the great troubles in Flanders, and it set forth his plans to assemble at the Escorial the *cuerpos reales* of his dead relatives for temporary burial in the provisional church pending the completion of their tomb beneath the basilica.

In these months the Congregación vigorously moved to increase the amount of building being done, with monthly costs rising to 5,000 ducados, and the master builders demanding more workmen.[85] A progress report from the prior and treasurer mentions several accomplishments: the infirmary tower gallery was finished (fig. 33, *3*); the cloister stairway (fig. 33, *4*) serving the King's apartment (fig. 33, *6*) had reached the fifteen-foot level; the infirmary walls (fig. 33, *13*) were at the level of the doorway jambs; the south façade was at the fifteen-foot level (fig. 33, *9W, 9E*); and the small vaults in the King's apartment were plastered, all in anticipation of the expected arrival of the King for Easter,[86] when the rooms would have to be ready. Standing higher than the rest of the south façade at that time, it was called the *torre del aposento*[87] during the time the King occupied it until 1571, but there is no evidence that he was there at Easter 1567 after all. The drawings by Luis Cervera (fig. 34) show the state of the rising walls from the exterior, but they do not display the completed kitchen and refectory buildings described by Sigüenza,[88] nor do they note the *torre del aposento* rising to the fifty-five foot level.

At Toledo's death (21 May 1567), his monument was already changed by many others and made both sterner and simpler. It remained intact only in plan, but altered nearly everywhere in elevation. Only the lower walls were visible in 1567 with unfinished towers rising jaggedly, deep excavations and an unfinished building here and there in a barren setting deeply scarred by the untidy fabric. Toledo's death also brought a new delay in the fulfillment of the King's plans. These were to bring together, for the ritual commemo-

[81] PM, p. 223 (AGS, 258, f. 342-343, 19 January 1566.

[82] PA, pp. LVI, LXIV (8 February 1567).

[83] PM, pp. 67-68, PA, p. CXII (AGS, 260, f. 30, 6 January 1567). Actually the Duke of Alba was placed in command, and Philip II stayed in Spain.

[84] DHM 2 (1917): 94-103.

[85] PM, 234 (AGS, 260, f. 95, 15 February 1567). In April Almaguer requested and received 10,000 ducados for two

months (PM, pp. 234-235, AGS, 260, f. 98, 20 April 1567).

[86] PA, p. LXX (AGS, 260, f. 403, 6 March 1567). Herrera was devising stone lifters and cranes (fig. 55) for this increased activity, at increased salary. AGP, *Cédulas* 3, 50; PM, p. 43; and AGS, 258, f. 488 (April 1567).

[87] PA, p. LXXIV (AGS, 260, f. 404, 30 April 1567).

[88] FME, p. 32. The Cervera drawings accompany Rubio, "Cronologia," pp. 54-58.

ration of his dynasty, all the necessary deceased and living participants as soon as the going pace of construction would allow. From the King's point of view, this objective would require his frequent residence at the site, but the hastily completed *aposento* under the choir-balcony was an isolated and unique habitation exposed to the noise and dirt of building. The friars all still lived in a cloister at La Fresneda, and the officials and laborers of the fabric all lived at the lower town.

The Escorial itself was still a mudhole of basement walls and unfinished vaults (fig. 35), where the *aposento* was like a module or showpiece, promising no more than a small sample of the future appearance of the monastery. The King could not have expected to have the friars living around him in less than five years. In the friars' view, however, their control of practical matters, through the prior in office, would be assured by the frequent presence of the King in the body of the monastery, participating with them, almost as a monk, in the rituals of the Church and in frequent masses of dynastic commemoration. From the master builders' view, communication with the Congregación would be improved when the friars could live in the monastery. Hence every interest was bent upon making the monastery ready, as a trial or rehearsal for fully realizing the chief purpose of perpetual commemoration, in the monastery buildings or compound, before the construction of the basilica, palace, and college.

THE COMPLETION OF THE REHEARSAL COMPOUND, 1567-1571

When Toledo died, a new urgency to make the monastery habitable dominated the fabric. After a slow start in 1568-1569, construction moved faster until 1571, when the King, with his household and the friars, as well as the eight bodies of his parents and relatives, whose memorial services were the main purpose of the Escorial, could all occupy their appointed places for the first rehearsals of the intricate ceremony of a royal tomb and palace. The rehearsal stage was in the southern range, using the five cloisters, where the monastery housed the King and court from 1571 to 1576.[89] The King lived under the choir (fig. 1, HH), while the court was installed in the future chapter-rooms and the friars in the small cloisters, thus concentrating all the elements of dynastic commemoration, in order to achieve through gradual enrichments the desired perfection of religious and courtly ritual that would be transferred from the rehearsal compound after 1586 to the completed basilica and palace.[90]

No successor to Toledo as royal architect was recognized for nearly ten years, and the rule of the priors continued under the aged Fray Juan del Colmenar, although the treasurer, Andrés de Almaguer, sought to encroach on his authority. Almaguer was retired and replaced in 1572.[91] As a prior, however, Colmenar was more easily circumvented than Huete (who died in 1565), and being ill, he asked to resign in 1570. After Toledo's death, innumerable questions remained after the makeshift haste of getting the King's apartment prematurely ready. The financing of construction was temporarily assured by news that the Council of the Indies would remit 10,000 ducados annually from New Spain for the Escorial.[92] Wall construction had advanced enough for flooring to begin, and large orders for lumber went out. Specifications were also written for stone to be cut into stairs, lintels, buttresses, and cornices; and slate workers were assembled and equipped to begin roofing.[93]

Gaspar de Vega was occasionally consulted in his capacity as master builder on royal works elsewhere, especially at Aranjuez and Uclés. Gerónimo Gili (a discípulo of Toledo) also was consulted, but neither was attached solely to the Escorial.[94] Gili, who was mainly a model maker, brought

[89] FME, p. 42, beginning 11 June 1571.

[90] In architectural diction, a compound is a cluster of units of different functions serving a common purpose. In this case it is the palace-monastery of which Chueca has studied the medieval antecedents in Spain (*Casas reales en monasterios*).

[91] Modino, "Priores," pp. 57, 70.

[92] IVDJ, envío 61, f. 147 (June 1567).

[93] AGP, 3: 54ᵛ. (10 June 1567); AME, I-90 (15 June 1567); PM, p. 138 (AGS, 258, f. 376, 14 July 1567).

[94] AGP, 3: 63ᵛ-64.

Castello's model of the main stair for the King to see in 1567,[95] along with others brought by Herrera and Escalante, and Vega was also asked at this time to bring everything relating to roofing for a decision.[96] Castello's appointment soon after as *criado del Rey*, to advise on "plans, models and other matters of painting" at the royal works, with an annual salary of 3,000 reales (8 ducados), suggests that he had no important connection with the Escorial, and that his *models* had more to do with painting than building the main cloister stair.[97]

As pointed out earlier, the writing of specifications for competitive bidding on contract was common practice for royal Spanish buildings before Philip II, but it did not become a matter of custom at the Escorial until 1569 when the master builders were obliged to write them out as *condiciones* instead of dealing directly on their own terms, which were often disadvantageous to artisans and laborers, and to the quality of the work. L. Rubio reconstructed the scribal procedure of the early years,[98] for which such documents are rare. The drawings were prepared first. Then *condiciones* were written, specifying how the work was to be done, whether on contract or as piecework; who was to pay for which materials (contractor or King); what prices were, by workmanship or by area; when the job would be completed. Simple agreements (*conciertos*) would be written for small tasks, but large and costly commitments for long periods were usually defined by *condiciones*. The order of priority was often expressed by the term *elección*, signifying choice or schedule.

For very large contracts the *condiciones* were made known in neighboring towns by proclamation (*pregón*), i.e. public posting with deadline dates. After the work was acceptably completed, it was measured and appraised (*medición y tasación*). Payments were usually monthly and made at the building site. Work generally began at once after award, which is therefore a reliable starting date,

while *pagos* and *libranzas* of money due help to determine the duration of the contract. For example, a mason was given the contract to fulfill *condiciones* for the south façade cornice in 1568, based on the only part of the building that was then ready for the molding to mark the fifty-five-foot level. This was the so-called "*aposento* tower" because it was the only section standing that high. Actually Toledo had planned a tower as this midpoint, but after the vertical enlargement of the monastery, it shrank to an almost imperceptible element three window bays wide, projecting only six inches as an *avant corps*. Thus these early *condiciones*, written by the first master builders, were a model draft that served for all later contracts to continue the same work. A preamble states that the work is to follow the drawings, for the cornice and for the window-lintel arches (*capialçados*) below it, as drawn by Pedro de Tolosa. Five paragraphs follow with further specifications and Tolosa's signature as author and as "his Majesty's master builder." In the *remate*, or award to lowest bidder, two masons entered their offers, and the contract was given to the bid for 9 ducados per *vara* (2.8 English feet),[99] which bettered another offer of 12 ducados.

For the years of Toledo's work at the Escorial, the archive there contains fewer documents, but at Simancas the early correspondence and payments record his presence more fully. Many of his letters are scattered in other collections which supplement those at Simancas and the Escorial.[100] After Toledo's death, and with the gradual reorganization of the *fábrica*, the records improved, especially when the master builders began to write the terms for contract bidders. Other valuable sources are the notes penned by the chief workman, Fray Antonio de Villacastín, either reporting on delays or authorizing work to proceed. These notes began in 1567 and continued until 1584. They pertain to every aspect of the work.[101]

[95] BM, Addison, 28350, 249.

[96] Camón ("Arquitectura trentina," p. 409) thought Vega became "director" at the Escorial when Toledo died, but the documents do not support it.

[97] The attribution of the stair to Castello is due mainly to Sigüenza (FME, p. 231), but contested by Portabales (PM, pp. 69-72), and Iñiguez (*Casas reales*, p. 103). Wilkinson ("The Escorial Staircase," pp. 80-83), rightly gives the present stair to Herrera.

[98] CD 162 (1950): 97 n. 1.

[99] AME, v-21 (29 June 1568).

[100] IVDJ, Z, AHN, BM, AVE.

[101] A published selection of his notes spans 1570-1600 (Anon., *Villacastín*). Nearly all the letters by him printed in this tribute by modern Spanish *aparejadores* came from Simancas (*Casa y sitios reales*, legajos 258-261). At AME, the earliest paper by him is an agreement (*concierto*), without signature, 6 June 1567 (AME, I-90), for door and window closures.

Compared with the nearly inactive year of To-ledo's death (1567) a rapid increase in contracts appears in 1569-1570, when the master builders were brought under the control of the Congregación. This had the effect of dividing work into smaller units. Sigüenza noted the difference in his own way.[102] Speaking of the days before *destajo*, he says, "all work was done on the King's account, that is to say, none was taken on by any contractors, unless it was by the two master builders, or preparators (*destajeros*) named Tolosa and Escalante. The King gave them a fixed salary, and they made patterns for cutting the stone, dealing with the quarrymen, as well as with those who cut it, and those who laid it, and it was they who did all the business." He goes on to say that when the church was begun (he says 1573), this procedure continued for over a year, but the progress was so poor that the building rose barely one course each year, whereupon Herrera divided the entire task of the church in ten contracts, each with its own master builder chosen from among many candidates.

Thus before 1569, the *aparejadores*, as master builders, made their own arrangements with as many subcontractors as needed. But after that date, written contracts with hundreds of individuals were the order of the day, and the contracts were for strictly defined tasks, becoming more diverse as the building approached completion, with many procedures of finishing and furnishing, of decoration and comfort, all requiring separate crews of workmen under differing terms of payment. Another consequence was increased delay between the writing of specifications and the acceptance of bids for contracts, as when *condiciones* for the building of the main church in 1573 did not come to *remate* (bidding) until the following year. After 1573 the records show fewer con-

diciones and many more *escrituras públicas* (legal instruments) made by the contractors.[103]

During the slack period after Toledo's death, the Flemish slaters began to make the shelters they needed at the Escorial for their tools and workbenches, after having supplied La Fresneda with its roofs. This was the temporary residence of the friars and court, where much work was needed on the water supply.[104] The steep gables of the King's house there (fig. 41) recall the façades of Flemish cities, and reveal the King's nostalgia for the *paises de Flandes* as well as the northern origins of the slaters who had been imported by the King for work on royal buildings as early as 1559.

At the Escorial, the treasurer, Almaguer, predicted that the brilliance of the slate roofs would be visible from Madrid. The pace of construction accelerated after 1568, when 400 workmen at the site were handicapped by an insufficiency of cartage and inadequate provisioning. The supplies of stone were not coming often enough, and the master builders were competing for laborers with the contractors, in a confusion between wages and piecework that led to the new regulations in September 1569.[105] Among their main tasks at this time were building the main stairway, essential to circulation in the monastery, and roofing the kitchen wing,[106] as well as paving the cloisters.

The sacristy of the provisional church and the Queen's apartment were located for the time being in the chapter-rooms, which would later fill the eastern half of the south block at ground level (fig. 1, R_x, &). These walls were then high enough for contracts to be written for the iron window grilles,[107] usually a sign, because of security, that rooms were near completion. On their north wall, adjoining the south range of the

Andrés, *Inventario*, Index, mentions him as correspondent in thirty entries, until 1598.

[102] FME, pp. 63-64.

[103] The earliest *escritura* in AME is a *concierto* (agreement) with masons for quarrying and shaping stone at La Fresneda in 1569 (II-43). By 1573 (ibid., IV-1) *escrituras* were more common than *condiciones* and *remates*, e.g. AME, III-12 (18 September 1573), drawn between Congregación and contractors, in an obligation by the masons to follow conditions as detailed, bearing the approval of Villacastín.

[104] AME, II-27 (n.d.) has plans, possibly by Herrera, for the dam and pond (300 by 200 paces) at La Fresneda, which are

still in use. Other papers on the Fresneda buildings: PA, p. LXXI (AGS, 260, f. 96, 17 February 1567); PM, p. 238 (AGS, 258, f. 327, 13 July 1567).

[105] PA, p. LXXIX (AGS, 260, f. 419, 16 February 1568). A nephew of Pedro de Tolosa struck a contractor with a stick over this issue (PA, p. LXXXV; AGS, 258, f. 45, 26 May 1568). Tolosa was punished with a fine and a suspension of some days by the treasurer's tribunal.

[106] Main stairway: AME, II-22 (10 November 1568). Trussing, sheds, gratings, chimneys, tiles, cloister floors: AME, III-10 (16 May 1568).

[107] AME, II-11 (26 April 1568).

main cloister, the first-floor cornice at the thirty-foot level (fig. 4) was contracted, as well as the fifty-five-foot cornice at the remnant of the "central tower" on the south block, which now rose as the King's tower, until the rest of the south block façade could absorb it as a slight projection in plan and elevation.[108]

Forward planning now included Herrera's making a *modelillo* of the roofs,[109] for which timbers were being purchased. Heated discussion arose at the end of the year over whether the main cloister should have single-stone architraves spanning the arcades or five-piece ones. The Council, Herrera, and the master builders wanted to risk the monoliths, but the King insisted on a compromise, with three-stone, flat-arch spans.[110] The main cloister was the largest unit in construction, until work at the basilica began. Many contracts were written for the cloister, beginning in 1569, but Toledo's design for it is established by his letter to the King in 1565, complaining that he and his master builders had been entrusted with its execution, and that some ignorant meddlers had interfered by insisting that the work be given to contractors instead of being done as piecework.[111]

In 1569 efforts were concentrated on completing the cloister in preparation for the greatly enlarged community of friar-priests who would expect especially comfortable cells as customary among Jeronymites. Workmen were assigned to the three floors above the sacristy in the east range, with cells for twenty friars on the second level, an entresol, and the attics, and twenty more over the chapter-rooms in the south range. Though Toledo claimed the designs, Herrera refined them further. This appears in the cloister supports (unadorned square piers in Toledo's plan (fig. 31); and articulated pilasters and half-column in Herrera's (fig. 42). Furthermore, Herrera improved

on Serlio: Serlio's drawing of the façade of the Theater of Marcellus in Rome (fig. 43), was raised for greater elegance on a pedestal of squarish proportion, instead of Serlio's recommended $\sqrt{2}$ rectangle for the lower Doric order (fig. 42).[112] Figure 42 is an elevation drawing for the corner bay at the sacristy entrance, showing the structure in elevation and section, with the high solid stone parapet rising 5½ feet to insure the *clausura* of the immense friars' garth. Figure 19, a preparatory drawing, shows details of the crowning parapet and gutters to shed rainwater from the inclined lead-sheeted cloister-roof terrace. The Ionic entablature is also based on the Theater of Marcellus,[113] combined with a pulvinated or cushioned frieze of convex profile. Figures 45-47 are tracings to show the plan of the north range with intercolumniations given as 14 and 31/44 feet[114] and the width of the cloister walk as 20 feet. The sacristy entrance (fig. 46) appears as a "warped" doorway made to reconcile inner and outer symmetry.

The building history of the main cloister began in 1569[115] with an underground cistern for the service of the sacristy font and basins. The large dimensions of the cloister arcades required architraves 16 feet long, which Lucas de Escalante wished to quarry as single stones.

Ten arcades and bay vaults of the west range, together with the south passage to the small cloister adjoining the provisional chapel, were contracted in 1569, together with one Doric column as a prototype and model.[116] Nine upperstory piers (*arbotantes*), to which the Ionic half-columns and pilasters would be attached, were in construction later that year, with their brick vaults.[117] These were in the west range.

The immense main stairway was the key element of circulation. Work on its bounding walls

[108] Thirty foot: AME, II-19 (31 August 1568); fifty-five-foot: AME, II-21 (29 June 1568).

[109] Figure 19 shows one of the eastern spires. The *modelillo* is mentioned in PM, pp. 82, 246 (19 March 1568).

[110] PM, pp. 250-252 (AGS, 258, f. 64); AGS, 260, f. 108, 15 January–14 February 1569.

[111] PA, p. XLIV (AGS, 261, f. 4, n.d.): "they wish to take away from me and my preparators [*aparejadores*] the famous large cloister, which Your Majesty ordered me to begin and continue according to the plans and designs I prepared, and put it all in the hands of ignoramuses . . . as well as the palace

of Your Majesty."

[112] Serlio, *Tercero y quarto libro*, pls. XXII, XXVII.

[113] Serlio, Book 4, XLIV-XLII.

[114] Herrera here tries to preserve the unit used in "casting out" a common denominator when finding the ratio of two measures.

[115] AME, II-37 (6/7 March 1569). FME, p. 353.

[116] AME, II -39, -40 (both September 1569); II-60 (29 January 1570).

[117] AME, II-70 (20 July 1570), piers; II-76 (20 August 1570), vaults.

began on Toledo's design before 1567, and the project then was for an open-center staircase rising in ramps around the walls, as shown in plan (fig. 31) where a fountain stands in the center. Work on its masonry shell began in 1567-1568,[118] but in 1571 it was decided to begin again on a new plan of parallel reversing ramps of the type now designated as "imperial." The work begun in 1567 was undone, but the exterior walls were kept as a square stair-tower rising high for its light above the cloister roofs, and built in 1570-1573.[119]

Work on the cloister itself continued until 1579 when the parapets were placed, but the fountain (fig. 49) was not begun until 1586. Sigüenza took credit for devising its program as a Garden of Eden with four rivers watering Asia, Africa, Europe, and America, although he criticized its execution as being too large for the cloister and causing chatter in a house vowed to silence.[120] The direct model for the idea may have been a similar *Fons Vitae* with four basins at Coimbra in Portugal, in the Manga cloister of Santa Cruz, built in 1533-1534 on designs probably by Jean de Rouen.[121] Herrera's design repeats in the garden the ordering of the basilica dome, in a variation where coupled columns alternate with niches beneath a diminutive replica of the ribbed dome and cupola. A further correspondence appears in the tabernacle (fig. 15), where dome and cupola repeat those of basilica and fountain. The design reappears on the basilica façade towers.

Herrera's emergence from obscurity accompanied the decree of 1569. In the words of the King, its purpose was to place more controls on the master builders, who had been wasting stone and cartage as well as fighting with the contractors.[122] It is preparatory to the more ample regulations of 1572. As architect in charge, Herrera took part in framing both documents.[123] In late 1569, the treasury was receiving 10,000 ducados monthly and the Congregación had been ordered to increase employment accordingly,[124] but there were shortages of lime, lumber, and cartage. The decree was at first generally disobeyed in all its parts: the account-books were not offered for inspection; the master builders disobeyed their orders and were employing whom they pleased.[125] The work at the site, however, moved rapidly: thirty masons raised the main stair to roof level; the main cloister arches and the kitchen portico (fig. 50) were rising; the refectory vault was roofed; friars' cells were floored; and scaffolds removed from the nearly completed provisional church. Cranes of Herrera's design sped the work at the main cloister and at the southwest tower, complete to the base of the spire,[126] and at the kitchen portico, but their operators were using them for their own profit. Herrera also designed the small-cloister fountains, after bringing to the site an Andalusian expert, Francisco de Montalban, who had built the waterworks at the Jeronymite cloister in Cordova.[127]

Sigüenza described the state of the works in some detail as of 11 June 1571:

Although the fabric was not rising swiftly, the entire south façade was up, roofed, and perfectly finished. The west and east fronts were well along, so that an abundance of lodging and the principal services were ready, not only for the friars to occupy the monastery but also for the King and his courtiers, although much of it was provisional. Further rooms were being arranged as the building grew. Two small cloisters were ready, and the two others were more than half built, as well as one range of the large cloister and a part of another. A small church with its choir and sacristy

[118] Iñiguez, *Trazas*, pp. 55-56, citing AGS, 258 (26 February 1568).

[119] Wilkinson, "The Escorial," p. 65; Iñiguez, *Trazas*, p.35. AME: II-82 (12 November 1570), carpentry; II-105 (n.d.), upper walls above cloister roofs; II-90 (1571), arcades, architrave, cornice; II-132 (n.d.), payments for stone doorjambs and window frames; II-177 (15 May 1572), upper east façade; III-35 (12 March 1573), roof carpentry.

[120] AME, VI-41 (1 April 1579), parapets; AME, X-17 (n.d.), fountain; FME, pp. 245-248.

[121] Kubler, "Claustral '*Fons Vitae*.' "

[122] DHM 3: 25-32, text of decree. PM, p. 254 (AGS, 260, f. 111-112, 23 July 1569), on fighting.

[123] Cervera, "Semblanza," p. 23; Llaguno, *Noticias*, 2: 283.

[124] PM, p. 255 (16 September 1569).

[125] PM, pp. 256-258 (12 October 1569).

[126] Main stair: PM, p. 258 (AGS, 259, f. 422, 30 January 1570); also PA, p. CXVI (AGS, 259, f. 435, 13 November 1570). Main cloister arcades, kitchen portico, refectory, cells, scaffolds, cranes: PA, pp. CVI-CVIII (AGS, 258, f. 66, 8 October 1569). Spire: PA, p. CXIII (AGS, 258, f. 87, 15 June 1570).

[127] AHN, 15188, no. 19 (23 March 1570). A contract for the cloister fountains is dated 8 March 1574 (AME, IV-3). Appointment as *maestro mayor de fuentes y encañados* at 300 ducados salary, AGP, *Cédulas* 4, f. 343v-344r, 19 October 1576.

were arranged, while the infirmary, pharmacy, refectory, kitchen, toilets, and hospice were the same as now.[128]

On the same day, the King moved his lodging from La Fresneda to San Lorenzo sleeping at the monastery for the first time in the *aposentillo* under the choir-balcony, "all very narrow and close," with a window allowing him to see Mass and divine office. All 15 friars and some courtiers also moved with him from La Fresneda, together with eight or nine novices. In August another dozen friars arrived from the Jeronymite house at Guadalupe,[129] raising the population to forty, although there was room for fifty. The bodies of his family were not brought for burial until June 1573.[130]

With these moves in 1571, preparations began for the long rehearsals that would continue until the basilica was ready in 1586 for the performance of royal commemorations in perpetuity. The great removal of royal bodies from various parts of Spain to the Escorial began in 1574, with eight imperial and royal ones arriving for reburial. The King, having decided that the number of friars in the monastery sufficed to fill the chaplaincies and perform the duties prescribed in the foundation and endowment, now instructed the community on their new tasks. These ceremonies were minutely planned and lasted eighteen days. This order of services commemorating the day of burial at the Escorial was to be celebrated every year. Their cost was borne by visiting nobles and clergy, of whom a courtier's joke was that their relatives would have nothing to eat but the bones after their inheritance had been spent on the burials at the Escorial.[131]

The commemorative masses were prescribed in exact detail: two daily for Philip II and another on his birthday. Queen Anne would have one mass daily. For the Emperor, sung mass on the birthday, and twelve masses more both on the birthday and the death-day anniversaries, in addition to the two daily masses for his soul at the main altar. The same order of ceremonies, but reduced in number by half, was allotted to the Empress Elizabeth. For other members of the family, the number of masses was again reduced, but they too were to be celebrated in perpetuity (*para siempre jamas*), including those for the soul of Queen Mary of England, Philip's second wife. A requiem mass was to be sung every day for all royal persons buried in the church. At every mass, Philip II was to be remembered with his successors and forebears.[132] Consistent with these provisions was the large number of costly relics (over 900 in 1574) sent from Venice, which were installed in eighteen wooden chests until they could be displayed in the basilica.[133]

Jehan Lhermite's explanation of the ritual fabric is clear and detailed, representing the received opinions of an intelligent and debonair courtier. During his fifteen years in Spain he came to know the Escorial intimately. As of 1597 the clerical population included one hundred priests, ten deacons and subdeacons, twenty young friars serving in the choir, twenty lay brothers to serve at masses and in the monastery, as well as fifty collegial students and seminarians. These inhabitants of the Escorial had as their principal duty the daily celebration of three sung masses, at dawn for the King, a requiem for the royal persons buried in the basilica, and the high mass. Three altars were privileged with indulgence at every mass to one penitent soul in purgatory. The other duties of the religious population were to conduct ceremonies and services on the arrival of royal persons, to appear in processions, and to assist in displays of treasures and relics. The relics of the saints and family of Jesus, as historical proofs, and the belief in damnation, purgatory, and the remission of sins, as verified by the Church, were the articles of faith for the ritual of the Escorial.[134]

[128] FME, pp. 42-43, based on JSJ, pp. 67-69.

[129] FME, pp. 42-43; Modino, "Priores," p. 262.

[130] JSJ, p. 83.

[131] JSJ, p. 113: "A vuestro tio le ha encomendado el Rey nuestro Señor los huesos de sus padres y vos los habeis de roer."

[132] DHM, 2: 143-163 (6 April 1573); JSJ, pp. 114-118, citing decrees of 1571.

[133] Sigüenza gives an entire *Discurso* (FME, pp. 365-376) to relics, categorized as being of Christ, Mary, and Saints, and as whole bodies, heads, arms, thighbones, lower legs, and minor bones.

[134] Lhermite, *Passetemps*, 2: 76-80; JSJ, pp. 90-119.

6

ASSEMBLING THE BASILICA

PREPARATIONS BEFORE 1574

After four years of increasingly intensive preparation, when the materials were being assembled, the contractual system restudied, and the designs reworked by Herrera, a royal decree of 11 May 1574 proclaimed the King's decision to begin building the basilica[1] in that year. In fact, more thought and discussion had been devoted to the basilica since the beginning than on any other part of the Escorial. The contracts for the basilica are long ones, but there are few of them. It is likely that at this late date the laboring force had become accustomed to the designer's demands, and that the trends to prefabrication, standardization, and the "correspondence of parts" presented fewer difficulties to the workmen who built the monastery.

The program and the physical boundaries of the basilica had been delimited before 1563, and some of its foundations were dug before 1570. The drainages were laid; the crypt had been excavated, walled, and vaulted in 1566; and by mid-1572 the floor level of the future basilica had been graded.[2] The deepest basement chambers are in the burial crypt with its upper and lower chambers (figs. 5, *C, D, E;* 44). It is likely they were excavated and lined with masonry vaults after the King ordered early in 1566 that the eastern basements be built for the secure and dry storage of building materials,[3] as a temporary use.

In 1570 much detailed study still remained to be done, taking form in the preparation of a large model before 1575, when the prior remarked in

[1] Rubio ("Cronologia," p. 27) uses the term to avoid confusion with the provisional church (*iglesia de prestado*). Ximenez, *Descripción,* pp. 274-275, relates basilical status to the presence of saintly relics. Etymologically, the Greek root (*basilikos*) justifies a restriction to churches associated with royalty in general, and in particular, to churches containing royal burials, especially in dynastic association.

The decree (Llaguno, *Noticias,* 2: 310) is paraphrased by Sigüenza (FME, p. 55): "His Majesty . . . seeing that [the foundations] were now level with the ground, decided that the plan should be laid out and that building begin furiously (*a toda furia*)."

[2] PM, p. 268 (AGS, 260, f. 147, 25 July 1572): "se acabaron

de igualar los cimientos de la yglesia." The *peones* were set to work on the entrance: "acabando el cimiento de la entrada de la yglesia" (PM, p. 270, 30 July 1572).

[3] PM, pp. 222-223 (AGS, 258, f. 342-343, 19 January 1566), also AVE, legajo 2 (26 May 1569), f. 133-137. A contract in AME (v-5, 7 July 1576), for "vaults beneath the main altar," pertains to the small chamber (called *pudridero*) above the crypt (fig. 5, *B*), used as "a place of burial for royal bodies." Their early arrangement is described by Lhermite (2: 152-153, as of 1598) and by Sepúlveda as of 1603, when twelve bodies were in it, a narrow dark vault, on two trestles (DHM, 4: 368-369). Philip's coffin was then in the middle, under the feet of the priest at mass.

a letter[4] that Martin de Açiaga, a sculptor (entallador) had been working for two years on a new model of the church. This was the third model on record, and it supplanted the unfinished one on which Diego de Alcántara stopped working after 10 September 1570.[5] The first model was Toledo's own, a small wooden one begun in April 1562 and finished on 23 June 1563. This model is recorded as having been taken to the attic (8 December 1569) to make room for another activity, perhaps Açiaga's.[6] None of these models has survived; they were probably all destroyed during one or another of the great fires which ravaged the royal buildings at the Escorial and in Madrid.

The early debates and conflicts of opinion over the first designs all were laid aside in 1567 when Toledo died, to be restudied only after the King, the court, and the friars took residence in the newly completed southern portions of the monastery in 1571. Herrera too joined them there when the King ordered (28 March 1571)[7] that a dwelling be built in the lower town for him to keep in order "the drawings and other papers in his charge." Some drawings for the church had been sent to Florence for the opinion of the Academy there in 1567 and new projects were solicited from Italian architects. When those drawings arrived from Italy (22 February 1573), the plans being made in Spain were already complete enough for the King to find little that was of value to him,[8] as would be expected from one who was sure of his ground and unwilling to consider changes.

After the frantic activity in 1570 to prepare the monastery for occupation by court and friars, the number of contracts let by the Congregación dropped sharply from thirty-one in 1570 to seven in 1571 and eight in 1572 (see Appendix 9). This recession may correspond to the reorganization of the fabric directed by Herrera, beginning with new key appointments, a radical simplification of the table of organization, and a new Instrucción. This was designed in 1572 to introduce speedier methods of building, by reducing paperwork, and devising a rational division of labor in a competitive harmony of equals sharing similar tasks. The key to the new dispensation was in the sudden "promotion" of the old aparejadores. Pedro de Tolosa was sent to build a monastery at Uclés, and Lucas de Escalante was ordered to the palace at Aranjuez. Angry at them both for having resisted the Instrucción, the King exiled them from the Escorial,[9] even after their long service since the beginning. He also dismissed and replaced the treasurer, Andrés de Almaguer, with Gonzalo Ramirez, who first appeared at the contaduria (countinghouse) in 1572,[10] bringing improvements in accountancy. Almaguer gave good service as treasurer, and he was an able inspector of building operations.[11] But he refused to face in the bad year of 1571 the questions of unemployment, of welfare assistance during times of failed crops, and of the animosity of those contractors who insisted on their right to give work to the people of their own choice.[12]

To fill the places of the two master builders, Juan de Mijares was appointed as sole aparejador, remaining in this office from 1576 to 1586. Mijares was an obvious candidate. He had served as master mason at the Hospital de Afuera in Toledo from 1549 to 1555 under H. Gonzalez de Lara, and again from 1564 to 1573, executing the designs by Bartolomé de Bustamante, who used the plain style in Spain before Herrera. Bustamante was also more versed in Italianate forms than other master builders.[13]

Mijares's first work at the Escorial as único

[4] PA, p. CLXIII (AGS, 259, 3 October 1575); Modino, "Priores," p. 297. Açiaga's salary was 4 reales daily and 2 reales for his helper.

[5] AHN, 15188, #32, 2 (Saltillo, "El Rey Don Felipe II," p. 139). He had been receiving 6 reales daily.

[6] PA, p. CVIII (AGS, 258, f. 66): "porque se desembarace el aposento donde estaua y sirua para algun official."

[7] Llaguno, Noticias, 2: 274. Herrera's title here is as nuestro criado.

[8] Llaguno, Noticias, 2: 310: "no creo que habra mucho que tomar dellas."

[9] Vicuña, "Juan Bautista de Toledo," Monasterio, pp. 163-

164 (citing PM, p. 263), 22 February 1571.

[10] AME, II-169.

[11] He requested a title of nobility for his services in 1572, and was replaced by Ramirez on 8 February 1572, asking piteously of the King where he was to go. PM, p. 269 (AGS, 260, f. 147, 25 July 1572). He died on 6 November 1572.

[12] Modino, "Priores," pp. 266-267.

[13] Wilkinson, "Juan de Mijares," pp. 122-132, on his career and place in the reform of Spanish architecture. PA, pp. 66, CLXIV (11 August 1576): appointment at the Escorial on salary of 25,000 maravedis annually, plus 25,000 as grant-in-aid (ayuda de costa), and 50 bushels of wheat for three years in

aparejador was to write the specifications for the masonry of a cornice to be constructed at the fifty-five-foot level (14 June 1576) on the palace building between the basilica and the north tower. His participation in practically all other *condiciones* may be assumed, and in March 1577 he was appointed with Villacastín to make the first appraisal (*tasación*) of the cost of the basilica. He also disbursed royal funds for grain and straw, and he defined the measurements of the basilica's north tower (1581) as well as those of the main library inside and out (21 November 1582). He was listed in 1582 as foreman (*sobrestante*) of one of six crews of masons, carpenters, sawyers, smiths, and cartmen. Thereafter he measured and appraised for the main altar, the dome, and the *sotacoro* entrance. In 1597, when he was master of the royal works in Granada, it was said that he rarely came to work, because "he was glad to have others working hard, as it was known how [hard] he had worked when he was *aparejador* at the Escorial."[14] Mijares joined the *fábrica* as the campaign on the basilica was gathering speed, and these documented notices of his activity do not reflect his importance as Herrera's principal aide during the grueling years of getting the basilica, the palace, and the college built together in short order.

When the contracts for building the huge grid of foundation walls under the future supports for the dome were written in 1573,[15] they were not given as piecework (as were the monastery foundations), but as contract bids as required in the Instruction of 1572.[16] The plan (fig. 52) in Herrera's hand shows a network of four interlacing foundation walls, each 28 feet thick and 174 feet long.[17] The *condiciones* were written by Tolosa and Escalante before their "promotions" away from the Escorial, and the award was made (among five bidders) to two who would divide the work. The stones forming the walls were to be of two sizes: 6 by 2 by 1½ feet, and 4 by 2 by 1½ feet, prepared at the quarries.[18] In 1574, when the materials had been assembled, other contracts were offered for building the foundations. The *destajeros* were to engage artisans and laborers at their own expense under the *condiciones* written by Tolosa and Escalante,[19] for columns of masonry with their linkages (*cadenas*) and responds being built on contract with labor on their own account (*a toda costa de manos*) as well as quarrying and rough-dressing the stone.[20] In other words, the masters were subcontracting for both quarry and setting these pillars (fig. 53), which are specified as "being on the south side, near the main cloister." They are probably the columns seen in the Hatfield drawing (figs. 65, 66) as unfinished bases. But the work had dragged during two years, and a new regime was needed, which would come into practice early in 1576. The Hatfield drawing is the only visual record known of the entire fabric at that date.

This drawing is in the collection of the Marquess of Salisbury at Hatfield House, endorsed in the sixteenth century in Lord Burghley's hand as "The King of Spaine's house,"[21] and showing the Escorial in construction after 1572. This date *post*

consideration of the heavier tasks allotted him than in his previous post at Aranjuez. Wilkinson does not discuss his work at the Escorial.

[14] PA, p. 46, 23 August 1597. References for his duties there are from AME documents (Andrés, *Inventario*).

[15] AME, III-6 (18 September and 23 October 1573).

[16] DHM 3: 38-39.

[17] The plan is labeled on the back "planta de los cimientos de la iglesia" in a sixteenth-century hand. Lopez Serrano (*Trazas*, p. 19) attributes it to Herrera. The depth is not given. The cloister supports resemble those of figure 72 attributed to Toledo.

[18] AME, III-12, f. 1ᵛ (18 September 1573): "pilares y sus correspondencias y cadenas de entrepilares y cadenas que fuere necessario dentro de las quatro paredes." Nineteen paragraphs specify how the work was to be done. The contractors were paid in 1573-1574 (AGS, *contaduria* 1087, 1573; 1148, 1574). The stone sizes are given in AME, III-74 (15 May 1574).

[19] The two contractors were paid monthly salaries of 150

and 200 reales before the contract; after it they were paid 1,000 reales (AGS, *contaduria* 1148, *datta* 1574).

[20] These payments (24 October 1573–16 March 1575) totaled 45,154½ reales, itemized as being for walls of brick, and stonework including voussoirs (AGS, *datta* 1575, *pliegos* 2d-3c).

[21] Skelton and Summerson, *Description*. Camón ("Arquitectura trentina," pp. 396, 424) puts its date as 1576-1577, and holds that the library façade then still followed Toledo's design in having two free-rising towers flanking the portico below the library.

The drawing may be the work of Fabricio Castello, an Italian painter who was at the Escorial in 1576 and was mentioned in 1583 as having depicted the entire construction on paper ("pinto sobre papel toda la maquina"). AME, V-14 (1576) and VIII-28 (1583). He later was commissioned to paint the battle of Higueruela in fresco in the King's gallery (figs. 2, 10; AME, XI-10).

quem is fixed by the absence of the northeast tower spire, for which the contract was granted then, to rise on the masonary shaft.[22]

The specifications for the "towers" on the west front, which were actually the ends of the library roof, are also of 1572.[23] The two window axes at each end of the library façade were originally planned by Toledo as towers flanking the portico: the name "tower" persisted, as well as their projection in plan only, but when the portico was finished in 1575, their identity as towers had vanished. The date *ante quem*, however, is fixed by the appraisal[24] of the west façade section adjoining the north "tower," in 1576, a section shown nearly complete to the rooftops on the Hatfield drawing, in four window axes.

In the nave the southern dome supports are shown on the Hatfield drawing as approaching the fifteen-foot level: these had been begun as piecework in 1570.[25] If the spireless northeast tower is taken as conclusive then, the drawing was done in 1572; but if the dome supports are considered, there is some evidence that the work on them began in 1573. Moreover, the section of the west façade of the college, seen as complete window axes, was not contracted until 26 April 1573, and appraised on 12 April 1576.[26]

A curious false start is recorded in 1574-1575 when Diego de Alcántara, an *aparejador*, spent nearly three months in Madrid preparing diagrams for which he was paid at the rate of 6 reales daily. The drawings displayed a "new way to build," and Alcántara was invited to come from Toledo in the spring of 1576 to display the method in practice on the laying of six courses of stone at one of the dome supports. His method included finishing the stone at the quarry rather than at the site, but he was unable to get more than two courses done and it was decided to abandon his experiment as too costly.[27]

The symbolic beginning of real work, however, was celebrated in March 1575 with the *fiesta de Fray Antonio*, described in Chapter Three, on the occasion of bringing the four first flooring stones to the site and setting out the markers for columns, walls, and pilasters (as if no prior failures had occurred).[28] Villacastín specified that the "first stones" were set at the easternmost columns adjoining the main altar, and that they were placed by Tolosa, Escalante, and himself, in an act of deference to the aging masters who had been "sent away."

The decision to rough-shape stones at the quarry has been wholly misunderstood as Herrera's "invention." Precedents for it were alleged in the Book of Ecclesiastes and in the writings of Andrea Palladio. It had been ordered for the Escorial as early as 10 April 1562 by Juan Bautista de Toledo,[29] in his own words as architect in charge. After much disagreement between Congregación and *aparejadores*, the King decided to visit the quarry himself, when Herrera's stone-lift (*cabrilla*) was in use, and to compare the work there with the same work at the site. He then decided to abide by his earlier order of 9 January 1576 to rough-dress at the quarry.[30]

The cost was certainly increased. Toledo's quarry-site rough-dressing of small stones in 1562 was different from the triple preparation required by Herrera's procedure: (1) rough-shaping at quarry, (2) dressing to fit adjoining faces at site, and (3) smoothing exposed faces for unity of surface, in an operation where the only economy was in the reduced cost of transporting the lighter shaped stones. As the scribe in the *fábrica* phrased it, the workmen at the quarry were to dress top

[22] AME, II-182-183 (13 October 1572). Payments to Oliver Sinot, a Flemish carpenter, began 17 October 1572, continuing in 1573-1574. More lumber was contracted for in 1579 (AME, VI-37). Two stages in its building may be involved.

[23] AME, II-146 (8 January 1572); AME, II-179 (15 February 1572) is the final agreement with Simón Sanchez and four associates.

[24] AME, V-16 (19 April 1576).

[25] AME, II-104, f. 2 (n.d.), petition by masons for payment on shaping stone.

[26] AME, III-17 and V-16.

[27] AGP, 4: 72 (7 April 1574); AGS, 261, 114 (5 March 1576)

on the diagrams. PA, p. CXXXV (11 December 1575), the experiment. PA, p. CXXXVI (2 March 1576), abandonment. Alcántara and Lorriaga were paid 150 ducados monthly for this work (AGS, *contaduria*, 1148, *canteros*, 1576). Figure 26, according to Lopez Serrano, might be his (*LS*, p. 17).

[28] JSJ, pp. 121-123; FME, pp. 55-56. Villacastín (DHM, 1: 17) gives the date as 14 June 1575.

[29] PA, pp. III-IV; PM, p. 159 (AGS, 258, f. 204, par. 10), for stone cut to Toledo's measurements for door and window frames ("que desbastadas en la cantera se lleven al pie de la obra donde se an de labrar").

[30] JSJ, pp. 163-164.

and bottom beds, trimming them and the edges to right angles, to conform with the given patterns. Paving stones were to be well trimmed and edged, with sharp edges and corners, and no nicks or nodules. The exposed faces were to be even cleaner than the bed, which was to be a bit wider and thicker, for the final smoothing to a united surface among all the blocks.[31]

THE BASILICA PARTITIONED IN TEN CONTRACTS

As Herrera's power increased in the fabric, the inflated numbers of permanent supervisors, whether *aparejadores, maestros mayores, sobrestantes,* or *mayorales,* dropped sharply in the reorganization that favored an unprecedented speed of construction after 1575, when two-thirds of the Escorial were completed in less time than the first third.[32] Sigüenza gave credit for the reorganization to Villacastín, in a long review of how stagnation had set in under Tolosa and Escalante until the King had asked the advice of Villacastín, who urged that many heads be put in charge, each of his own section, to work in a competition, not only of speed but of quality.[33] Sigüenza was writing here from memory rather than documents, thirty years after the events, and after the death of Villacastín, whom he greatly admired. Herrera's own account was dated 12 October 1584, in a biographical memoir composed in support of his request for financial aid. He claims that after his reorganization of the work on the basilica, the economies in management (*manejos*) alone exceeded the entire cost of construction since the reorganization, not to mention having done in eight years what would have required eighty under the old regime.[34] There is no record of any disagreement or conflict between Herrera and Villacastín in their long association. Both deserve credit for the reorganization, on which they probably collaborated, to have ten crews divide the task that had formerly been assigned to one formless labor force, as if knitting the church course by course instead of building it by ten sections rising simultaneously. Sigüenza's account of Villacastín's words brings forth the idea of harmonious competition among equal bodies of workmen; and Herrera's words stress the managerial economies and the saving of time.[35]

Late in 1575 (over two years after the foundations were begun and three years after the reorganization of 1572) contracts were prepared for building the basilica walls in ten units (*destajos*). Master builders throughout Spain were invited to bid.[36] The King said at the site (probably on 30 September) that he wanted the construction of the church to be entirely open to contractors, under separate estimates for each of the ten sections, prepared by the Congregación. The contractors were both master builders and master masons. The bidding opened on 10 November in the presence of three persons representing the King, the bidders, and the mayor of the lower town in case of disagreement.

Three estimates were supplied to the bidders by the Congregación for each one-tenth portion: to the thirty-foot level, to the fifty-five-foot level, and everything beyond. Each crew was to consist of forty artisans, on a salary allowance of 250 ducados monthly; an allowance of 100 ducados annually to each crew for equipment; and a single

[31] Modino, "Priores," pp. 301-302, citing the *Registro* (11 November 1575–3 February 1576), which is in the library of the Augustinians (not the archive) at the Escorial.

[32] Juan Velasco had urged action on their swollen numbers as early as 1 July 1569 (PM, p. 253, letter from Almaguer).

[33] FME, pp. 63-64: (quoting Villacastín) "traiga muchos cabos . . . muchos maestros y destajeros que la tomen a su cargo . . . porque cada uno hara presto la parte que le cupiere, y tras esto labraran a porfia, no solo en la presteza, sino en la bondad de la obra." Villacastín ("Memorias," DHM, 1: 17-27) says

nothing of this.

[34] Llaguno, *Noticias,* 2: 335: "por la orden que yo di, se ha ahorrado de hacienda por el ahorro de los manejos tanto como ha costado todo lo que se ha gastado en todo lo hecho despues de la nueva orden."

[35] JSJ, pp. 159-160, credits Villacastín with the ten crews as adviser to the Congregación, and Herrera with the economies of shaping stone at the quarry.

[36] AME, IV-18, 19; Modino, "Priores," pp. 296-298, 300-305.

allowance of 100 ducados for moving expenses. Each crew was to have two masters.[37] The sixty bidders came, with travel grants of 2 ducados daily, from twenty-three towns and cities.[38] After twenty of their number were selected, two to each crew, the chosen bidders met in the prior's quarters to discuss with Herrera the question of rough-shaping the stones at the quarry. Those opposed said the finished stone was too fragile to transport, which had never been customary in Spain. They objected also that it would be more expensive. The others, who were "on the King's side," favored the increased speed, and recommended that rough-faced stone be dressed (*retundido*) at the site after being set in place.

The ten crews (*partidas*) began work on 8 January 1576 under the following masters (names in italics were new at the Escorial in 1576):

1. *Juan de la Maza, Francisco de Carranza*
2. *Francisco del Rio, Diego de Sesniega*
3. *Juan de la Puente, Martín Ruiz de Berriz*
4. *Sebastián Campero, Francisco de Atuy*
5. Gregorio de la Puente, Diego de Matienzo
6. Juan de Soria, Francisco Gonzalez
7. *Juan de Bocerraiz, Juan de Matienzo*
8. Simón Sanchez, Pedro del Carpio
9. Nicolas del Ribero, *Juan de Ballesteros*
10. *Juan de Olabarrieta, Domingo de Azeiza*

The only veterans of the 1560s were in *partidas* 6 and 8. Latecomers of the 1570s paired in *partida* 5, and one of 1573 paired with a newcomer in *partida* 9.[39] The crews and the sections of the work were distributed at random by the masters' taking lots (fig. 54).[40]

The contracts early in 1576 specified the portion of the church for which each of the ten crews was responsible. The two contractors directing each *partida* undertook to supervise the stonecutting and setting of the large and small blocks as

assigned by the Congregación, to the required heights, all in finished condition according to plans and elevations as provided, and ready for inspection and appraisal of value. All twenty *destajeros* were required to post bonds (*fianzas*) guaranteeing their responsibility. The extent of each *partida*'s duty was loosely defined in the contracts, but a plan (fig. 54) makes it clear that the territory of each crew matched another symmetrically. The narthex and choir were divided between crews 1 and 2. The nine-part square of the church made 4 quarters, shared among crews 5 (southeast), 8 (southwest), 7 (northwest) and 9 (northeast). The sanctuary was shared by crews 4 (south) and 6 (north). Crew 3 took the north bell-tower, and crew 10 the south aisle wall adjoining the main cloister. The symmetrically axial division by pairs of crews working on parallel and mirroring tasks was bound to produce an intense, harmonious competition among the artisans in the coupled teams, reflected in Sigüenza's account of Villacastín's role,[41] and also in 1576, when Gregorio de la Puente proudly laid the first stone to reach the thirty-foot mark, inscribed *30 pies*.[42] Work began on all parts of the church at once, starting at the bottom in 1576 and rising together with a terminal date fixed by the stone Villacastín laid on 13 September 1584 as the last one (he refused to be present for the first one in 1563) seven years after the work began on the basilica.[43]

The year 1577, so promising at its beginning when the thirty-foot level had been reached in the basilica, turned into a year of the worst disasters in building the Escorial: the mutiny of the masons in May; the burning by lightning of the southwest tower in July; and the destruction of the scaffolds for its repair in an October gale.[44] At that time also the number of large building contracts dropped from fourteen in 1576 to two (see Appendix 9). One of these was to repair the

[37] PA, pp. CXXXI-CXXXII (26 November 1575); JSJ, pp. 159-160.

[38] AME, IV-18, 19 (n.d.). JSJ, p. 159, mentions sixty bidders.

[39] The search for masters in the south began in 1570 (AME, II-120), when Sebastián Campero was first consulted. The contracts for *partidas* 2, 7, and 10 are in AME, V-6 (14 January 1576).

[40] Modino, "Priores," p. 298 (1 December 1575).

[41] FME, pp. 63-64.

[42] Villacastín, "Memorias," DHM, 1: 19. The contracts in AME, V-6, 7 are incomplete, but have been pieced out as to where each *partida* worked, from AGS (*contaduria* 1148, *datta* 1576, *pliegos* 1-5).

[43] Villacastín, "Memorias," DHM, 1: 27: "Hizose la iglesia dende el suelo hasta ser acabado en siete años: siete sin los cimientos, porque ya estaban hechos dos años antes [1575]." He had forgotten that the masonry grid under the pillars was begun in the fall of 1573.

[44] JSJ, p. 207; Rubio, "Cronologia," p. 61.

burned-out tower, and another to roof the palace east wing.[45] Appraisals were begun on the work to date of the ten *partidas* by Mijares, Villacastín, and an outside mason,[46] now that the thirty-foot level had been reached. Sigüenza praised Villacastín's judgment and Herrera's planning for the astonishing feat of raising the basilica thirty feet in one year, with one *aparejador*, the contractors, and the foremen "all working in such harmony and brotherhood that no quarrels or differences of any consequence were to be heard."[47]

The payments made in 1577[48] also show small amounts of new construction. The main activity was on the palace wing, from basilica to the northeast tower, then called the Queen's apartments (fig. 1, *87-95*; fig. 2, *14-15*). Other outlays were for landscaping and for equipment, such as library purchases and seventeen cranes. Sigüenza says of this time that the church alone was served by twenty two-wheeled cranes, some rising on scaffolds to the roofs (figs. 65, 66). Others were at work in the palace court, on the royal house, at the main portico, and in the college, operated by crews shouting commands all day long to the wheelmen, who turned and raised the loads on wooden cabledrums housed underneath the cranes.[49] Sigüenza comments especially on the helpfulness of the cranemen in friendly emulation and competition, each wishing not only to excel but to help others.

The masons' riot on 20 May was more a result of hostility between them and the mayor of the lower town than of grievances about laboring conditions, and it was also a regional demonstration by the northern masons against civil government in the rough town where most workmen lived, an old town both dependent upon and disrupted by the King's privileged building artisans. There is no evidence as yet that it arose from discontents within the fabric.[50]

At this time also, grave doubts arose about the stability of one dome support where the stones were showing fractures. It is reported that public fears caused Herrera reluctantly to reduce the height of the dome's pedestal by eleven feet, and to eliminate the niches, which reduced the mass of the pillars. Sigüenza blamed the flaws on the carelessness of irresponsible master builders.[51] They had failed to match the grain of the courses, or to smooth stones that were too coarse. They had flooded the mortar with too much lime and had seated some stones over voids, loading the outer facing stones excessively. Herrera may have believed that his decision to omit the pedestal was supported by Alessi's stunted dome in Genoa (fig. 25 B). In any event, no evidence is known about how Herrera might have designed the suppressed eleven-foot pedestal.

The first of a long series of great roof fires ravaging the Escorial began on 21 July 1577 when lightning struck the tip of the southwest tower. The whole spire burst into flames melting the ten chimes of the monastery. The ball and cross atop the spire dragged down a chimney through the attic roof of the southwest cloister. The same storm damaged the sacristies. A windstorm in October destroyed the scaffolds built for repair, damaging the roofs more than did the fire.[52] Through this series of calamities befalling an unfinished building, the ten *partidas* of the basilica continued their rapid work.

When the crews had finished their first two stints to the fifty-five-foot level, the next contracts were written in 1578 for the arches supporting the dome and for the groined barrel vaults. The hemispherical dome (fig. 56) was contracted in 1579, and the main interior cornice under the dome was ready for work to begin in 1581.[53] By Easter 1582, Sigüenza tells that the dome was being closed. The church interior was filled with scaffolds, cranes, centerings, platforms, and beams. On 23 June 1582, the cross was placed atop the spire of the dome, with ceremonies celebrating the completion of the church.[54]

[45] AME, vi-9 (15 January 1577); AME, vi-8 (25 May 1577).

[46] AME, vi-6, f. 243-264 (29 April 1577).

[47] FME, p. 72.

[48] AME, vi-5.

[49] FME, pp. 83-85. Iñiguez, "Ingenios," pp. 181-213. Cranes with treadmill drums were portrayed in Roman art and described by Vitruvius (Iñiguez, "Ingenios," p. 201).

[50] FME, pp. 73-75.

[51] FME, pp. 316-317; Llaguno, *Noticias*, 2: 126.

[52] Villacastín, "Memorias," DHM 1: 20; JSJ, pp. 196, 207.

[53] AME, vi-24, f. 58-60 (20 November 1578), agreement for southwest quarter of dome, contracted to G. de la Puente and Diego de Matienzo; AME, vii-34 (9 March 1581), contract for cornice at vault impost.

[54] FME, p. 98.

The King had departed in 1580 to stay in Portugal until 1583. When the Portuguese King Sebastian died in Africa in 1578, his uncle, King Philip, assumed his throne as heir. Herrera accompanied Philip as chamberlain and architect. The assembly of the basilica continued smoothly in their absence, without record of discontent at the site. Jacome da Trezzo was the sculptor in charge of executing the architectural framework of the main altarpiece, for which a memoir by him enumerates the stone pieces quarried before 16 July 1581.[55]

When the King returned from Portugal late in March 1583, he could, when climbing to the dome see its masonry completed,[56] although the naves still were filled with scaffolds. After the scaffolds (originally built in 1578-1579)[57] were removed, the marble floors were laid in the naves. The granite walls had already been shaved down "the thickness of a cord," to remove the layer which had been left for safe transport from the quarry, "making the church look as unified as a cliff rather than made of different pieces, and bringing forth the uniform color, grain, and joining of the stones."[58] This final smoothing was extended to the church façade early in 1585.

The sanctuary as a triptych, with lateral wings to contain orant figures including the donor (fig. 11),[59] had also been decided when the Hatfield drawing was made (or before), but as late as 12 February 1576 the artisans were still unsure whether the sanctuary was to be rectangular or apsidal,[60] and Herrera was asked for drawings (of which figure 47 may be an example) to clarify the question. Figure 47 emphatically asserts rectangular form in a tracing, where only one doorway gives a view to the altar, from the bedroom in the "canceled tower" south of the sanctuary. The two balconies in the sanctuary, to hold the orant families of Charles V and Philip II, portrayed as figures of gilded bronze nine feet high, were begun in July. The granite paving of the main entrance court (fig. 21), which resembles an early Christian atrium, was contracted on 29 March 1586[61] as the last major new contract concerned with the building period of the basilica.

ARCHITECTURAL DRAWINGS FOR
THE BASILICA

The core of the drawings by Herrera was engraved under his direction and published by him in eleven plates in 1589.[62] The drawings in his own hand have nearly all disappeared. Among thousands of working drawings made by him and under his direction, only thirty or forty related to the Escorial are known today. The most inclusive attributions are by Iñiguez, who accepts all but seven or eight of the fifty-five drawings published by Lopez Serrano as being by Herrera or by his draftsmen.[63]

The earliest of these (before 1567), is probably the longitudinal section (fig. 26) showing an apse in a scratchy drawing, variously attributed to Diego de Alcántara (Lopez Serrano), Juan Bautista de Toledo (Iñiguez), and Paciotto (Rubio). An assistant to Toledo is the most likely. The drawing shows a section of the domed crypt,

[55] PM, pp. 289-290 (AGS, 261). Another account (AGS, 261, f. 246, 12 May 1581) from Milan, enumerates the statues and bronze ornaments for the *retablo* being made by Pompeo Leoni and assistants since 1579. Trezzo wrote Herrera in Portugal on 13 May 1581 to complain that money was woefully lacking to pay quarry workers supplying jasper, and he turns to Herrera "come bon amigo y capo desta obra" (Babelon, "Jacopo da Trezzo," p. 278).

[56] FME, p. 104; JSJ, p. 364.

[57] AME, vi-40 (23 May 1578–27 January 1579).

[58] AME, viii-31 (1583); AME, x-2, f. 64-66 (28 February 1585); FME, p. 102.

[59] Panofsky, *Tomb Sculpture*, pp. 76-80, "active effigy" type; Buser, "Kneeling Effigies." Sepúlveda ("Historia," p. 358) describes the arrangement of the tomb figures as "dividida en entrambos coros al modo de un soberano teatro y partido coliseo" ("divided in two choirs in the manner of a sovereign theatre and parted stage").

[60] Modino, "Priores," p. 303, citing AGS, 261.

[61] AME, x-19, f. 20[r,v].

[62] Cervera, *Estampas*, Chap. 2, reconstructs the documentary history of Herrera's association with the Flemish engraver, P. Perret, after 1583.

[63] Iñiguez, *Trazas*, p. 52. Lopez Serrano (Trazas) accepts only thirty-one.

with its upper and lower choirs, and the burial chambers. They are all identical with Perret's engraving after Herrera's section (fig. 5, *B, C, D, E*). But the basilica has no portico, and the *sotacoro* entrance is a double span of groined vaults instead of the flat vault carried on four supports as built, in imitation of Palladio's tetrastyle hall and vestibule designs. If this drawing corresponds to Toledo's ideas for the basilica, Herrera's execution owes him only the chambers of the crypt. All else is different.

The beginning date (7 January 1576) for the walls of the basilica to rise allows many drawings to be considered as prior to that year. These are figures 45-47, which all show discarded plans for the sanctuary. Figure 47A indicates four spiral stairs to the choir-balcony, which were never built. Figure 57 is a tentative and discarded early plan for the *sotacoro*, probably after 1570, when Palladio's tetrastyle halls in houses were first published, showing square piers, no portico, deeply niched walls, and single entrances from the courtyard and to the nave. The towers are not considered, nor the open courts, nor the entrance chapels taking light from those open courts (fig. 1, *41, 42*). The corners of this plan resemble the terrace-stairway grottoes on the east and south platforms (fig. 99). Figure 53 has three tentative plans for the dome supports, more complicated than in execution. The smallest one is closest to what was actually built. Figure 52 for the interlacing grid of foundation walls beneath the dome supports may antedate 18 September 1573, when the contracts were written.

Figure 58 is meant to show how unsatisfactory for the King's needs were the partitions on the floor plan of his apartment, and how the door-jambs entering his bedroom needed recutting, for him to see to the altar and to the east and south windows. In effect, as his bed was placed he could see nothing at the altar, and the doorway to the altar may have been redesigned to function more nearly as the prototype at Yuste. The *aposento* was in construction before the basilica, in 1572 and earlier.[64] The changes seen in figures 45-47 may have produced the desired angles before 1576.

Four drawings for the south church tower relate to work under way in 1576 on contract to two different crews. Figure 59 is a working drawing for the second floor, showing stairs and partitions. In its final arrangement (fig. 2, *F*) this tower room was cleared of partitions to make a single large hall to house the choral library. Hence the drawing reports temporary or tentative designs, with working corrections, such as a narrower door entering room *K* (fig. 2), which was destined to be used as the choir sacristy. Figure 60 records the two plans of the upper towers above the eighty-six-foot level, as contracted on 17 November 1579.[65] The upper sheet is a working drawing with corrections and additions; the lower sheet is a more carefully finished transfer, omitting stairs and partitions, but also showing the lower stage in solid, and the upper in dotted lines. Figure 61 is by the same draftsman as the preceding transfer, and it is a measured drawing valid for all eight faces of the two towers, in a process of modular standardization that characterizes construction at the Escorial after 1572.

This character, of modular design by large repeating elements, emerges again in figures 62 and 63. These are both large and definitive working drawings for use in construction. Figure 62 looks west at the north-south cross section of the basilica, stretching from altars 21 to 39 (fig. 1). Figure 63, which looks like a replica of figure 62, is actually a cross section looking south, from the south tower at the right, to the north end of the interior elevation, along an east-west line (fig. 1, *M* to *DD*). The central unit here is the organ loft, and the drawing reversed is equally correct for the north aisle elevation from *I* to *50* on figure 1. In other words, one drawing is equally applicable to the interior elevation on three sides, north, south, and west of the square, as well as to the aisles (fig. 4, *K-L*), looking east or west, and north or south (fig. 5, *K-L*), where the aisle elevations of the dome supports repeat the design of the intercolumnar intervals flanking the choir-balcony elevation.

The airshafts (*patinejos*), which adjoin the tower bases, were altered in execution, and differ from the drawing of the narrow façade seen on figure

[64] The foundations of the end wall of the sanctuary in the basilica were in construction on 21 March 1570 (AGS, 258, f.

83, par. 13).
[65] F. del Rio and D. de Sesniega, AME, VI-42.

63. As executed, the airshaft façades incorporate the design of the towers (fig. 61): the wide façades use the upper-tower design, and the narrow façades are adaptations of the lower-tower story. Thus the airshafts below the fifty-five-foot cornice repeat the tower design as a hollow inversion (fig. 54).

In explanation of figures 62 and 63 it is necessary to point out that when the basilica was finished, its closed bronze gates at the entrance from the forechurch (*sotacoro*) into the square nine-part plan marked the forechurch as a place of worship for the people of the town and passers-by.[66] But the basilica itself, under the dome and including the sanctuary, was regarded as the main chapel and closed to all but the courtiers and members of the King's household, because it was a royal chapel of restricted access, like the royal dwelling and private quarters, where the King wished to be with his family and children, undisturbed by other people ("otra gente comun").[67] This restriction, according to Sigüenza, was regarded as harsh by many secular folk, but it was also the place reserved for the processions of the friars, for whose devotions and services with the royal family the forty altars were built beyond the gates from the forechurch.

From the beginning of services, however, the crowds of curious visitors from the surrounding cities, Madrid, Toledo, Segovia, Avila, made it necessary to extend worship by the display of relics from the chapel of the crucifix behind the choir (fig. 2, C). This opened at the central façade window into the open forecourt (now known as the Patio de los Reyes, fig. 21). At the open chapel (to use the Mexican term) relics were visible from the courtyard before the principal mass each day, and again twice before evening services. The mass itself could be viewed only from behind the closed gates in the forechurch,[68] although the liturgy and sermon were inaudible from that distance. The remarkable resemblance of this arrangement with the use in America of open chapels for the conversions of native peoples in an atrium, is a reminder that the Escorial was built in large part with the income remitted from the New World.[69]

[66] Lhermite, *Passetemps*, 2: 24 (1597) reports that the *sotacoro* was "the small church of the people underneath the choir, with only two altars for masses."

[67] Sigüenza (FME, p. 112): "His Majesty ordered that the main chapel inside the gates (the entire square is no more than one chapel) be closed to all people excepting the most important gentlemen and attendants of his household (*caballeros y criados mas principales de su casa*)."

[68] FME, pp. 112-114; JSJ, p. 406; Andrés, "Historia y descripción," AIEM, vols. 7 and 8.

[69] AGP, 3: 197 (see App. 5): the *Casa de Contratación* at Sevilla forwarded for building the Escorial 30,000 ducados annually beginning in 1570, raised from Indians through the institution of *repartimiento* (assignment or distribution of Indian labor to colonists in return for their Christian education). On open chapels, J. McAndrew, *Open-Air Churches*, and G. Kubler, *Mexican Architecture of the Sixteenth Century*.

7

COMPLETING THE BLOCK

THE BASILICA required the chief effort and took precedence over all other work at the fabric for seven years at least, but while it was in construction, other parts of the *cuadro* were not neglected. Work continued on the royal dwelling (or King's house), together with all its services in the palace buildings of the northeast quadrant (which Sigüenza regarded as "a monastery of friars without cassocks"),[1] as well as on the entrance portico containing the library. The Hatfield drawing (fig. 65) offers a clear view of conditions about 1576; the south third was nearly complete; the north third was partly up at both ends; and the central zone was hyperactively busy.

The King and court did not move from their temporary quarters in the eastern end of the south range until August 1585, when the royal family first occupied their permanent quarters in the northeastern quadrant, on the occasion of consecrating all the altars and blessing the basilica and its bells. The ceremonies of dedication were delayed until 30 August 1586, in preparation for the transfer of eighteen royal bodies from the temporary vault in the monastery to another storage crypt (fig. 5, *B*) beneath the altar in November.[2] Assembling all the parts of the complicated ritual life of the Escorial now at last was accomplished, after fifteen years of rehearsal in the provisional quarters assigned to royal family, court, and friars. But most of the northern third of the building, including the palace and the college, were yet to be finished.

"THE KING OF SPAINE'S HOUSE"

This, as it was called by Lord Burghley,[3] is a strange house indeed, without any ceremonious outside entrance, lacking exterior ornament, flush with the garden terrace, appended below a mon- astery and a palace, and wrapped around a church sanctuary (figs. 1, 2, 5). Its building grade was one whole story below the platform of the rest of the Escorial, and its attic level rose no higher than

[1] FME, p. 119.
[2] FME, p. 110; JSJ, pp. 407-411.

[3] Identification on the back of the Hatfield drawing, 1587 (Skelton and Summerson, *Description*, p. 100).

the thirty-foot cornices of the rest of the edifice. Modesty, retirement, and simplicity are expressed.

The master's bedroom on the third floor has a view of the altar, beneath which is a dynastic crypt. The master's other views are to Madrid and the Tagus valley, and his rooms surround a small cloistered court abutting the windowless wall of the basilica (fig. 67). He can also enter walled formal gardens surrounding his house on three sides. He never has afternoon sun in the shadow of the tall basilica, but the north garden is a shady place for summer heat, and the south garden a warm one in the winter mornings. The interior entrances to the house are like fortress passages of granite in the bases of massive towers never built: access through them is by tortuous and strangely proportioned corridors[4] from the sacristy and cloister of the monastery on the south, and from the palace court and galleries at the north. The kitchens are 750 feet distant, including eight turns and one stairway.

From the outside it seems a small house (fig. 67). On the exterior it is two stories; on the court it is three. The *piano nobile* is second level outside, but third level inside, around a sunken court. On the inside its rooms of state are ample and plain, but its private apartments are minute (figs. 68, 69). The ground floor and the upper floors were respectively summer and winter dwellings: the south side for the King and the north for the Queen. In the attics were habitations for courtiers and services, almost at the level of the upper-floor tribunes and choir balcony in the basilica (fig. 6, *H-I*).[5]

A courtier in 1597, Jehan Lhermite described the King's apartments as he knew them then:

His quarters are behind the main altar . . . with one dwelling below, and another above, both alike. . . .

The entrance is by a small door from the main palace court, marked *93* [fig. 1] leading into a long twisting passage, somewhat dark. The first chamber (at *98*) is where those coming and going may wait; the second (at *99*) is for ordinary audiences; and the third (at *100*) is a very fine drawing room where his Majesty would usually promenade with his children at sunset. . . . At either end were low and comfortable seats with backs, on legs like pillars, containing iron pivots so that the occupant might swivel back and forth by pushing lightly on the floor. His Majesty often used this pleasant and agreeable invention, sitting in it to contemplate the lovely landscape. The fourth room is where his Majesty usually took his meals (at *101*), hung all about with fine drawings of gardens in perspective, and of plants and herbs and flowers from the Indies, as well as animals and birds . . . and farther in, one enters his Majesty's bedroom (at *102*).[6]

Work began on the King's house in 1570-1572,[7] when the flat sanctuary wall and the three ranges surrounding what would eventually be called the Patio de los Mascarones were in construction, although the rooms would not be occupied by the King until 1586. During the interim the space was probably used for safe storage of building materials. Contracts for the courtyard walks on three stories were signed on 29 July 1578.[8] The Hatfield drawing (fig. 66) shows the King's house as it appeared in 1576 with the outer walls completed; the sanctuary wall up at least to floor level in the sanctuary, and the corridors still to be built. The corridors are like an inner lining for the U-shaped, two-storied ranges of vaulted chambers (fig. 1, *98-101*). These parts of the court were built two years after the so-called towers flanking the sanctuary (fig. 1, *97, 102*).[9]

The towers were fashioned in the same way as the lower stories of the prior's tower, but omitting the spire and five upper stories.[10] Beneath the thirty-foot cornice (fig. 6) the tower was ac-

[4] Chueca (*Invariantes*, pp. 36-44 and *Casas reales*, p. 205) compares these twisting passages to Islamic traditions of domestic planning.

[5] LS, p. 25ᵛ.

[6] *Passetemps*, 2: 69-70. Lhermite uses *Sumario* numbering.

[7] AGS, 158, f. 83 (21 March 1570): "En el cimiento de la pared alta de la yglesia se da mucha priessa" refers to the end wall of the sanctuary. Also AME, ii-107, f. 111 (30 July 1570), f. 185 (22 January 1572), f. 189 (14 February 1572), on roofing for north, south, and east ranges as approved by Villacastín.

[8] Rubio, CD 162 (1950): 112-113.

[9] AME, v-35, f. 107-114ᵛ (10 May 1576), and Rubio, CD 162 (1950): 112-113 (29 July 1578). The same *condiciones* covered the service buildings in the palace (fig. 1, *80-81*), and prices are included. "Towers": AME, v-35, 115ᵛ-119ᵛ (13 April 1577).

[10] AME, v-35, 115-119ᵛ (13 April 1577): "torre de la esquina del quarto [i.e. building, or range] de su Majestad que se hace por su mandato." The north "tower" was the Queen's apartment (Lhermite, *Passetemps*, 2: 31, in 1597 notes that the Prince and the Infantas then occupied it).

tually the King's apartment, opening on the sanctuary by a door at the third-floor level of the King's courtyard, and underneath the gigantic bronze kneeling figures of the King and his family (fig. 7). The "tower" connected with the monastery by a narrow passage five stories high and one window-bay wide (fig. 6, *H*), surmounted by a huge "thermal window" lunette, like those lighting the vaults and interior of the basilica. Today at the Escorial they are still called the *ventanas de las reliquias* ("windows for the chapels of the relics," figs. 1, *L, M*; 71), because they back-lighted those chapels in the ground floor of the basilica. The main function of the two tower lunettes was to light large chambers in the attics, serving as passages from the monastery attics to those of the towers and royal apartments. Thus the puzzling lunettes are vestigial tower tops, and

they light a network of passages connecting various attic levels, as well as the basilica.

The two interior stairways just east of the towers were begun in 1578,[11] after the paving stones were contracted for the little courtyard (fig. 1, *103*). At the turn of the year, the window grilles were ordered, and in 1580 the marble fountains of Herrera's design (fig. 67 A, E) for the patio mark the end of the use of the court as a construction area, and the beginning of its final preparation as the courtyard of the King's residence.[12] No contracts are preserved after 1581 for this area other than for decoration. The contract for the King's kitchens was for a distant place, in the service buildings (fig. 1, *76*), and later, in the northern outbuildings. Hence the King's house was built by 1581 but not decorated, furnished, or occupied by him until 1586.

THE PALACE COURTYARDS

As a royal residence the Escorial offers so many unusual and atypical features that its use must be compared with other royal seats of the time. Of the eleven that were within fifty miles of Madrid, the Escorial is much the largest, but it was the least suitable as a residence, being mostly a monastery, and least of all a palace. Its principal use by the royal family was as a religious retreat, and the court often remained at Madrid when the King was at the Escorial. The other large royal residences were either fortresses (the Alcazares of Madrid, Toledo, and Segovia), or ample country houses (Aranjuez and El Pardo). Several small properties were rarely visited, usually as travel relays (Vaciamadrid, Fuenfria, Valsain). Others were ancillary to the large seats, and were used by hunting parties: such were Campillo and Monesterio within the boundaries of the lands belonging to the Escorial,[13] and Açeca near Toledo, and the Casa de Campo west of Madrid.

Thus the palatial aspects of the Escorial were its

least marked features, being necessary for the residence of the King's family and household, but unnecessary for those functions of government not represented in the household. When the family came for Easter week or the summer after 1586, it was with the immediate household only and the indispensable gentlemen, ladies, and servants, who were mostly housed far from the King's house and near the kitchens, because the royal family and their attendants filled the King's house and the Queen's building on all floors.[14] Until 1571, no lodging at all was possible at the building site, and the King's party always stayed at La Fresneda,[15] southeast of the lower town, where the friars lived in a small monastery built for them by the King. His appearances there in 1562 and 1563 were brief daytime visits, and he never came during 1564-1566 or in 1569-1570. During 1571 when the friars and the King moved to the monastery, he stayed at the monastery for short visits in June, July, August, and October,

[11] AME, vi-18 (24 October 1578). The contract is for three stairways. The third may be the one connecting the main cloister with the King's house (fig. 1, *N-O*). Paving stones, AME, vi-18 (22 March 1578).

[12] AME, vi-24 (12 October 1578), window grills; AME, vi-42 (8 February 1580), fountains.

[13] Lhermite, *Passetemps*, 1: 278-279, 313, describes them as of 1596.

[14] Sigüenza noted that the palace, which seemed large to him, was always filled with crowded and discontented people living even in the attics (FME, p. 272).

[15] Called La Granjilla today, and owned privately (App. 7).

but no stays are recorded again until May 1575. Thereafter he was always in residence during Holy Week (and less often at Nativity) with the exception of 1581 and 1582 when he was in Portugal. His longer stays were to celebrate church holidays during the temperate months, and he avoided the hottest season when malaria struck in low-lying districts like the lower town and La Fresneda.[16]

For the period after 1586, the court's available lodgings are described in *Sumario*, p. 17 v, as well as on figure 72.[17] This plan of the buildings surrounding the palace courtyard is at attic level. Ten rooms are shown in the attic of the north building, on a long corridor facing south. Chimney flues warmed seven of the rooms. Figure 73 shows six floors of the east building, containing one apartment on the ground floor; two on the entresol (mezzanine floor); six at the thirty-foot level; eight rooms at forty-five-foot level; and seven rooms in the attics, totalling twenty-five units (ten apartments, fifteen rooms) for the royal family and attendants. In all ranges the available rooms for the court totalled sixty-eight, of which twenty-five were for the family, and the remaining forty-three for the court.

East range	25 units
North range	9 units above rooms for ambassadors
West range	6 over kitchens
T-range[18]	14 at ground level
	14? at upper level

The gentlemen of the table may have dwelt in the T-range and over the kitchens, until the *casas de oficios* were built outside the block. The lesser gentlemen of the chamber may have been assigned the attic rooms, and the principal aides lived in the attics of the King's house. But it is apparent that fewer than one hundred members of the household could be accommodated inside the palace. This was only on important occasions,

and by moving established persons out of their customary billets. In effect, the palace was like a small hotel, staffed and occupied by the household, with assistance from over six hundred retainers.[19] About one in ten lived away from San Lorenzo.

A valuable source on the composition and size of the household at the end of the century is the charming chronicle of Jehan Lhermite.[20] In 1590 the household included these officials:

 7 gentlemen of the chamber and their
 8 gentlemen aides of the chamber;
 3 barber-surgeons (all Flemings);
10 billetting masters (maitres d'hotel);
 4 chapel beadles, and
 5 equerries,

but in 1600, under the rising star of the Duke of Lerma, the "universal minister," or minister of everything for Philip III at Valladolid, the household was enlarged:

11 active gentlemen of the chamber and 5 "on reserve";
11 aides to the chamber and 11 more "on reserve";
 4 barber-surgeons (Flemish);
 9 officers of the King's "Bureau" (formerly billetting masters);
 4 beadles, and
 9 equerries,

plus uncounted other gentlemen of the table and chamber without appointment, as in 1590. These were the full household lists at Madrid, but for visits to the Escorial the numbers were much reduced to small groups chosen to accompany the family.

During its construction the palace compound was called the Queen's buildings. In 1589 Herrera called the east range the *Aposentos Reales* ("Royal Dwellings"), to include the family and courtiers; and he called the north range *Aposentos de Caballeros* ("Gentlemen's Dwellings"), for the courtiers (figs. 1, 2). The latter was contracted in 1574 (19

[16] C. Vicuña, *Anécdotas*, pp. 62-68; *Hoja del lunes*, 2 December 1963, p. 21.

[17] Attributed to Juan Gomez de Mora, who was *maestro mayor* in 1616-1617 (AME, xv-28, 29).

[18] "T-range" means the courts and buildings numbered *80-81* on figs. 1 and 2.

[19] AME, xv-19 (1610) is an alphabetic list of 658 names of retainers in all the Escorial properties, mostly employed at San

Lorenzo el Real and active serving its kitchens, livestock, gardens, stables, bakery, hospitals, storerooms, crafts, professions, and transports. Additional to these were the personal servants of the court, who came and went with their masters.

[20] *Passetemps*, pp. 96 f., 313f. He came to Spain in 1587 and became an *aide-gentilhomme de la chambre du roy*, or *ayuda de camara*.

December), and its fifty-five-foot cornice on 7 July 1576.[21] Early contracts for the palace buildings have not been found, but payments are recorded for windows and shutters for the "building to the north of the church" (i.e., the Queen's building), indicating that a large part of it was ready for carpentry during the 1570s,[22] as seen in the Hatfield drawing (fig. 74), where nearly the entire east wall, from the church to the north corner, is complete to the fifty-five-foot cornice on fifteen window axes.

These window intervals and proportions were identical with those of the monastery, and they are a reminder that the palace quarters conformed to monastic appearances, rather than the reverse. The northeast tower, which contained the palace toilets, morever, is twin to the prior's corner at the southeast corner. Only the foundations of the north range are visible on the Hatfield drawing. The contracts for the remaining façade walls of these outer palace buildings were written in 1573.[23] The roofing of the east range to house the royal apartments was written in 1576.[24] Work was complete enough in this sector for the stuccoworkers to decorate three upper-floor vaults in the Queen's apartments in 1583, shown on figure 73. These were rooms two stories high on the ground floor (fig. 75), called the *necessaria* ("toilet"); the *sala* ("drawing room") and the *cuadra* ("hall").[25] After this date no more large structural contracts appear for the Queen's buildings.

The large royal court (fig. 1, *85*) has ample arcaded galleries on three sides, as ample as those of the main cloister of the monastery. Two rainwater reservoirs lie under its granite paving.[26] The kitchens and other services[27] for the palace buildings occupy the western half of the courtyard. They were vaulted and were fitted with doors and windows in 1582.[28] The three kitchens opened on small courtyards, and above them were more apartments for courtiers. The low ranges in a T-shape, separating the three courts, had lodgings for kitchen and palace servants on two floors, and they were roofed with flat decks sheathed in lead (*Sumario*, 18ᵛ).

Outside the building on the garden side at the east, the doubled stairways from the ground-floor terraced garden to the lower park (fig. 1) were not ordered until August 1583.[29] The steep incline below the eastern end of the Escorial required much leveling and filling to complete the niched retaining wall on this side, and to build up the platform extending eastward under the King's windows (fig. 99). Outcrops of rock under the Queen's garden terrace had to be leveled and removed in 1584.[30] The wall dividing the King's garden from the friars was built in 1584.[31]

ARCHITECTURAL DRAWINGS OF THE PALACE

Figures 46 and 47 are related as copies of a tentative design with spiral stairs at the choir. Both differ from the palace plan as built, having four arcade supports at the south end instead of five, and being only eighty feet wide in the east-west dimension instead of one hundred as built. Furthermore, figures 46 and 47 show no porticoes surrounding the south kitchen court (fig. 1, *81*), and access to the basilica entrance (fig. 1, *41*) is blocked or closed. In relation to the basilica, these

[21] AME, IV-1, f. 87-89 and V-5, f. 16-17; AME, V-26 (14 April 1576).

[22] AME, II-166 (8 February, 10 October 1572), f. 3ʳ.

[23] AME, II-7 (4 May 1573), f. 66-75, is for the upper three floors on 4 window axes adjoining the basilica, seen as still unbuilt on the Hatfield drawing (also AME, III-18; AME, IV-1). The drains underlying the north palace building consisted of 1204 *varas* (2.8 feet each) of archstones (*dovelas*) laid in 141 sections 10 by 5 by 3 feet thick (AME, III-14), approved by Villacastín (10 September 1573.)

[24] AME, V-35, f. 25-26 (15 January 1576); AME, VI-9 (15 January 1577).

[25] AME, VIII-20, f. 96 (14 April 1583), f. 99 (20 May 1583).

[26] AME, VIII-20 (20 May 1583).

[27] Begun 1572 (AME, II-187, 30 April 1572), contract for walls of rubble.

[28] AME, VIII-21 (10 November 1582), vaults; AME, VIII-2 (1 April 1582), carpentry; AME, VII-40, f. 9ʳˑᵛ (n.d.), doors and windows.

[29] AME, VIII-21, f. 12-15ᵛ (28 August 1585), King's garden stairs; ibid., f. 16-19ᵛ, Queen's stairs.

[30] AME, VIII-31 (1583), King's windows; AME, IX-1, f. 33-35ᵛ (19 January 1584), Queen's terrace.

[31] AME, IX-2, item 5 (1584).

drawings are safely dated as tentative designs before 1576. At the other end (fig. 1, *94*), the definitive design for the entrance passage to the King's house as shown on figures 46 and 47 may also be dated in 1576 or before because of its agreement with figure 1. The Hatfield drawing also supports this view, in showing advanced construction at the southeast corner of the Queen's court and none at the southwest corner (fig. 74). The drawings at the small, square service court suggest that only the foundation walls existed (figs. 76, 77). The columniation of the main court was also still undecided on its south side, and in the east college court, the Hatfield drawing shows the college terrain as an access road for a stone-wagon drawn by five yokes of oxen, bringing in cut stone for the north wall of the church (fig. 78).

Figure 76 is a more complete and developed working plan for the entire palace quadrant, but differing from figure 1 in the kitchen plans by including a rejected design for their layout. Two kitchens are shown with a common chimney stack, but two dining rooms take the place of the kitchen at figure 1, *78* in the *Sumario*, which provided only one dining room for three kitchens: *76* and *77* (back-to-back) and *78*, smaller than the first two, but with access to the covered walk leading to the King's house at *93*. The central kitchen (*77*) was surely for palace servants, and the north kitchen (*76*) opened into the entrance hall for all the kitchens at *75*, which also gave access to the dining hall at *79*, where the gentlemen of the chamber, the majordomos, and others took their meals. Figure 76 can be dated in late 1573 by the dotted lines showing underground conduits and rainwater cisterns in the Queen's court.[32] A legend in Herrera's handwriting says that a passage (*paso*) leads to the vaults below the Queen's building, under which the drain from the cisterns was to run. Part of the passage appears in the basement plan on figure 72, with stairs leading down to it from the winding stair above.

Figures 72 and 73 give much detailed information about the building levels. Figure 73 is extremely sketchy for the north range, indicating only that the winding stair at the east end rose to the thirty-foot level, but was incomplete above that floor. This fixes the date of the drawing before 1576, when the fifty-five-foot cornice was contracted for the north building façades. Figure 88C at the extreme left shows a section through the north range at the kitchen entrance vestibule (fig. 1, *75*). Above the barrel-vaulted bay are two floors of chambers. The lower one is thirteen feet high; the upper only seven feet.

THE COLLEGE AND SEMINARY BUILDINGS

Reconstruction of the early history of the design marks three stages between 1562 and 1565. Sigüenza states his view of the King's wishes at the beginning, when Juan Bautista de Toledo was preparing the "universal plan," as if Sigüenza were looking at Toledo's wooden model begun in April 1562.

The King intended [at first] to build a house for no more than fifty friars, together with another house for himself, where not only he and the Queen would be suitably lodged as well as other royal persons, but also their gentlemen and ladies in waiting. Between these two houses the church was to be placed, where [friars] would celebrate mass, and the others hear it, and for this purpose the architect Juan Bautista divided the block or rectangle in three main parts, with the church and general entrance at the center. The south side he divided into five cloisters, one large, and four small, which were all together as big as the large one. The other third he divided in two main parts: one for the ladies and gentlemen, and another for the services of the royal house and the monastery, like kitchens, stables, granaries, ovens, and such needs. And at the eastern end he extended beyond the block the royal dwelling, to embrace the sanctuary on both sides, with windows and oratories near the main altar.[33]

By omitting all mention of the college, Sigüenza implies that the entire northern third was devoted to the services of both the palace and monastery in this first design and model. He then goes on to

[32] AME, III-14 (10 September 1573) is a contract for these.

[33] Cervera, *Estampas*, p. 20; FME, pp. 30-31.

deal with the second design and model, which were ready in April 1563.[34] "The ground plan of this design by Juan Bautista differed little from the first one, but the elevation was much altered," especially by suppressing various towers: at the centers of the north and south façades; two flanking the main entrance; and two adjoining the sanctuary, which were to have bell towers, "as seen in the drawing and wooden model kept today in the monastery." There is still no mention of a college or seminary, and the quarters they would eventually occupy are described here as being for the "ordinary services" as before.

The next step taken by the King was to double the number of friars, whereupon various opinions came from other architects, with Villacastín's ideas finding acceptance: to raise the western cloisters to the same height as the eastern block, with uniform floor levels and roof-ridge heights throughout the entire structure.[35]

These remarks are confirmed by the documents about the college, which begin only in 1565. The abbey at Párraces near Segovia was the temporary location of the college from 1565 to 1575. The preliminary discussions and its *constituciones* are dated 25 and 27 December 1565,[36] but the final decision to transfer the college and seminary from Párraces to the Escorial was taken by the King on 15 June 1575,[37] ten years later. The collegians were divided equally between theology and liberal arts, and came from other Jeronymite houses, with San Lorenzo itself supplying eight. Four professors were the faculty, receiving annual salaries between 300 and 500 ducados plus lodging, grain, medical care, and an allowance of 20 ducados for firewood.[38] The collegiate atmosphere was rigorously seminarian. On 24 September 1575, twenty-four collegians and thirty seminarians arrived from Párraces and were lodged for twelve years until 1587 in the hospice cloister (fig. 1, *PP*) of the monastery, where the college had opened on 1 October 1575 with furniture and images provided by the King. In 1587 their numbers were increased to thirty-two collegians and forty

seminarians in the new buildings (fig. 1, *50-69*), which were even more austere and spartan than the equivalent cloisters of the monastery, being perceptibly fewer and plainer than the comfortable cloisters and cells of the friars. During their twelve-year stay in the monastery, the collegians participated in the rehearsals of the ritual of the Escorial as planned by the King, together with the other celebrants, friars, royal family, and court. And after 1587, every part of that ritual could be separately housed in conformity with Toledo's modified "universal plan" and the King's wish to commemorate his parents and relatives with suitable splendor, in a chapel for which the college would be a perpetual source of celebrants.

Their buildings, begun only in 1573, were the last major part of the Escorial to be contracted, although the initial design, doubling that of the small monastery cloisters, was part of Toledo's "universal plan." The earliest contract is for a northward continuation of the west façade from the still-unbuilt main entrance (fig. 78).[39] It continued the design of the monastery façade as its replica in left-half symmetry, faithfully repeating all its parts in reverse order. The contract specified a northward length, 118⅜ feet, between the main portico and the college entrance (fig. 1, *49* and *63*), as the west range of the future southwest court of the college (*56*), including the "tower" that would finally be the north roof above the library, but it did not include any part of the Vignolan entrance façade. The east (or inner) face of this section in construction is clearly delineated on the Hatfield drawing in 1576 (fig. 78), where four door-axes are shown as completed to the roofs and dormers.[40] Beyond this point on the Hatfield drawing appear three stories of the northern extension beyond the college portico to the northwest towers;[41] shown from the east as an outer window wall and as unfinished inner face.

New contracts for the college lapsed from 1574 to 1579 during the press to complete the basilica and palace. But work resumed on the northern section of the west façade and the northwest

[34] FME, p. 31.

[35] FME, pp. 31-32.

[36] M. Modino, "Constituciones del Colegio," pp. 143-147.

[37] JSJ, pp. 134-149: FME, pp. 59-60.

[38] Modino, "Constituciones del Colegio," p. 177.

[39] AME, III-2 (4 April 1573). This section was also known

as the "building of the professors" (*cuarto de los doctores*). Payments for it continued into 1576 (AME, III-64, 15 June 1574, flooring; AME, V-16, 19 April 1576, appraisal).

[40] AME, IV-2 (14 June 1574), contract for wooden floors on four stories of the *cuarto de los doctores*.

[41] AME, V-19 (15 October 1574).

tower, as well as beginning on the north range on contracts to rise to the thirty-foot level including stairs.[42] The carpentry for the northwest tower (fig. 79) was ordered[43] at a time when work on three spires was in progress: repairs to fire damage on the southwest tower, and on the two new towers at the ends of the north façade. Basements, cisterns, and foundations were contracted only when it became possible, after the completion of the basilica, to excavate in the staging area, as portrayed on the Hatfield drawing (fig. 78). The southwestern college cloister was begun late that year. The refectory and its vestibule began to rise in 1581, when the north range was reaching the fifty-five-foot level. The crossing tower of oblong plan and elevations (fig. 80), less intricate than its twin in the monastery (fig. 97), was also begun.[44] The north range was now reaching the fifty-six-foot level, including the northwest tower and the college kitchen block (fig. 1, 66) to the crossing tower (59). This work also formed the east and north ranges of the seminary cloister (66), for which the arcaded court façades were contracted at the end of 1581, to be finished in one year.[45] Doors and windows for the north entrance (63) and the refectory (67), and for the kitchen (65), as well as for the north face of the northwest tower, were ready by 1582.[46] The south closure of the college court from entrance to basilica, forming the north façade of the forecourt (fig. 1, 48) began in 1582. The entrance façade of the college, replicating the monastery kitchen doorway, was commissioned in 1582.[47]

All the cloister walks of the college were ready for roofing with timbers early in 1583. The kitchen vault was under contract at the same time.[48] The organization of the water supply is implied by a contract for the three courtyard fountains of the college.[49]

The covered promenade (fig. 1, 55, called *publico passeadero de los Collegiales*, HS, 13ᵛ) between the lecture halls (52, 53) marks the concern of those who planned the college for a place where boys could exercise during bad weather, there being no access to gardens or other playgrounds in the building. The room opened directly on the cloisters of the two college courts.[50] The college refectory (58) was finished together with the crossing tower (at 59) in 1583.[51] Flooring the college buildings began in 1584, and the spire of the northwest tower rose in March.[52] In 1585 the college was being floored, furnished, and decorated, and the finished work was assessed, but it was not ready for students and faculty until the fall of 1587.[53]

It is worth noting that no drawings of any sort survive for the college, and it may be asked whether very many were necessary, given the repetition of the same units of design worked out in monastery and palace. The only striking novelty in the college plans is the assembly room (fig. 1, 56), with its access to both college cloisters and nearness to refectory and lecture rooms. Yet the college presented many problems of adjusting the program of a boarding school to the plans and elevations of a monastery, of which it was designed to be the "double," as another cruciform courtyard system. In practice, matters turned out very differently, to satisfy the functional needs of a collegiate program not foreseen by the first architect's designs. The buildings needed auditoriums, recreational space, and special professorial dwellings, all in an even more subdued ornamental mode than the monastery. When construction

[42] AME, vii-1 (19 December 1579); AME, vii-4, f. 16-18 (17 December 1579). Stone was ordered on 1 February 1581 (AME, vii-34, f. 27ᵛ-30ᵛ) by Villacastín.

[43] AME, vii-6 (27 March 1579).

[44] AME, vii-24 (12 March 1580), basements; ibid. (9 December 1580), cloister; AME, vii-34 (18 April 1581), refectory; ibid. (3 March 1581), north range; ibid. (6 March 1581), crossing tower.

[45] AME, vii-40 (29 November 1581), f. 1ᵛ·ʳ; published in part by Rubio, CD 162 (1950): 111.

[46] AME, vii-36 (7 August 1581–20 December 1581); AME, vii-42, f. 4ʳ (n.d.); AME, viii-1, f. 15-16 (19 April 1582).

[47] AME, vii-4 (16 February 1582).

[48] AME: vii-20, f. 15ᵛ (12 January 1583), also viii-29; viii-20, f. 20-22 (5 January 1583), kitchen vault.

[49] AME, viii-20, f. 127-128 (16 July 1583). Also payments to F. de Montalban (salaried since 1576) in 1583 for installing fountains and conduits (AME, viii-26).

[50] AME: viii-20, f. 131 (22 July 1583); also viii-29, f. 12 (19 July 1583).

[51] AME, viii-31.

[52] AME: ix-1, f. 61ᵛ-64 (15 February 1584), flooring; ix-15, f. 15-18 (8 March 1584), spire. Andrés de Léon was paid from 9 March 1584 to 16 July 1585 for this work (AME, ix-24).

[53] AME: x-3; x-6.

finally could begin in 1579, the precedent and format of the monastery made possible a greater speed in building than was ever achieved during the fumbling years under Juan Bautista de To-

ledo. Not only the monastery but the basilica provided both procedures and equipment that were lacking before Herrera's regime.

THE LIBRARY PORTICO AND FORECOURT

Work could not begin on the narrow door of the portico under the library until the transport of stone into the building for the construction of palace, basilica, and college had ceased. A portico was part of Toledo's "universal plan," and two drawings attributed to him (fig. 83)[54] show alternate and unrealized projects. The towers he planned bear ungainly domes and obelisk spires. Their lower stories below the fifty-five-foot level resemble these sections of the façade as built, but the pilasters were more prominent in these two drawings than they are in the actual façade, while lacking the paired pilasters of the final design that mark off the "towers" from the library and portico façade. One scheme (A) has eight Doric half-columns of colossal order (i.e., embracing two or more stories of apertures), mounted on the thirty-foot cornice and distantly resembling a Palladian church façade. Scheme B resembles distantly again the work of Galeazzo Alessi as at S. Maria Presso San Celso in Milan.[55] It had a strongly parted and bridged pediment, as if to stress the union of college and monastery in the library. The colossal order is doubled vertically, one above another, spanning five tiers of windows. In the tower the upper order enframes large apertures surmounted by "thermal" lunettes and oculi, as at the kitchen and college porticoes.

The great difference between pre-Herreran and Herreran designs is most easily measured here: the two portico projects are awkward efforts to produce a façade for the forecourt without adequately acknowledging the existence of the library. But Herrera's solution (fig. 82) accentuates the library as a cross-volume behind the façade by

cancelling the towers and stressing the library roof, which rises two stories higher than the rest of the west front.

Herrera's use of Vignolan models here, such as S. Maria dell'Orto in Rome, of 1566-1567[56] might seem too literal until his unprecedented and surprising treatment is considered. Taking a conventional façade design associated with clerestoried churches, Herrera stated the consecrated character of the entrance, and its advocacy as San Lorenzo el Real in the statue of the saint above the royal arms. The threefold function of the portico under the thirty-foot cornice is expressed by blind fenestration, on the two facing vestibules giving access to monastery and college. These flank the doorway frame, which opens to forecourt and basilica. The church façade, which has no church, not only determines a sacred aspect of the forecourt but also marks and measures out the extent of the library above the threefold portico, which has two stories separated by the immense Doric entablature bearing obelisks and spheres. These different grids of columns, entablatures, obelisks, and pediment thus define functions and convey information.

Like a medal, this façade has a reverse: on the other side of the portico is the rear façade of the forecourt, not only mirroring the articulation of the basilica façade at the other end, but also stating the triple portico and the two-level library in more complex patterns of pilasters, fenestration, and cornices, and in differing degrees of projection with interlocking rhythms. By this device of doubling the façade, in combination with an open atrium, the entire central axis, from portico to

[54] Ruiz de Arcaute, *Herrera*, opp. pp. 17, 32. Iñiguez, *Trazas*, pp. 44-45 and 127, n. 83, claims to have seen these drawings in AME before 1936, among other drawings for the building, which he was unable to find again.

[55] Façade begun 1556 by Vincenzo Seregni; redesigned by

Alessi in 1565. This church, like the Escorial, has a forecourt (by Cesare Cesariano in 1513), a rare form in Renaissance building (P. Mezzanotti and G. C. Bascapé, *Milano*, pp. 52-53).

[56] Walcher Casotti, *Il Vignola*, 1: 91.

sanctuary, becomes a hieratic space. The King's house is a place of transition between monastery and court, lower than they, yet an extension of the sanctuary, like a retro-sacristy behind the altar, next to the crypt, housing the King near his family, both dead and alive.

The two façades are axially related to the King's house: they state the presence of the basilica, and the presence of the dynasty and King as well, under the rubric of San Lorenzo el Real. The western entrance façade is the width of the forecourt behind it, but the façade is also a lateral façade marking the long library, which is six times as long as it is wide. Thus it is a façade of triple use, serving the atrium and the library as well as the church, which is separated from it by library and atrium. But the twisting contrast between façade and an even longer transverse library body is a contrast almost as deliberate as those of nineteenth-century revival designs. The sense of contrast is compounded by capping the library edifice with a steep, Flemish, hipped, slate roof, in a manner previously justified only in Serlio's designs after 1541 for French clients in Book Seven, from which Herrera may have taken his license to mix national traditions, under royal protection and encouragement.

The earliest mention of supplies for building a library is a memorandum entitled "Lumber Needed for the Library Rooms" in 1570, at the time when every effort went toward finishing the King's temporary residence in the monastery.[57] The "library rooms" are surely the friars' cells on the third-floor level of the hospice cloister (fig. 2, PP). These were known to Jehan Lhermite[58] as the manuscript library in 1597, where some five thousand volumes were kept.

The key element of circulation for this northwest zone of the monastery was what Juan Bautista de Toledo intended as a tower, but which was reduced by Herrera to being the southern end of the library roof. On the ground floor the so-called tower contains the main entrance to the monastery, as well as the stairway giving access to the hospice cloister (fig. 1, PP). On the third floor that same stair still leads to the libraries and archive, which today still occupy most of the northwest cloister.[59] The tower is plainly visible on the Hatfield drawing as of 1576 (fig. 84), including part of the future roof over the main library (then still unbuilt). The builders' contract[60] refers to it as "the tower over the library, with chimney, doors, windows, and roof." Its construction began in 1572.

The north tower, containing the portico and stairs to the college, has identical form and function. It is also shown with slate roof on the Hatfield drawing in 1576, with the void between it and the south tower, where the future library would be built (fig. 84).[61] Sigüenza, who was the librarian, noted that the collections required a room on the fifty-five-foot level, above the principal library, of the same dimensions and fenestration, in addition to the rooms on the south side of the forecourt on the third floor, which had housed the manuscripts since 1570.[62]

Thus the library building was like a bridge between monastery and college above the traffic at the door, of which the towers were not only the pylons but also the stairways and portals. The whole entrance portico was a traffic center among basilica, college, and monastery, bridged by the Vignolan façade under its wide roof. The contract for the main entrance block between monastery and college, signed on 6 December 1575 by Mateo de Lorriaga, included Juan Bautista Monegro, who would carve the patron saint's statue and the royal arms.[63] The work was near completion on

[57] AME, II-180 (7 November 1570); AME, II-120 confirms them as being in "el quarto de mediodia en el patio principal." This contract is for flooring three cells (celdas) above the library. The final accounting for this carpentry is in AME, III-44 (26 November 1574).

[58] Passetemps, 2: pl. 9, légende rr, and p. 18. Today these rooms and the dormitory (fig. 2, Q) are still in use as the library of the Augustinian friars, and the manuscript shelves are kept in the wardrobe (fig. 1, MM; fig. 2, Q).

[59] Almela, "Descripción," p. 58 (written 1594).

[60] AME, II-179 (15 February 1572); payments AGS, contaduria 1026, e.g. pliego 30 (September 1572), for 37,000 mara-

vedís monthly for all expenses. Simón Sanchez, mason in charge, was then also being paid for building the garden stairs below the temporary dwelling of the King (ibid., f. 18 v, 24 May 1572).

[61] AME, V-16 (13 May 1576): listing of final costs for the work as built by Diego de Matienzo, both in the tower and in the adjoining professors' dwellings on the north side, as well as for the south tower (14 May 1576) by Esteban Frontino.

[62] FME, pp. 300-302.

[63] AME, VIII-2 (21 January 1582).

both outer and inner façades in 1583[64] when the King returned from Portugal. The main library was ready for stuccoing on 3 September 1583, before the frescoes were painted by Pellegrino Tibaldi.[65] A drawing for life-size figures in the British Museum is intended for the north bay of the library vault (fig. 98). It is probably by Pellegrino Tibaldi,[66] and bears routine annotations signed by Herrera. Francisco de Mora is mentioned, who began his activity as architect at the Escorial on 22 August 1579.[67]

The forecourt appears in the Hatfield drawing

during construction of the basilica in 1576 (fig. 84), filled with cranes and serving as a stoneyard for storage and stone dressing. The façade and towers of the basilica were not yet rising, and the palace and college were advancing only at extreme east and west. The area between them also served as a stoneyard and hoisting area. When the college was nearly complete, after 1579, and during work on the entrance portico, the forecourt was left as the only large area for stone dressing and storage before use, until it could be paved with granite in 1586.[68]

[64] AME, III-69 (agreement 20 November 1574; *remate* 6 October 1575), published by Rubio, CD 162 (1950): 106-108. The agreement was renewed in 1579 (AME, VI-42, 18 September) and again in 1583 (VIII-29, 20 February 1583).

[65] AME, IX-28, f. 8-9, also x-3, f. 121-124 (7 April 1585); payments began to Tibaldi (AME, x-15), who was called "il Buonarroti reformato" by W. Hiersche (*Ludovico Carracci*, p.

18). He had served Philip II since 1561 in Milan, and four years as *Ingeniero del esercito* there (G. Rocco, *Pellegrino Pellegrini*, p. 213, letter from Philip II at Elvas, 29 January 1581).

[66] Reproduced and transcribed by Iñiguez, *Trazas*, p. 80, his figure 36.

[67] Cervera, *Estampas*, p. 56, n. 18.

[68] AME, x-7 (29 March), and x-19, f. 16[r,v].

8

THE SURROUNDING
STONESCAPE

FROM EVERY angle of view the Escorial recurrently appears as a great stone platform carved from the mountain flank on its western and northern fronts, and erected on a granite shelf, rising twenty feet above the southern and eastern declivities. The effect of a landscape design executed entirely in stone, a stonescape,[1] is intentional, and it was surely part of the primary scheme proposed by Juan Bautista de Toledo at the behest of the King—a stonescape as in certain Quattrocento paintings of ideal cities drawn with single-point perspective in Renaissance Italy.[2] From the beginning of building, the mental image of the Escorial among its builders was of a granite structure on a granite pedestal in a landscape of granite.

The question of foresight arises here, of the ex-

tent to which the lost original plans of the Escorial anticipated the final form of the structure. The answer reached in the present investigation is that major changes occurred as the need for them arose, and they fit easily into a medieval tradition of architectural improvisation still current in the sixteenth century. Originally conceived as a block (*cuadro*) on its shelf in majestic isolation from other buildings, the design was gradually extended to include various outbuildings (fig. 8), which were indispensable, but needed separation from one another, in the medieval tradition of planning for protective isolation during plagues. The first of these was the infirmary at the southwest corner, which was expanded west and south beyond the *cuadro* as early as 1564.[3]

THE HOSPITAL BUILDINGS

The earliest outbuildings at the Escorial were the parts of the hospital outside the main block, ex-

tensions of the services for the sick that occupied the upper stories and basements of the southwest

[1] The word is not in the dictionaries, but it is in general use as an extension of seascape or mountainscape.

[2] E.g., *A City Square*, panel painting, Walters Art Gallery (Baltimore), *Catalogue of Paintings*, #677 (attributed to Luciano

de Laurana).

[3] On the medieval tradition to which these scattered facilities belong, see Dieter Jetter, "Klosterhospitäler," pp. 313-337.

cloister and tower (fig. 1, *RR, V, VV*), as well as the sun-corridors for convalescents (fig. 1, *XX*) and the pharmacy (*botica*), added on the west as shown in fig. 7. In emergencies, like the epidemics of *catarro* and waves of malaria that struck the community, the upper floors could supply more beds in the southwest cloister, which was known as the *enfermeria*.

The sun-corridors on two floors and the pharmacy are properly regarded as outbuildings because they have no inside communication with the main edifice other than an outside walk pegged into the southwest tower base (fig. 36). The exit from the main building was the door-sized window at the east base of the infirmary tower, opening on the corbeled walk that crossed the width of the tower to the upper sun-corridor. This arrangement allowed convalescent friars to sit in the sun (fig. 38) on warm mornings, and in the shade on sultry afternoons, and they could be fed in the dining room for the ill (fig. 1, *TT*) from the monastery kitchen. The southwest cloister (fig. 1, *RR*) was reserved for them also, with four cells, each housing two south windows, and other cells as needed on the upper floors, with their own stairs adjoining the infirmary tower.

The *botica* building was a pharmacy built later on, around an oblong courtyard on three floors where medications were prepared. Doctor Almela (1594)[4] described eight rooms in the lower levels where syrups, juices, infusions, and oils were compounded, and five more rooms at ground level for the alembics and furnaces to distill syrups and essences. On the upper floor were the two largest alembics, one for distilling botanicals and another for producing distilled water at the rate of 180 pounds daily, in one room. In another small chamber, were smaller stills for extracting quintessences from simples and compounds.[5]

The term *corredores del sol* appears in the King's hand,[6] and the plan to build them was first mentioned by the King in his own written memoir of 1564,[7] determining the sequence of construction, and ordering that the infirmary cloister be built first, beginning with a design (to be prepared) for the basement vaults. He then wanted further study of the connection between the tower and the outdoor corridors in order to contract for their construction. If it were decided that the foundations of the prior's tower, where the declivity was greater, should be reinforced by filling in some of the basements there, then the same should be done under the infirmary tower. In effect, a massive retaining wall backs the sun-corridor, which faces south (fig. 38). In addition, the whole extension of the platform, south and west of the infirmary tower, serves to stabilize the foundations at this slope down to the rectangular basin ten feet lower.[8]

A memorandum in 1566 specifies the stone to be cut for the masonry of the passage on the south tower face, and the infirmary cloister stairway was contracted on 24 May 1567.[9] Accordingly there is no documentary reason to question the sun-corridors as being built on the design and under the supervision of Toledo before his death. But work continued thereafter until at least 1578.[10]

The *botica* building, however, was not begun until 1585.[11] The covered passage and arcade (fig. 85) crossing the road to the Compaña (the utility compound) was not contracted until 1586, in connection with the building of the western plaza and the completion of the niched retaining wall (*muro de nichos*) to its westernmost end underneath the *botica*.[12]

[4] DHM, 6: 67-9.

[5] Some of these stills are illustrated by Lhermite (*Passetemps*, 2: 72-75, and pl. 13-15, as of 1597). Sigüenza (FME, p. 401) expresses some disapproval of this new medicine, "which the doctors in our Spain do not yet dare to use in our bodies."

[6] AGS, 258, f. 207 (July 1564).

[7] AGS, 258, f, 210ʳ (late September to early October), published PA, p. xxɪɪ; PM, p. 192, and by Zuazo, "Antecedentes," p. 149, refuting an attribution to Herrera by Lorente Junquera, p. 140.

[8] Zuazo, "Antecedentes," p. 149. AME, ɪɪɪ-70 (10 November 1574); AME, v-35 (4 January 1576); and L. Rubio, CD 162 (1950): 120 (28 September 1577) are for the outer *muro de*

nichos and not for the hidden retaining wall behind the sun-corridors.

[9] AME, ɪ-66 (28 April 1566), and ɪ-94.

[10] Llaguno, *Noticias* 2: 313 (15 December 1578). This document names Garcia de Alvarado as the mason who finished building the sun-corridors, and it was the basis for Lorente's attributing the work to Herrera.

[11] AME, ɪx-28, f. 8 (6 May 1585), *condiciones*, published in part by L. Rubio, CD 162 (1950): 120-122; AME, x-3, f. 145ᵛ-153 (6 January 1585), contract.

[12] AME, x-8 and 17. PM, p. 73, shows an engraving with the southward continuation of the niched wall under the roadway (Rotondo, *Historia descriptiva*, no. 104).

THE COMPAÑA

There is good reason to believe that the King at first intended to give the services—such as kitchens, crafts, and stables—a much larger area within the block than was finally decided in 1565. At that time the college was assigned the northwestern quadrant, displacing all the services that were originally to have been housed there. Sigüenza enumerated these as "kitchens, stables, granaries, ovens, and others,"[13] but when the college was confirmed, the kitchens were separated into different buildings. Three were put into the palace compound; one in the monastery; one in the college; and later on, others were installed in the outbuildings of the Compaña and the *casas de oficios*. The Compaña eventually became the general service headquarters, across the road from the kitchen entrance to the monastery and between the Escorial and the mountain rising to the west, on a narrow strip of flat terrain remaining at the foot of the Abantos range. Like the site of the monastery, it too had been a pasture for transhumant flocks and herds before it was staked out as San Lorenzo. From the beginnings in 1561, land was set aside here for the large livestock holdings of the new enterprise, on the site of the buildings later known as *La Compaña* facing the monastery.

At first fenced enclosures and temporary sheds were built for the animals and wagons. These expanded rapidly under the direction of the friars into a large collection of monastic farmyards and hospice buildings, which were finally designed as a series of courts extending north and west from a pivotal two-storied courtyard, connected to the monastery by a covered passage (fig. 85) leading to the infirmary buildings. Such farm buildings were always necessary complements to Jeronymite life, and their management was entrusted, as usual in medieval monastic life, to a friar-vicar and other friars with a knowledge of farming.[14]

Doctor Almela in 1594 understood the purpose of the Compaña as being for the needs of the provisioners (butchers, bakers), artisans (saddlemakers, tailors, carpenters), and herdsmen (muleteers, shepherds, oxherds, cattlemen), but Sigüenza adds that it was the wish of the royal founder, in conformity with the laws given to Moses on the mountain, to separate all animals from the temple of the Lord, keeping humans near the temple and animals in their farmyards.[15] Nine different courtyards are described as being of the Compaña. The most imposing one faced the monastery as a two-storied court of masonry mirroring the design of the Escorial in slightly simpler forms, and still in use today, remodeled as the University. Eight other courtyards spread west and north: one for the smithy; two for slaughtering and butchering; two for firewood and lumber; two for poultry; and one for pigs. Wagons, carts, and cattle used the principal south portal of the Tuscan order, entering a wide court (206 by 128 feet), surrounded by colonnaded walks of square piers and lintels, containing smithies and wagon sheds, as well as three stables for friars, guests, and muleteers.

The pivotal residential building was the Compaña proper facing the monastery and connected to it by a covered walk. Its east range contained a refectory with kitchen and rooms for travelers, and an infirmary and artisans' workshops on the upper floor. In the south range a vaulted refectory (98 by 21 by 14 feet) was used to feed the poor on tables with benches. Church decorations for Holy Week were also stored in the Compaña, like the towering wooden monument for the display of the Sacrament and relics in the basilica at Easter. Jehan Lhermite described the Compaña in 1597 as large, ample, and of very fine construction, built at a cost of about 150,000 ducados, more than half of it (80,000) spent for the water-driven flour mill, which was a novel experiment in Spain.[16] Two drawings (section and plan) of this mill, with two turbines driving the grindstones, bear writing by Francisco de Mora, and a possible correction by Herrera (fig. 86).[17] The ar-

[13] FME, p. 31.

[14] Almela, "Descripción," pp. 86-87; Sigüenza, FME, p. 401, notes that the large Compaña courtyard was then almost the size of the main cloister.

[15] Almela, "Descripción," pp. 85-90; FME, p. 400.

[16] *Passetemps*, 2: 75.

[17] LS, p. 25. Iñiguez, "Ingenios," pp. 211-213, suggests that the idea of the turbine drive may come from Joanelo Turriano, or from the German water-driven machinery at the Mint in Segovia. L. Rubio (CD 162 [1950]: 536, 547) shows that the

chitect in charge was Francisco de Mora, designated by Herrera.[18]

Contracts for construction were signed on 19 July 1590 for the foundations and walls of the corrals and workshops,[19] and on 17 January 1592 for the north range of the new Compaña, with the flour mill, granaries, and ovens, for which excavations into the mountainside were necessary. The east range facing the monastery began in 1592, when the north range was roofed and the stable buildings were paid for, with stalls sheathed in iron.[20] In 1593 the main court was paved, carpentry installed, and furniture ordered, including twenty beds and twenty tables and stools for the hospice in 1594.[21]

In the eighteenth century the east range of the Compaña became an extension of the hospice of the monastery, with rooms on both floors for guests.[22] The upper floor of the south range was converted to hospital use for the college and for the poor. On the ground floor were artisans' workshops, and a refectory for servants and travelers. The west range contained dwellings for servants at the monastery, and the north range continued as the flour mill and bakery.

THE NORTHERN SERVICE BUILDINGS
(*CASAS DE OFICIOS*)

The earliest mention of work on the northern service buildings outside the block appears in a contract of 1581,[23] but the scribe merely mentioned the *casa de oficios* together with another contract for the basilica that was more urgent. Further details are lacking beyond mention of the *casa*, but the date suggests that the drawings discussed here for a later replica (the "second" *casa de oficios*) were patterned on lost drawings for the first service building, built to the east of the second one, and before it. The documents also include a series of contracts and payments for a residence to the east of the second one, called the *casa de los doctores catedráticos*, and built from 1583 to 1585. These are the professors of the college, for whom an earlier group of dwellings in the college was named and erected in 1573-1576, standing north of the west façade entrance. The college buildings, however, were not ready for occupancy until 1587, and it would seem that the plan to house the professors in the college was abandoned in favor of the extramural residence begun in 1583,[24] which provided three dwellings in one building laid out more or less like the later second one to the west.

The King's *segunda casa de oficios*, facing the north kitchen portico (fig. 1, *69*), was not built until 1587-1588, for the service of the King's table and for the residences of its courtly officers, and to accommodate the overflow of servants of the table from the palace itself. Sigüenza regretted that the servants' quarters in this building were "as good as those of the gentlemen of the King's table."[25] Figure 87 also documents Sigüenza's remark about the servants' rooms being above their station, with written lodging assignments. The

two drawings date from 1596. Lhermite observed that the mountain water sufficed to drive the turbines only in the winter months.

[18] On 22 July 1579 (Cervera, "La Cachicania," p. 219, n. 4). Ximenez (*Descripción*, p. 388) attributed to Mora the Compaña, the passage to it, and the garden pool below the sun-corridors.

[19] AME: xi-46, f. 5-7; xii-5, f. 2-3.

[20] AME, xii-5, f. 11-12, 16ᵛ-18; ibid., 20ᵛ-22 (north roof). Stables: Almela, "Descripción," p. 86; AME, xii-7 (1592).

[21] AME: xii-17, f. 18 (1593); xii-30, f. 23 (23 July 1594).

[22] Ximenez, *Descripción*, pp. 386-388.

[23] AME, vii-35, f. 14ᵛ-21 (6 April 1581).

[24] AME: viii-30 (8/10 November 1583), specifications for masonry and brickwork on "aposentos de los doctores del colegio"; ix-1 (17 January 1584), contract for carpentry; ix-2 (2 November 1584), agreement (*obligacion*) to roof *las casas de los doctores*; ix-24 (18 January–12 April 1585), payments for windows; ix-28 (21 February 1585), appraisal of masonry *en los tres casas de los doctores*; xiii-22 (1596), appraisal of parapet (*paredon*) in front of the *casas de los doctores* (f. 31) and between it and the *casa de oficios*. This last document makes it clear that the professors were living in the easternmost unit, which was built before the second *casa de oficios*, housing the King's kitchen services.

[25] FME, pp. 402-403: "Se iguale lo que es servicio con lo que es lo primero."

finest rooms on the south exposure, however, were assigned to the gentlemen of the table, as well as the mayordomos and their aides, while the cooks and stewards had rooms nearer the kitchens and storerooms. By 1589, when the *Sumario* appeared in print, there was no mention whatever of the extramural professors' houses, and the two *casas de oficios* then standing were described as both being for the service of the royal table.[26] In other words, the houses for professors had become housing for courtiers attached to the King's table.

More drawings in Herrera's own hand exist for these buildings than for any other part of the Escorial.[27] The drawings all are for the second *casa de oficios* to be built, designed specifically for the royal kitchens and table service as the western one of a symmetrical pair (fig. 7, left edge). Their foundations were excavated from the hillside to the north, and a difference of about twenty-two feet is marked between the building grade of the palace and the upper street above the two houses. The lower street drainage at the building level of the Escorial runs off to a sewer[28] underneath the stone fence separating the street from the north plaza (*lonja*) of the palace. This section is carefully studied on figure 88C, where the pitch is marked as 2 feet in 136, and 1 foot in 50. The lower street rooms at ground level were marked (fig. 89) for a pharmacy, a fruiterer, and a bakery, probably reserved for the occupants. Other rooms to the north and without windows are marked as cellars and for food storage.

The south façade to roof cornice is the same height—fifty-five feet—as the north front of the palace, but the roofs there rise higher. On figure 90 each unit has a large, two-storied kitchen with access from the colonnaded court. A chapel entered from upper street level was planned in the northwest wing (fig. 87A), but this scheme was postponed in favor of smaller and lower kitchens with oven rooms and access to small kitchen courtyards with entrances from the high street. The temporary plan is figure 87B, which is annotated in the manner of the *Sumario* as a text explaining the drawings. The kitchens are now the largest rooms in the block. Rooms throughout are specified as being for the service of the King or for the royal family's service (*sus Altezas*), or for both (*para su magestad y altezas*). Cold-storage rooms (*guardamangieres*) are marked at the northern corners. As noted earlier, the contracts for this edifice were drafted in 1587 (foundations) and 1588 (south façade).[29]

The closing of the northwestern stonescape, with other residential and ministerial buildings completing the wall of houses (fig. 91), was accomplished in the eighteenth century, in a literal revival of Herrera's style beginning in the 1770s. The *casa de infantes* on the west displaced some farmyards of the Compaña in 1771[30] with subdued replicas of the severe façades of the monastery and college, based both on Mora's Compaña and Herrera's service buildings. Two new ministries closed the north wall of houses (*casas de ministros*, 1785). After this time all the northern outbuildings were used as dwellings for court officials and their servants, and the town of San Lorenzo was redesigned by the office of Juan de Villanueva, who also remodeled the palace. The enclosure of the Escorial by these walls of housing was perhaps not foreseen by Herrera, and it certainly was not part of Toledo's "universal plan," but Villanueva extended Herrera's system of outbuildings as wall separating the palace from the upper town. It is a steep wall of houses among which visitors must climb stairs or ramps to leave the level plazas at the Escorial.

[26] *Sumario*, 1589, 15v-16: the eastern one is specified as "casa para officios de boca del servicio Real," and the western one as "para aposentos de officiales de boca."

[27] LS, pls. 39 (fig. 88D)-49 (fig. 90). L. Rubio, CD 162 (1950): 98: LS, pls. 40 (fig. 88C), 41 (fig. 88E), 42 (fig. 89), and 44 bear Herrera's signatures; pls. 46 (fig. 87B) and 49 are attributed to Herrera; pls. 39, 43, 45 (fig. 87A), 47 (fig. 88A), 48 (fig. 88B) are of unknown authorship. Lopez Serrano says the last three, pls. 47, 48, and 49, are by assistants. Eleven drawings from the office of Juan de Villanueva (six are illustrated by Valenzuela, "El Escorial"), now kept in AGP, were

made in 1785 for the remodeling of the first two *casas*, and the addition of two more blocks of three units each, as westward extensions of the *casa de oficios*.

[28] AME, XI-19, 1588 (payment).

[29] Rubio, CD 162 (1950): 114-115 (12 March 1587; 9 February 1588). Also AME, XI-15 (another copy, same date, different signatures). Further work: AME, XII-17, f. 21v-25 (1593), masonry; AME, XIII-7 (1595), carpentry, on *Oficios Nuevos que se hacen para el servicio de la casa real*.

[30] Ximenez, *Descripción*, p. 388; G. Kubler and M. Soria, *Art and Architecture*, p. 52.

THE PLAZA PROMENADES
(*LONJAS*)

At the Escorial the *lonjas* serve both as plazas for the townspeople to gather and as promenades for play and exercise. Figure 88C states the width of the north *lonja* as 136 feet (Spanish), and the plan by Jürgens (fig. 91) shows the two-colored paving-stones marking the *lonja* as three 44-foot squares wide.[31] The west plaza is five wide, or 220 feet, and the ratio of the widths is 3:5 (taken by 44-foot squares). This module is based on the width of the square towers on west and north fronts. The grid of the squares is apparent only at the northwest intersection of the promenades. At the various entrances to the block, the intercolumniations are reflected in different grids that obey the rhythmic intervals of the two façades (fig. 2, 1597).[32]

Historically these *lonjas* are part of the Spanish medieval tradition of paved church entrances and approaches, in different colors and linear designs. At the Escorial they are always open to the public, unlike the garden terraces to east and south, reserved for royalty, court, and friars, together with the meadows and hillsides below them. In 1587 (the date on figure 7 in Perret's signature as engraver) the clearing of the building debris at the façades had begun, but the paving and parapets were still to be completed. Figure 7 is therefore an anticipation, and is the guide that has governed the recent restorations of the *lonjas*, which alternate between decay and repair, like a beach at the monastery upon which the world's waves beat.

Work could not begin on these promenades until the building itself was complete. The first contract was for leveling and removal of earth at the west and north façades by cubical units (*estadales*, about 3.3m on a side)[33] to be taken to the declivity northeast of the Escorial, where the long northward-stretching earthen platform, called the *Terrero*,[34] was built to make in due time a municipal park dedicated to Philip II. The low parapets with long granite benches lining the inside faces, and granite spheres marking the entrances, were contracted a year later.[35] The avenue outside the parapet at the west façade, between the monastery and the Compaña, was laid out, paved, and appraised in 1590. The geometrically patterned granite paving stones reflecting the façade compositions were contracted in 1596, when nearly 2,000 yards were ordered.[36]

ROOFINGS OF SLATE AND LEAD

The stony effect of the granite façades is enhanced by the use of dark gray slate roofs with sheets of lead at the gutters and in the valleys. These concavely covered roofings endow the Escorial with a suppleness in the high-peaked gables compensating for the monastery of long unbroken plane façades. But they too are part of the stonescape, changing hue with the hours of the day in a varying counterpoint: granite, rosy at twilight, and steely under overcast skies, when slate changes from dark blue to dull pewter. The stonescape is never long without change in the turbulent mountain climate; under some skies the stone appears like fine-grained golden-hued limestone;

[31] O. Jürgens, *Spanische Städte*, Taf. xii.

[32] These dimensions and ratios are those of the restorations in this century. In 1589 Herrera stated the work width as 140 and the west as 200 feet (fig. 1, and *Sumario*, p. 15ᵛ). The modern repavings have departed from Herrera's design, shown in figure 7.

[33] AME: ix-28, f. 12-13 (21 February 1585); x-2, f. 82-86 (24 February 1585); x-28, f. 24-25 (n.d.), (*Terrero*).

[34] AME, xii-24 (n.d.), includes a plan of the fill needed at the northeast corner of the palace *lonja*. It shows an elevation of the parapet, drawn possibly by Herrera (on Herrera's handwriting, L. Rubio, CD 161 [1949]: 170-173).

[35] AME: x-8, f. 48-51ᵛ (31 August 1586); x-17 (27 December 1586). Rubio, CD 162 (1950): 98-99.

[36] AME: xi-42, f. 14-15 (23 November 1590); xiii-16 (31 May 1596).

under others it seems coarse and leaden. At sunset the west front appears aflame from within its own substance; in the afternoon shadows, the granite grows blue under black slates. At daybreak the slates sparkle, but the granite becomes blue, turning to gray. These steep roofs at the Escorial distinguish it from all other buildings in its age, the late Renaissance, and in its tradition the royal residence. The steeply dormered slopes of scaly slate are of Flemish ancestry and workmanship, and the complex pyramidal assemblage of each of the six spires acknowledges the presence of the Low Countries in the Spanish Empire, while the granite façades with their proportionally distributed fenestration belong to the Vitruvian tradition via the Renaissance in Italy.

The slate-sheathed carpentry spires are presented in a drawing both in plan and elevation (fig. 19).[37] It differs from the present shape, one of many rebuildings after fires, by having only one row of dormers instead of two. The drawing also lacks parapets, but it shows concavely curved silhouettes for the pyramidal turrets at the corners of the square spire base. In 1589 (fig. 3), Herrera allowed Perret to engrave them without curvatures, as seen today, but the Hatfield drawing shows them curved. Figure 19 is a simplified study that lays out the complex form of the two eastern corner-tower spires. An attribution to Toledo is denied by the main portico drawings (fig. 83) assigned to him, which would show, were they his, that he preferred domes to spires.

The design of the spires was generated by different geometric figures visible in the plan as a square containing an octagon. Both octagon and square are divided into nine squares. The central square is the base of the tapering needle, and it contains another square inscribed with its corners touching the midpoints of the base. The passage in elevation from the octagon to square is angled at 60° to form an implicit equilateral triangle. The method is alien to Renaissance design, and it came

to the Escorial with Flemish carpenters and slaters who worked in medieval guild-habits of generating elevations from plans, as exemplified in the work of Mathäus Roriczer.[38]

Unlike the spires of the two crossing towers in college and monastery, these corner-tower constructions of timber and slate served no known lighting needs. The eight dormer windows were unconnected to the rooms underneath, but they ventilated the interior as well as animating the corner silhouette with their quaint northern and hooded profiles.[39]

A variant was used on the western towers, reducing the square bases by one-ninth at the inside, or cloister corner, to produce L-shaped shafts in the tower plans (fig. 79). These sacrifices were necessary to allow the corresponding cloisters the same dimensions as the others in college and monastery (fig. 1, *66, RR*). In each case, the suppressed spire corners correspond to one of the corner bays in the cloisters below. The staircases were inserted into two more units of the nine-square division, and the rectangular remainder of each tower floor, equal to six squares, was turned into two-room apartments, respectively of two and four squares. This process of design is another instance of "warping" inner and outer surfaces into a skewed shape. The evidence here suggests that the design of these corner-tower spires was established before 1564. Work on the southwest spire was going on in 1571, and the southeast spire rose in 1572, but the northern spires were contracted only in 1579.[40]

The design of the palace court completely conforms on the exterior with the steep Flemish slate roofs of the monastery and college, but from the courtyard the nearly flat Italianate roof-terraces on north and east ranges (figs. 4, 92) successfully mask the stark exterior roofs, so that they are invisible from all points at ground- and upper-floor levels.

The attics are understood as being just over or

[37] Zuazo (*Orígenes*, p. 33), gives the plans of the spires as built: the corner squares are separated by rectangles of triple proportion, to achieve a more slender spire than in the nine-square project.

[38] P. Frankl, "The Secret of the Medieval Masons," pp. 46-64.

[39] Andrada, "Reconstrucciones," pp. 330-331.

[40] Southwest: AME, ii-168 (13 October 1572) payment to

Oliver Sinot on specifications in AME, ii-149 (13 March 1572), mentioning a *traza*. The southeast spire also was built by Oliver Sinot (AME, ii-182, 13 October 1572). The infirmary spire, having been burned by lightning in 1577, was rebuilt at once (AME, vi-8, 9 September 1577). The northwest (college) spire was contracted together with the northeast spire (AME, vi-41 and vii-6, 27 March 1579), but its construction was delayed five years (AME, ix-1, f. 49-51ᵛ, 8 March 1584).

under the eaves, while the garrets are in the peak of a gabled roof, providing at the Escorial a number of lodgings nearly equal to those in the lower stories and entresols. In the small cloisters of the college and monastery, each range had three attic and four garret dormers on the cloister sides, with the possibility of at least three hundred chambers under the slates in the eight courts. But in the palace court and main cloister the dormers are in single row only, lighting the garrets, while the attic dormers appear only on exterior façades, suggesting that another one hundred chambers at least were available above the eaves. In the palace ranges, figure 4 shows round-arched windows at the eaves, which are clerestory windows rather than dormers, lighting the upper entresol chambers.

Sigüenza, followed by Santos and Ximenez, devoted one chapter to these "humble parts" (*partes menudas*),[41] pointing out that the two levels of chambers rose twenty-five feet under the ridgepoles. The lower level of *camaranchones* ("wide chambers") was the more desirable attic story (fig. 93), and the *desvanes* ("garrets") were in the less desirable triangular peak. The garrets were assigned to novices in the monastery and to servants in the palace and college. Warmed in winter by over fifty chimney stacks, they were intolerable under slates and sheets of lead heated by the summer sun.

Sigüenza attributed the steep roofs in the Escorial to Fray Antonio de Villacastín as of 1564, when the capacity of the monastery was doubled by increasing its height. But he specified as Villacastín's contribution only the arrangement of the dormers in two rows on the roofs, three in the lower, and four in the upper rows of each range.[42] Sigüenza praises the way in which the friars' cells in the attics thus opened directly to the light instead of being shielded from it behind cloister walks. His praise, however, not only makes the worst rooms appear best, but the attribution is wrong, because roofing in slate on wooden frames was introduced to Spain by Flemish carpenters, such as Oliver Sinot[43] and others before him.

FENESTRATION

Visitors to the Escorial have always asked how many windows and doors there are. The question testifies that the fenestration is important in the stonescape's total effect on the spectator. The earliest guess, by Fray Jeronimo de Sepúlveda, ventured 15,000 in 1603.[44] The distribution of the windows varies according to exposure and rank. The fewest are on the cold north side, and the greatest number on the east. Basement transoms are the smallest, and the next in size are those under the eaves. The dormer windows in the roofs are the only ones of wood, small upright rectangles, more widely spaced, and fewer than the windows in the lower stories. Between basement transoms and attic dormers are four tiers of windows on all façades excepting the King's house. On all floors the exterior windowsills usually mark the floor levels inside.

North and south façades differ, however, in the number and spacing of the window axes. The south façade has forty-seven, equally spaced and divided

$$3–20–3–18–3$$

(southwest tower–cloisters–refectory–chapter-rooms–southeast tower). The north has only twenty-nine, being more exposed to winter weather, and they are unequally spaced, and divided unequally by pilasters (lacking on the south) in the irregular rhythm

$$2–1–2–2–3–2–2–1–2–2–3–2–2–1–2$$

which stresses the college, kitchen, and palace entrances at the underlined intervals. This order was

[41] FME, pp. 393-399; Santos, *Descripcion*, pp. 39-99; Ximenez, *Descripción*, pp. 379-385.

[42] FME, pp. 222-223.

[43] AME: II-67 (28 February 1570), kitchen roofs; II-142 (1571), spire of infirmary tower. Also Iñiguez, *Casas reales*, p. 188, on slate roofs in 1563 at Valsain and the Alcazar in Madrid.

[44] DHM 4 (1924): 354. Salcedo de las Heras in 1867 counted 2,618 windows.

altered, in the remodeling of 1785 by Villanueva, in order to stress the displacement of the palace entrance toward the center, by rearranging the pilaster intervals[45] at the former kitchen portal, and resetting each lateral entrance one window axis farther away from center. Views of the north façade are rare. The painting by Antoine Joli (before 1771) may be inaccurate in having doors in the northwest tower base, but it records the morning light of late June, when the sun is at its northernmost position (fig. 94).

As to their structure, the earliest apertures, especially window surrounds, were more complicated than later ones. An early document indicates that although Toledo was seeking to standardize the specifications of stone door and window frames[46] for cutting and shaping at the quarry, their actual use at the south façade reveals a gradual simplification in several structural assemblages. The earliest windows, in the lower southwest tower and south façade have relieving arches built with voussoirs (fig. 95) over the flat lintel stones, as portrayed by Serlio.[47] Toledo and the King discussed these lintels under relieving arches (capialçados) in a long letter from the architect glossed by the King, who decided on single-stone lintels.[48] The relieving arches were accordingly in use only on the lower western half of the south façade. Elsewhere after 1565 trabeated lintels are the rule, excepting on the lower west façade near the southwest tower, where the discredited capialçados were used.[49]

Other structural features show a similar progression toward greater simplicity, as in the stairways. Windows on early stairs, built under Toledo's direction, have vaulted lintels made of long voussoirs increasing in width from exterior to interior wall surface (fig. 96A). Such intricate pieces of stereotomy recall the elaborate stonecutting seen in the manuscript by Andrés de Vandelvira.[50] These were abandoned on later stairways after Toledo's death, in favor of trabeated stone

construction, with countersunk iron beams (barrones) supporting the soffits of the longer granite spans (fig. 96B).

The north façade, with clustered or grouped window axes squeezed together or spread apart, differs greatly from the south front, as if to stress a contrast between the secular life of the college and palace on the north with the monastery on the south. But at the eastern façades flanking the King's house, the palace and monastery are identical, sharing the same fenestration and elevations, differentiated only by the many palace chimney stacks, and justifying Sigüenza's claim that court and palace were a monastery too.[51]

The west façade presents still another system of thirty-seven vertical divisions by pilasters. Here the order is

2–3–1–(3)–1–3–[2–(7)–2]–3–1–(3)–1–3–2

marked centrally by the immense portico, and laterally by college and monastery entrances. The building rests on the basement transoms and a three-foot plinth (fig. 50), the partly sunken design being shown to full effect. The lateral entrances, being nearly identical, are subordinate. The northern one is the main approach to college and seminary, but the southern door is the kitchen entrance, approached by a ramp for wagons and mules, which could descend by another interior ramp to the storerooms to deliver firewood and provisions.

The fenestration of the King's house differs from the other façades, beginning at Toledo's discarded "tower" bases (fig. 6, K, H-I). On both floors the windows are wider and taller than the largest ones in the monastery, and their spacing is regular without pilastering, but a cornice between stories at the fifteen-foot exterior building level defines an entresol that is marked nowhere else. It indicates a domestic scale, and its expressive purpose may be to stress the retiring tastes of the monarch, who would have liked to be a modest gentleman with an annual income not over

[45] Moya Blanco, "Caracteres," p. 167. The coursing stones originally cut for pilasters were probably reset in new positions.

[46] AME, I-69 (7 February 1566; 11 February 1567): "Memoria de la piedra y pieças q se mandan al presente sacar." It specifies the dimensions of jambs (pilares quadrados), sills (sillares), and voussoirs (dovelas). The rubble hearting is also described, and the unit prices are given.

[47] Tercero y quarto libro, f. xvii^v.

[48] PA, pp. XXXVI-XXXVIII (11 July 1565).

[49] Padre Luciano Rubio kindly pointed them out to me in July 1978.

[50] No. R-10, Biblioteca, Facultad de Arquitectura, Madrid.

[51] FME, 119: "no . . . Corte ni Palacio sino monasterio de monjes sin habito."

8,000 ducados.[52] On the exterior it is less sump-tuous than any other façade. Only the windows are larger than elsewhere, but its building and roof levels are lower than those of palace or col-lege and monastery (fig. 5, *I-H*), resembling the plainest of Serlio's country houses.

In Toledo's first designs for the monastery, to hold only fifty friars, the crossing towers of the college and monastery cloisters rose only half their present height. In their final form the height was doubled, like the cloister stories. This in-crease of the cloister heights on north, south, and west sides made their lighting more difficult, as the sun was blocked from the lower stories in all seasons. Herrera's solution in the monastery was to increase their fenestration wherever possible, and he made the crossing towers serve as light wells, catching sunlight for all levels at the quad-rangular intersections of the four-cloister units (fig. 97). In the *Sumario* (11ᵛ), he mentions the many windows on all floor levels, to light the surrounding passages which connect the different ranges (*cuartos*), corridors, and courts. The top-most of seven levels (a) corresponds to the eight dormers lighting the dome under the spire, and the next one down (b) to the free-standing shaft windows. The four next levels correspond to the lower attic (c) or *camaranchón*, and the top cloister floor (d), with the mezzanine *entresuelo* (e) below it, and finally, the two levels (f, g) of apertures below the thirty-foot level in the refectory. Thus the crossing tower functioned as a trap for day-light on many levels, most of it serving to illu-minate the dark lower floors at the intersections of the cruciform cloister ranges, entering by eighty apertures of seven stories.

At the college tower the plan is different be-cause of the need for wide lecture halls (fig. 1, *52, 53*), and the length of kitchen and recreation hall (fig. 1, *65, 55*), with the result that the tower is a rectangle of 4:3 proportion with only eight ap-ertures per floor, and these limited to bottom and top levels. The apertures were reduced from eight to twenty-four, with the need to separate differ-

ent functions in the boarding-school ranges of the cruciform cloister.

In general, the distribution of doors and win-dows uses few elements. The windows come in six sizes for most parts of the monastery, palace, and college, and in three for the King's house, and the doorways are also limited in variety. Sigüenza observed that most apertures were of double-square proportion (*dupla* according to Ser-lio), but large public doorways were propor-tioned 2:3 (*sesquialtera*).[53]

In the basilica the fenestration on its three prin-cipal façades, west, north, and south sides, is dominated by an unusual form called the arched pediment, where the entablature of the *fastigium* of the Roman temple is interrupted by an arched aperture. Sigüenza spoke of it as meaning the par-ticipation of divinity in the temple, beyond giving more light and having more authority.[54] The theme was revived by Alberti and varied by Pal-ladio. Ancient examples appear on a Hadrianic medal of the temple of Jupiter Capitolinus erected on the site of the Temple of Jerusalem, as well as on Roman coins showing temples to local deities in Palestine, Syria, and Phoenicia.[55] One at Or-ange was drawn by Giuliano de Sangallo, and the palace of Diocletian at Spalato includes it. L. B. Alberti used it in 1466 at S. Sebastiano in Mantua (fig. 28), and Galeazzo Alessi incorporated it in 1552, at S. Maria di Carignano in Genoa (fig. 25), on the three principal façades as at the Escorial, in a more awkward form as a lunette inside the ped-iment, yet serving as at the Escorial to improve the interior lighting. Herrera's use of the arched pediment also helps to establish his knowledge of Albertian and Palladian effects.[56]

The lateral vaults of the basilica are perforated by ten large clerestory lunettes of semicircular outline, with vertical divisions marking three lights in each window (figs. 4, 5). These lunettes resemble and are derived from the upper fenestra-tion of vaulted Roman imperial baths after Tra-jan. Palladio was probably the intermediary. He used the three-part lunette repeatedly beginning

[52] Porreño, *Dichos*, p. 148.
[53] FME, p. 228.
[54] FME, pp. 320-321.
[55] Hébrard and Zeiller, *Spalato*, p. 164. Orange: C. Hülsen, *Il Libro di Giuliano da Sangallo*, pl. 25.
[56] The examples by Palladio are at Villa Malcontenta (before

1561), Villa Poiana, and Villa Barbara (built 1560) at Maser. M. Walcher Casotti (*Vignola*, 2: 216) sees these effects as me-diated by Vignola's first project of 1568 for the Gesù façade at Rome which, preserved in a medal, had an arched pediment (ibid., fig. 217).

with early villa designs (1541-1545), where he used the "thermal" window as an expression of large vaulted structure, to mark groin-vaulted chambers of great spans.[57] Other architects prior to 1560 were reluctant to adopt this post-Vitruvian theme, but it was almost a signature for Palladio, who learned its use in his detailed studies of the ruins of Roman baths. After 1558, he began to apply it to religious buildings.[58] Among the earliest drawings preserved of the Escorial is the section for the basilica before 1567 (fig. 26). A large thermal window (one of six?) appears in the transept wall but no other fenestration is shown here at clerestory level. It is perhaps the earliest dated appearance of the thermal windows now known in Spain. Its author may have known of Palladio's experiments in this direction in churches after 1558, but figure 26 is too early (1561/1562?) to depend on Palladio's *Quattro libri* of 1570.

Some apertures show irregularities that may be grouped under the rubric of symmetrical warping.[59] They occur at places where interior and exterior shells differ in plan, elevation, and spatial geometry. An example in ground plan is the south doorway between the library and the adjoining cloister (fig. 2, *R,O*), drawn in 1589 as a blind doorway, but opened later by cutting the jambs on the bias, to reconcile the conflicting symmetries of library end-wall and cloister walk. In the library a three-part symmetry commanded, and on the other side in the cloister the same opening was shifted farther east to occupy an axially symmetrical position on the long corridor, in obedience to the doctrine of correspondence among similar parts. Because neither symmetry can be sacrificed, the wall itself must be warped to accommodate the conflict of symmetries, while permitting an aperture to function.

In elevation, the wall membrane may be warped both vertically and horizontally, as in the east library wall above the bookcases (fig. 98). The inside and outside of this wall obey different proportional systems. The inside proportions are governed by the functions of storing and using books in a regular grid, but the outside proportions are determined by the spatial geometry of the forecourt between the library and the church

façade. The resulting discrepancy warps the window wall vertically: the inside window is lower than the outside one. Both lintel and sill are sharply inclined, and the jambs are warped horizontally and asymmetrically. Another example is in the King's apartment (fig. 1, *102*) at the eastern exit and the symmetrical repetition on the north side (fig. 1, *57*), where warped passages appear in the thick "tower" wall.

Larger discrepancies between symmetries of inside and outside the same wall are treated without warping. The huge vaulted chamber (fig. 1, *MM*) designed to store the friars' clothing and bedding, rises thirty feet, but the half-oval section of the vault arches over three window-axes in two stories on the forecourt façade. Its position there, however, is asymmetrical relative to the window-axes (which are symmetrically grouped) but symmetrical relative to the cruciform plan of the four cloisters. The membrane between the room and the court is not warped, but the principle of correspondence is ignored, and the spectator in the forecourt sees the vault spanning three window-axes in a proportional system differing in rhythm from that of the forecourt. The two rhythms may be diagrammed to show the different lengths of court and cloister, varying roughly as 20:21.

| cloister | 9 | 3 | 9 |
| court | 8 | 4 | 8 |

Other large vaulted chambers at ground level, rising to the thirty-foot cornice, likewise require either ignoring a discrepancy or warping the wall. The first solution (by ignoring) is followed in the refectory (fig. 1, *OO*) and the twin chapter-rooms (fig. 1, *&, R_x*) and the sacristy (fig. 1, *R*), as well as the parlor (fig. 2, *E*) and the provisional church (fig. 1, *GG*). In the college are the lecture halls (fig. 1, *52-53*) and in the palace, two large reception rooms for the royal family (fig. 1, *89, 90,* and fig. 75). All higher than their neighbors, these chambers are vaulted spaces incorporating windows at the upper level and rising to the thirty-foot exterior cornice.

Two warped walls appear in the palace. One is at the palace stairway (fig. 1, *86*) on the mezzanine level, where the stair cage and the palace gal-

[57] G. Zorzi, "Palladio," p. 60.
[58] G. Zorzi, *Antichità*.

[59] Sigüenza, FME, p. 279, calls them "ventanas puestas en viaje [bias]."

THE SURROUNDING STONESCAPE



lery both require different intervals of symmetry. The essential window at the top landing is warped to accommodate both symmetries. Another is in room *79* on figure 1, where courtiers took their meals, adjoining the service entrance vestibule (fig. 1, *75*). Here a west window, obeying the exterior proportioning among twenty-nine axes, was warped to light the dining-room corner. This warp repeats on the upper floor to give one gentleman's chamber two windows instead of the usual one. There is also an unwarped asymmetry at the vestibule (fig. 1, *75*), analogous to the one at the wardrobe in the monastery. The original service entrance was at a narrow pilastered bay between wider ones, to mark the lesser rank of its users, who were servants and cooks. It was also the entrance where carriages could enter, turning into the palace gallery and up the ramp into the royal courtyard (fig. 1, *86*). Room was needed at the carriage entrance to turn, and to take and leave passengers, relaxing the urgency for interior symmetry on the north wall.

Symmetrical warping has never been systematically studied, but there is reason to associate its occurrence with the heavy thick walls of military architecture, where angles of fire conflict with other conditions, such as stability. Both military and domestic planning share this conflict of interior and exterior requirements. The warping of the wall is its result. At the Escorial its presence may be owing in part to the military background of Juan Bautista de Toledo, as well as to the Plateresque tradition in stereotomy that was embedded among the masons of Spain and Portugal, and emigrated with them to the Indies, especially New Spain.[60]

STAIRWAYS

At the Escorial they are characterized by abundant daylight at every floor, modular uniformity, utilitarian placement, and structural simplicity. All are at corners where traffic converged, or at intersections, like the main cloister stairway, called "imperial," which served five cloisters on three levels (fig. 1, *FF*; fig. 2, *L*). Near the corner towers the stairs are paired, parallel, and reversing flights, separated by unbroken masonry walls, wide enough for everyday traffic in the monastery and college. In the northeast buildings used by courtiers and their servants, the need often existed for at least eight stairways, of which two were in the King's house, three in the Queen's building, and three in the courtiers' floors of the north range. But at the monastery, each of the four small cloisters had only one stair at a corner, while the larger cloister had three stairways in addition to the "imperial" one.[61] The landings of all these stairways were level with the floors they served, and the upper floors were uniformly level throughout[62] in all directions and without exception.

On the lower floor, however, the need for carriage and wagon services required entrances by ramps from ground level to the building level at the monastery and palace kitchens, as well as at the royal entrance (fig. 1, *55, 49, 75, 83*). The entresol levels also were distinct, and approached by separate flights (fig. 1, *86*; fig. 2, *9*). The widest treads had the lowest risers, as in the "imperial" stairs and at the ample "open-center" stairs in the palace (fig. 1, *86, 80*), and at the six paired flights from the garden terraces to the meadow south and east of the platform.

These garden stairs seem redundant until it is noted that the gardens and meadows formed separate domains for different users. The palace gardens on the east terrace were divided as the ladies' garden adjoining the King's house at its south.

[60] F. Chueca, *Vandelvira*; also, Banda y Vargas, "Hernán Ruiz II," pp. 85-91, and Hernán Ruiz II, "Libro de Arquitectura" (both discussed by M. Gomez-Moreno, *El Libro español de arquitectura*, 1949, pp. 12-13; 14-71. Portugal: G. Kubler, *Portuguese Plain Architecture*, and *Mexican Architecture of the Sixteenth Century*, passim.

[61] The term *imperial* came into use for this type of stair in this century. The earlier sources always referred to it only as the *escalera principal*. Wilkinson, "Escorial," p. 65, n. 1.

[62] Ximenez, *Descripción*, p. 140: "the entire 30-foot level is on one plane throughout monastery, college, sanctuary, and palace, without our having to go up even one step into any room or service whatever."

The King's garden was the easternmost projection of the platform. The Prince's garden opened north of the King's house. The court used the garden east of the Prince's wall to the northeast tower. The friars' garden occupied all the southern terrace, turning north at the corner to the wall of the ladies' garden. Thus the friars had the use of four stairways; the King, Queen, and Prince used the axial stairway, and the court had the use of the northeastern one.[63]

The twelve flights are all identical, built to the same specifications, of which the prototype was probably written for the stairs leading down from the temporary dwelling of the King at the center of the south-façade garden terrace.[64] At the foot of each pair of stairs is a richly designed underground garden pavilion designed for hot weather with stone seats and niches.

The Hatfield drawing (fig. 99) shows the stairs to the prior's garden under construction in 1576. Subterranean exits are being built beneath an overpassing stair and platform of brick. These rest on a building grade about twenty feet below garden level. At garden level, niched retaining-wall sections are in construction. The entire area will finally be filled to garden level, which is the level of the basement floors (fig. 3, L, M, N, O), twenty feet below the ground-floor platform of the monastery.

The exterior housing of the main cloister stairway (figs. 48, 100) includes and covers not only the square plan of the three parallel flights and the landing at the fifteen foot level, where the lower ramp divides in two parallel rising flights, but also the corridors flanking the stairs on north and south, in an oblong tower with inset corners on its west façade. The shaft of this tower rises eighty-two feet, as high above the surrounding roofs as does the monastery crossing tower, but its dormered roof is half the height of the crossing tower spire (fig. 6). The windows of this stair-tower serve as a clerestory, not alone for the stairway and its vault but also for the flanking corridors. The clerestory level has five east windows and four facing west. Under the stairway vault, only seven of fourteen windows admit light; the other seven are painted windows. Only seven serve the stairs, and the other four light the upper floor corridors.[65]

BASEMENTS AND CISTERNS

Their network underneath the Escorial is also part of its stony world, but no complete plan exists of their distribution (fig. 101). The south and east buildings are supported by a system of basement vaults receiving direct light from ninety-nine grilled windows set into the sloping façade wall, or talus, designed by Juan Bautista de Toledo (fig. 4, R, S). Other vaulted basements underlie the west buildings, where they also form a network for services and storerooms.[66] These were lighted by window shafts like transoms, angled upward to the building level, and forming a row of twenty-four window heads at the juncture of façade and paving (figs. 7, 50).[67] On the north front no basement windows appear at any point (fig. 102), because the basement network is lacking under these buildings, excepting under the north gallery walk of the palace courtyard, where the carriage driveway runs.

Thus the southern and eastern basement chambers are not really underground, but rise at the building grade of the garden-terrace platform, which is fifteen feet lower than the building grade at west and north. Their typical plan appears on

63 Andrés, DHM 7: 299, n. 1.

64 AVE, legajo 2, f. 86-91 (5 October 1570), and AME, II-75 (14 August 1570), based on lost working drawings for the flights of thirty-three steps, nine feet wide, and listing all materials needed with their prices.

65 Ximenez (*Descripción*, p. 59) corrected Sigüenza's faulty dimensions (FME, p. 231; 45 by 40), giving 59 feet long, 41 wide, and 82 high for the stair cage. Quevedo (*Historia*, p.

319) and Rotondo (*Historia*, p. 253) copy Ximenez but mistake the painted windows for real ones when saying there are fourteen.

66 FME, p. 394; Santos, *Descripción*, pp. 93-98; Ximenez, *Descripción*, p. 401.

67 As drawn by Serlio in Book Seven, p. 57 (ed. 1619) for a house he built at Fontainebleau before 1547. Rosenfeld, *Serlio*.

figure 73 (bottom) showing a narrow barrel-vaulted series of long chambers underneath the east palace gallery, built of coursed foundation masonry. Doorways open at intervals into chambers that are also barrel-vaulted, but at right angles to the long vaults, all opening into one another by arched doorways forming a corridor (fig. 103). Thus a series of outer chambers or corridors, with high transom windows, is backed by another series of long chambers without their own light, which were perhaps for storage, connecting with the corridor and with each other. Other types of basement underlie the main rooms, such as refectory and monastery kitchen, and support the cloister walks. Underneath the chapter-rooms on the south façade, the basement vaults are doubled to span the thirty-five-foot widths with medial support. Cisterns to store rainwater are under the cloisters. The toilet halls were drained by tanks (balsas) supplied with running water from mountains and springs. The only description of these balsas is by the engineer Pedro Salcedo de las Heras, whose rare lithographed plan of the Escorial appeared in 1876.[68] The balsa was like an inverted vault of stone thirteen meters long surmounted by supporting arches to hold up the toilet with sixteen cubicles in the chamber above.[69]

DUCTS AND DRAINS

Throughout the basements the waterlines serving the outlets on all floors, including the gardens and fountains, and totaling eighty-six,[70] ran in tunnels, permitting the plumbers (fontaneros) to repair and clean them. Sigüenza briefly described the eight cisterns under the garths in the cloisters and college (fig. 1, LL, RR, 56). The two largest ones were under the forecourt. In each pair one filled while the other was in use. Another cistern served the sacristy from rainwater collected in a second cistern under the main cloister. Throughout the buildings more than fifty fountains and spigots distributed the water, many of them on the upper floor in bronze conduits, in a system having over seventy turn-off points above and below ground level. The toilet buildings in the monastery, college, and palace were served by sewer tanks through which unused water from all services flowed constantly.[71]

The system itself (fig. 105) is described in a manual of maintenance composed in 1645 by the vicar at that time, Fray Nicolás de Madrid, who had solved the problem of the flooding in the burial crypt.[72] This flooding was brought on by having dug the floor of the vault 1.40 meters deeper than originally built, in order to meet the requirements of the new design by J. B. Crescenzi and J. B. Lizargarate[73] for a domical vault forty feet high. The drainage waters from the two open courts flanking the sotacoro (fig. 1, 41, 42) and the unexpected appearance of new springs in the foundations of the basilica, were the origins of the flooding, which recurred in 1691-1692 because of the drains' being closed by invading vegetation and backing up in underground chambers to their ceilings.[74]

The main supply, in addition to runoff from the roofs, came from the mountain streams on the heights near S. Juan de Malagón as a gravity system with enough pressure to raise part of the water in sealed pottery and bronze ducts to the thirty-foot level for use in the upper rooms. The kitchen received hot water from heaters seven to eight feet high, and its sinks had both cold and hot taps. The pressure in the system[75] could be controlled by closing ducts not in use; it was essential that raised tanks on the same duct be built at exactly the same level to prevent loss from the higher to the lower.

The main ducts from the mountain were chan-

[68] Two copies are in the map collection of the Biblioteca Nacional, and its publication was reviewed by Mariano Borrell in Revista europea, no. 117, 21 May 1876.

[69] A plan accompanies AME, II-112 (16 November 1570) (fig. 2, N).

[70] Ximenez, Descripción, p. 38.

[71] FME, pp. 394-396.

[72] Andrés, ed., "Libro de la Fontaneria," pp. 290-318.

[73] Ximenez, Descripción, p. 322.

[74] Andrés, ed., "Libro de la Fontaneria," pp. 293, n. 1, 316-317.

[75] Ibid., pp. 304, 309-310.

neled into a series of cisterns with filters of crushed rocks leading underground to eight ducts entering the service portal of the palace (fig. 1, 75). These were gathered in an underground tank, which could be emptied for cleaning by diversion into the toilet sewer under the northeast tower, the toilet building for the palace (fig. 1, 87; and fig. 73). From it eleven main ducts of pottery tubing, which were fitted sections sealed with bitumen, supplied and drained the buildings. These main pottery ducts were laid in subterranean passages large enough for a repairman to walk upright, and were lined with two continuous benches at knee level, where the tubes were laid. Their repair was frequent, because heavy rains would break the tubes, and ice would dislodge the bituminous seals.[76]

Some ducts were only for fresh water; others were to drain the buildings of unneeded water from fountains and troughs into the terraced gardens and into the toilet sewage tanks for their constant cleansing. The largest *balsa* (fig. 1, *KK* was called by Herrera a place of great cleanliness (*Sumario* 11ᵛ.). It was recently rebuilt for the fourth centennial (1963) as a stairway, but a ten-foot section of it is still visible, as a tank twenty-two feet wide with an inverted-vault bottom of coursed masonry about ten feet deep in a wide trough shape, half-oval in section. Another smaller one was under fig. 1, *62*, as in the college. Both are drawn in the Salcedo plan of 1876 (fig. 104).

During heavy rains, when dirty water entered the system, all was passed directly into the *balsa* by closing all but the drainage ducts. The expert on hydraulic systems was Juanelo de Turriano of Cremona, who had been at Yuste with Charles V. It is likely that he was consulted on the choice of the site and that he advised on the layout of the water supply, although his name appears in the documents only in 1578[77] when he gave advice on the bells of the basilica.

The system at the Escorial was not built all at once, but piecemeal according to the needs of the occupants. Two main ducts may have been enough for the monastery until the 1570s, and the other mains were laid when the excavations for palace and college began. The building of the final state of the system was the work of Francisco de Montalban, who first appeared on the payrolls in 1576 as master builder of fountains and ducts (*maestro mayor para fuentes y encañados*), at the same rank with Herrera and foreign artists brought to Spain as painters. In 1585 he was allowed to return to his native Andalusia to work on the military defenses of the coast. Going back to the Escorial in 1588, he was designated as *maestro mayor de los edificios del agua del Rey* and *fontanero mayor del Rey* in 1593. His last recorded payment of salary was in 1595,[78] and his work at the Escorial marks a technological peak in the Spain of his period.

It is likely that hydraulic considerations, from the beginning, affected not only the choice of the site but also the mode of planning by the least number of building levels, with the least possible number of entresol floors and minor stairways and ramps. These appear only in the eastern half for the court and high-ranking friars. The palace, basilica, monastery, and college all share the same building grade, with one major functional exception. This is at the northeastern corner of the palace (fig. 4, *M-L*), where the building grade was four steps lower (fig. 1, *83*) to allow carriages and wagons to enter the building and rise on a ramp to the level of the palace court at the royal entrance, designated by Herrera (*Sumario*, p. 15) as the vestibule for the royal guard and for royal persons to alight. The only other wagon ramp was at the monastery kitchen entrance, where provisions and fuel had access to the basements on a downward incline flanked by short flights of stairs into the kitchen. Such a lower access level therefore appears only at the palace and kitchen entrances, and at the main portico and forecourt (figs. 3, *A-B*; 5 *N-P*).

The advantages of this arrangement, whereby 75 percent of the building stood on a five-foot pedestal[79]—excepting at the six entrances, three on the west façade and three on the north (fig. 1,

[76] Ibid., p. 298. Specifications and drawings of one section, AME, II-91 (1570).

[77] AGS, 261, f. 170-171; RA 71 (1963): 23. A manuscript treatise attributed to him in the Biblioteca Nacional (Madrid) is a compendium in twenty-one books (incomplete) on sixteenth-century hydraulic knowledge.

[78] AME: v-14 (1576), x-1, xi-16, xii-17, and xiii-1.

[79] Figure 50A, attributed to Herrera, shows the monastery kitchen entrance in a drawing which can be dated before 1567. AME, I-94 (6 December 1567), contract for thirty-foot cornice.

SS, 48-49, 63, 69, 75, 83)—allowed not only a stairless circulation level among nearly all parts of the complex but also a clear separation by level between services and residences. In addition, the five-foot platform provided space to arrange ducts and drains as needed, even after the buildings were up, and in tunnels convenient for repairs. Its existence suggests forethought about the plumbing as well as hierarchy. Two early contracts clarify the situation in 1566, showing that the ducts were built within the basement foundation walls as well, with other connections being laid in underground basement trenches.

A small sketch plan of some early plumbing appears on the back of specifications written in Villacastín's hand for digging the ducts in the monastery basements. Some ducts had been built in the foundation walls, and their depth below building grade was to govern the excavation. The plan represents the storeroom (*bodega*) under the kitchen. These specifications are the earliest servicing example of *condiciones* in the monastery archive.[80] Another example is for the main basement duct between the toilet building and the kitchen.[81] Both were to be built after the foundations walls were finished, but some of the ducts had already been provided in those walls for the overflow from the kitchen to the toilet cistern.[82] Contracts for the tunneling of ducts are rare after 1570, perhaps indicating that their building and repair had been assumed by a separate service under the orders of the *fontanero mayor*.

[80] AME, I-64, f. 2ᵛ (15 January 1566).
[81] AME, I-66 (22 April 1566).

[82] AME, II-91 (1570), plan.

9

EVENTS AFTER 1600

VALLADOLID, LERMA, AND THE
BUEN RETIRO

The Duke of Alba correctly predicted in 1577 that the fabric would be finished more quickly than its decorations, to which the King replied, on another occasion, that he had made a dwelling for God, and his son if he wished might make one for his own bones and those of his parents.[1]

After Philip II died, the Escorial was long neglected, beginning when his son, under the control of the Duke of Lerma (1553-1625), turned as monarch to other projects. Luis Cervera has described these new interests as

creations where nature and building were united with new urban elements. Nature became more human and beautiful for the enjoyment of her charms. Delicate flowers and plants were acclimated to make gardens which were then enriched with statues and fountains and pools filled with rare varieties of fish. Reservoirs were built and rivers were used for boating parties and for fanciful entertainments. . . . The buildings surrounded by this splendidly landscaped nature are joyously spacious, amply housing hosts of guests and servants in rooms richly furnished with fine collections, often in separate pavilions united by galleries and passages, enframing plazas and courtyards where bull-

fights, comedies, balls, and other open-air diversions might be privately held.[2]

The Duke of Lerma had begun his domination of Philip III (1578-1621) by inducing the young King in 1600 to move the court from Madrid to newly created pleasures in Valladolid, thus isolating the monarch from his family and counselors, and surrounding him with nobles, courtiers, and servants of the Duke's choosing. At first the court was lodged in a group of town houses belonging to the Duke, rapidly enlarged by further purchases east and west of the river, and connected by covered passages and surrounding plazas set aside for the life of the court.

Valladolid had already become the geographical center of Palladian tradition in Spain with the work of Juan de Nates after 1589 (Huelgas Reales and the Angustias church in Valladolid, 1597-1604) and Diego de Praves (Vera Cruz church, Valladolid, 1581-1595), whose son Francisco translated Palladio's first book, dedicated to Olivares in 1625.

The favorite later decided, however, to bring

[1] Sigüenza, FME, p. 72: "Mas tardaran, Señor, en hacerse los adornos de esta fabrica que la principal." Ximenez, Des-
cripción, p. 321, repeating Santos (1654).

[2] Cervera, Conjunto, p. 11.

the King even farther away, to his own domains at Lerma, southwest of Burgos, where a festive palace compound came into being after 1604 on designs in part by Francisco de Mora, and built at the King's expense, including the *casa principal* completed in 1616, and a large ducal palace and plaza finished in 1618 by Juan Gómez de Mora, with corner towers and spires. Entertainments began at Lerma for the King and court as early as 1613, in a park that Lope de Vega then described as better than Aranjuez.[3] The completed palace dominated a colonnaded plaza surrounded on two sides by private houses in a picturesquely irregular and open manner, contrasting with Herrera's formal geometry. The palace is connected by a bridgelike wing with a monastery, and the ducal cluster also included industrial activities such as a print shop, textile factory, and dye-works. The façade, overlooking the Arlanza river valley and the palace park, is scanned by seven window-axes. The second and sixth project slightly to produce an in-and-out effect in the upper stories, enriching the otherwise plain masonry with unexpected rhythms, as a five-part façade (fig. 106) within the symmetrical three-part towered front, a complex variation on the exterior system of the Escorial.

When Philip IV became King in 1621, the same pattern of government by a favorite minister (*valido*) continued under the Count-Duke of Olivares (1587-1645), who in 1633 commissioned Alonso Carbonell to build parts of the Buen Retiro palace

in Madrid on the rural property he donated to Philip IV for the entertainment of the King and court in 1631. The name *Retiro* means a retreat for periods of mourning and fasting, adjoining San Gerónimo, the monastery founded by Enrique IV after 1460, and built in its present form by Ferdinand and Isabella in 1503 at the eastern edge of Madrid above the Prado. As at Lerma, the palace buildings were a loose assembly of separate elements connected by passages and opening on large parks and gardens (fig. 107) for court festivities.[4] A list of Carbonell's work at this date, signed by him, enumerates the King's building, another for his gentlemen, three towers, the decorations inside the buildings, five stairways, the ladies' passageway, a cow barn, an aviary, a walled nursery garden for the Queen, stables and ballcourt, and an arsenal. All was built with astonishing speed on secret funds raised by Olivares's agents from the sale of royal appointments to municipal offices throughout Spain. These funds were used for the costly Retiro buildings where Olivares oversaw many details. Caturla described the palace as "an extended garden made up of small gardens" on the principles of intimacy and surprise.[5] Between them, Lerma and Olivares in effect diverted royal funds to their own purposes as *validos* and *ministros universales*. The Escorial received only minor attention with the completion of the crypt and the sacristy decorations.

THE PANTEÓN

At Philip II's death the Escorial was complete except for the structure of its primary or initial purpose, the underground circular burial chamber intended for the tombs of the dynasty. The crypt itself, on Herrera's design with a rectangular two-storied choir, was in existence (fig. 5, *C, D, E*) only as a masonry shell without decoration, lighting, or drainage. The royal bodies were stored, not in it, but in a temporary chamber (popularly called the *pudridero*) immediately under the altar

table, built and paid for in 1576 (fig. 5, *B*).[6] It consisted of three vaulted chambers with eight niches for coffins, built within the masonry above the crypt and slightly eastward of it.[7] The body of Charles V was in the center and beneath the feet of the priest celebrating the Mass, and Philip II lay at his father's right. All built under Herrera's direction, these chambers are briefly described in the *Sumario*.[8] Two spiral stairs gave access to an upper balcony for the royal family and

[3] Ibid., p. 527, v. 14.
[4] Caturla, *Buen Retiro*, pp. 35-47.
[5] Ibid., pp. 22, 46, 47.

[6] AME, v-5-8, contract and payment.
[7] Andrés, "Relaciones," p. 161.
[8] HS, p. 23.

a lower choir for the friars. Two additional straight stairs entered the round crypt from the palace on the north and from the sacristy on the south.

Figure 44A shows Herrera's circular plan, with the four stairs and four light shafts to the exterior, in a tentative study prior to an octagonal scheme, which appears sketched on figure 44B. Both drawings were projects for the marble flooring, though none was used.

No more was done until 1617-1635, when the design was altered from a circular to an octagonal plan by G. B. Crescenzi, who turned the axes of the octagon within the circle 45 degrees away from conformance with the square plan of the sanctuary (Fig. 44C). By this design Crescenzi pointed alternate apexes of the octagon at the sides of the square, disorienting the spectator, who enters by the present stairway, facing an altar he believes to be east, but which is more to the north. This peculiar orientation of the octagon was probably made necessary by earlier interior windows, which entered the crypt from north and south on symmetrical angles (fig. 44A).

Crescenzi was ennobled as Marqués de la Torre and knight of Santiago by Philip IV.[9] After Crescenzi died in 1635, the work languished until 1645, when Fray Nicolás de Madrid resumed the project, completing it by 1654, following the designs by Crescenzi, and assisted by Alonso Carbonell and Bartolomé Zúmbigo. New designs were needed for the vault lunettes and the floor scheme, but the bronze ornaments and marbles assembled by Crescenzi could still be used.[10]

Fray Francisco de los Santos, writing before 1656, had the task of describing this newly decorated crypt, which he called the Pantheon,[11] devoting nearly half his book to its description and the rituals of transferring the royal bodies into it from the upper vault where they had been kept since 1586.[12] Santos implied that the design as executed was as much the work of Pedro Lizargarate as of Crescenzi, although the bronze decorations are known to have been made in Italy on Crescenzi's designs, after his journey to commission them in 1618-1619. Both the marbles and the bronzes recall Italian fashions of the time, and the large foliated rinceau designs resemble leafy compositions by Agostino Mitelli.

Among Lizargarate's tasks the most difficult was to lower the floor of Herrera's crypt 5½ feet to accommodate Crescenzi's taller design. But the drainage was unfavorably altered, and the chamber filled with water, until Fray Nicolás de Madrid found that an abundant spring had been opened by the excavation, and provided adequate drains into the main sewer to the garden. A large window was also opened from the King's courtyard into the crypt, admitting more morning sunlight. The present entrance stairway (fig. 108D) from the sacristy antechamber provides comfortable access for crowds of visitors. Additional rooms for the burial of lesser royal persons were also provided in the basements south of the main crypt. These are described as rooms measuring 36 by 16 by 16 feet on two floors, connected by spiral stairs, and providing fifty-one additional niches for burials.

Crescenzi was known as the superintendent of the work, and although lodging was provided for him at the site, he preferred to live in Madrid on his extraordinary annual salary of 1,200 ducados. In 1626 his competence and honesty were questioned by several master craftsmen, three of them foreign metalworkers, and the fourth a marble-working mason.[13]

Santos illustrated the new crypt with engravings by Pedro de Villafranca (fig. 108). The entrance doorway to the new stair is dated 1654 (opp. p. 124). The stairway appears in plan and elevation (opp. p. 127), and the crypt is shown in plan (opp. p. 130) and two sections (opp. pp. 133,

[9] J. Brown, *Images and Ideas*, p. 107.

[10] The documentary history is given by F. Navarro, "El real Panteón," pp. 713-737, and J. J. Martín, "El Panteón," pp. 199-213. F. Iñiguez, "La Casa del Tesoro," discusses Velazquez's part in selecting the paintings. According to Llaguno, *Noticias*, 4: 16, Carbonell designed the new doorway and stair, the pavement and the altar, which all were built by Zúmbigo. See also Andrés, "Relaciones," pp. 167-207, and on Zúmbigo, an Italian, the study by Elisa Bermejo, "Bartolomé Zúmbigo," pp. 291-302.

[11] *Panteón* in modern Spanish has come to mean any cemetery, although the term is inappropriate in English, where its Greek meaning as a memorial to all the gods still survives.

[12] Santos, *Descripción*, pp. 113-185.

[13] Llaguno, 4: 376. Martín ("Panteón," p. 202) mentions Juan Gómez de Mora as writing the specifications for the vault with Pedro de Lizargarate; and regards him as the architect, with Crescenzi functioning only as an "ornamentalist in bronze."

136). The gilded bronze chandelier from Genoa is also illustrated (opp. p. 137).[14]

After the Panteón, little remained to be done to improve an edifice that had filled out its intended limits in a way allowing few further changes. Thus when Fray Francisco del Castillo was prior (1660-1665) the only tasks on which he could report progress were placing Sigüenza's inscriptions on the pedestals of the Kings' statues; correcting a few defects in the Panteón; and restoring the altars of the provisional church and the chapter-rooms.[15]

THE SACRISTY

There had arisen an urgent need to enrich this room, two stories high and measuring 108 by 33 by 28 feet. Nine window-axes lighted it, and the altarpiece at its southern end was fashioned as a *capilla trasparente*, with daylight pouring through the altar monstrance (fig. 109), as at the main retable of the basilica. In the sacristy the need was to display a sacramental wafer sent from Germany in 1592, which, after profanation in Holland by Protestants, displayed miraculous stigmata. Within the *camarín* (or treasure room adjoining), the jewels donated to the cult of the sagrada forma were kept in a chamber of marble mosaics. This work, designed by José del Olmo, was hidden from the public by the painting, *Sagrada Forma*, by Claudio Sanchez Coello after 1685, which could be moved down like a window sash on tracks at its sides into the lower story, in order to reveal the *camarín* on the days of the veneration of the sagrada forma each year. Martin Soria characterized the picture as a "vast aerial extension of the Sacristy," representing the scene there in 1684 when Charles II and the court received the relic.[16]

JUAN DE VILLANUEVA AS ROYAL ARCHITECT

Palladian ideals seemed forgotten in Spain soon after Juan Gómez de Mora died in 1648; it was said much later that "the simplicity, the grace, and the gravity of architecture" died with him.[17] But when Juan de Villanueva returned from Rome in 1765 he brought back the practice of Palladian principles, after six years as a pensioner of the Spanish Academy, learning much in the Roman climate for the renewed study and appreciation of Palladio's work.[18] In Spain his patrons were the royal family after 1767. Their desire was that the Escorial as a royal residence should provide housing for the court outside the palace. The difficulties had been acute in 1765 when the funeral of Isabella Farnese brought the court and many foreign visitors to the Escorial. When the Marqués de Grimaldi as minister of state suggested to the friars that they build and lease dwellings for the court, the friars rejected the proposal as indecorous. Finally they permitted private construction for use only in the lifetime of the owner, to prevent excessive and rapid growth. In six years, the new buildings housed over one-thousand persons.[19]

In 1767 Villanueva was appointed as architect to the Jeronymite community on the recommendation of Antonio Ponz. His first commissions were houses for the French consul and for the Marqués de Campo-Villar, and in the 1770s he built the Casa de Infantes (1771) on the west side of the Escorial and two villas for the Infantes (1772). These are the Casita de Arriba for Don Gabriel and the Casita de Abajo for Don Carlos.[20]

On 11 April 1781 Villanueva became chief ar-

[14] The references are to Santos, *Descripción*. The plates were reused by Ximenez in 1764.
[15] Andrés, "Nueve cartas," pp. 116-127.
[16] Kubler and Soria, *Art and Architecture*, p. 289.
[17] Ceán-Bermudez, *Ocios*.

[18] Pevsner, "Palladio and Europe," pp. 92, 93.
[19] Quevedo, *Historia*, pp. 188, 194. Quevedo maintains that the friars insisted on exterior conformity with Herrera's work (p. 191).
[20] Discussed and illustrated by Chueca and Miguel, *Villa-*

chitect at the Escorial, commissioned to rebuild parts of the interiors and to rearrange the entrances on the north façade. These are recorded in a series of drawings from his office dated in 1785 for the palace, monastery, college, and town of San Lorenzo. His last work at the Escorial (1793) was the new stairway[21] in the north block, and the rearrangement of the north façade entrances (figs. 1, 102).

When searching for the Villanueva drawings at the Palace archive in Madrid (and accompanied by its Director, Don Federico Navarro), I first saw the drawings of 1785 in a disused basement room of the Archivo General de Palacio in January 1964, together with several other portfolios of royal residences. Note taking was permitted, but photographs were not granted until 1978. The Escorial plans were in two portfolios (*carpetas*), with eighteen sheets in the first,[22] and twenty in the second.[23]

NINETEENTH-CENTURY EXPROPRIATION AND RENEWAL

After the early endowments were given by Philip II, Pope Sixtus V granted exemption to the community of the Escorial from episcopal rule (*Ut concessiones*, October 18, 1586). The direct vinculation to the Holy See as "being of no diocese" (*nullius dioecesis*) then conferred on the prior a spiritual and temporal jurisdiction like that of a bishop in the monastery's dependencies and properties.[24] During the Enlightenment, however, this exemption was contradicted when Pius VI recognized in 1791 the right of Charles IV to choose and confirm the prior. Such a right had previously been exercised only by the friars in chapter meeting. The surrender of this right to the Crown thus weakened the friars' right to their endowments when Napoleon's brother José decreed, as *rey intruso*, the total expropriation and secularization of conventual properties in Spain along French revolutionary lines. At the Escorial each friar's daily allowance was reduced to 6 reales, and the premises were plundered by the French. In 1814 Ferdinand VI restored their properties to all religious communities, but thereafter exclaustration and expropriation were decreed again and again, in 1820–1823, 1837–1844, and 1854–1856.

At the Escorial the missionary overseas enterprise in the college survived the secularization under an administrative abbot assisted by a "corporation" of royal chaplains, until Isabel II appointed her confessor, Padre Antonio Maria Claret, to be in charge of the Escorial from 1857 to 1868 as president of the corporation. After Isabel II lost the throne in 1868, the Escorial again suffered the expropriation of six of its most choice estates, including La Granjilla, Las Radas, and Campillo, which became "national properties."[25]

The seminary and college were reopened in 1861 and Padre Antonio Claret undertook the most urgent repairs there and in the monastery, basilica, and library. He also reorganized the farms, mills, and water supply, and had new furniture built, much of the old having been used for fuel. Part of the library taken during the invasion was returned. Claret's repairs were utilitarian, in the taste of the time, and limited by small funds. But the original splendor of the cult was revived in the basilica, within the abilities of the small community of priests, and against complaints from the secular clergy, who were opposed to the continuation of an extinct Jeronymite community.[26]

Before the First Republic (1870–1874) the Padres

nueva, pp. 108 (town houses), 110–120 (Casa de Infantes), 123–131 (Casita de Abajo), and 134–144 (Casita de Arriba).

[21] Villanueva's drawings have not been found for this stair, but it is shown on Salcedo's plan of 1876 and on Andrada's plans (figs. 104, 118).

[22] Numeros 12–23 on *laminas* 7–8 were missing from portfolio 1 in June 1978.

[23] See Appendix 8, where the titles as written are supplied

from my notes, and the locations in parentheses are deduced from the numbering on the map (*lamina* 2).

[24] G. del Estal, "El Escorial en la transición," pp. 565–569.

[25] Zarco, *El Monasterio*, p. 208. La Granjilla is the present name of La Fresneda.

[26] Estal, "Transición," pp. 585–594; C. Fernandez, "Claret," pp. 541–556.

Escolapios were given the college in 1869 by the government of the September revolution. In 1872 Amadeo I returned the monastery the week after lightning had destroyed the roofs of the northwest buildings. The needed repairs lasted nine years. In 1874 the Republic validated the return of the monastery, and it was later returned to the royal patrimony in the reign of Alfonso XII. He founded the college anew in 1875 for orphans of the armed services, of government employees, and of those in royal service. The monastery was transferred in 1875 to the Augustinian order, followed by the library in 1886.[27] In 1896 the Compaña was remodeled as the Colegio de Estudios Superiores de Maria Cristina, in honor of the Queen Regent.

These functions were entrusted to the Augustinians under a contract by which they assumed juridical responsibility and monastic benefit of the Escorial, in continuation of the original agreements between Philip II and the Jeronymite order in 1567. The college now provided primary and secondary instruction, and the seminary offered higher studies in theology and canon law. But during the Second Republic the Augustinians were obliged to abandon the schools in 1933-1934. Ninety-eight friars expelled from the monastery were executed in 1936 by militiamen, and the building's basements became a storehouse of munitions for the battle of Brunete. At the end of the civil war, wild fig trees a yard high, sown by the rooks nesting in the dormers, grew in the abandoned cloister courtyards.[28] In 1939 the Augustinians resumed their work at the Escorial, and it progresses today, under a new contract with the Patrimonio Nacional drawn in 1960, which continues the original foundation by Philip II as patron and the Jeronymite order as beneficiary, but separates inheritance (*patrimonio*) from trusteeship (*patronato*). The palace properties are administered by the Patrimonio Nacional, and the monastery and schools are entrusted to the Augustinians[29] by the Spanish State, under the authority of the Patrimonio Nacional.

In the view of the Augustinian friars who now live in the Escorial, the monastery was originally an answer from the Catholic world to Protestant dogmatic pluralism, having unity in its living purpose more than in the external harmony of its architectural form, being born at the Council of Trent rather than at San Quintin, and obeying the six primary injunctions of the act of foundation in 1567. These were, and remain, prayer and cult in the basilica; filial piety and royal burial in the crypt; studies of ecclesiastical culture and humanistic learning in the library; sacerdotal training in the seminary; university preparation in the college of arts and theology; exercise of charity with sick and poor in hospital care and almsgiving. The palace is one among the various dwellings of the royal patron,[30] whose inheritance includes the Patrimonio Nacional.

NATURAL DESTRUCTION

THE GREAT FIRES

As the lessons of medieval architectural archaeology make clear, the history of an old building cannot be written without a full account of the disasters, repairs, and restorations that have slowly replaced the original surfaces inside and out during many campaigns of rebuilding, in a "fossilization" that perpetuates the original form while replacing the original visible substance with other material.

In 1577 new building activity nearly ceased because of a series of disasters at the fabric; great storms, popular indignation at the rumored expense of the Escorial, and discontent at court with the hold of the Jeronymites over the King, as well as the labor troubles among the stonemasons, and the riots in the lower town, and general discontent among the people, because of the new 10 percent sales tax, which threatened the future of the fabric with fears of public riots.[31] For the first time a royal guard of halberdiers accompanied the

[27] Estal, "Transición," pp. 594-599; letter (December 1979) from Gregorio Andrés.
[28] C. Vicuña, *Anécdotas*, pp. 212-219.
[29] Estal, "Transición," p. 609-614.
[30] Ibid., pp. 562-563.
[31] FME, pp. 73-75.

King to the fabric, making their rounds night and day to prevent further uprisings.

To cap it all, a conflagration broke out in a high wind during a lightning storm on the night of 21 July 1577 at the southwest tower, setting the wooden spire aflame and melting its lead sheets in valleys and gutters and flashings. The King, the Duke of Alba, and some courtiers went to the cloister roofs where a bucket brigade began work so the burning timbers could be thrown clear of the building.[32] Such fires were a continuing threat, in large part because the resinous local lumber used in floors and ceilings was dangerously vulnerable until lightning conductors were installed.

The most destructive fire at the Escorial began on 7 June 1671. Starting from a chimney in the college attics, the blaze spread "like a rocket," in the chronicler's words, through the roofs into the north and east buildings of the palace. As in a forest fire, different areas of the roofing exploded into flames when the temperature rose to the kindling point in the attics, where exposed resins in desiccated timbers along drafty roofs were both tinder and fuel. Even the monastery roofs, separated from the origin by the forecourt, burst into fires, destroying two-thirds of the manuscripts kept on the floor below the attics,[33] a wooden-ceilinged former dormitory of novices above the vestiary. In the main library where printed books were shelved, a hastily built brick wall at the north entrance warded off the worst from the vaulted, book-lined room, although the entrance and shelving at the south end near the monastery door were damaged.[34] The monastery archive, then housed in a cell above the sacristy, and the gigantic choir books of the community were saved, probably by staying in, or being moved into, the basilica under stone vaults and low-pitched roofs of slight rise, sheathed in lead, which resisted the fire.

Manuscripts that were removed to the main cloister staircase caught fire in the surrounding blaze when the flames reached the refectory cross-ing tower and broke out in the stairway roofing. Then the prior's tower spire burst into flame, burning the insides to the ground floor, and spreading through the south range, always burning down from the roofs through the brick floorings laid on pine rafters, floor by floor to the basements, fed by resin and molten lead. After eight hours the combustible parts of the building were being consumed altogether in scenes like the Last Judgment, with flames pouring from the upper windows on all sides (fig. 112).

The fire continued for three days in the rooms and cloister walks at all levels, sparing only the basilica, and leaving the fabric open to the skies, all partitions gone, like a destroyed city. The only standing remains were the library, the palace tower, the infirmary tower, the King's house, two or three floors here and there in the cloisters, and a few friars' cells on the ground floor. The sacristy, chapter-rooms, the old church, refectory, vestiary, and lecture halls escaped damage, being vaulted,[35] allowing the inhabitants at first to huddle in a few chambers without beds or clothing. The rubbish and cinders were cleared by a thousand men from the towns of the region, but the repair crews on walls and roofs were slack and unenthusiastic until 1672.

During the early repairs on the hasty designs by Gaspar de la Peña, the new roofs were nearly flat, lead-covered surfaces like those of the palace and basilica, and the buildings were to be rebuilt one story shorter. But the prior, the Queen Mother, and many friars insisted that the Herreran designs be repeated. In October 1672 the proposals by Bartolomé Zúmbigo were adopted, to protect the attics with vaulted interiors under steeper roofs than those planned by Herrera, but of the same height (presumably to gain space for the vaults). At intervals fire walls separated these chambers. The work continued until 1679 under the energetic prior, Fray Marcos de Herrera, who has been compared with Villacastín.[36]

Sixty years later in 1731, another general blaze

[32] Ibid., pp. 78-81; AME, vi-8 (9 September 1577), contract for repairs to the spire.

[33] Fray Juan de Toledo, "Relación," p. 74-75: "Muchos . . . manuscritos se sacaron pero la mayor parte se quemo." Extensive details in Andrés, *Incendio de 1671*, 1976, pp. 26-28.

[34] Andrés, ed., *Incendio*, pp. 26-28.

[35] Ibid., p. 12.

[36] Ibid., pp. 92-97; "Relación," pp. 105ff., contains detailed documentation about the rebuilding, 1671-1677. In this edition, Andrés notes (p. 85) that Zúmbigo's footings, which rose one and a half meters to receive the burden on the new roofs, were used in 1960 to carry the new steel roofing frames, with the result that the new slate roofs were built with rows of dormers that fail to correspond with the heights of those in

threatened in the same place, a chimney in the college, possibly caused by students' carelessness, but the rebuilding of the 1670s had provided fire-walls in the attics, so that the flames were controlled by the bucket brigade bringing water from the cisterns under the palace courtyard. It began at half past one on the afternoon of 6 September and spread to the crossing tower of the college,[37] which was "like a volcano spewing fire." Slate workers fighting the fire threw the burning timbers to the ground. The northwest tower was saved by having been rebuilt in the 1670s with the spire not resting directly on the bearing walls. Nor was there any high wind in 1731, and the rebuilding had made more use of vaulted attics than before, which also reduced the spreading fires.

Next morning the fire broke out again in a college kitchen, caused by burning lumber that had fallen from the roofs. For several days the water brigades continued to wet the smoldering embers. The fire watches were on constant alert, and supplies of water in case of need were brought to danger points. Some difficulties arose with workers drafted from neighboring towns as fire-fighters, and they had to be locked into the building. But they were well fed, and praised by the friars in person, who gave them comfort and arranged shifts allowing some to go home for urgent reasons.

This time the repairs were governed by earlier experience of firefighting. The first measure was to assure an abundant supply of usable lumber, and to protect it not only from fire but rain and snow. Roofs were rebuilt to be less high than before damage, and boards were used only when tile, lead, or slate were lacking. Rapid repair and survival of winter rigor were the order of the day. Clever ways of procuring lead from the ministries in Madrid were devised, and the distinction between monastery and palace was clearly defined when payment for services was demanded. Trees for lumber, bought out of season, were cut when needed, and stored in the main portico entrance and palace galleries and the college-kitchen courts. Ingenious ways of circumventing the royal pen-

ury were devised. Throughout reconstruction, the concern for retaining the original intention is constantly evident, although its difficulty is equally apparent, as when the forty-foot mast for the crossing-tower spire had to be raised through a hole drilled in the tower vault.

The fire of 1744 burned out the Compaña on 1 September, destroying half the grain harvest, the hospital, and part of the water-driven mill. It began in the tannery about midnight, probably in an adjoining store of tallow. Only two Capuchin friars, guests of the monastery, were available to fight the blaze, which spread from end to end in half an hour, leaving the building roofless after three hours. The fire burned for two days more, destroying the floors with their brick pavings, although the sixteenth-century wooden Holy Week monument was saved by being taken out to the paved plaza. After ten days a water canal was built to bring enough water to put the fire out and flush away the debris. As in 1671 nearly all possessions were destroyed, although the tannery where the fire began was the least damaged place.

The fourth memorable fire struck the college on 8 October 1763, starting in a palace-kitchen chimney (while Charles III was in residence) at eight in the evening, and spreading rapidly to the northwest corner and college crossing tower, but stopping at the northeast tower. This time no tools were available for opening the wall as needed in the early stages, but the rebuilding after 1732 with less wood and more brick in the spire proved its worth. By now it was also thought that firewalls in the attics might be disastrous weights if built too solidly. Furthermore firewalls visible externally were unsightly and of little use other than to show their location. Some military engineers were on the scene with the King's escort, but their practice was criticized as being to breach walls, sometimes too freely.[38]

After these enlightened analytical accounts, the fire of 23-25 November 1825 was narrated in a romantic manner by Fray Juan Valero with an abundance of dramatic adjectives conveying the windy horror of the blaze, but failing to mention its cause. It broke out in the roofs over the dwell-

the 1589 engravings. This account by Fray Juan de Toledo contains details of the community's finances in the 1670s.

[37] Andrés, "Relaciones," pp. 83-102. These accounts are probably official reports of an investigative character.

[38] The eighteenth-century fires were described and succinctly analyzed by an anonymous writer, or writers, using language even more concise than Sigüenza's, in a manual for use by firefighters in future crises. Ibid., pp. 83-122.

ing of the King. The friars themselves carried out the royal belongings, and the slate workers were as usual the principal firefighters, assisted by some five hundred workers recruited from nearby towns. The flames spread northward in the attics to the palace tower, with great inconvenience to the royal family and the court in the cold weather after the destruction of their quarters. Some forty yards of roofing, including six dormers and three chimneys, were damaged.[39]

THE PLAGUE OF TERMITES

By July 1953 termite infestation of the Escorial was a matter of public concern.[40] The Spanish government, being aware of Spain's growing attraction to world tourists, began to place ample funds for the repair and restoration of the Escorial at the disposal of the Patrimonio Nacional in the buildings service, the Servicio de Obras. With the approaching fourth-centennial celebrations spurring the work, Ramón Andrada Pfeiffer became architect-in-charge and was entrusted with the immense task of replacing the timbered roofs and floors with steel, concrete, building tile, and stone. The work was to include all parts of the edifice and annexes. Museums of architecture and painting were to be provided. This program exceeded the scope of the 1671 rebuilding by several factors. All of it was dedicated to preserving the original form, while replacing vulnerable materials with the durable floors and roofs of modern fireproof constructions.

The most immediate need was to rebuild the four corner towers, where even the masonry and ironwork inserts had suffered serious damage from termites. The tower shafts had been weakened not only by fires and termites, but also by structural defects at the corners and windows. Floor timbers, twisting and bending under high wind pressures, were producing dangerous masonry bulges and fissures. The weak bondstones of the windowsills and lintels inadequately tied together the wall masses between windows. All these weaknesses were remedied by steel bandings, countersunk behind the stone coursing, to

resist the shearing forces and contain the vertical loads in the towers. The wooden spires were replaced with triangulated structural steel frames, calculated to resist wind pressures far higher than those usual at the site.

By 1963 the crossing towers in monastery and college could be rebuilt. Their spires had been redesigned after 1671 in a more intricate design than originally shown by Perret in 1589. These baroque shapes used by Bartolomé Zúmbigo in 1673 were actually 3.75 meters higher than the original ones and decorated with medial ridges (figs. 80, 113A). The new structural steel frames of the spires reverted to the graceful, concavely curved profiles of Herrera's design, using brick ribs at the base to carry a hollow-tile sheathing to which the slates were fastened (fig. 113B).

Almost as urgently as after one of the great fires, all the roofs of the monastery, college, and palace needed the same fireproof replacement. In the process (fig. 119) more ample accommodations were secured for seminary and university needs, by introducing entresols and making more use of the attics than before, with the result that the Escorial today can house a larger resident population than at any time in its history.

During the restorations for the fourth centennial in 1963, the entire palace quadrant, including the King's house, was rebuilt and restored to service as a series of museum rooms. A collection of building tools, models, and views was installed in the palace basements as the museum of architecture (fig. 103). The paintings that were once in the Escorial are exhibited in the King's house and in the palace rooms. The lower floor of the King's house was originally the summer dwelling of Philip II, less exposed to heat and light than the identical upper rooms for winter use. The lower floor had served other uses (fig. 115), and it was all in wretched condition after long disuse following the redecorations made for Philip IV and Charles II, who had used the rooms in summer. The King's courtyard (fig. 67), with its wall fountain, had been much altered since the seventeenth century. These ground-floor closures of wood and glass were removed to recover the original

[39] Ibid., pp. 123-126.
[40] R. Andrada ("Reconstrucciones," pp. 323-326) describes the disintegration of the mortar by formic acid, and the destruction of the timbers by the wood-eating *Reticulitermes lu-*

cifugus. Pesticides and drying the walls were needed in the extermination. The origin of the infestation was the box hedges of the south-terrace gardens, whence it spread to the building itself in this century.

design, which is perhaps Juan Bautista de Toledo's, together with the airshafts, the main cloister, and part of the sun-corridors at the southwest corner.

Other rooms of state restored to use are the two-storied chambers in the east palace block, originally designed for royal functions as a squared vestibule with a long five-windowed gallery (fig. 75). These had been partitioned in two stories of small offices, and were restored to use as galleries for the display of paintings, vaulted as originally intended, like the chapter-rooms and their vestibule in the monastery. As Andrada observed,[41]

the doorways to these rooms from the palace-gallery walk are symmetrical with it, but not with the eastern windows, which obey the monastery fenestration (fig. 1).

Andrada also restored the original north entrance to the crypt, with its cyclopean blocks of granite coursing, which was blocked in the octagonal Panteón at the recess containing the burial of Philip IV. Its flight was steeper and shorter and more confined than the ample southern approach built before 1654, but in plan the two stairs form symmetrical if uneven approaches (fig. 44C).

RAMÓN ANDRADA'S RESTORATION AND REBUILDING

During the process of restorative rebuilding, Ramón Andrada and his associates produced seven plans, which document the condition of the fabric before the work of restoration. These plans also record changes made before restoration began. As a group these plans give more information than any published since 1589, going beyond the Villanueva drawings, which were more concerned with remodeling certain interiors than with the fabric as a whole. Andrada's plans have generously been made available for this book.

Two of these are of the building at lower level (*Planta Baja*). The earlier one (dated 1964; scale 1:200) shows the entire plan at the level of the King's house, or fifteen feet above the main entrance level (fig. 117). Metric-scale dimensions are given throughout in nearly every chamber, including many nineteenth-century partitioned enclosures that were removed during the restoration. The built-in furnishings are carefully recorded in some rooms as in the archive where the manuscripts have been stored by the Augustinians, in the original vestiary, rebuilt for the purpose with a balcony giving access to the upper shelves in the nineteenth century (fig. 1, *MM*). The monastery kitchen plan appears as it was before its conversion into a sitting-room for visitors. The college toilet building of Herrera's time is shown as still in use, before the grand stairway was built in its

shell. What is now the tourist entrance in the center of the north façade appears filled with small partitioned rooms pertaining to the palace. The present tourist passage from the palace court to the basilica through the north airshaft court was still to be made possible, but the college access to the basilica by a stairway ascending in the thickness of the wall to the choir balcony is shown as in use (unrecorded in any other plan are the chambers in the basilica walls at this fifteen-foot level). Hence this first plan appears to record conditions at a period when major parts of the palace still were in government use, before the modifications of the 1950s.

The second ground plan (dated 1972; scale 1:300) was prepared, like the others at this scale, to show the areas where new plumbing was installed in the monastery as well as the new stairways in college and monastery (fig. 118). Villanueva's palace stairway appears as built after 1785, to give access at the palace entrance to the courtiers' quarters on the upper floors of the north building. The stairway occupies the space that was a guardroom (fig. 1, *83*). Figure 118 shows the shift of the palace entrance eastward to provide a more direct access to the palace court than in the sixteenth-century design.

Other stairways recorded in figure 118 are new constructions within the confines of the toilet

[41] Ibid., p. 341.

buildings in the monastery and college. In the monastery the principal (or "imperial") stair was opened for tourism, making it necessary to build another for the friars' *clausura*. The new stair was fitted into less than half of the toilet building in the monastery. In the college, the new stairs were treated more monumentally, taking up a larger part of that toilet building. Both stairs were also intended to improve the fire exits from the upper floors. In the sacristy the *camarín* and altar of the *Sagrada Forma* are shown, as well as the relation of the two chapter-rooms to the vestibule separating them.

The *Planta Primera* (fig. 119) is again at the fifteen-foot level (1972; scale 1:300). It shows in detail the upper floor of the palace service buildings with all their partitions, as well as the entresol rooms at that level in the north palace building. The plan of the monastery kitchen describes its condition after conversion as a reception-room for visitors. The original *locutorio* (fig. 1, *EE*) is now used as a thoroughfare for tourists from the basilica narthex to the main cloister and chapter-rooms. The plan of the sanctuary and royal dwelling at this level gives much the same information as the Salcedo lithograph (fig. 104) in 1876, although the older document shows the fragmentation of the eastern gallery.

The *Planta Segunda* (fig. 120) is at the thirty-foot level (1972; scale 1:300), corresponding to Herrera's in figure 2, on which it is based. In the palace the remodeling of the upper gallery on north and east sides as royal rooms is indicated, as well as the replacement of a double flight by a spiral stair. These changes were probably of nineteenth-century date. The partitioning of the monastery library between the two northern cloisters is also marked, and still exists. All these nineteenth-century partitions are drawn in a single-line convention, to separate them from the doubled outlines of the original walls. Many friars' cells, however, still display the same plans as in Herrera's publication.

The *Planta Tercera* (fig. 121) corresponds to the rooms below the fifty-five-foot level (1972; scale 1:300), mainly dormitories, apartments, and friars' cells. Of special interest is the plan of the basilica at this level, with the clerestory passages at the bases of the transept windows above the organs, and the many small stairs, both spiraled and straight, leading from level to level within the bounding walls. At the King's house, stairs lead to the garrets, which are below this level, under the roofs as shown. In the main cloister, the east-range friars' cells are on two levels, one at thirty feet and the upper one as an entresol below fifty-five feet, where the rooms are the upper ones, built under the new roofs.

The *Planta Cuarta* (fig. 122) displays the top-floor chambers and dormitories under the roofs (1972; scale 1:300), as rebuilt in the monastery, and as left over from the eighteenth-century use of these quarters in the palace. The level is between fifty-five and sixty-five feet, just under the feet of the builder Kings on the basilica façade, at the external clerestory passage between the towers. On the west façade the level is between the thirty-foot and fifty-five-foot cornices. On south and north façades it is the floor above the fifty-five-foot cornice.

The *Planta de Cubiertas* (fig. 123) shows roofs and vault exteriors (1967; scale 1:200), with all their dormers, spires, towers, chimneys, ridges, valleys, pinnacles, and spheres, before the roofs were rebuilt. On the east palace roof, four fire-walls built after the conflagration of 1671 appear. Four more are on the north palace roofs. All eight walls include chimney stacks.

EPILOGUE

A SIXTEENTH-CENTURY
MEANING OF
THE ESCORIAL

A QUEST for meaning characterizes the thought of the twentieth century everywhere in humanistic studies, and it is a quest justified by exploring and mapping old and new terrains of which the resources are still uncertain. The Escorial today raises so many questions about the traditional ideas with which we treat the history of art in the sixteenth century, that these questions are the subject of this postlude. The general conclusion is that a key to the Escorial's meaning in the minds of its sixteenth-century makers, is found in Fray José de Sigüenza's knowledge of the aesthetic system of Saint Augustine.

MANNERIST STYLE AS PSYCHOHISTORICAL ANALYSIS

Prior to the 1920s the Escorial was usually classified as a Renaissance monument, but the sixteenth century then emerged among art historians as a separate period in the history of European art, separating the Renaissance of the fifteenth century from the Baroque art of the seventeenth. Many now normally designate the Escorial as a "mannerist" building. The term is derived from *maniera*, the pejorative expression used in six-

teenth-century Italy to describe the work by those who imitated the principal artists of the High Renaissance. Thus Nikolaus Pevsner: "The Escorial . . . is evidently a monument of the purest Mannerism, forbidding from outside and frigid and intricate in its interior decoration; but it is essentially Italian in style."[1]

But today historians of art are far from unanimous about the Escorial. Manfredo Tafuri,[2] for in-

[1] "The Architecture of Mannerism," p. 137. His criteria for architectural Mannerism are discordant motifs, contrary directions, alternately exclusive rhythms (e.g. ABBAAB), and

contrasting austerity and preciosity. He concludes by admitting "national modifications as a possibility" for subclasses.

[2] *L'Architettura del manierismo*, p. 331.

stance, cannot find in its "gloomy mass . . . the symbol of the inhibitions expressed in a hallucinatory and introverted Mannerism," but only extensions of the . . . humanistic revolution of the Florentine Quattrocento." Arnold Hauser, however, claims that the severity and simplicity are "nothing but exhibitionist play with puritanism and asceticism. The building displays its "introversion" in a shriekingly ostentatious manner . . . the hideout of a lonely man withdrawn from the world, and the colossal proportions serve no practical purpose and are nothing but as a sham. Philip II lived in his palace like a monk in his cell; the Escorial combines grandeur with exaggerated simplicity in the same mannerist fashion as he did in his way of life."[3] In this way the Escorial is "explained" by the supposition that architectural forms necessarily and adequately correspond to identifiable psychic states and types. Yet the visual forms correspond less to individual psychology than to collective traditions in architectural design. The assumed equation between architectural morphology and psychic states has underlain the theory of Mannerism since its first definition in the 1930s, when the repression by belligerent authoritarian states on the learned world in Italy and Germany led to a search for similar catastrophes in the past, and to the selection of the sixteenth century as the "type-specimen." Hauser's treatment of Mannerism is an allegorization of what he calls "struggle against the despiritualization of culture." But Mannerism and culture both

are allegorical abstractions and the "struggle" must be allegorical also, that is, existing less in historical events than in our perception of them.

In Spain too the theory of Mannerism found hospitable ground. José Camón Aznar had earlier named the later or second period of Italian Mannerism in Spain as *escurialense* and as *filipino*, but in 1959 he shifted to *trentino*, honoring the Council of Trent (begun late in 1563) in its Counter-Reformational work, and choosing the Escorial as its dominant example, with stress on the Mannerist "tensions" among its forms, as in the church towers without bases, the obelisks supporting spheres, and the heavy, lid-like cornices.[4] Another Spaniard, Padre Alfonso Rodríguez Gutierrez de Ceballos, S.J., includes José Camón among the theorists of European Mannerism, and he regards Mannerism in architecture as recognizable by visual forms conveying both "emotional distortion" and "self-regulated discipline" (*auto-controlada disciplina*).[5]

If psychic states and architectural forms were this closely related in the process of design, then architecture as a whole would long ago have been recognized as a dictionary of psychic attitudes. But no such view now seems tenable. Architects continue to explore values peculiar to their craft and to a perpetually changing technology, rather than becoming practitioners of a psychodiagnostic method of expression. Old buildings still require the historian to discover the values that were intended by their makers.

ESTILO DESORNAMENTADO AND PLAIN STYLE AS LABELS

Carl Justi first used *estilo desornamentado* in a lecture given at Bonn in 1879 to characterize the work of the architects of the Escorial.[6] It was then a current expression in Spain that Justi employed in the history of art. He stressed its negative character as owing to a change of taste following the ornamental richness of the Renaissance in Italy, when Toledo and Herrera, as he says, turned pedantically to Vitruvius and Vignola.[7]

Justi intensely disliked the Escorial: he referred

[3] *Mannerism*, 1: 282. Prior to Hauser's are the remarks by Werner Hager ("Zur Raumstruktur des Manierismus," p. 138), citing the Escorial as showing "Manneristic introversion" in its plan "hermetically turned inward."

[4] "Arquitectura trentina," pp. 373f., and "El estilo trentino," pp. 421-442; B. Diez, "El Concilio de Trento y El Escorial," p. 547, who relates the catholic purification of Trent

to the bare "classic" simplicity of the Escorial, but without introducing Mannerism, and denying the existence of a "Tridentine style" (p. 539).

[5] *Bustamante*, p. 111.

[6] "Philipp II als Kunstfreund," in Justi, *Miscellaneen*, 2: 1-36.

[7] Ibid., p. 16: "It is the style of the learned architects of

to it as "among the trials of the art pilgrim," and as "bitter and bold," built in haste, like Philip's fortresses in the Old and New Worlds.[8]

Later on, when writing for Karl Baedeker's guide to Spain, his hostile remarks were expanded, to say that the Escorial was the work of an unchecked will incapable of genius, and of a "repulsive aridity," having "neither beauty nor truth, in the absence of freedom."[9] Miguel de Unamuno rebutted Justi in 1922 by saying that his criticisms were not aesthetic but political, and that Justi was incapable of enjoying "architectural nudity."[10]

Both Justi and Unamuno were unaware that such an architecture had appeared before in Portugal, where it was called "plain style" (estilo chão) in the nineteenth century.[11] Plain style differs from desornamentado by its freedom from academic rules and Italianate forms. In Portugal both the court and the nation had been depleted before the death of Manuel I by his imperial establishment that arose after the Age of Discovery. John III (1500-1557), son of Manuel the Fortunate, was like Philip II a successor to lessened powers, withdrawn, lonely, and frugal, reigning a quarter-century earlier than Philip. As in Spain, military architects were dominant, bringing refractions from Palladio and Vignola, but working in a new and un-Italian diction of minimal ornamentation. Actually, desornamentado architecture was later and of shorter duration in Spain than plain style in Portugal, which persisted until 1706 when John V received new wealth from Brazil.[12] It is also to be noted that Philip II was half Portuguese, reared by Portuguese nurses, speaking Portuguese, and spending over half his reign after 1570 as King of Portugal. Like his cousin John III he felt obliged early in life to correct the extravagance of his father's reign.[13]

In Spain the most accurate testimony on the King's beliefs about architecture is by José de Sigüenza. As librarian and humanistic adviser (a position like that in the Italian city-states), and historian of the building of the Escorial, from 1567 to his death in 1606, he reflects in his book the ideas of the patron and his architects during its construction. He had no use for Renaissance magic and prophecy; he was a learned scholar of patristic Church writers, especially Saint Augustine, and he was thoroughly acquainted with construction and with the problem of deciding how a building should *not* look.

His position about figural decoration was to prefer plain style and *estilo desornamentado*. Like the cleansing of design from historical ornament in the period 1920-1950, plain style provided a fresh starting point in sixteenth-century Portugal and Spain. Sigüenza always speaks with the King's voice on these matters, as well as for many patrons of architecture in Spain after 1560, with whom he shared a distaste for extravagance and ungoverned imagination. It is clearest when he describes as an eyewitness the Manueline monastery of the Jeronymites in Lisbon, which he saw after 1580, while the King was in Portugal with Herrera.

He had seen the work of Diego de Siloe in Granada, and said that though he was then the best architect in Spain, he was unable, "being fond of foliage," to arrive at the good imitation of antiquity, and unable also to make a Corinthian order.[14] Of the Manueline monastery of the Jeronymites at Belem near Lisbon, begun in 1497, which he visited and studied in detail, he says: "This modern[15] architecture is always adorned with foliage and figures and moldings and a thousand impertinent faces. As the stone was hard, its cutting was difficult and cost infinite money and

northern Italy . . . that seeks effect only through proportional relations, and reduces ornament to its soberest measure according to Roman patterns. It was regarded as a return to the 'purity of antiquity,' but its diffusion was owing more to a change in taste after the overloaded and painterly ornament of the renaissance." Note Justi's priority here to Göller's theory of "aesthetic fatigue" published in 1887 (note 17, below). Justi continues: "The negative character of its contribution is characterized by the adjective *desornamentado* . . . these builders were pedants who could hear only the stiff Latin of their Vitruvius and Vignola."

[8] Ibid., pp. 16, 18.

[9] K. Baedeker, *Spanien und Portugal*, pp. 109-116, reflecting

F. von Schiller's play of 1787, *Don Carlos*.

[10] Unamuno, *Andanzas*, pp. 50-51.

[11] J. de Castilho, *Lisboa antiga*, 1: 144, (written in 1879). Kubler, *Portuguese Plain Architecture*, pp. 3, 165-171.

[12] Kubler, *Portuguese Plain Architecture*, pp. 3, 6, 170.

[13] March, *Niñez de Felipe II*, 1: 207-208, letter of 1546 from Prince Philip to Charles V warning him of the coming impoverishment of Spain. On the architectural aspects of his reign in Portugal, Chueca, "El Estilo herreriano y la arquitectura portuguesa," pp. 215-253.

[14] *Historia*, 2: 45.

[15] Ibid., p. 71. "Modern" at this time and in this context meant late-medieval gothicizing architecture.

time. The part now finished shows well what I mean. This south façade, and the church . . . are all marble, full of finials, rainspouts, protrusions, corbels, pyramids and a thousand other foolish things whose names either I nor the stonecutter can say." Here is the voice of the King his patron, as when Sigüenza says of the Escorial, reflecting the ideas of the patron and the architects during the construction, that "architecture does not consist in being of this order or that one, but in being a well-proportioned body of parts that assist and respond to each other, even though made only of stone cut from the quarry, artfully laid beside and above one another, coming to a whole of good

measures and respondent parts."[16]

These comments by Sigüenza on the history of architecture in his century clearly allude to the recurrent alternation of phase between rich and simple surfaces, governed by a rule of taste that makes either phase appear distasteful after its products have saturated the available terrain. That rule of taste was studied and identified as *Formermüdung* ("aesthetic fatigue") in 1887 by Adolf Göller.[17] E. Gombrich has recently observed that no universal law is present but only the logic of situations, as when an inflationary "demand for stimulation outruns the capital of inventiveness."[18]

RENAISSANCE MAGIC?

If the form and expression of a work of art cannot be defined without an exact knowledge of its maker's controlling intention, then a wrong understanding of intention deforms all other critical judgments, and its correct definition must be the primary requirement. The hypothesis that Renaissance ideas of magic underlie the design of the Escorial demands testing for its relevance to the known intention of the builders. A recent iconographic study[19] of selected parts of the Escorial suggests that its building was the expression of aberrant and covert views held by the King and Herrera, who both are alleged as being deeply absorbed in astrology and occult learning, to such a point that Herrera's architectural activities are seen mainly as having "provided a perfect cover" for his "occult services," which were "fundamentally astrological and perhaps largely concerned with medicine" rather than architecture. By this hypothesis it is asked whether Herrera was not "a Magus, a man deeply versed in Hermetism and occult lore, who by virtue of this was attached in a special way to the King?"[20] It is also claimed

that the King was interested in "astrology and the occult,"[21] and that both Herrera and the King were adepts of the philosophy of Ramón Lull (1235-1315) and of the pseudo-Lullian writings that took Lull's name "to spread all kinds of Hermetic and occultist tendencies."[22]

Such an argument also required its author, René Taylor, to deny that Sigüenza was credible. He is presented as "the creator of the 'white' legend of Philip II," and his views condemning astrology are dismissed as a "tirade."[23] In addition, Sigüenza's claim that he invented the "idea and design" (*invención y traza*) of the library murals, is discredited as a fantasy.[24] Because Sigüenza was hostile to astrology, his credibility as a chronicler had to be questioned by Taylor, who says that Sigüenza "was certainly consulted about the program, seeing that he was the librarian of the monastery. He probably did a certain amount of research in connection with it and finished up persuading himself that he was the originator of it all."[25] But Sigüenza said in the same paragraph of which the closing sentence was quoted above,

[16] Unamuno, *Andanzas*, p. 53.

[17] *Zur Ästhetik der Architektur*, Stuttgart, 1887, written when eclecticism was dominant in European architecture, as it was in Spain too during the first half of the sixteenth century, in the coexistence of Gothic, Renaissance, and Moorish forms. Kubler, *Shape of Time*, pp. 80-81.

[18] *The Sense of Order*, pp. 212-213.

[19] René Taylor, "Architecture and Magic," pp. 81-109.

[20] Ibid., pp. 85, 86.

[21] Ibid., pp. 83, 85, 86, 87.

[22] Ibid., p. 82.

[23] Ibid., p. 86.

[24] Sigüenza made the claim in his continuation of the *Memorias* by Juan de San Jerónimo, as of 1592 (p. 441), and FME, p. 299: "descubro el intento que tuve cuando puse aqui estas historias" ("I now reveal my purpose when I put these stories here.").

[25] Taylor, "Architecture and Magic," p. 88, n. 74.

that he included astrology among the library scenes in order to show the Creator's wish that humans need not fear the influences or constellations of the stars. Over these, prayer and penance exercise a greater power. This view of Sigüenza's parallels the King's own, as seen below.

Sigüenza also explained his choices on the principle that a royal library must include every taste as a royal table does ("Esta libreria es real, y han de hallar todos los gustos como en mesa real lo que les asienta.")[26] Finally he repeated that the invention and scheme of the library frescoes was his ("la invencion y traza de las historias es mia") and he notes that the painters sometimes could not follow his wishes, "because the painters did not know enough about the matter," as in the design of the sun clock in *King Hezekiah Watching the Regression of the Sun's Shadow*.[27] Taylor assumes that Herrera planned the library frescoes, but the only evidence is a drawing by Pellegrino Tibaldi with notations in Herrera's hand (fig. 98). These are solely about the architectural framing of the fresco panel and have nothing to do with its subject, *Gramatica*, or its interpretation.[28]

The King's position on astrology confirms Sigüenza's explanations of the frescoes, and Sigüenza's remarks parallel the King's beliefs. As the iconographer Sigüenza remarks, the value of astrology is denied when it is recalled that the Creator alone knows the names of all the stars, and that humans need not fear their influences and constellations.[29] The King's own aversion to astrology is related by Baltasar Porreño, his biographer, who should be fully quoted. He says that the King was presented in 1578 with a horoscope by an astrologer at the birth of his son, the future Philip III. The angered King "tore apart the entire book leaf by leaf, saying that they are insane who, with such rash judgments, wish to forestall that of God, and that they are vain and baseless."[30] Porreño went on to relate that Philip even ordered an astrological prophecy, foretelling great

evils for a previous year, to be published, "in order to prove the emptiness of the author in this manner, as none of the disasters he threatened had happened . . . and letting it be understood that Christians need take little notice of such forecasters and empty astrologers (*judiciarios*). Porreño also remarks that the King detested superstitions, and that he deliberately acted contrary to them, in matters such as the fear of traveling or doing any important act on a Tuesday. Like other rulers, however, he encouraged the drafting of horoscopes with divergent forecasts, among which the appropriate ones could be used as needed. On astrology in general, Sigüenza probably reflected the King's opinion when he said of the *catarro universal* in 1580 (an epidemic of influenza?) that "our astrologers, who are used to overrating things, did not foresee it in their horoscopes."[31]

Another episode, clearly revealing the hostility of the King and Herrera to alchemy, appears in a letter by Herrera (25 June 1572) to the King. Remarking on the pretensions of one alchemist, Herrera writes, "although I consider these matters of alchemy as a joke . . . it still seemed to me I should send Your Majesty [his] petitions," and the King replies in the margins, that he too considers "and always considered [alchemy] as a joke," and that the alchemist's papers should be returned to him.[32]

Both Herrera and the King were orthodox collectors and students of the works of Ramón Lull, like many other well-educated Spaniards. As collectors they inevitably were offered, and acquired for the library of the Escorial, many pseudo-Lullian writings of doubtful orthodoxy. Herrera's interest was limited to certain mathematical aspects of Lull's *Arte magna*, as exemplified both in his architectural designs and in his theoretical writings. The King's interest in the beatified *Doctor illuminatus* (1232/5-1315) was probably based on the Mallorcan's avowed purpose to convert Moslems to Christianity.[33] Lull died as a martyr re-

[26] FME, p. 289. Also, "las librerias son apotecas y tiendas comunes para toda suerte de hombres y de ingenios."

[27] FME, p. 299.

[28] The notes are transcribed by Iñiguez, *Trazas*, p. 80. Herrera mentions a *memoria destas historias* as a manuscript which was at that moment either with the King or Francisco de Mora. It has not reappeared anywhere, but it was surely by Sigüenza, who may have published most of it in FME, pp. 281-300.

[29] FME, p. 299.

[30] Porreño, *Dichos*, pp. 41-46. Written before 1626 and first published in 1639.

[31] FME, pp. 95-96.

[32] IVDJ, unnumbered legajo labeled "libros," f. 261. Full text in Appendix 4.

[33] M. Cruz Hernandez, *Llull*, pp. 43-50; on Lull and Philip II, pp. 326-327.

turning from his mission to Africa. The *Ars Lulliana* itself was a combinatorial method for categorizing all possible ideas, which Herrera applied in his *Discurso de la figura cubica*.[34] It bears no trace of Hermeticism or occultism, nor does any other writing by Herrera, although both he and the king collected all works related in any way to Lullianism, as humanists concerned with an admired literary oeuvre.[35]

In sixteenth-century Europe, "magic" still conveyed the late Latin and Greek meanings as *magica* or *ars*, and *magike* as *techne*, equivalent to technical crafts. Only after 1600 were the modern cognates to become common as *magie* (French) or *magia* (Italian, Spanish, Portuguese), both adopted from Greek *mageia* formed on *Magos*, whence Magus or magician. Thus until 1600 in Spain, the word *magica* still meant "natural magic," i.e., that which did not need recourse to the "agency of personal spirits." It was usually recognized in the Middle Ages as a legitimate department of study and practice, as long as it was not employed for maleficent ends, as in the "black magic" of modern writers. By "natural magic" medieval writers sometimes meant the making of an image under selected astrological conditions, in order to affect the health of the person represented, as well as applying a medication to a weapon in order to heal the wound made by it. But usually, natural magic comprised processes adapted to the laws of physical causation.[36]

On review, the effort to find a division in sixteenth-century knowledge, between rational processes and occult practices, seems unnecessary. The distinction vanishes when the entire spectrum of the received knowledge of the age is surveyed, as by Michel Foucault.[37] He regards the epistemological framework of the sixteenth century as one where *Divinatio* and *Eruditio* were hermeneutically identical, because they both depended on the theory of resemblances for an understanding of all signs, from Stoicism to the seventeenth century.

Divination and erudition remained inseparable for as long as knowledge consisted of interpretations about previous utterances, instead of experimental demonstrations and proofs of new hypotheses. The medieval principle of similitude, which was supreme in the mental life of Europe throughout the Middle Ages, found its widest expression via the printed word during the sixteenth century.

The four similitudes that were recognized as organizing knowledge until 1600 were *convenientia* (or the chain of resemblances in space); *aemulatio* (or similitudes by replication, mirroring, and rivalry in linked duplications); *analogia* (or the reversible joinings of *convenientia* and *aemulatio* with mankind as the center); and *simpatia* (or the convergences of sameness, which are opposite to antipathy). Taken together, sympathy and antipathy form the sovereign principle of similitude.

Since every resemblance requires a sign for recognition, making likeness visible, further interactions are between sympathies and emulations, which mark analogies. Emulation is marked by analogy, which in turn is a sign of sympathy. Likewise *convenientia* (or proximity) is known by emulation, and sympathy is a sign of the same "convening."

In this tangle of sign and content, divination was an integral part of knowledge. The concept of magic was integral, in the sixteenth century, to knowledge itself, and more an equivalent of erudition than a rival of it. Taylor rightly sees *magia* in Renaissance texts as "in no sense restricted to demoniacal magic," but he surely errs in viewing the King and Herrera as covert adherents of Hermetism and occultism, and in suggesting without proof that Herrera was a Magus performing "occult services for his master."

[34] J. Rey Pastor, ed. (facsimile of the manuscript in the Escorial library).

[35] To Lullian scholars today the presence of more than 100 Lullian items in Herrera's library of 400 volumes means that this important collection was made to be deposited in the library of the Escorial, because it was not to be sold after his death on 15 January 1597, by order of the executors of his will, of whom one was the King's keeper of jewels (J. Carreras, "Lul-lisme," pp. 41-60; T. and J. Carreras, *Historia*, 2: 258-263, 263-267; Ruiz de Arcaute, *Herrera*, p. 141). In the opinion of the brothers Artigas Artau, Herrera followed the Lullian scholarship of an older generation in the reign of the Catholic Kings, especially Cisneros, and the Librarian Dimas de Miguel, who detested scholasticism but accepted the humanistic orientation of Lullian scholarship in Paris among the Neo-Platonists, such as Lefèvre, Bouvelles, or Lavinheta, whose printed works were in Herrera's library (Carreras, "Lul-lisme," p. 19).

[36] *OED, Compact edition*, 1971, s. v. "magic."

[37] *Les Mots et les choses.*

SIGÜENZA AND THE AESTHETICS
OF SAINT AUGUSTINE

Fray José de Sigüenza (1544–1606) first professed as a Jeronymite at El Parral in 1567. He later said that he had seen at the Escorial "the opening of most of its foundations, the closing of the arches, the covering of the vaults, the finishing of the pinnacles and domes, and the raising of the crosses on the highest spires."[38] This passage suggests that even as a novice before 1567, Sigüenza had been coming to the Escorial often enough to claim authority as an eyewitness to most of its construction, and learning about architecture from its builders. During the years before the community could occupy the Escorial, Sigüenza lived in the college at Párraces, traveling to the Escorial as professor and preacher, in the years of his early literary work. At the Escorial he succeeded his revered predecessor, Benito Arias Montano, as librarian, iconographer and keeper of relics, professing a second time in 1590 as customary in order to be recognized as a full member of the community there.[39] As librarian in the 1580s, he planned the programs, not only of the cycle of frescoes in the library, but also of the fountain of the Evangelists in the main cloister garden. He also composed the Latin texts (at the King's request) to accompany Monegro's statues of the biblical Kings on the basilica façade. His history of the Jeronymite order appeared in 1600 and 1605. M. Menéndez Pelayo ranked him with Miguel de Cervantes and Juan de Valdés among the foremost Spanish writers of that period,[40] on the evidence of the *Historia* as an example of *estilo llano*, which parallels the *estilo desornamentado* of the building he chronicled. He became prior of San Lorenzo in 1604. His two-part treatise on the

Escorial, divided as monastic history and architectural analysis, first printed in 1605, was probably written after 1590.

As professor, librarian, and historian of his order, Sigüenza was familiar with the works of Saint Augustine (A.D. 354–430), under whose monastic rule the Jeronymite order was founded in 1374. While librarian, Sigüenza catalogued, in his own hand, forty manuscripts attributed to Augustine in the library of the Escorial. Among them was *De Baptismo parvulorum*, then believed to be the oldest work in the Escorial, and supposedly written in Augustine's hand.[41] It was in the King's own collection, and Sigüenza asked the King how he knew the manuscript was in Augustine's hand. The King replied that he had heard it from his aunt, who had given it to him as a valued relic, together with a ninth-century Gospel. The latter Sigüenza dated as no older than the fourteenth century, although the King believed it had belonged to Saint John Chrysostom.[42]

Sigüenza's special knowledge of Augustinian aesthetics appears in his history of the Escorial throughout the second part, in the architectural analysis of the parts of the building, and at length in the discourse on the basilica.[43] This section provides a key to the entire preceding analysis that fills Book Three of the *Historia*. It provides the reader with an explanation of the Augustinian concepts and terms that reappear throughout the foregoing analysis of the building.

Sigüenza cited two treatises by Augustine. *De ordine*, written in 386, is his most substantial contribution to aesthetic ideas. *De vera religione* (c.

[38] FME, p. 7. An older biography is the *Elogio* by Juan Catalina Garcia, written in 1897, and published in the second edition of Sigüenza's *Historia*, 1: v–111. More definitive is the book by Gregorio Andrés, *Proceso*, based on the documents at the University Library in Halle.

In a letter (7 November 1979) Luis Auberson notes that Sigüenza's civil name would have been Martinez Espinosa for his father Asensio Martinez and his mother Francisca de Espinosa.

[39] He wrote an *Instrucción de maestros y escuela de novicios* in 1580, and a life of St. Jerome, published in 1595. The *Instrucción* did not appear in print until 1712, and it was reprinted in

1793. Occasional poems by him appeared in 1584 and 1597. His trial by the Inquisition (1592–1593) ended in his acquittal. The teachings of Arias Montano were more on trial than the actions of Sigüenza himself. (Andrés, *Proceso*, pp. 36–50).

[40] *Historia de las ideas estéticas en Espana*, 2: 423.

[41] FME, p. 307. Sigüenza's catalogue of the Latin manuscripts was printed by G. Antolín (*Catálogo de los códices latinos*, 5: 331–512). The manuscripts of Augustine's works appear on pp. 345–347.

[42] FME, pp. 307–308; letter (December 1979) from Gregorio Andrés.

[43] FME, pp. 202–352; Discurso 12, pp. 321–323.

400) alludes to the principal themes of Augustine's aesthetic position.[44] *De ordine* is about God's authorship of the order of the universe: God loves order and is its creator. The universe is one and its beauty is God's. The Augustinian aesthetic system, however, is limited to the domains of sight and hearing, where pleasure can transcend utility. In the visible world, the most beautiful proportions are in architecture and dance. In sound they are found in consonance and rhythm. Common to both domains is the Pythagorean explanation peculiar to mankind, of beauty as number. The fine arts are the work of reason under the guidance of various disciplines, as when poetry is judged by grammar. By reason again, the soul knows divine beauty without the aid of the senses, for the world is only a dim reflection of that beauty.

J. Rief places Augustine's thought about *ordo* as central to the theme of ascent to God. He fixes Augustine's aesthetics as the objective part of the philosophy in which personal ascent is driven by the love of God through different layers of reality toward knowledge of the absolute.[45] Such aesthetic thought is in his view a minor part of Augustine's total philosophy, embedded as it is among activities of seeking and finding truth, achieving faith, attaining love, and constructing a theology of history.[46]

De vera religione is about Platonic beauty contemplated only by spirit and existing unchanged everywhere. It is manifested in the human body given by God, and in every other creature by concord and peace among the parts. Sin does not spoil the beauty of creation, which is safeguarded by punishment, the trial of the just, and the perfection of the blessed in heaven. Authority and reason are the conditions of the knowledge of beauty and its judgment.

This treatise also contains a dialogue with an architect about the correspondences of arches built to face each other. Augustine asks whether they are beautiful because they please, or please because they are beautiful. The architect replies that correspondence is beautiful because of similitude and harmony. And Augustine adds that their beauty is incomplete, for if it were complete, they would cease to appear as bodies, which can only feign unity with God. Thus Augustine affirms that pleasure is a consequence but not a cause of beauty, and that the cause lies in the unity, harmony, and equality of God. Here Augustine also rejects the curious illusions of magicians, actors, and poets, in favor of the Scripture that corresponds to the law and the truth.

As Svoboda concludes, the aesthetic system of Augustine is the most complete to have been transmitted from antiquity.[47] It still has great interest today because of its formalist base; its idea of organic unity; the opposition of sensing and meaning in works of art; the study of rhythmic classes; and the analysis of emotion and aesthetic judgment. His eclectic synthesis of Greco-Roman aesthetic ideas is adapted to Judaeo-Christian needs by identifying God with Plato's supreme idea, by placing a high value on moral allegorization, and by a mistrust of theater and the figural arts of painting and sculpture. This aversion characterized early Christian sensibility, as explored first by Alois Riegl in his pages on Augustinian aesthetic thought and late Roman art.[48]

Riegl was among the first to understand the relevance of Augustine's aesthetics to late-antique expression. He stressed Augustine's youthful inclination to dwell empirically on specific objects and experiences of aesthetic significance.[49] Important to him was Augustine's recognition of the interdependence of beauty and its absences. Central to his own theories was the confirmation from Augustine of the positive value of nonmaterial forms such as window openings (*perforatis*), in rhythmic combinations, in contrast to Aristotle's preferences for solid forms. Riegl also related the thought of Augustine to late-antique forms in thermal and basilical architecture.

Sigüenza anticipated the rediscovery of Augustine's aesthetics with his analysis of the Escorial, and the views of Augustine are present in the work from beginning to end. For instance, Augustine's thoughts about concord and harmony

[44] Svoboda, *L'Esthétique de Saint Augustin*, pp. 20-48, 102-114.

[45] *Ordobegriff*, p. 362, A. Schopf.

[46] *Augustinus.*

[47] *L'Esthétique de Saint Augustin*, pp. 199-200.

[48] *Spätrömische Kunstindustrie*, pp. 393-400.

[49] E. Chapman, *St. Augustine's Philosophy of Beauty*, p. 1, on Augustine's empiricism as always beginning from concrete experience.

among the parts of the human body appear in the *Prologo* as part of the discussion of architecture, but Sigüenza properly cites Galen, whom Poseidonius, Augustine's source, followed.[50] Sigüenza begins by sketching the purpose and meaning of the Escorial as being

a collection of all the great qualities that have been celebrated as such in the course of the centuries, leaving out every superfluous thing and all that serves only ambition and display. Thus those who see the building as I portray it here, and as it is represented entire, will also see the abundance, proportion, commodity, relation and utility of its parts, like Galen, who read much divine wisdom in such harmony and correspondence, and affirmed that he had written a book of the praises of God. And he who well observes the parts of this monastery may say that it is an excellent translation of the same divine wisdom.

The first part of Sigüenza's book about the Escorial is historical, recounting its foundation and building.[51] The second part is descriptive, analytical, and pedagogic, also arranged by *Discursos*, beginning at the façades, entering the west portico, proceeding through the cloisters and college to the King's house, returning to the library and the basilica and sacristies. Sigüenza treats the reader as a beginner unfamiliar with architecture, introducing him gradually to its terms and practices; explaining the parts of churches and the nature of the classical orders; slowly acquainting him with the remarkable novelty in Spain of the severe style of the Escorial; and using constantly in different contexts such Augustinian terms as *equal, similar, congruent, harmonious, concordant* and *correspondent*, in respect both to form and meaning.

Discurso XII describes the fabric and decoration of the basilica. Here, near the end of the architectural analysis, Sigüenza begins a compact discussion of Augustinian aesthetics:

One of the great beauties of this building is seen in how all its parts imitate one another, and how much the whole is in all the parts. The building which fails to keep this order shows the poor resources and under-

standing of its architect, in not having bound together or unified the whole body. What we call correspondence is none other than the right reason of art . . . with the authority not alone of Vitruvius . . . but that of the divine Augustine, doctor of the church, who as a man of high genius, wished among a thousand other matters of learning found in his books, to touch also on this of correspondence in architecture.[52]

In this way Sigüenza marks Augustine's place over Vitruvius in the minds of those concerned with building the Escorial, and he continues to review the history of Spain and the position of the King:

As Spain had lost the habits of the fine arts in the savagery and wildness of the war against the Moors . . . people were astonished to see preserved here [at the Escorial] so much correspondence in architecture, and believed that it was only the taste or inclination of King Philip, or an idle curiosity, that wherever a door or window appeared, another should respond to it. . . . Thus we may say that this Prince, as we learn from Saint Augustine, returned us to reason and made us notice that the arts contain reason both in themselves and in the proportion they make with our souls.[53]

Sigüenza clearly declares here the explicit aim of the enterprise of the Escorial as to effect a rebirth of architecture on Augustinian principles under the King's aegis.

Another section, Book Two, Chapter Eleven, cites *De ordine*. Sigüenza quotes Augustine, who is inside looking out, as follows on the arrangement of windows:

In this building where we stand, if we look closely at each part, it cannot fail to offend when a doorway on one side is unevenly matched on the other side with one placed at random. . . . This is because in buildings where necessity makes no forcible demand, the poor proportion of the parts gravely offends our sight. But when on an inner wall three windows appear, one in the center and two equally spaced at its sides, the entering sunlight is evenly distributed, and their sight is a joy . . . for it is a certainty that the soul is drawn to them.[54]

[50] FME, pp. 5-6; Svoboda, *Esthétique*, p. 42.

[51] In the manuscript version (prepublication) in the Escorial Library, and in the first two editions (1600-1605 and 1907-1909), the part entitled "De la Fundacion del Monasterio" is

Book Three of the *Historia de La Orden de San Jeronimo*, and the second part, "De las partes del edificio" is Book Four.

[52] FME, p. 321.

[53] Ibid., pp. 322-323. [54] Ibid., p. 322.

Elsewhere Sigüenza quotes from *De vera religione*, Book One, Chapter Thirty, where Augustine writes also on music, dance, and poetry, the following passage on architectural intervals: "Reason is when we ask or consider, seeing two unequal windows placed side by side, why they offend us, although the same windows one above the other, or even being on the same level, would not be repugnant. And why is it that they do not offend or appear bad, when being unequal, they are arranged in a perpendicular column?"[55] Farther on Augustine adds (in Sigüenza's extract): "In all the arts correspondence and agreement give pleasure, and when they are present, all is beautiful, for correspondence loves unity and equality, whether in the likeness of equal parts, or by the gradation and ordering of unequal parts."[56]

Sigüenza later turns to the description of the small courtyards (*patinejos*) behind the towers of the church. "Whoever sees them will find well set forth what Saint Augustine teaches, that the very nature of mankind, and the reason with which he is endowed, compose between them a great harmony, for both are filled with beauty. This harmony matches the light of understanding and the seeds of the sciences placed in man by the Creator, as the highest unity and equality that the sainted Doctor seeks in his book, in order that from the architecture beheld by sight may arise other thoughts more abundant and worthy of harvest by mankind."[57]

This splendidly mixed metaphor concludes Sigüenza's discourse on Augustinian aesthetics. He knew the principal points of Augustine's position, and like Augustine, he was vividly aware of aesthetic qualities and problems. His treatment of them, though compact, is centuries ahead of his time, defining Augustinian aesthetics as a topic that would not be apprehended again so clearly until the works of Riegl and Svoboda. In the process, Sigüenza linked Augustine with Philip II and the Escorial in a systematic and credible way, implying that a resurrection of Augustinian ideas about architecture was present, more than a pagan renaissance.

[55] Ibid. [56] Ibid. [57] Ibid., p. 323.

APPENDIX 1

COELLO'S *SAINT JEROME AND SAINT AUGUSTINE*

Double portraits of Jerome and Augustine are rare, especially with these episodes that show Jerome as cardinal at his last communion aged ninety, and Augustine as bishop on the seashore with the child. Alfonso Sanchez Coello painted *Saint Jerome and Saint Augustine* in 1580, and it was appraised in 1581 at 180 ducados (Zarco, *Pintores españoles*, p. 84). The streaky defacement has been on the altar of Jerome since before 1931, when it showed on Zarco's reproduction (ibid., after p. 154).

Sanchez Coello brought the altar and the seashore together, and Augustine takes the place of the customary crowd of Jerome's disciples supporting him, so that we are led to think of Augustine as Jerome's follower. Augustine, however, was interrupted at his seaside meditation on the Trinity when he saw a child trying to empty the sea into a hole it had dug in the sand, carrying the water in a seashell. "It is impossible," said Augustine, but the child answered, "No more so than for you to understand the mystery of the Trinity." The textual source of this scene is perhaps an apocryphal letter by the pseudo-Augustine to Cyril, bishop of Jerusalem, written no earlier than the twelfth century. As Augustine was writing to Jerome to ask about celestial glory, Jerome appeared to him in a vision to tell Augustine of having died and entered the ranks of the blessed. During the vision Augustine also heard these words: "Augustine, Augustine, quid quaeris? Putasne brevi immittere vasculo mare totum?" ("Augustine, Augustine, what do you seek? Do you think you can put the whole sea in a little vase?") (Courcelle, *Iconographie*, 2: 100, 104, n. 2). The stories of the child and the vision began to be represented pictorially after 1450. Réau lists twenty-three representations of the child on the beach. Many others are known, but none other in the category of the Escorial double portrait.

There is more to say about the churchly attribute that Augustine holds on the book in his right hand. This attribute never appears in the seaside scene with the child other than in the Escorial painting. The book is held with the spine against Augustine's body. The building on its cover is a symbolic model of the Escorial without the basilica. The north façade is clearly portrayed, but instead of having twenty-nine window-axes, the model has only nineteen. Behind it is one immense cloister, recognizable as the two-storied court of the Evangelists. On the west façade the main portico is faintly visible, and the four corner spires are recognizably portrayed. The model may refer to the celestial city, in the context of the perfection of resurrected bodies (*Civitas Dei*, XXII, 30, 1), and the book may therefore be Augustine's *City of God* (G. del Estal, "Transición," pp. 578, 616; R. Taylor, "Architecture and Magic," p. 97).

APPENDIX 2

THE KING'S DECREE OF A
TAX EXEMPTION

AGP, *Patronato*, legajo 1:

Este es traslado bien y fielm[en]te sacado de un t[ras]l[a]do de una çedula R[ea]l de Su Mag[esta]d que esta asentada en los libros de la contaduria de la fabrica r[ea]l de S[an] lor[enz]o ques como se sigue.

El Rey, por quanto nos edificamos un monasterio de el orden de san geronimo junto a la dehesa de la hereria y lugar del Escorial juridiscion de la ciudad de segovia, cuia advocacion es de S. Lorenço. Y es nuestra Voluntad que por el tiempo que la dicha fabrica durare y no mas in aliende nuestros oficiales Peones destaxeros y otra qualquier gente que actualmente trauajare y sir-viere en ella y por esta raçon viuiere i morare en el dicho lugar del escorial no sean empadronados por Vecinos del dicho lugar y sean libres y exemtos de pagar pecho ni derecho ni moneda forera ni otra cosa alguna, porende de por esta nuestra çedula mandamos al con-cejo justicia alcaldes Regidores y homes buenos del di-cho lugar del escorial i a nuestros receptores y otras quales q[ue] de las persona o personas que tienen o tu-vieren cargo de coger en venta o fieldad o en otra qualquier manera las rrentas de el dicho lugar que por el tiempo que segun dicho esta dicha fabrica durare no enpadronen por Vecinos del dicho lugar del escorial ni echen repartimiento alguno, ni pidan otro ningun pe-cho ni derecho ni moneda forera a los dichos nuestros oficiales. Y ministros y la demas gente que actualm[ente] asistiere y trauaxare en la dicha fabrica aunque uivan y tengan casas alquiladas en tanto que acavada la dicha fabrica los dichos maestros y oficiales i la demas gente que huviere trauaxado en ella no gocen de esta exemçion que asi les hacemos y que por rraçon della no se a visto que se entienda ni entiendan que an de adquerir ni ad-

quieran Posesion ni propiedad ni otro derecho alguno para exemçion de los lugares donde (fueran vecinos sino solam[en]te para el dicho lugar de el escorial i sitio del dicho monasterio y por solo el tiempo que que sir-vieren i trauaxaren actualm[en]te en la dicha fabrica i aquella durare i no mas ni atiende segun dicho es—Y para que asi se guarde y cumpla mandamos a nuestros contadores maiores a que asienten el traslado desta nuestra çedula en los nuestros libros que ellos tienen y sobrescrita i librada dellos den y entreguen este original a Andres de Almaguer nuestro contador y veedor de la fabrica del dicho monasterio. [Thirty-nine lines follow of officials whose compliance was ordered with wit-nesses on 18 and 24 January 1563. Exemption from taxes granted to the fabric, as of 15 January 1563 (copy written in 1633).]

This is a copy well and faithfully made from the copy of a decree by His Majesty which is recorded in the books of the accounts of the fabric of San Lorenzo, as follows.

The King: Inasmuch as we are building a monastery of the order of San Jeronimo near the meadow of La Herreria and at the place of the Escorial, in the juris-diction of the city of Segovia, of which the advocation is to San Lorenzo; and as it is our wish that during the time the said fabric shall last, and no longer or beyond, the officers and administrators of the fabric of said monastery, and our artisans, laborers, and contractors, as well as any other people who actually labor and serve in it, and for this reason, do live and dwell in the said place of the Escorial, should not be enrolled as residents of that place, and should be exempt and free from payment of tax or tribute or leasehold or any

other charges there. Wherefore, and by this our decree we order the council, court of justice, mayors, aldermen, and arbiters of the said place of Escorial, and our tax receivers, and others who are charged to take in possession or trust or any other manner the revenues of said place, where for the time as said, that this said fabric shall endure, they are not to register as residents of the said place of Escorial, nor levy any service nor demand any tax or leasehold from our said officers and administrators, and any others who labor on the said fabric, even though they inhabit rented dwellings, for as long as the said fabric continues with said masters and artisans and other people who labor on it, who shall not enjoy exemptions other than as stated here. On account of it, no understanding exists that [such tenants] may acquire or will acquire possession of, or property in, or any other right of exemption from the places where they are residents, but solely at the said place of Escorial and the site of the said monastery for the time of their service and labor in the said fabric, and for no longer as stated . . . 18 January 1563.

The copy was made on 6 April 1633 for Licenciado Diego de Quesada, who was then inspector and paymaster of the *fabricas reales del monasterio real de San Lorenzo*. Its existence suggests that the exemption was still claimed by officers and laborers of the fabric, which had become a plural body (the document was known to Rotondo, *Historia*, p. 22, who mentions it briefly).

APPENDIX 3

MONEYS FOR THE FABRIC OF
SAN LORENZO

AGP, "Libro de despachos de las obras y bosques de S. M. que comiença desde XXVIII de Noviembre de 1565, y se acaba en fin de Xbre de 1572." Folio 197:

Dinero para la fabrica de Sant Lorenzo el real. N[uest]ros officiales de la casa de la contratacio[n] de las Indias q[ue] resid[e]is en la ciudad de Sevilla; ya sabeis lo que tenemos mandado a los n[uest]ros officiales de la nueva Spaña para que de lo procedido de los repartimientos de Indios que en aquella tierra estan en n[uest]ra corona real, os embie en cada un ano treynta mill du[cado]s°. Por quente aparte para cosas de n[uest]ro servi[ci]o, y como os ordenamos que luego q[ue] llegasen a essa ciudad los embiasedes al monasterio de sant lorenzo el real a poder del pagador de la fabrica del para los gastos della que es el effecto para que los tenemos consignados y en cumplimiento dello, en esta ultima flota de que ha venido por qual don Chr[ist]oval de Erasso entendemos han enbiado los d[ic]hos treynta mill ds, y n[uest]ra voluntades q[ue] se traygan para el d[ic]ho effecto a esta villa de madrid y se entreguen a lorenço spinola ginoues residente en esta n[uest]ra corte. Porende yo, vos mando que luego, en recibiendo esta n[uest]ra çedula desconta[n]do las averias y otros derechos y gastos q[ue] se hizieren lo que liquidamente, restare de los d[ic]hos treinta mill d[ucado]s lo embieis, con persona de recaudo y confiança en nombre y por quenta de vos el n[uest]ro thes[orer]o de la d[ic]ha casa de la contratacio[n] a esta d[ic]ha villa de Madrid para q[ue] se entreguen al d[ic]ho lorenço Spinola, lo qual assi hazed, no embargante que estaua mandado acudir con ellos al pagador de la d[ic]ha fabrica y otra qualquier orden

n[uest]ra que tengais en contrario porque esta es n[uest]ra voluntad, y mandamos que tomen la razo[n] de esta n[uest]ra çedula fran[cis]co de Garnica n[uest]ro Contador y Joan delgado n[uest]ro secretario fecha en St Geronimo de madrid a diez de Septiembre de mill y qui[niento]s y setenta anos Yo El rey Por m[anda]do de su Mag[esta]d m[arti]n de gaztelu señalada del lic[encia]do minchaca, y doctor velasco, y Cont[ad]or Garnica.

Moneys for the Fabric of S. Lorenzo el Real

To our officers at the house of trade with the Indies, who reside in the city of Seville: you know that we have ordered our officers in New Spain to send you each year 30,000 ducados of those proceeds from the distribution of Indians which belong to our royal crown, on a separate account for matters of our service. And as we have ordered you to send these funds, when they arrive in that city, to the monastery of S. Lorenzo el Real, in the account of the paymaster of the fabric for its expenses, which is the purpose for which we have assigned them, and in completion thereof. With the last fleet which arrived we learn from Don Cristobal de Erasso that the 30,000 ducados were sent. Our wish is that they be brought to this town of Madrid for that purpose and be delivered to Lorenzo Spinola, a Genoese residing at our court. Wherefore I command that on receipt of this our decree, having discounted damages and other fees and costs as claimed, the remainder of the 30,000 ducados be sent under safeguard with a trustworthy person in your name and account as treasurer of the said house of trade to this town of Madrid, for delivery to the said Lorenzo Spinola,

which you are to do, notwithstanding the previous order to bring these moneys to the paymaster, and any other order that might be contrary, because this is our will, and we order that Francisco de Garnica our paymaster and Juan Delgado our secretary be authorized by this our decree, dated at San Jeronimo in Madrid on 10 September of 1570. I, the King. By order of His Majesty (Signatures of Martin de Gaztelu, Licenciado Minchaca, Doctor Velasco, and Paymaster Garnica).

APPENDIX 4

HERRERA AND THE KING
ON ALCHEMY

From IVDJ (unnumbered legajo, entitled "libros"), f. 261, Note from Juan de Herrera to the King, probably at Madrid. (I am grateful to Gregorio de Andrés for confirming my transcription):

A 25 junio, 1572

Aunque tengo estas cosas de Alchimia por burla, y se las muchas que se han hecho a los que se han hecho credito y dineros, me ha parescido todavia embiar a V. Md estos memoriales de un Juo fernandez vezino de aqui, q aunque se me embiaron anoche abiertos, no se si tuvo V. md lugar de verlos, y creo que si se ha de hazer caso de los muchos anos y hazda que este hombre ha gastado en buscar este secreto que agora ha hallado (a lo que dize) V. Md querra ver a solas y sin ruido esta maravilla, y sino, no haura para q remitirle a donde rian de sus capitulos, pretendiendo el tanto secreto en ellos [rubric of Juan de Herrera].

Aunque me dieron este memorial ayer salien do de la capilla vi yendo por el corredor el perjuizio del y como vi de lo q trataba me paresio q muy bien le podria juntar con los demas pero bos hareis bien en no remitirle y tampoco se a quien y yo lo tengo y he tenido siempre por cosa de burla y si a cudiere a bos os podreis informar del y decirle q quando lo tenga acabado del todo q entonces le auise q yo aseguro q nunca sea esto y bobelde los capitulos q guarde pr entonces.

Herrera's note:

On 25 June 1572

Although I consider these matters of alchemy as a joke, and know how much such men have profited from credit and cash, it still seemed to me necessary to send Your Majesty these petitions from one Juan Fernandez, residing here [Madrid]. Although they were sent as open papers to me last night, I do not know if Your Majesty has had occasion to see them. I believe, if one takes into account the years and property spent by this man in searching for the secret, which he now claims to have found, that Your Majesty would want to witness this marvel in private and without noise. But if not, there would be no reason not to refer what he writes, pretending to such secrecy, to those who laugh at his main points.

The King's reply, in the margins:

Although they gave me this petition yesterday as I was leaving the chapel, I saw while I was in the corridor the damage it might do. And as I saw what he was after, it seemed to me that it would do very well to put him together with the others. But you would do well not to send him away or to whom [?] I too consider and have always considered it a joke, and if you should have to, you might inform and tell him that when he has it all finished, that he advise you, as I am certain that this never can be. Then return him his petitions, which you will keep for the present.

APPENDIX 5

THE COST OF THE WORK,
1562-1601

IVDJ, envío 61, f. 305-308 (*Relacion del costo de la obra 1562-1601*)

[Folio 1ʳ] R[eal] Mon[asterio]. Del dinero que se a traido y
 entregado en esta fabrica del monesterio de San
 Lorenzo el R[ea]l para las obras de ella, desde q[ue]
 se començo hasta fin del ano de *1597* en esta
 manera—

 ANO 1562

En quatro de abril de 1562 se entregaron por cedula
de su mag[estad] a Pedro Ramos que hizo el off[icio]
de pagador de la fabrica del d[ic]ho monesterio tres
mil ducados Para dar principio a la d[ic]ha fabrica. 1,125,000

en 29 de Jullio del dho ano se entregaron al dho
p[edr]o rramos otros tres mil ducados p[ar]a el
d[ic]ho effetto— 1,125,000

desde 6 de 7 bre del dho ano de 562 hasta 15 de
mayo del ano sigui[ent]e de 563 se entreg[ar]on a
Ju[an] de Paz Pagador de la dha fabrica 5 q[uento]s
437d 500mrs. Por q[uen]ta del tessorero Domingo
de orbea 5,437,500

m[e]r[ce]d q[ue] Le Hizo de las alcaualas de la villa
de medellin y su condado 34,817,013

el dho dia 28 de mayo de 563 Recivio el dho Ju[an]
de paz Pagador mil ducados A q[uen]ta de nicolao
de grimaldo ginoues 375,000

Desde 3 de 7 bre de *1563* hasta 4 de Hebro de *1564*
recivio el dho Pagador Juan de paz *5 qs 610d*, q le
entrego el contador andres de almaguer Por orden
de su magd— 5,610,000

 [page total] 48,689,900

[Folio 1ᵛ] ANO DE 1564

Desde *29* de Julio de *1564* hasta *26* de Junio de *1567*
recivio el dho Pagador 5339U500 m[ara]v[edi]s porqta
de Sevastian de Santoyo en uirtud de una cedula del
secretro Po de oyo— 5,339,500

Desde *11* de noviembre de *1564*. Hasta *19* de mso
1565 Recivio el dho Pagador siete qos y qui[nient]
as mill mrs. *Porqta de ju[an] de lestar en virtud de una*
C[edula] de su Mag[estad]— 7,500,000

Desde *11* de Xbre de *1564* hasta 13 de Julio de *1567*
recivio El dho Pagador 6466 Ud mrs. Por qta de
Pode Santoyo pagador de las obras de M[adri]d 6,466,500

ANO 1565

Desde 18 de Abril de *1565* hasta 6 de otubre de *1569*
reciuio El dho Pagador *39923U598* mrs. Por quenta
de los Jueces de la Casa de la Contratacion de Sevilla
y por qta de los officiales de la nueva españa 39,923,598

Desde 9 de 7 bre de 1565 hasta 6 de Sept de *1567*
recivio el dho Pagador 30,750,000 mrs. Por qta de
melchor de herrera tessorero de su magd. 30,750,000

en qtro de nov del dho ano de 1565 reciuio el dho
Pagador 1125 U mrs Por qta del Contador fran'o de
montoya q se cobraron Por orden de fran[cis]co de
eraso 1,125,000

Desde seis de abril de 1566 hasta nueve de agto del
reciuio el dho Pagador 1566U869 mrs por qta de
Ju[an] de Orbea recepttor general de la consignacion
de las guardas de su majestad los 527 U mrs de ello
se cobraron del arcediano de m[adr]d de lo Proçedido
de los frutos y rentas Pertenecientes a la abadia de
parrazes 1,566,869

El dho dia 6 de abril de *1566* reciuio El dho pagdr
778 U mrs q le entrego Ju[an] de mᵒ tallane Criado
de su magestad de lo que por su orden cobro de los
Contadores Maiores 778,000

 [page total] 93,439,467

[Folio 2ʳ] Desde *25* de mayo de *1566* hasta 11 de otubre de
1568 recivio El dho Pagador 19163 U mrs Por qta
de Ju[an] Gutierrez Tello tessorero de la cassa de la
contratacion de Sivilla y alferez mayor de la dha
ciudad. Por auerlos cobrado de sancho loys de
agusto del offo de la S Cruzada de Camara de la
dha Nueva españa 19,153,000

en 9 de Agosto de *1566* recivio el dho Pagador *28 U*
q le entrego diego perez administrador de la aBadia
de parrazes de lo proçedido de la renta de ella (nota
q staua ya acumulada a S Lorenzo) 952,000

en siete de Dizb del dho ano de *1566* reciuio el dho
Ju° de paz quinientos mill mrs porq[uen]ta de el li-
cen[cia]do Calera Correg[id]or de Vizcaya de los
m[a]r[a]v[edí]s Pertenescientes al offo de Prevoste de
la viª de Bilbao 500,000

ANO DE 1567

en *31* de mayo de *1567* recivio El dho Pagador mil
ducados de franco de sotomayor correg[id]or de
m[adri]d q los cobro de don rrodrigo de Cuya s la
villa de tamamee 375,000

[The old value of the ducado was still in use as 375
mrs instead of 429 (Bringas, "Notas," p. 60)].

desde 6 de 7 bre de *1567* hasta 19 de octubre del dho
ano 7046U398 mrs recivio el dho Pagador Por qta
del tess[orer]o de la Casa de la contratacion de Sev-
illa q su magd mando entregue çiertas scrivanias 7,046,398

Desde 27 de junio de *1567* hasta 26 de septiembre de
1569 8430U500 mrs q Reciuio el dho Pagador Por
quenta de Ju[an] de viueas receptor general de res-
guardar de lo Procedido de los derechos de las cajas
q se meten en estos reinos 8,430,500

ANO DE 1568

Desde *29* de mayo de *1568* hasta 6 de mayo de *1569*
reciuio El dho Pagador 1719U548 mrs q Le entrego
Ju[an] F[ernan]dez Espinosa Por auerlos cobrado por
poliza del alcalde Tejada de la audiencia de Sivilla de
la prosedido de los frutos del beneficio de villa mar-
tinez 1,719,548

 [page total] 308,176,446

ANO 1569

[Folio 2ᵛ] en 18 de hebrero de *1569* reciuio el dho Pagador dos
mil ds que Le embio el Sr. Gaztelu de los quatro mil
ds que se trajeron de campos 750,000

en 31 de Março de *1569* reciuio El dho Pagador
2250U mrs q se le libraron en don gomez tello
Xiron gouernador del arçob[ispa]do de Toledo 2,250,000

Desde *25* de Junio de *1569* hasta *16* de sepre del dho
ano reciuio el dho Pagador 6752U mrs q le entrego
luis neve por çedula de su magd 6,752,000

Desde *13* de octubre del dho ano de *1569* hasta (en
once a[n]os) *14* de otubre del ano de *1580* reciuio El
dho Pagador 67725OU mrs. Por quenta de lorenzo
spinola y compania Jinoveses a q ta y conforme al
asiento q con su magd tenian tomado 677,250,000

ANO 1574

en *17* de Sepre de *1574* Reciuio el dho Pagador Ju de paz 1483U420 mrs q le entrego por çedula de su magd el Reçeptor de la contaduria de q tos de los alcançes que an resultado a los que del se toman de la haz[ien]da de su magd 1,483,420

ANO DE 1580

Desde 24 de otubre de *1580* hasta *28* de en 4 a[n]os abril de *1584* reciuio el dho Pagador 310125U mrs. Por qta de Ju° Fe[rnand]ez de [E]spinossa Tessorero de su magd 310,125,000

en *29* de marzo de *1584* Reciuio el dho Pagador Diez mil ducados en reales Por qta de Antto de gueuara del consejo de su magd 3,740,000

Desde *8* mayo de *1584* hasta vi de en seis a[n]os noviembre de *1590* Recivio el dho Pagador 453750U mrs. Por quenta de bar[tolo]me portillo de Solier Tessorero de su magd 453,750,000

Desde *23* de agosto de *1589* hasta *ocho* de abril de *1591* Reciuio El dho Pagador Tomas de paz [repeated on next page]

[page total] 1,456,100,420

[Folio 3ʳ]

Desde *23* de agosto de *1589* hasta ocho de abril de 1591 reciuio el dho pagador Thomas de paz 57750U mrs. Por qta de alonso moreno tendre tessorero de la Casa de la moneda de la Ciudad de segovia 57,750,000

Desde 10 de Julio de 1591 hasta fin del Reciuio Domingo de mendiola pagador de la dha fabrica otro pagador. Diez y ocho q[uen]tos de gonzalo de salazar y Ju° de Carmona Sanchez 18,000,000

Desde 4 de mayo de *1591* hasta 23 de hebrero de *1598* Reciuio el dho pagador 230250U mrs por quenta de Don pedro mejia de Tovar que haze el off[ici]o de Tessorero general de su magd 230,250,000

en *18* de sepbre de *1595* reciuio El dho Pagador tres mil ducados Por qta de Antto de Herrera en quien staua depossitado el a[r]bitrio y compusiçion de las cassas de la villa de M[adri]d 1,125,000

Desde 9 de marzo del *1592* hasta 15 de abril de *1597* reçiuio el dho Pagador 1012U500 mrs por qta de gaspar frias de miranda. Mayordomo de la Hazienda de aranjuez 1,012,500

Desde 31 de mayo de 1592 hasta 23 de sepbre 1597 reciuio el dho pagador 2550V000 mrs Por qta de Antt° bota guardajoyas de su magd 2,550,000

en 11 de mayo de *1596* reciuio el dho Pagador men-
diola 22U reales Por qta de luis baroan i Çapatta
tenedor de la thesorer[i]a de aragon 748,000

Mas Parece por otra memoria q[ue] fe queda P[edr]o
de Quessada q se trajeron a la dha fabrica las sumas
siguientes

Desde Primero de marzo de *1598* hasta 17 de sep-
tiembre del dho ano reciuio el dho pag[ad]or Do-
mingo de mendiola Viente v un quentos Por qta de
hetor pi Camilo y ambrosio Spinola y comp[añi]a
Deputados de la Contrataçion de los ombres de
Neg[ocio] 21,000,000

 [page total] 332,435,500

[Folio 3ᵛ] Desde *14* de marzo del dho ano de 1598 hasta *19*
 de agosto siguiente reciuio El dho Pagador q[ua]tro
 c[iento]s ducados Por qta de antto boto
 guardajoyas de su magd 150,000

 en 24 abril de *1598* reciuio el dho Pag q[ua]tro
 c[ient]os y cinq[uen]ta d[ucado]s Por qta de Gaspar
 frias de miranda mayor[do]mo de la haz[ien]da de
 arranjuez 168,750

 Hasta esta part[i]da se trajo siendo bivo Su magd p.
 q tiene e[n]ciero y los de abajo despues que murio

 Desde *11* de otubre de *1598* hasta fin de Xbre del
 reciuio el dho Pagador Domingo de mendiola nueve
 q[uent]os por q[uent]a de hetarpi camilo y ambrosio
 spinola ombres de neg[ocio] 9,000,000

 en Pr[imer]o de Agosto de *1598* digo *1599* reciuio
 el dho Pagador q[ua]tro mil d[ucado]s Por qta de
 Antto ximenez Pagador de los ombres de armas del
 Reino de Navarra 1,500,000

 en 27 de otubre de *1601* recivio el dho pagador 44U
 Reales 1,496,000

 [page total] 12,314,750

Por manera q suma y monta todo lo que se a gas-
tado en la dha fabrica desde 4 de abril de *1562* q se
comenzo hasta fin del ano de 1601 mill y nouecien-
tos y ochenta y un quentos y ciento y Çinqta y cinco
mill y nouenta y seis mrs que hazen çinco millones
y duçientos y ochenta y tres mill y ochenta ducados
y nouenta y seis mrs

[1ʳ] 48,689,900 maravedis
[1ᵛ] 93,439,467 maravedis
[2ʳ] 308,176,446 maravedis

[2ᵛ] 1,456,100,460 maravedis
[3ʳ] 332,435,500 maravedis
[3ᵛ] 12,314,750 maravedis

[2,251,156,483]
1,981,155,096 mrs 5,283,080 ds 96 mrs

5 millon 283,080 ducados y 96 mrs

[Folio 4ʳ] A ssede advertir que en esta fabrica y gasto entra
todo lo gastado en el quejigal Plantia de la viña y la
Cassa bodegas y Venta y la lauor de la viña despues
de plantada por algunos a[ño]s.

yten entra toda la labor de la fresneda Jardines y
plantia de arboles y estanques, çercas y paredes.

entran tanbien todas las paredes de los vados y las
çercas del Campillo y monesterio con la torre del
Campillo y Calle de alamos y todo el plantio de alli.

entra la fabrica de la Compaña y molino de ella y de
los dhos molinos y batan y arcas de agua y la Cassa
de torre de lodones y la puente de guadarrama.

entran las manos de bordadores tan solam[en]te
porq[ue] las sedas lienzo oro y seda es por q[uen]ta
de Ant[oni]o boto.

entran finalm[en]te aqui las armas reales y figuras de
bronze de los sepulcros y altar mayor—y la custodia
y retablo del—

Tanbien se aduierte que demas del dho Gasto q[ue]
atras queda sumado se gasto en la sacristia des
d[ic]ho convento Por q[uen]ta de Antt[oni]o° boto
guardajoyas de su mag[esta]d otros tre[s]çientos mill
ducados Poco mas o menos en los brocados sedas
telas oro plata y seda bronze dorado Lienzo aderesos
de Relicarios ebano y Lamparas—y Libros de la li-
breria—

Tanbien se a de aduertir q[ue] del d[ic]ho dinero
Por çedulas de su mag[esta]d Para la obra de ma-
drid y del Pardo lo sigui[ent]e

en 6 de hebrero de *1587* se dieron del dinero librado
Para esta fabrica al pagador de m[adri]d Por çedula
de su mag[esta]d Para los obras del Pardo 1 q[uent]o
500U 1,500,000

en 21 de Julio 1589 se dieron al d[ic]ho Pagador ca-
torze mil ducados para las d[ic]hos obras 5,250,000

mas Para las destilaciones de las aguas de botica
695U343 695,343

mas se dieron a Hector picamilo Jinoues y Antto[nio]
Juarez de vitoria cambio *477U500* mrs Por d[ic]hos

Santos q[ue] hizieron pagar en rroma a federico zu-
carro pintor q[ue] estuvo en esta fabrica de su/
sala[rio] q[ue] se la pagaua en rroma Por q[uen]ta de
su mag[esta]d 477,500

 7,922,843

[Marginal note] Los 7 q[uent]os 922U843 mrs de
estas 4 partidas que en ducados son 21127 ducados
[plus 581 mrs] se an de bajar de la suma principal
del gasto desta fabrica por no se auer gastado en ella

Lo que[e]sta librado Para la obra del retablo y cus-
todia armas y figuras del y de los entierros desde 23
de marzo de *1580* digo *1581* hasta fin del ano del
1597 de que no esta averiguado q[uen]ta hasta aora
76 q[uent]os 612U500 mrs que en ducados Monta
204,300 ducados lo gastado en el retablo y las fi-
guras. 76,612,500

[Folio 4�v] Suma el gasto y entreg[a] Principal 5,283,080 Ducados
 Por q[uen]ta de ant[oni]° boto 300,000

en suma 5,583,080 Ducados

de estos se bajan q[ue]se sacaron pa[ra]

obras de m[adri]d y del pardo 201,127

R[e]sta q[ue] se an gastado en la
d[ic]ha fabrica 5,701,955
 en s Lorenzo el R[ea]l a 6 de
 Jullio *1602* (rubric)

The terminal note is in the hand of Fray José de Sigüenza:

el coste que a tenido la obra del monest° de san lor-
enzo el Real Desde el ano de 562 que se enpeço hasta
601 monta *5 milliones 701,955 ducados.*

[Folio 305ʳ] Royal monastery. Of the money which was
 brought and delivered to the fabric of the royal
 monastery of San Lorenzo for the works on it,
 from its beginning until the end of the year 1597 as
 follows.

 YEAR 1562

On 4 April 1562, delivered by royal decree to Pedro
Ramos who served as paymaster to the fabric of the
monastery, 3,000 ducados to begin work. 1,125,000

[Throughout the building period the ducado was
valued at the Escorial as being worth 375 maravedis,

although the gold value was changed in 1566 to 429 maravedis. Sigüenza, FME, p. 418, gives the author's name as Pedro de Quesada, "who helped me greatly."]

On 29 July, another 3,000 ducados for that purpose were delivered to Pedro Ramos— 1,125,000

From 6 September 1562 until 15 May 1563, Juan de Paz, paymaster, was sent 5,437,500 maravedis from the account of the treasurer, Domingo de Orbea 5,437,500

YEAR 1563

From 28 May 1563 until 18 August 1569 there were delivered 34,817,013 mrs to Juan de Paz, paymaster of the fabric, from the account of Don Rodrigo Portocarrero, Count of Medellín who owed the King for the grant of the sales tax in the town and country of Medellín 34,817,013

On 28 May 1563 Juan de Paz as paymaster received 1,000 ducados from the account of Nicolas de Grimaldo, Genoese 375,000

From 3 September 1563 until 4 February 1564 Juan de Paz received as paymaster 5,610,000 maravedis from the accountant Andrés de Almaguer on His Majesty's order 5,610,000

[page total] 48,689,900

[Folio 305ᵛ] ### YEAR 1564

From 29 July 1564 until 26 June 1567 the paymaster received 5,339,500 maravedis from Sebastian de Santoyo by decree from the secretary, Pedro de Hoyo 5,339,500

From 11 November 1564 until 19 March 1565 the paymaster received 7,500,000 maravedis from Juan del Estar by royal decree 7,500,000

From 11 December 1564 until 13 July 1567, the paymaster received 6,466,500 maravedis from Pedro de Santoyo, paymaster of the royal works at Madrid 6,466,500

YEAR 1565

From 18 April 1565 until 6 October 1569 the paymaster received 39,923,598 maravedis from the magistrates of the House of Trade in Seville, and on the account of the officers of New Spain 39,923,598

[At 375 maravedis/ducado this equals 106,463 ducados or better than three years' remittances from New Spain.]

From 9 September 1565 until 6 September 1567 the paymaster received 30,750,000 maravedis from Melchior de Herrera, treasurer to His Majesty — 30,750,000

On 4 November 1565 the paymaster received 11,-250,000 maravedis from the accountant, Francisco de Montoya, which were collected by order of Francisco de Eraso — 1,125,000

From 6 April 1566 until 9 August 1566 the paymaster received 1,566,869 maravedis from Juan de Orbea, receiver-general of the consignment of the royal accounts. 527,000 maravedis of this sum were collected from the archdeacon of Madrid out of the proceeds of crops and rents belonging to the abbey at Parraces — 1,566,869

On 6 April 1566 the paymaster received 778,000 maravedis from Juan de Montallana of the King's household, collected on royal order from the head accountants — 778,000

[page total] — 93,439,467

[Folio 306ʳ]

From 25 May 1566 until 11 October 1568 the paymaster received 19,153,000 maravedis from Juan Gutierrez Tello, treasurer of the House of Trade in Seville and chief lieutenant in that city, who collected the sum from Sancho Loyz de Agusto of the Office of the Holy Crusade in New Spain — 19,153,000

On 9 August 1566 the paymaster received 28,000 ducados delivered by Diego Perez, administrator of the abbey at Parraces, from its income — 952,000

[Note that this income had been already accumulated at San Lorenzo.]

On 7 December 1566 Juan de Paz received 500,000 maravedis from Licenciado Calera, magistrate in Biscay, out of the money belonging to the Provost's office in the town of Bilbao — 500,000

YEAR 1567

On 31 May 1567, the paymaster received 1,000 ducados from Francisco de Sotomayor, magistrate of Madrid, who collected them from Don Rodrigo de Gudinez of the town of Tamamee — 375,000

From 6 September 1567 until 19 October 1567, the paymaster received 7,046,398 maravedis from the treasurer of the House of Trade in Seville, from various notarial offices as ordered by His Majesty — 7,046,398

From 27 June 1567 to 26 September 1569, the paymaster received 8,430,500 maravedis from Juan de

Viveas, receiver-general of the proceeds from taxes
in the strongboxes of kingdoms 8,430,500

YEAR 1568

From 29 May 1568 to 6 May 1569 the paymaster
received 1,719,548 maravedis delivered by Juan Fer-
nandez Espinosa, collected from the crops of the liv-
ing of Villa Martinez, on contract with mayor Te-
jada in the jurisdiction of Seville 1,719,548

 [page total] 308,176,446

[Folio 306ᵛ] ## YEAR 1569

On 18 February 1569 the paymaster received 2,000
ducados sent by secretary Gaztelu from 4,000 du-
cados which were brought from Campos 750,000

On 31 March 1569 the paymaster received 2,250,000
maravedis delivered from Don Gomez Tello Xiron,
governor of the archbishopric of Toledo 2,250,000

From 25 June 1569 until 16 September 1569 the pay-
master received 6,752,000 maravedis delivered by
Luis Neve on royal decree 6,752,000

From 13 October 1569 to 14 October 1580 (eleven
years) the paymaster received 677,250,000 mara-
vedis from Lorenzo Spinola and company, Genoese,
according to agreement made with His Majesty 677,250,000

YEAR 1574

On 17 September 1574 the paymaster Juan de Paz
received 1,483,420 maravedis delivered by the re-
ceiver of accounts, from balances resulting from
withdrawals from His Majesty's properties 1,483,420

YEAR 1580

From 24 October 1580 until 28 April 1584 (in 4
years) the paymaster received 310,125,000 mara-
vedis from Juan Fernandez de Espinosa, treasurer to
His Majesty 310,125,000

On 29 March 1584 the paymaster received ten thou-
sand ducados in reales from Antonio de Guevara of
His Majesty's council 3,740,000

From 8 May 1584 until 6 November 1590 (six years)
the paymaster received 453,750,000 maravedis from
Bartolomé Portillo de Solier, treasurer to the King 453,750,000

 [page total] 1,456,100,420

[Folio 307^r] From 23 August 1589 to 8 April 1591 the paymaster
Tomás de Paz received 57,750,000 maravedis from
Alonso Moreno, treasurer at the Mint in the city of
Segovia 57,750,000

From 10 July 1591 until [month's] end the paymas-
ter Domingo de Mendiola (another paymaster) re-
ceived 18 million from Gonzalo de Salazar and Juan
de Carmona Sanchez 18,000,000

From 4 May 1591 to 23 February 1598 the paymas-
ter received 230,250,000 maravedis from Don Pedro
Mejia de Tovar, serving as the King's general treas-
urer 230,250,000

On 18 September 1595 the paymaster received 3,000
ducados from Antonio de Herrera who is entrusted
with the taxation and settlement of claims on the
houses of Madrid 1,125,000

From 9 March 1592 until 15 April 1597 the paymas-
ter received 1,012,500 mrs from Gaspar de Frias de
Miranda, the majordomo of the properties at Ar-
anjuez 1,012,500

From 31 May 1592 until 23 September 1597 the pay-
master received 2,550,000 maravedis from Antonio
Boto, keeper of the jewels of His Majesty 2,550,000

On 11 May 1596 the paymaster received 22,000 reals
[the real de plata was worth 34 maravedis (Ulloa,
Hacienda, p. 55)] from Luis Baraon y Zapatta, the
acting treasurer of Aragon 748,000

It further appears from a report by Pedro de Que-
sada that the following sums were brought to the
fabric

From 1 March 1598 until 17 September of that year
the paymaster, Domingo de Mendiola received 21
million from Hector Picamilo and Ambrosio Spi-
nola and company as deputies of the men of business 21,000,000

[page total] 332,435,500

[Folio 307^v] From 14 March 1598 until 19 August of that year
the paymaster received 400 ducados from Antonio
Boto, Keeper of the King's jewels 150,000

On 24 April 1598 the paymaster received 450 duca-
dos from Gaspar Frias de Miranda, majordomo of
the properties at Aranjuez 168,750

To this point the listing is during the lifetime of
the King and the entries below follow his death.
[Sigüenza, FME, p. 418, gives the lifetime total as
5,260,560 ducados.]

From 11 October 1598 until month's end, the pay-master Domingo de Mendiola received nine million from Hector Picamila and Ambrosio Spinola, men of business	9,000,000
On 1 August 1599 the paymaster received 4,000 ducados from Antonio Ximenez, paymaster of the militia of the Kingdom of Navarre	1,500,000
On 27 October 1601 the paymaster received 44,000 reales	1,496,000
[page total]	12,314,700

Hence the sum and amount of all expense of the fabric from 4 April 1562 when work began, until the end of 1601, was 1,981,155,096 maravedis, which equal 5,283,080 ducados 96 maravedis. [The page totals, however, add to 2,251,156,483 maravedis or 5,283,080 ducados. The discrepancy is 270,001,387 maravedis].

[Folio 308ʳ] It is to be noted that this expense of the fabric includes all that was spent at El Quejigal in the vineyard, housing, cellars, the inn and the labor on the vines after planting for several years.

Item. Also included is all the work at La Fresneda, on gardens, tree-plantings, ponds, fences and estate walls.

Included too are all the walls at the fords and the fences of Campillo and Monesterio, as well as the turret of Campillo and the poplar-lined roadway with all its planting.

Included is the fabric of the Compaña with its mill and other mills and the fulling mill and the water cisterns, and the dwelling at Torrelodones and the Guadarrama bridge

Included are the embroiderers alone, because the silks and cloths of gold and silk go on the account of Antonio Boto.

Included finally here are the royal arms and the bronze figures of the burials and the main altar—and the monstrance and altarpiece of it—

Also to be noted is that besides the expense listed above, there was spent in the sacristy of the monastery another 300,000 ducados on the account of Antonio Boto, keeper of the royal jewels, more or less all of it on brocades, silks, cloth of gold and silver, gilt bronze, linen, reliquary ornaments, ebony, and candelabras—and library books—

It is also to be noted that of the said moneys the following were given by royal decree to the works at Madrid and El Pardo:

On 6 February 1587, money delivered for this fabric [the Escorial] was given by royal decree to the paymaster at Madrid for works at the Pardo, amounting to 1,500,000 1,500,000

On 21 July 1589, 1,400 ducados were given to the said paymaster for the said works 5,250,000

as well as for potions distilled in the pharmacy, 695,343 695,343

In addition 477,500 maravedis were given to Hector Picamilo, genoese, and Antonio Juarez de Vitoria, moneychanger, for the said paintings of saints, to be paid for in Rome to Federico Zuccaro, who stayed at the fabric and was paid in Rome on His Majesty's account 477,500

 [page total] 7,922,843

The 7 million 922, 843 maravedis of these 4 entries amount to 21,127 ducados [plus 581 maravedis], which are to be taken from the principal sum of the expense of the fabric, as not having been spent there.

The expenditure on the main altarpiece, monstrance, coats of arms and figures of the burials, from 23 March 1581 to the end of 1597, for which there is no account until now came to 76,612,500 maravedis or 204,300 ducados spent on altarpiece and figures 76,612,500

The total expense and funding total on account 5,283,080 ducados
with Antonio Boto 300,000

Totaling 5,583,000 ducados

To be reduced by withdrawals for the works at Madrid and the El Pardo 201,127

The remainder spent on the fabric [of the Escorial] [This figure should be corrected to 5,371,873.] 5,701,955

 At S. Lorenzo el Real on
 4 July 1602 (rubric)

[The terminal note is in the hand of Fray José de Sigüenza:] The cost of the work on the monastery of San Lorenzo el Real from the year 1562 when it began until 1601 amounts to 5 million 701,955 ducados.

Sigüenza, who annotated this document at length, estimated that the average annual cost of building the Escorial was 160,-000 ducados for thirty-six years. He also estimated the expense of its parts as follows (FME, pp. 421-27):

sacristy	400,000 to 550,000 ducados
basilica	51,104 (without decoration)
altarpiece, tabernacle, royal burial figures	862,104
paintings and frescoes	26,469
organs	26,899
choirstalls	24,200
choir shelving	6,846
library furnishings	44,844
grillwork in basilica	50,620
sanctuary sculpture	140,000

Sigüenza estimated the total cost of the basilica with its decorations as between 1,040,000 and 1,240,000 ducados. (FME, p. 423: his figures total 1,181,982 ducados, after we reject the lower estimate [345,802] for the sanctuary decorations in favor of his more inclusive one of 862,104.)

He goes on to estimate the remaining major expenses:

cloister frescoes	38,171
library frescoes	18,165
library shelving	12,727
statues of Kings	10,945
vestments (material only)	21,600
altar cloths (material only)	100,000
Holy Week monument	4,809

If Quesada gave the cash flow, Sigüenza told how it was spent.

APPENDIX 6

A SATIRE AGAINST THE SITE OF THE ESCORIAL

The manuscript in the Bibliothèque Nationale in Paris (MS. Port. 23, fols. 515-18) was first published by Morel-Fatio, *L'Espagne*, pp. 680-83. The version by Zarco (*Discursos*, pp. 109-12) is much abbreviated (reprinted by Alvarez Turienzo, *El Escorial*, pp. 186-87).

Sir:

I cannot lay the blame elsewhere, than on the bad influences of this town and royal domain, that your honor, being bred in such civility as is the parent of courtesy and brother of grace, should ask of me something so foreign to all this, which is to demand many letters and answer none. Godsbody! Am I so happy, am I always so even-tempered, and your honor so joyless and busy, that I must always write, and your honor never answers? This is why the servant is aggrieved with his master; the vassal with the King, the slave with his master, and the son with his father. Yes, I too am of flesh and bone, sad without money, gloomy when there is no work, melancholy being indisposed, and finally discontented in knowing that God never sheds his favor on my affairs (as the unhappy prophet said).

The blame for it all lies on this discourteous countryside, and on this (I was about to say, accursed) town of the Escorial. It is a town without manners, a graceless mountain, an unwelcoming place where (excepting the building and the holy and sacred things of the Monastery) all else is abhorrent and abominable. There the country has no land but only rocks; the sky has no horizon, because to all the north and west, and part of the south, the height of the peaks not only blocks most of the hemispheric prospect, but also prevents the best and most healthful winds.

As in summer the heat is not moderated by the gentleness of the zephyr, nor can the cold north wind be tempered by the heat of the summer, so the rigor of cold is not warmed by the softness of the site. When clouds or fogs appear, by which I mean the larger part of the year, it is almost a perpetual night, and when the air clears it is as by mistake. With every blizzard from the mountain the snow drifts and blows over the domain in the months when it is least expected and desired, so that at the same moment it is winter in the midst of summer, and it snows when no snow is possible, and against all laws of nature. All these inclemencies cause the residents to succumb to illnesses from which few escape. Even the goddess of health herself, should she be here in summer, would fall ill.[1]

Plants fail to thrive, trees do not increase, flowers freeze, fruits are hail-struck, and whatever escapes fog, ice, and hail is devoured by deer. The waters are hard, the winds penetrating, the cold insufferable, the heat intolerable; meats are skinny, fishes rotten, fruits tasteless, vegetables lanky, flowers scentless, women colorless, graceless, and lacking in wit; the men slovenly, gross and rustic; thus even the King, by the fatal climate of the country, sleeps as if forgetting his grandeur, sleeps there on a bed of coarse sacking. The Prince is clothed in woolens and learns his grammar

[1] The allusion is to malaria (Vicuña, *Anécdotas*, pp. 62-68).

badly. The Infanta [Isabel Clara Eugenia] and her ladies-in-waiting lose their beauty here,[2] and their complexions harden like those of sheep-herders. Chamberlains, and secretaries dress like huntsmen, courtiers like cowherds, office seekers like seminarists. The friars live in boredom, the merchants live in despair, and the palace servants prefer the fritters of Madrid to that manna of the desert provided at the King's table.

There perpetual disorder and disharmony rule among endless ambition and scheming because the Prince, instead of being reared among people, wanders like a goat in the underbrush. The ladies who ought to wear festive dress, make embroideries in chain-stitching, or blend perfumes, instead are sifting gunpowder and filling powder-flasks, cleaning shotguns, making shot and decoys, twisting the cords for crossbows, polishing spectacles, feathering arrows. They leave for the hunt like nymphs with their Diana, and forget their marriage vows by going among the stags in rut.

The monks, who professed celibacy, are like tomcats mewing in the attics, hearing the soft voices of the ladies, with the court at the backs of the dormitory.

In the church one is among continual interdictions, because to enter not even a bull of the Crusade suffices. The saints' names are known only by report, all of them being so far and high that they can hardly be seen. The famous painters there have forgotten their art, and their drawing has lost the pace and movement that elsewhere endowed their images and figures almost with life, but giving death there to their people. What can I say about the men, if even the books become savages fleeing from the sight of scholars,[3] and hiding among the enchanted lockers of the invisible library?

The fable of Orpheus tells how his music attracted to him not only animals but also moved the very stones to follow him; and how by knowledge and eloquence he persuaded men who lived like beasts in the hills to live with him in cities, bringing the stones down from the mountains and the trees from the hills with which to build them. But at the Escorial all is different, where city dwellers, leaving the pleasures of their homes and towns and courts, go forth among these unhappy crags and peaks, moved not by the music of Orpheus, but following a spell woven of the sickly and deceitful hopes of one or another royal minister.

At the Escorial the waters are that very fountain of Diana at which Actaeon was turned into a stag, because while many hunters spend their summers by these

ponds, thinking they will be refreshed by the waters of their deprivations and pretensions, their wives in Madrid and elsewhere put the crescent moon on their husbands' brows.

How good and fit is this place for noting and observing omens, having instead of all kinds of birds, only owls, cuckoos, and storks! As at lake Avernus, good birds flee the Escorial, but as if in compensation at every step, under every rock, in every patch of grass, and under every thicket are large lizards, great vipers, uncounted snakes, and every kind of poisonous serpent living in this domain.

If you want to stay indoors, all is hot, dirty, disgusting, and abominable, filled with fleas to devour you, mosquitoes to sting you, bedbugs to suck your blood, harpies to seize your food, and furies to drive you mad. If you want to go out for exercise, the flat places are fenced in, and the slopes are so steep that you climb with your hands and come down on buttocks.

What a pity it is to see a poor merchant descend sweating from the royal domain, out of patience after waiting in vain, and on arriving at his inn, to find it unswept, without food, the water tepid, the wine vinegary, the table shaky, the cloths dirty, plates broken, clothing stiff with grease, everything covered with flies, and when trying to sleep, attacked in bed by sudden hosts of fleas and bedbugs greater than the armies of Xerxes.

But those who stay in the domain are no better off, because everything has a bad stretch in which all goes wrong, all is upset, all is confused. At the same instant the stag roars, the lady-in-waiting moans, the wolf howls, the friar sighs, the ass brays, the office seeker murmurs, the pig grunts, the merchant complains, the weather thunders, the soldier curses, the geese cackle, and the favorite belches.[4] Whether in the town, the royal domain, or in the courtyards, there are heard at the same time Castilian, Portuguese, and German in a confusion beyond that of the ark of Noah. Is it a wonder that the Royal council is beset by extravagant caprices unseen by eyes and unheard by ears? Is it a miracle that with so many petty matters [*gritillos*] on their minds so many unsure secretaries should have ill-understood thoughts? Is it a nightmare that everyone in this place becomes a rustic, wild in thought and uncivilized under the influence of this climate? They finally run like unset clocks; when it is twelve they chime two, and at one, ten. They are like doors unhinged; they think what they do not dare; they say

[2] As Catherine, the second Infanta, is not mentioned, Morel-Fatio concludes that the date of the satire is after 1585, when she married the Duke of Savoy, leaving the Spanish court for Italy (*L'Espagne*, p. 680).

[3] Referring to the shelving of library books with their

gilded fore-edges showing, and the spines hidden from view at the back of the shelf, a custom intended to preserve the books rather than keep them from being used, since the place of each volume was fixed in the catalogue. FME, pp. 304-305.

[4] Possibly Cristobal de Moura, court chamberlain.

what they do not understand; they hear what is not needed; they judge what they cannot attain.

Now then, if the siting of lands instills in them their characteristics (as Galen thinks) and repairs their customs, let us consider what men be these, who live and stay all the year at the Escorial; and in conclusion, suffice it to say that they who live at the Escorial are in the hills—that is to say, in a countryside outside the world, as they say in Grammar, *extra annis solisque viam*; also it is the nature of the Escorial to have in it only scraps of slag, as at the mines, where after the gold and silver and other metals have been extracted, the slag remains, made of stone, clods, ashes, and other useless things.[5] Neither more nor less, so it is in that town and domain, after the furnace fires have extracted from the wretched merchants in the inns all their gold, silver, and copper, leaving the dross, barely worth throwing on the trash heap.

I truly believe that in these hills and valleys, as well as on their rough slopes, there live Sisyphus condemned to roll his rock, and Ixion to his wheel, and Tityus to lose his entrails, and Tantalus to die of hunger and thirst, from all of which may God preserve your honor.

[5] The author of the satire follows an erroneous etymology for Escorial, as fixed by Antonio Gracián (1540-1576). The etymon is not Latin *escoria* ("slag"), but *esculus* (old Castilian *esculo*), meaning the evergreen or holm oak (*Quercus ilex*), which is abundant in the area, and known today as *encina* (Vicuña, *Anécdotas*, p. 6).

APPENDIX 7

LA FRESNEDA

Fresneda was originally a village converted into a royal park by the gardener of Charles V at Yuste, Fray Marcos de Cardona, who was brought to Fresneda by the King. The cloister, of twelve cells with a chapel, refectory, and kitchen, was built to adjoin the Flemish-style country house, of brick with a high gable and tile roofs. Both cloister and house being finished in 1564-1565.[1]

The estate of La Fresneda was always an important annex for the Escorial, first as a temporary residence for the King while the monastery was in construction, as well as for the friars and the court until 1571. Thereafter it became a place of recreation for the court, where costly buildings arose, surrounded by elaborate gardens and reservoirs. Jehan Lhermite, a courtier who knew it well, described it as a pretty house among pastures, orchards, woods, and ponds for fish raising, with swans, pleasure boats, and skating in winter. The friars had a small cloister there for their recreation and convalescences, although they were unaware that its fishponds were malarial.[2]

Much of the best fine-grained granite for the Escorial was quarried at La Fresneda, and a big brickyard and kiln existed on the estate after 1575. Enclosure within a granite wall began soon after the King and friars moved to the monastery in 1571, and at the beginning of the frequent use of royal property by the court.[3]

The gardens were enhanced by fountains whose walls were painted as a forest garden with people by Rodrigo de Holanda in 1580. A new and larger pond was dammed in 1583. More fountains were built, along with pleasure boats, such as a *galera* and a *barca* in 1585-1586, and a garden dining pavilion in 1592.[4] Thereafter most of the expense until the King's death in 1598 was on the gardens, and little that was new happened until 1621 when a fire damaged the King's small house, which was repaired by substituting slates for the original tiles.[5]

In 1626 it was called the "palacio de la Fresneda" for the first time, probably corresponding to its true character as a retreat for the court from the monastery. Today it is in private hands, well kept and much rebuilt, but freed at last from malaria.

[1] Ximenez, *Descripción*, pp. 389-392; AME, I-29, payments for windows; AME, I-33a, plastering and whitewash; AME, I-34a, carpentry; AME, II-132 (1570-1571), improvements in chapel and refectory.

[2] AME, I-80 (1567-1569), payments for work on the Canaleja pond. Lhermite, *Passetemps*, 1: 277, 313; AME, II-93 (1597).

[3] AME, II-40 (4 September 1569); AME, IV-13 (1575), on the brickyard; AME, III-6 (1573), contracts for enclosure walls.

[4] AME: VII-10 (1580); VIII-21, pond; VIII-35, fountains; IX-32, X-12, boats; and, XIII-8, pavilion.

[5] AME, XV-35. Luis Cervera has prepared complete architectural drawings of the sixteenth-century buildings on the estate. These will soon be in press.

APPENDIX 8

CATALOGUE OF DRAWINGS FROM THE OFFICE OF JUAN DE VILLANUEVA, 1785

Seventeen sheets (I, 17-18; II, 6-20) are not listed here, because they pertain to buildings beyond the original periphery of the Escorial, in the town. These were designated in the descriptive legend as *casas propios de S. M.* ("houses belonging to His Majesty"), rather than to the monastery.

Lamina 1 in the first portfolio was the title page: "Plan Topographico de todo el Sitio y Geometricos de las Casas propias de S. M. en las que hasta acqui se han alojado los Criados y familia de S. M. egecutado de su Rl Orden comunicada por el *Exmo Sor* Conde de Floridablanca *Secreto* de Estado a el *Exmo Sor* Duque de Medinaceli Mayordomo mayor. Ano de 1785."

Lamina 2 is the map of San Lorenzo as a town, keyed with numbers corresponding to the architectural drawings in the first portfolio, and signed by the draftsman, J. de Merlo, who also signed sheets 3-5.

The remaining *laminas* 3-16 contain the numbered drawings noted on the map. The complete portfolio as I studied it in January 1964 included all the following drawings:

CATALOGUE OF DRAWINGS

Numero	Lamina AGP		Title as Written
1	3	777	Patios del Palacio (fig. 110A)
2	3	777	Plan de cantinas del palacio (fig. 110A)
3	4	776	Plan de entresuelos que comprende parte del palacio
4	5	775	Plan principal que comprende parte del palacio
5	6	774	Plan de entresuelos del colegio (fig. 110B)
6	6	774	Plan principal del colegio y seminario (fig. 110B)
7	6	774	Plan de entresuelos del colegio (fig. 110B)
8	6	774	idem (fig. 110B)
9	6	774	idem (fig. 110B)
10	6	774	Plan de entresuelos debajo del piso principal del claustro del colegio (fig. 110B)
11	6	774	idem (fig. 110B)
12	7	—	Plan principal del patio y claustro del convento
13	7	—	Plan segundo de las celdas del callejon a Oriente encima de las celdas del claustro principal
14	7	—	Plan bajo del claustro de la Compaña
15	7	—	Plan principal del claustro de la Compaña
16	7	—	Plan bajo de la sala capitular del Convento
17	7	—	Plan segundo de las celdas del callejon a medio dia encima de las celdas del claustro principal
18	7	—	Plan de cantinas del convento (basement, prior's tower)
19	8	—	Plan bajo de la parte del convento (at entrance to basilica)

Numero	Lamina	AGP	Title as Written
20	8	—	Plan de entresuelos del convento (southeast cloister?)
21	8	—	Plan principal del convento (at refectory)
22	8	—	Plan de entresuelos debajo del principal (southwest cloister, infirmary)
23	8	—	Plan de entresuelos del piso principal (northwest cloister, library?)
24	9	773	Plan bajo de la primera casa de oficios
25	9	773	Plan bajo de la segunda casa de oficios
26	10	772	Plan de entresuelos de la primera casa de oficios
27	10	772	Plan de entresuelos de la segunda casa de oficios
28	11	771	Plan principal de la primera casa de oficios (fig. 111A)
29	11	771	Plan principal de la segunda casa de oficios (fig. 111A)
30	12	770	Plan de entresuelos de la primera casa de oficios
31	12	770	Plan de entresuelos de la segunda casa de oficios
32	13	769	Plan de guardillas de la primera casa de oficios
33	13	769	Plan de guardillas de la segunda casa de oficios
34	14	768	Plan principal de la casa propia de S. M. para familia del Secret° de Estado y de Indias
35	14	768	Plan de Entresuelos
36	14	768	Plan bajo de la casa propia de S. M. intitulada de la Patriarcal
37	14	768	Plan principal de la casa propia de S. M. intitulada de la Patriarcal
38	14	768	Plan de guardillas . . . de la Patriarcal
39	14	768	Plan bajo . . . Estado y de Indias
40	14	768	Plan de guardillas . . . Estado y de Indias
41	14	768	Plan bajo de la casa de los perros
42	14	768	Plan bajo de la casa tahona del rey
43	14	768	Plan principal de la casa tahona del rey
44	14	768	Plan bajo de la casa propia de S. M. intitulada de Cristobal Canosa
45	14	768	Plan principal . . . Cristobal Canosa
46	14	768	Plan de guardillas . . . Cristobal Canosa

Numero	Lamina	AGP	Title as Written
47	15	767	Plan bajo de la casa propia de S. M. para el Patriarcal
48	15	767	Plan principal de la casa propia de S. M. para un cirujano de familia
49	15	767	Plan de guardillas . . . cirujano
50	15	767	Plan bajo de la Casa propia de S. M. intitulada del conde de Ricla
51	15	767	Plan principal . . . Ricla
52	15	767	Guardillas de la casa propia de S. M. intitulada del conde de Ricla
53	15	767	Plan principal de la casa propia de S. M. para la Superintendencia
54	15	767	Plan de entresuelos . . . Superintendencia
55	15	767	Plan de entresuelos de la casa de los perros
56	15	767	Plan bajo . . . Superintendencia
57	15	767	Plan bajo de la casa propia de S. M. para los talleres de carpintero y cerrajero
58	16	766	[Plan de la casa] Marcos Gomez
59	16	766	idem
60	16	766	idem
61	16	766	Plan bajo de las cocinas nuevas del Pretil
62	16	766	Plan bajo de la casa de postas
63	16	766	Plan principal de la casa de postas
64	16	766	Planos . . . para los aguadores de la cava
65	16	766	idem
66	16	766	idem
67	16	766	idem

The second portfolio (labeled as *2ª parte* in 1964) contained another series of numbered *laminas*, drawings of the outbuildings at the northern boundary of the Escorial called the *casa de oficios*. These sheets are only five in number and they form a distinct group identified by a legend on *lamina* 1: "Proyecto para el R¹ Sitio de Sⁿ Lorenzo, que consiste en cortar la altura de los principales de las Casas de Oficios, 18. pies dejandolos unos a 9. pies y otros a 8. de altura, y aciendo nuebos Entresuelos aumentando en las entradas de los Pisos vajos algunas avitaciones, y sobre estas otras tantas en cada Piso hasta el quarto, que en todas arrojan 44. avitaciones nuebas 3. de a 12 piezas y 6. de a 7. en pral, 4. de a 4. piezas y 2. de a 2. en lo vajo, 8 de a 7 piezas y 4 de a 5 en Entresuelos

2ᵒˢ, 8 de a 4 piezas, 8. de a 3. y 2 piezas sueltas en guardilla, regulando su coste a 3600 MS. poco mas o menos." They too are numbered as *laminas* corresponding to the AGP numbers:

Lamina	AGP	Title, as Written
1	778	Projecto (north elevation, sections, fig. 111B)
2	779	Plan principal
3	780	Plan entresuelos
4	781	Plan entresuelos segundos
5	782	Plan de guardillas

All five are related to the projected (but rejected) remodeling of the Herrera *casa de oficios* (fig. 111B), while the plans of those buildings in the first portfolio all record their actual condition in 1785 (fig. 111A). It is fortunate that these examples of Herrera's own work were not subjected to an occupancy that would have been more than doubled. Yet the evidence (AGP 769-73) is that tenementlike conditions of crowded housing already had prevailed in them for many years. (*Numeros* 24-33 or *laminas* 9-13).

APPENDIX 9

TYPES OF CONSTRUCTION CONTRACTS,
BY YEARS

Though incomplete, the documentation now available after 1566 is abundant enough to allow a rough estimate of the amount of construction contracted and paid for annually. Where contracts were lacking, payments (*pagos, libranzas, dattas*) have been used. It would be possible, but not necessary here, to record the duration of each contract, especially if a thorough search were made at AGS for payments.

Dated appraisals (*mediciones*) of the value of finished work are useful to determine missing dates of completion. Estimates of cost (*tasaciones*) are also useful. It should be noted that the AME repository is incomplete, and that the exact number of missing documents cannot be estimated (Andrés, *Inventario*, pp. 3-6), there or at AGS.

GRAPH OF CONTRACTS, 1566-1586

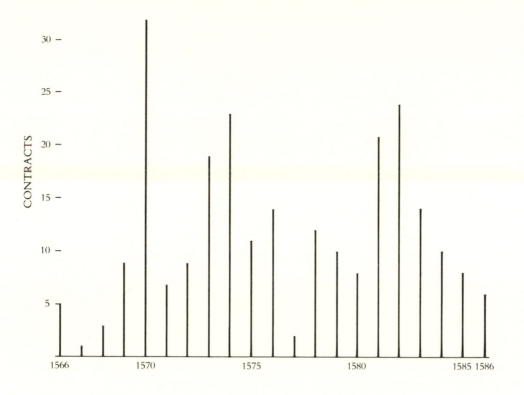

TABLE OF CONTRACTS, 1566-1586

Date		Description	AME Reference
1566	N.d.	Basement drains and ducts	I-64
	Dec.	Masonry, small cloisters	I-65
	19 Apr.	Drains, ducts between kitchen and toilets	I-66
	N.d.	Southwest tower gallery, stone	I-68
	28 Apr.	Door and window frames, stone	I-68
1567	8 June	Temporary dwelling of King, masonry, vault	I-90
1568	16 May	Small cloisters, paving	II-10
	29 June	Cornice, kitchen passages	II-21
	10 Nov.	Kitchen roofing	II-22
1569	6 Mar.	Main cloister cistern vault	II-37
	15 Jan.	Vaults in provisional church	II-38
	N.d.	Vaults in main cloister	II-39
	4 Sept.	Arcades in main cloister	II-40
	N.d.	Infirmary chimney, west building	II-44
	6, 13 July	Infirmary tower, masonry	II-46
	5, 9 May	Upper-story flooring	II-47
	16 Jan.	Kitchen vault	II-117
	N.d.	Paving, small cloisters	II-50

TABLE OF CONTRACTS, 1566–1586 (*continued*)

Date		Description	AME Reference
1570	29 Jan.	Main cloister arcade	II–60
	29 Jan.	Paving, provisional church	II–61
	1 Mar.	Refectory vault	II–64
	20 Mar.	Roofing over toilet building	II–66
	20 Mar.	Roofing over west building	II–67
	28 July	Basement and passage at vestiary building	II–69
	20 July	Upper arcades, main cloister	II–70
	22, 27 July	Main stair, north aisle	II–72
	9 Aug.	Plastering 14 courtiers' quarters in chapter-rooms	II–74
	14 Aug.	Garden stairs at provisional royal dwelling	II–75
	22 Aug.	Upper-floor vaults, main cloister	II–76
	18 Oct.	Spire, southwest tower	II–78
	12 Jan.	Roofing over main stair	II–82
	N.d.	Entablature, main stair	II–90
	N.d.	Drains and ducts	II–91
	N.d.	Roofing, west building	II–93
	N.d.	Vaulting in chapter-room	II–94
	10 Jan.	Vaulting in chapter-room	II–99
	N.d.	North-cloister building	II–102
	N.d.	Flooring 3 cells	II–102
	N.d.	Foundations under basilica	II–104
	N.d.	Main stairway, cloister arcades	II–105
	N.d.	Refectory crossing tower	II–106
	30 July	Roofing over provisional royal dwelling	II–107
	N.d.	Choir windows, provisional church	II–109
	N.d.	Royal dwelling, south and east wings	II–111
	16 Nov.	Completion of toilet building	II–112
	N.d.	Northeast cloister	II–113
	21 Sept.	Wall of niches, southeast corner	II–114
	21 Sept.	Royal-kitchen walls	II–114
	29 Jan.	Tiles for interior finish	II–125
1571	9 Apr.	Stairs serving provisional church	II–132
	N.d.	Finishing provisional royal dwelling	II–133
	N.d.	Carpentry on roofing chapter-rooms	II–145
	2 Mar.	Spire, southwestern tower, carpentry	II–149
	17 May	Carpentry in kitchen	II–153
	29 May	Pendentives, cloister crossing tower	II–155
	20 July	Carpentry roofing, conventual library	II–159
1572	1 June	Doors, windows, vault main stair	II–176
	15 May	Cloister façade, main stair	II–177
	15 Feb.	South end, library building	II–179
	15 Mar.	Main cloister arcades	II–180
	13 Oct.	Spire, southeast tower	II–182
	22 Jan.	Flooring in royal-dwelling attics	II–185
	5 Feb.	Windows, shutters for northern cloisters	II–186
	N.d.	Garden stairways to niched wall	II–188
	14 Feb.	Roofing, royal dwelling	II–189
1573	16 Mar.	Sacristy rafters	III–5
	N.d.	Sacristy roofing frames	III–6

TABLE OF CONTRACTS, 1566–1586 (*continued*)

Date	Description	*AME* Reference
18, 23 Sept.	Foundations under basilica supports	iii–6
28 Apr.	North-palace wing adjoining basilica	iii–7
4 May	North-wing drains	iii–7
6 Sept.	Carpentry, sacristy	iii–8
29 Aug.	Main cloister, lower vaults	iii–10
18 Sept.	Foundations, basilica supports	iii–11,12
4 May	North-wing drains	iii–14
26 Apr.	College, west façade	iii–17
4 Apr.	Building north of main-west portico	iii–20
26 Mar.	Sacristy rooms adjoining southeast tower	iii–21
28 Apr.	College, entrance to northwest tower	iii–21
4 Feb.	30-foot cornice, vestiary	iii–22
31 May	Roofing, vestiary	iii–25
5 Sept.	Roofing, main sacristy	iii–27
21 May	Roofing, reception hall of monastery	iii–29
19 Dec.	Roofing, library	iii–32
12 Mar.	Roofing, main stairway	iii–35
1574 N.d.	Masonry, hospital rooms, niche wall	iii–67
26 Nov.	Stone for north doorway, main portico	iii–68
20 Nov.	Main entrance, west façade	iii–69
10 Nov.	Wall of niches and stair-chambers	iii–70,71
26 Nov.	2 supports of dome, basilica	iii–72
15 May	Foundations and supports	iii–74
8, 20 Aug.	Chimneys in southern cloisters	iii–75
7 July	Revetment and flooring, main sacristy	iii–76
26 July	Brick vaults, northern cloisters	iii–77
26 Feb.	Roofing frames, vestiary	iii–85,86
N.d.	Flooring, northern cloisters	iii–90
26 Nov.	Main portico, north entrance	iv–1
23 Dec.	Main portico, south entrance	iv–1
26 Sept.	Revetment, flooring, sacristy	iv–1
15 Oct.	Masonry, west façade	iv–1
19, 25 Feb.	Carpentry, northern cloisters	iv–2
22 Feb.	Flooring, cells, northeast cloister	iv–2
2 Mar.	Stairway, adjoining prior's tower	iv–2
14 June	Flooring, professors' building	iv–2
29 June	Stairway, northeast cloister	iv–2
8 July	12 fountains for northern cloisters	iv–3
9 July	6 columns for main cloisters	iv–3
27 July, 19 Sept.	Paving, northern cloisters	iv–3
1575 2 July	Arcades, main cloister	iv–6
N.d.	Prior summons 25 master masons for church	iv–18,19
6 Apr.	Ducts adjoining Queen's kitchen	iv–20
N.d.	Roofing frames, King's dwelling, north	iv–22
16 July	Carpentry, main library	iv–23
15 July	Roofing frames, library ends	iv–24
8 Jan.	Paving, northwest cloister	iv–26
23 Oct.	Plastering upper corridors, main court	iv–39
N.d.	Doors, windows, Queen's building	v–1

TABLE OF CONTRACTS, 1566–1586 (continued)

Date		Description	AME Reference
	N.d.	21 grilles for windows of main court	
[11 Nov. 1575–			
3 Feb. 1576		Contracts for basilica]	
1576	N.d.	North-palace building, 55-foot cornice	v-5
	7 July	Vaults beneath main altar	v-5,8
	N.d.	Stairs, north palace	v-5
	N.d.	Queen's building, last façade, carpentry	v-5
	14 Jan.	Basilica contracts	v-6,7
	18 Mar.	Attic cells, southern block	v-21
	24 Jan.	Windows, doors, shutters, Queen's building	v-23
	12 Sept.	Roofing frames, Queen's building	v-25
	N.d.	Cross on spire of northeast tower	v-35
	15 Jan.	Roofing, Queen's building	v-35
	20 Mar.	Main cloister, 13 vaults, lower floor	v-35
	10 May	Royal dwelling, courtyard paving	v-35
	13 Apr.	Royal dwelling, masonry for corner towers	v-35
	25 May	Carpentry in entresols of Queen's building	vi-8
1577	9 Sept.	Replace carpentry, burned southwest tower	vi-8
	15 Jan.	Carpentry over frames, Queen's building	vi-9
1578	22 Aug.	Masonry for royal-dwelling courtyard	vi-18
	24 Oct.	3 stairways in royal dwelling	vi-18
	N.d.	Attic carpentry, Queen's building	vi-19
	N.d.	Scaffolding, basilica interior	vi-19
	10 Jan.	Doors, windows, upper choir façade	vi-23
	N.d.	Masonry, small court, palace	vi-23
	21 July	12 grilles, Queen's building	vi-24
	31 July	Corridors, royal dwelling	vi-24
	20 Nov.	Dome, basilica (one-quarter)	vi-24
	12 Oct., 31 Dec.	9 grilles, royal dwelling	vi-24
	15 Dec.	Corridors, infirmary (Llaguno, *Noticias*, 2:313)	—
	13 Dec.	4 window grilles, royal dwelling	vi-24
1579	10 Jan.	Main altarpiece and lateral wings	vi-40
	29 Jan.	Scaffolding, naves, basilica	vi-40
	27 Mar.	Spire, northeast tower	vi-41
	1 Apr.	Balustrades, main cloister	vi-41
	1 Apr.	Flooring throughout monastery	vi-41
	18 Sept.	1st contract for main portico	vi-42
	7 Nov.	2nd contract for main portico	vi-42
	7 Nov.	Dome and cupola, basilica	vi-42
	7 Nov.	Basilica towers above 86-foot level	vi-42
	27 Mar.	Spire, northwest tower	vii-6
1580	21 Dec.	6 statues from Monegro for basilica façade	vii-13
	12 Mar.	College foundations, cisterns, vaults	vii-24
	18 Mar.	Basilica flooring, marbles	vii-24
	8 June	Chimneys, north building, palace	vii-24
	9 Dec.	College, southwest cloister	vii-24

TABLE OF CONTRACTS, 1566–1586 (*continued*)

Date		Description	AME Reference
	N.d.	Garden stairways	vii-24
	15 Sept.	Carpentry, palace kitchens	vii-26
	N.d.	Niched wall, eastern façade	vii-29
1581	17 Jan.	Paving, college, southwest cloister	vii-34
	1 Feb.	North-palace block, façade masonry	vii-34
	9 Mar.	Basilica cornice at dome base	vii-34
	20 Mar.	Northwest tower, masonry	vii-34
	12 Apr.	Globe of sheet metal to top dome	vii-34
	28 Apr.	College refectory and crossing tower	vii-34
	3 Mar.	College north block and kitchen to crossing	vii-35
	6 Mar	College crossing tower	vii-35
	8 Apr.	Choir balcony, basilica	vii-35
	6 Apr.	North air-shaft court	vii-35
	10 Apr.	North tower chamber	vii-35
	7 Aug.	Doors of main portico and refectory crossing	vii-35
	13 Aug.	Northwest tower, summit cornice	vii-36
	29 Sept.	Dome parapets, balustrades, pilastering	vii-35
	20 Nov.	Niched wall staircases	vii-35
	19, 30 Nov.	Northwest college, court masonry	vii-35
	14 Dec.	Carpentry, flooring, King's kitchens	vii-35
	13 June	Roofing frames, King's kitchens	vii-41
	7 Dec.	Choir-balcony pilasters, vaults	vii-41
	N.d.	Carpentry, college kitchen	vii-42
	N.d.	Northwest tower spire	vii-42
1582	29 Mar.	20 window grilles, 100 faucets, main cloister	viii-1
	12 July	Removal of scaffolds from dome	viii-1
	9 Apr.	Windows, north face, northwest tower	viii-1
	N.d.	North range, northwest college court	viii-2
	7 Jan.	Stone for basilica tower above top cornice	viii-2
	21 Jan.	Statue of S. Lorenzo and royal arms, main door	viii-2
	2 Feb.	Stone for college, south wall, main court	viii-2
	9 Feb.	Roofing frames, portico, college	viii-2
	8 Feb.	20 window grilles, 6 faucets, royal dwelling	viii-2
	19 Feb.	Façade, college portico	viii-2
	N.d.	Flooring stone, main portico and court	viii-2
	5 Mar.	16 stone spheres for church tower	viii-2
	1 Apr.	Doors and windows for north-palace wing, kitchens	viii-2
	24 July	Windows and shutters for Queen's wing	viii-2
	6 Sept.	Scaffolds for painting forechurch and choir vaults	viii-2
	18 Sept.	Smoothing and plastering towers inside and out	viii-2
	N.d.	College kitchen, carpentry	viii-2
	19 Nov.	Passages from kitchens to King's quarters	viii-2
	24 Nov.	5 grilles for main portico	viii-2
	28 Dec.	Smoothing and plastering basilica masonry	viii-2
	28 Feb.	Paving half of King's court	viii-4
	16 Feb.	Entrance façade, college	viii-4
	9 Feb.	Carpentry, college from portico to north tower	viii-5
	9 July	38 windows for northeast tower	viii-5

TABLE OF CONTRACTS, 1566–1586 (*continued*)

Date		Description	AME Reference
1583	5 Jan.	Kitchen vault, college	VIII-20
	N.d.	Niches to completion, south terrace	VIII-20
	20 May	Paving Queen's court, smoothing walls	VIII-20
	22 July	Masonry, college assembly hall	VIII-20
	5 July	Roof frames, flooring from college entrance to tower	VIII-20
	20 July	Altarpiece columns	VIII-21
	20, 22 July	Architectural surround, burial group	VIII-21
	28 Aug.	Garden stairs from King's dwelling	VIII-21
	28 Aug.	Garden stairs from Queen's building	VIII-21
	10 Nov.	Housing of college professors, masonry	VIII-22
	31 Dec.	Paving houses of professors	VIII-22
	2 July	Payments for marble flooring, basilica	VIII-23
	N.d.	Payments for 14,504 frames of glass for basilica	VIII-25
	16 Mar.	Crossing tower, college, masonry	VIII-29
1584	17 Jan.	Carpentry, houses of professors	IX-1
	8 Mar.	Spire, carpentry, northwest tower	IX-1
	3 Feb.	Flooring college	IX-1
	22 Mar.	Smoothing and plastering court and south front of	IX-1
	N.d.	college wall separating gardens of King and friars	IX-2
	27 Apr.	Paving basilica interior	IX-2
	1 Nov.	Pottery ducts and drains for Malagon water	IX-2
	24 July	Finishing burials at sides of altar	IX-2
	2 Nov.	Tile roofing, professors' houses	IX-2
	3 Sept.	Plastering, library walls	IX-14
1585	6 May	Pharmacy addition to infirmary	IX-28
	4 May	Brickwork and masonry at stairs of main door	IX-28
	2 May	7 doors basilica entrance, with grilles, locks	IX-29
	N.d.	Marble flooring, choir, antechoir, libraries	IX-31
	16 Jan.	Jasper slabs for steps to main altar	X-2
	28 Feb.	Smoothing of basilica façade to 56-foot level	X-2
	30 Dec.	Plastering chapter-room vaults and vestibule	X-2
	24 Feb.	Leveling terrain for western and northern plazas	X-2
1586	29 Mar.	Paving, forecourt	X-7
	4 July	Passage to Compaña bridging street	X-8
	31 Aug.	West plaza, parapet	X-8
	20 Oct.	Niches overlooking reservoir	X-8
	22 Dec.	Fountain in main cloister	X-8

LIST OF ABBREVIATIONS

MANUSCRIPT ARCHIVES

AGP Archivo General del Palacio Real, Madrid.

AHN Archivo Histórico Nacional, Madrid

AME Archivo de la Real Biblioteca del Monasterio del Escorial.

AGS Archivo General de Simancas.

ASF Archivio di Stato di Firenze.

ASV Archivio di Stato di Venetia

AVE Archivo de la Villa de El Escorial (Municipalidad).

BM British Museum, Department of Manuscripts.

BNM Biblioteca Nacional, Madrid.

IVDJ Instituto de Valencia de Don Juan, Madrid.

MAN Museo Arqueológico Nacional, Madrid.

Z Archivo Zabalburu (Heredia Spinola collection) Madrid.

PHOTOGRAPHIC COLLECTIONS

EK Edward G. A. Kubler.

MAS Arxiv Mas, Barcelona.

PAN Patrimonio Artístico Nacional, Madrid.

PRINTED WORKS

AEA *Archivo Español de Arte*

AIEM *Anales del Instituto de Estudios Madrileños*

CD *La Ciudad de Dios*

CDIHE *Colección de documentos inéditos para la historia de España*

DHM *Documentos para la historia del Monasterio de San Lorenzo el Real de El Escorial* (ed. J. Zarco Cuevas).

EEC *El Escorial 1563-1963. IV° Centenario*

FME José de Sigüenza, *Fundación del Monasterio de El Escorial*, 1963.

HS Juan de Herrera, *Sumario y breve declaracion*, 1589.

JSJ Juan de San Jerónimo, "Libro de memorias deste Monasterio de Sant Lorencio el Real."

LS Matilde Lopez Serrano, *Trazas de Juan de Herrera*, 1944.

PA Amancio Portabales, *Los Verdaderos artífices de El Escorial . . .* , 1945.

PM Amancio Portabales, *Maestros mayores, arquitectos y aparejadores de El Escorial*, 1952.

RA *Revista de archivos, bibliotecas y museos*

ARCHIVAL REFERENCES

The archival evidence used in this work comes from a number of archives, and it is classed as correspondence, legal instruments, and royal decrees.

1. Many day-to-day letters and notes concerning construction were annotated by the King in his hand, and they are the most detailed record of the affairs of the fabric during the building period. The largest collection of these papers is at Simancas (AGS), where it was recently catalogued by Amalia Prieto Cantero, after having been transcribed in part and interpreted by Portabales.[1] During various periods at the archive in 1963-1964, and again in 1978, many of the relevant pages were microfilmed from the section now called *Casa y Sitios Reales*, as well as others recording payments in *Contaduria mayor*.

The call-numbers (or signatures) at Simancas were changed in the 1960s. These changes are discussed by Prieto Cantero.[2] The correlations between old and new call-numbers emerge from the catalogue by Angel de la Plaza Bores published in 1962.[3] As the documents published by Portabales, Rubio, Iñiguez, and Modino were all given with the old signatures, I use the new legajo numbers also when referring to their works. The correspondences for the sections pertaining to the Escorial are as follows.

New	Old
(*Casa y Sitios Reales*)	(*Obras y Bosques*)
legajo 258	legajos 1, 2
legajo 259	legajos 3, 4
legajo 260	legajos 5, 6
legajo 261	legajos 7, 8

(In addition the following legajos of *Contaduría mayor* at Simancas contain payments to artisans and workmen on contracts, as well as receipts for work done at the Escorial; 1530, 1520, 1421, 1026, 1086, 1148, 1087, 399, spanning the years from 1563 to 1582).

Other collections of correspondence are in Madrid at the Instituto de Valencia de Don Juan (IVDJ) and the Archivo Zabalburu (Z); and in London at the British Museum (BM). The King's correspondence about the Escorial at the Instituto, from 1561 onward, is principally contained in envio 61 (caja 82), which has recently been arranged on tipped sheets for binding. Gregorio de Andrés, the librarian, is also cataloguing other bundles of papers at the Instituto for an inventory.

At the privately owned Archivo Zabalburu, the relevant documents are 128 items in caja 146, including correspondence of the King. A card catalogue prepared by Padre Alonso Pedro, OSB, exists at the archive. The King's marginal comments appear in the correspondence of 1563.

Other *villetes* (royal orders) by the King about the Escorial are in the Gayangos collection at the British Museum. The chief volumes are Addison 28350 (letters about various royal domains, 1560-1568) and Addison 28355 (mainly letters to the King from the priors about the Escorial, 1563-1575).[4]

2. Specifications (condiciones) and contracts are preserved both at the Monastery and in the Villa at the town hall of the lower settlement, called El Escorial (the upper town is called San Lorenzo de El Escorial). The catalogue of the Monastery ar-

[1] Prieto Cantero, "Inventario," pp. 7-127; PA; PM.
[2] "Inventario," pp. 7-10.
[3] *Guia*, section 10, nos. 172-176, pp. 83-87.
[4] Gayangos, *Catalogue*.

chive (AME), by Gregorio de Andrés, has been appearing in installments of the *Archivo Español de Arte* (1972-1976), made available as a separate volume with index in 1978.[5] The documents in the Villa have not yet been catalogued in a publication, although I was allowed to take notes on them in January of 1964.

3. Royal decrees, bearing among other matters on the Escorial, are preserved in the Archivo General del Palacio Real (AGP), in a series of vol-

umes of *Cédulas reales*. Especially pertinent to governance of the fabric is the register of the minutes of the Congregación's meetings from 1573 to 1834.[6]

The Archivo Histórico Nacional in Madrid also has a substantial series of documents and letters scattered among other papers (Consejos, legajos 15188, 1570; 15189, 1577; 15191, 1579). Some items were published by Saltillo in 1953, of which only eight relate to the Escorial (1570-1579).[7]

[5] Andrés, *Inventario*.
[6] AGP, Patrimonio, legajo 1793, "Libro de Acuerdos de la R. Fabrica."
[7] Saltillo, "Felipe II," pp. 137-154.

BIBLIOGRAPHY

Alberti, Filippo. *Elogio di Galeazzo Alessi*. Ed. Luca Beltrami. Milan, 1913.

Aliquo-Lenzi, L. *Gli scrittori calabresi*. Messina, 1913.

Almela, Juan Alonso de. "Descripción de la octava maravilla del mundo." DHM 6 (1962): 5-98.

Alvarez-Ossorio, Francisco. *Catálogo de las medallas de los siglos XV y XVI, conservadas en el Museo Arquelógico Nacional*. Madrid, 1950.

Alvarez Turienzo, Saturnino. *El Escorial en las letras españolas*. Madrid, 1963.

Andrada Pfeiffer, Ramón. "La Primera piedra del Monasterio de El Escorial." *Reales Sitios* 8, no. 27 (1971): 73-76.

———. "Las Reconstrucciones en el Escorial." In EEC 2: 323-349.

———. "Total renovacion de las cubiertas del Monasterio de El Escorial." *Reales Sitios* 6, no. 19 (1969): 19-28.

Andrés Martinez, Gregorio de. "Correspondencia epistolar entre Felipe IV y el P. Nicolás de Madrid sobre la contrucción del Panteón de Reyes, 1654." DHM 8 (1965): 159-207.

———. "Historia y descripción del Camarín de reliquias de El Escorial." AIEM 7 (1971): 53-60; AIEM 8 (1972): 115-127.

———. *El Incendio del Monasterio de El Escorial del año 1671. Sus consecuencias en las artes y las letras*. Madrid, 1976.

———. *Inventario de documentos sobre la construcción y ornato del Monasterio del Escorial existentes en el Archivo de su real Biblioteca. Anejo de Archivo Español de Arte*. Madrid, 1972.

———. "Nueve cartas inéditas del P. Francisco del Castillo a Felipe IV sobre diversas obras en el Monasterio de El Escorial (años 1660-1663)." CD 180 (1967): 116-127.

———. *Proceso inquisitorial del Padre Sigüenza*. Madrid, 1975.

———. "Relaciones sobre los incendios del Monasterio de El Escorial." DHM 8 (1965): 65-136.

———. "Relación historial del incendio y reconstrucción del Escorial (1671-1677), por el padre Juan de Toledo." *Hispania Sacra* 29 (1976): 77-256.

———. "Toponomia e historia de la Montaña Escurialense." AIEM 2 (1966): 15-26.

———, ed. "Libro de la fontaneria." DHM 8 (1965): 219-318.

Antolín, Guillermo. *Catálogo de los códices latinos de la Real Biblioteca del Escorial*. Vol. 5. Madrid, 1923.

Auberson, Luis Manuel. "El Misterio de la boveda." In *ABC* (Madrid), 1964.

———. "San Lorenzo, flor y cumbre de los martires." In *Monasterio de San Lorenzo el Real*, pp. 333-362. El Escorial, 1964.

Augustine, Aurelius. *San Agustín. Obras de San Agustín en edición bilingüe*. Madrid, 1946-1959.

Babelon, Jean. "Jacopo da Trezzo et la construction de l'Escurial." In *Bibliothèque de l'Ecole des Hautes Etudes Hispaniques*, vol. 3, 1922.

Baedeker, Karl. *Spanien und Portugal*. Leipzig, 1897.

Banda y Vargas, Antonio de la. "El Arquitecto andaluz Hernán Ruiz II." In *Anales de la Universidad Hispalense*, no. 23. Seville, 1974.

Bermejo, Damian. *Descripcion artistica del Real Monasterio de S. Lorenzo del Escorial y sus preciosidades despues de la invasion de los franceses*. Madrid, 1820.

Bermejo, Elisa. "Bartolomé Zúmbigo, arquitecto del siglo XVII." AEA (1954), pp. 291-302.

Bertrand, Louis. *Philippe II à l'Escorial*. Paris, 1929.

Bonner, Gerald. *St. Augustine of Hippo: Life and Controversies*. Philadelphia, 1963.

Borrell, Mariano. Review of plan by Pedro Salcedo de las Heras. In *Revista europea*, no. 117 (21 May 1876).

[Brambilla, F.] *Colección de las vistas del rl. sitio de sn. Lorenzo*. Madrid, 1832.

Braudel, Fernand. *La Méditerranée et le monde méditerranéen à l'époque de Philippe II*. Paris, 1949.

Bringas, José M. "Notas de economía. Consideraciones sobre el costo del Monasterio de El Escorial." *Arquitectura* [Madrid] 5, no. 56 (1963): 56-60.

Brown, Jonathan. *Images and Ideas in Seventeenth-Century Spanish Painting*. Princeton, 1978.

Bulič, Frane. *Kaiser Diokletians Palast in Split*. Zagreb, 1929.

Buser, Thomas. "El Escorial, Kneeling Effigies, and Mass for the Dead." Unpublished study.

Cabrera de Córdoba, Luis. *Historia de Felipe II, rey de España*. 2 vols. Madrid, 1876-1877.

Cabrillana, Nicolás. "La Fundación del Monasterio del Escorial: Repercusiones económicas y sociales." AIEM 5 (1970): 377-407.

Caimo, Norberto. *Lettere d'un vago italiano ad un suo amico*. 4 vols. in 2. Milan, 1759-1767.

Calvete de Estrella, Juan Cristoval. *El felicísimo viaje*. Antwerp, 1552 (reissued Madrid, 1950, 2 vols.).

Camón Aznar, José. *Arquitectura plateresca*. 2 vols. Madrid, 1945.

———. "Arquitectura trentina." In *Summa Artis*, ed. J. Pijoan, vol. 17 (1959).

———. "El estilo trentino." *Revista de ideas estéticas* 3 (1945): 429-442.

———. "Problemática de El Escorial." *Goya*, no. 56-57 (1963): 70-85.

Canevazzi, G. "Intorno a Jacopo e a Giacomo Barozzi." In *Memorie e studi*, 1908.

Carducho, Vicente. *Diálogos de la pintura*. Madrid, 1633.

Carreras y Artau, Joaquín. "El Lul-lisme de Juan de Herrera." In *Miscel-lanea Puig y Cadafalch*. Vol. 1. Barcelona, 1947.

Carreras y Artau, Tomás and Joaquín. *Historia de la filosofia española*. Vol. 2. Madrid, 1943.

Casale, Giovanni Vincenzo. "Planos de arquitectura." BNM, Bellas Artes, nos. 16-49.

Castilho, Julio de. *Lisboa antiga. O bairro alto*. 4 vols. Lisbon, 1954-1962 (3rd edition).

Catalina Garcia, Juan. "Elogio de Fr. José de Sigüenza." In *Historia de la Orden de San Jerónimo por fr. José de Sigüenza*, 1: i-lii. 2 vols., Madrid, 1907-1909.

Caturla, Luisa. *Pinturas, frondas y fuentes del Buen Retiro*. Madrid, 1947.

Ceán-Bermudez, Juan Agustín. *Ocios de Don Juan Agustín Ceán-Bermudez sobre bellas artes*. Madrid (1822), 1870.

Cervera Vera, Luis. "La Cachicania del Monasterio de San Lorenzo el Real." AEA 22 (1949): 215-231.

———. *El Conjunto palacial de la Villa de Lerma*. Valencia, 1967.

———. *Las Estampas y el Sumario de El Escorial por Juan de Herrera*. Madrid, 1954.

———. "Juan de Herrera y su aposento en la Villa de El Escorial." CD 160 (1949): 527-555.

———. *El Retrato de Juan de Herrera dibujado por Maea y grabado por Brandi*. Valencia, 1977.

———. "Semblanza de Juan de Herrera." In EEC 2: 7-103.

Chapman, Emmanuel. *Saint Augustine's Philosophy of Beauty*. New York, 1939.

Chateaubriand, François-René de. *Mémoires d'outre tombe*. ed. Maurice Levaillant. 4 vols. Paris, 1948-1949.

Chueca Goitia, Fernando. *Andrés de Vandelvira*. Madrid, 1954; Jaen, 1973.

———. *Arquitectura del siglo XVI*. Ars Hispaniae, vol. 11. Madrid, 1953.

———. *Casas reales en monasterios y conventos españoles*. Madrid, 1966.

———. "El Estilo herreriano y la arquitectura portuguesa." In EEC 2: 215-253.

———. *Invariantes castizos de la arquitectura española*. Madrid, 1947.

———. *Madrid. Ciudad con vocación de capital*. Madrid. 1974.

Chueca Goitia, Fernando, and Miguel, C. de. *La Vida y las obras del arquitecto Juan de Villanueva*. Madrid, 1949.

Constable, Giles. *Monastic Tithes from Their Origins to the Twelfth Century*. Cambridge, 1944.

Corominas, Juan. *Diccionario crítico etimológico de la lengua castellana*. Madrid, 1954.

Courcelle-Ladmirant, Jeanne, and Courcelle, Pierre. *Iconographie de Saint Augustin*. 3 vols. Paris, 1965-1972.

Covarrubias Horozco, Sebastian. *Tesoro de la lengua castellana*. Madrid, 1611.

Croce, Benedetto. "I fratelli Martirano." In *Curiosità storiche*, pp. 65-76. Naples, 1921.

Cruz Hernandez, M. *Llull*. Madrid, 1977.

Custine, Astolphe de. *L'Espagne sous Ferdinand VIII*. 4 vols. in 2. Brussels, 1838. 1:333-350.

Daddi-Giovannozzi, Vera. "L'Accademia fiorentina e l'Escuriale." *Rivista d'Arte*, ser. 2, vol. 17 (1935): 423-427.

Danti, Egnatio. "Vita di M. Iacomo Barozzi da Vignola." In J. Barozzi da Vignola, *Le Due Regole della Prospettiva Prattica*. Rome, 1583.

Davies, Trevor. *The Golden Century of Spain*. London, 1937.

Diez, Bonifacio. "El Concilio de Trento y El Escorial." CD 158 (1946): 535-547.

Donato, Alessandro. *Roma vetus ac recens*. Rome, 1725.

Donato Martinez, José. "Fuentes para la historia del monasterio." In *Monasterio de San Lorenzo el Real*, pp. 307-332. El Escorial, 1964.

Enciclopedia universal ilustrada europeo-americano. 70 vols. Barcelona, 1908-1930.

El Escorial 1563-1963. IVº Centenario. Ediciones del Patrimonio Nacional, 2 vols. Madrid [1963].

Estal, Gabriel del. "El Escorial en la transición de San Jerónimo a San Agustín (Titularidad jurídica y circunstancia histórica)." In *Monasterio de San Lorenzo el Real*, pp. 578-584. El Escorial, 1964.

———. "La Iglesia, Trento, y el Escorial." In EEC 1: 472-482.

Fernandez, Cristobal. "El Padre Claret, restaurador de las empresas filipinas escurialenses." In *Monasterio de San Lorenzo el Real*, pp. 515-560. El Escorial, 1964.

Fernandez Alvarez, Manuel. *Economía, Sociedad y Corona*. Madrid, 1963.

Filangieri di Candida Gonzaga, Riccardo. *Castel Nuovo, Reggia angioina ed aragonese di Napoli*. Naples, 1934.

———. "Rassegna critica delle fonti per la storia di Castel Nuovo." *Archivio Storico per la Provincia Napoletana*, N.S. 25 (1939): 237-322.

Foucault, Michel. *Les Mots et les choses*. Paris, 1966.

Frankl, Paul. "The Secret of the Medieval Masons." *The Art Bulletin* 27 (1945): 46-64.

Fray Antonio de Villacastín. Símbolo y ejemplo de aparejadores y ayudantes de la ingenieria. Madrid [1944?].

Gachard, Louis Prosper. *Correspondence de Philippe II sur les affaires des Pays-Bas* [1558-1577]. Brussels, 1848-1879.

———. *Relations des ambassadeurs vénitiens sur Charles Quint et Philippe II*. Brussels, 1856.

———. *Retraite et mort de Charles Quint au monastère de Yuste, lettres inédites*, 3 vols. Brussels, 1854-1855.

Gachard, Louis Prosper, and Piot, P. *Collection des Voyages des souverains des Pays-Bas*. vol. 4. Brussels, 1884.

Garcia Lomas, Miguel Angel. "La Organización laboral y económica en la construcción del Escorial." In EEC 2: 297-309.

Garcia Mercadal, José. *Viajes de extranjeros por España y Portugal*. 3 vols. Madrid, 1962.

Gautier, Théophile. *Voyage en Espagne*. Paris, 1845.

Gayangos y Arce, Pascual de. *Catalogue of the Manuscripts in the Spanish Language in the British Museum*. London, 1875-1893.

Giner Guerri, Severino. "Juan Bautista de Toledo, segundo architecto de la Basilica Vaticana, junto a Miguel Angel (Estudio crítico sobre su actividad en Italia)." *Analecta Calasanctiana*, 19 (1977): 59-121.

Göller, Adolf. *Zur Ästhetik der Architektur*. Stuttgart, 1887.

Gombrich, E. H. *The Sense Order*. Ithaca, 1979.

Gomez-Moreno, Manuel. *El Libro español de arquitectura*. Madrid, 1949.

Gonzalez Palencia, Angel. "Documentos relativos a la obra del patio del Alcazar de Toledo." *Cuadernos de arte* (Granada), 2 no. 1 (1937): 11-14.

Gonzalez Valcarcel, José Manuel. "El museo de la arquitectura del monasterio." In EEC 2: 311-322.

Guinard, Paul. "El Escorial visto por los escritores franceses." In EEC 2: 661-682.

Hager, Werner. "Zur Raumstruktur des Manierismus." In *Festschrift für Martin Wackernagel*, pp. 112-140. Cologne-Graz, 1958.

Harris, Enriqueta, and Andrés, Gregorio de. "Descripción del Escorial por Cassiano del Pozzo (1626)." AEA 45, no. 179 (1972): pp. 1-33.

Haupt, Albrecht. *Geschichte der Renaissance in Spanien und Portugal*. Stuttgart, 1927.

Hauser, Arnold. *Mannerism: The Crisis of the Renaissance and the Origin of Modern Art*. 2 vols. London, 1965.

Hébrard, Ernest M., and Zeiller, Jacques. *Spalato, le palais de Dioclétien*. Paris, 1912.

Hempel, Wido. *Philipp II und der Escorial in der italienischen Literatur des Cinquecento*. Mainz, 1971.

Henermann, Theodor. "El Escorial en la crítica estético-literaria del extranjero, esbozo de una historia de su fama." In *El Escorial: Revista de cultura y letras*, 1943, pp. 319-341.

Herrera, Juan de. *Sumario y breve declaracion de los diseños y estampas de la Fabrica de San Lorencio el Real del Escurial*. Madrid, 1589 (facsimile editions, 1954, 1978).

———. *Discurso de la figura cúbica*. Ed. J. Rey Pastor. Madrid, 1935.

Hiersche, Waldemar. *Ludovico Carracci*. Parchim, 1913.

Hollstein, F.W.H. *Dutch and Flemish Etchings, Engravings and Woodcuts, ca. 1450-1700*. Amsterdam, 1949-1974.

Hülsen, Christian. *Il libro di Giuliano da Sangallo*. Leipzig, 1910.

Iñiguez Almech, Francisco. "La Casa del Tesoro, Velazquez y las obras reales." *Varia Velazqueña*, (Madrid) 1 (1960): 661-676.

———. *Casas reales y jardines de Felipe II*. Madrid, 1952.

———. "Los Ingenios de Juan de Herrera." In EEC 2: 181-214; and RA 71 (1963): 163-170.

———. *Las Trazas del Monasterio de San Lorenzo de El Escorial*. Madrid, 1965.

Jahrbuch der Kunsthistorischen Sammlungen. 12: cxcviii, no. 8743. Vienna, (1938).

Jetter, Dieter. "Klosterhospitäler: St. Gallen, Cluny, Escorial." *Sudhoffs Archiv* 62 (1978): part 4, pp. 313-337.

Jürgens, Oskar. *Spanische Städte, ihre bauliche Entwicklung und Ausgestaltung*. Hamburg, 1926.

Justi, Carl. *Miscellaneen aus drei Jahrhunderten spanischen Kunstlebens*. 2 vols. Berlin, 1908.

Kaftal, George. *The Iconography of the Saints in Central and South Italian Painting*. Florence, 1965.

Krüger, Karl Heinrich. *Königsgrabkirchen der Franken, Angelsächsen und Langobarden*. Munich, 1971.

Kubler, George. "The Claustral 'Fons Vitae' in Spain and Portugal." *Traza y Baza* 2 (1972): 7-14.

———. "Francesco Paciotto, Architect." In *Essays in Memory of Karl Lehmann*, ed., L. F. Sandler, pp. 176-189. New York, 1964.

———. "Galeazzo Alessi e l'Escuriale." In *Galeazzo Alessi e l'architettura del Cinquecento*, ed., C. Maltese, pp. 599-603. Genoa, 1975.

Kubler, George. *Mexican Architecture of the Sixteenth Century*. 2 vols. New Haven, 1948.

———. "Palladio e l'Escuriale." *Bollettino del centro internazionale di Studi di Architettura Andrea Palladio* 5 (1963): 44-52.

———. "Palladio e Juan de Villanueva." *Bollettino del centro internazionale di Studi di Architettura Andrea Palladio* 5 (1963), 53-60.

———. *Portuguese Plain Architecture: Between Spices and Diamonds (1521-7106)*. Middletown, 1972.

———. *The Shape of Time: Remarks on the History of Things*. New Haven, 1962.

———. "Ucareo and the Escorial." *Anales del Instituto de Investigaciones Estéticas* 8 (1944): 5-12.

Kubler, G., and Soria, M. *Art and Architecture in Spain and Portugal and Their American Dominions, 1500 to 1800*. Harmondsworth, 1959.

Lhermite, Jehan. *Le Passetemps*. Ed. Charles Ruelens. 2 vols. Antwerp, 1890-1896.

Llaguno y Amirola, Eugenio. *Noticias de los arquitectos y arquitectura desde su restauración, por D. Eugenio Llaguno y Amirola, illustradas y acrecentadas con notas, adiciones y documentos, por D. Juan Agustín Ceán Bermudez*. 5 vols. Madrid, 1829.

Lopez Serrano, Matilde. *Trazas de Juan de Herrera y sus seguidores para el Monasterio del Escorial*. Madrid, 1944.

Lorente Junquera, Manuel. "La Galeria de Convalecientes obra de Juan de Herrera." AEA 17, no. 63, (1944): 137-147.

McAndrew, John. *The Open-Air Churches of Sixteenth-Century Mexico: Atrios, Posas, Open Chapels, and Other Studies*. Cambridge, Mass., 1965.

Mancini, G. *Vita di Leon Battista Alberti*. Florence, 1911.

Manna, Gian Antonio. *Prima Parte della cancelleria di tutti privilegi . . . di Capua*. 1570.

March, José M. *Niñez y juventud de Felipe II. Documentos inéditos sobre su educación civil, literaria y religiosa y su iniciación al gobierno (1527-1547)*. 2 vols. Madrid, 1941.

Martín Gonzalez, José Juan. "Nuevos datos sobre la construcción del Alcazar de Toledo." RA 68, no. 1 (1960): 271-290.

———. "El Palacio de Carlos V en Yuste." AEA 23 (1950): 27-51.

———. "El Panteón de San Lorenzo de El Escorial." *Boletín del Seminario de Estudios de Arte y Arqueología* 26 (1960): 230-235.

———. "El Panteón de S. Lorenzo de El Escorial." AEA 32 (1959): 199-213.

Megnie, Luis de León. *El Escorial*. Madrid, 1891.

Menendez Pelayo, Marcelino. *Historia de las ideas estéticas en España*. 5 vols. Santander, 1940.

Meunier, Louis. See Robert-Dumesnil.

Mezzanotti, Paolo, and Bascapé, Giacomo C. *Milano nell'arte e nella storia*. Milan, 1948.

Milizia, F. *Memorie degli architetti antichi e moderni*. 2 vols. Bassano, 1758.

Modino de Lucas, Miguel. "Constituciones del Colegio de S. Lorenzo el Real." DHM 5 (1962): 129-225.

———. "Fidelidad de Hijo." *ABC* (Madrid), 7 August 1957.

———. "Los Priores de la construccion de San Lorenzo en su correspondencia con el rey y sus secretarios." In *Monasterio de San Lorenzo el Real*, pp. 195-306. El Escorial, 1964.

Monasterio de San Lorenzo el Real. El Escorial en el cuarto centenario de su fundación, 1563-1963. El Escorial, 1964.

Morel-Fatio, Alfred. *L'Espagne au XVIe et au XVIIe siècle*. Heilbron, 1878.

Morigia, Paolo. *Historia brieve dell'augustissima casa d'Austria, con la descrittione della rara al mondo fabrica dello Scuriale di Spagna*. 53 vols. Bergamo, 1593.

Morterero Simón, Conrado, and others. *El Escorial. Octava maravilla del mundo*. Madrid, 1967.

Moya Blanco, Luis. "Caracteres peculiares de la composición arquitectónica de El Escorial." EEC 1: 115-180.

Müller-Hofstede, Justus. "Zum Werke des Otto Van Veen 1590-1600." *Bulletin des Musées Royaux des Beaux-Arts, Bruxelles* 6 (1957): 157-159.

Negri, Emmina, de. *Galeazzo Alessi*. Genoa, 1957.

———. *Galeazzo Alessi. Mostra di fotografie*. Genoa, 1974.

Navarro Franco, Federico. "El Real Panteón de S. Lorenzo de El Escorial." In EEC 2: 713-737.

Navascués Palacio, Pedro. "El 'Manuscrito de Arquitectura' de Hernán Ruiz, el joven." AEA 44 (1971): 295-321.

Paciotto, Francesco. "Memorie cavate da un giornale fatto di proprio mano del Conte Francesco Paciotto." In C. Promis, *Miscelanea di storia italiana* 4 (1863): 437-438.

Palladio, Andrea. *I Quattro libri dell'architettura*. 4 vols. in 1. Venice, 1570.

Palmes, J. C. *Architectural Drawings from the Collection of the Royal Institute of British Architects*. [London] 1961.

Pane, Roberto. *Andrea Palladio*. Turin, 1948.

Panofsky, Erwin. *Renaissance and Renascences*. Stockholm, 1960.

———. *Tomb Sculpture: Four Lectures on Its Changing Aspects from Ancient Egypt to Bernini*. New York, 1964.

Pascoli, Luca. *Le Vite di scultori, pittori ed architettori moderni* [1730]. Rome, 1933 (facsimile edition).

Passarge, Ludwig. *Aus dem heutigen Spanien und Portugal*. Leipzig, 1884.

Pereda de la Reguera, Manuel. *Bartolomé de Bustamante Herrera*. Santander, 1950.

Perez-Pastor, Cristobal. "Noticias y documentos relativos a la historia y literatura española." *Memorias de la Real Academia Española*. Vol. 11. Madrid, 1914.

Pevsner, Nikolaus. "The Architecture of Mannerism." *The Mint*, no. 1 (1946): 116-138.

———. "Palladio and Europe." In *Venezia e l'Europa. Atti del XVIII Congresso della Storia dell'Arte*, Venice, 1955, pp. 92, 93.

Pfandl, Ludwig. *Philip II: Gemälde eines Lebens und einer Zeit.* Munich, 1938 (reprinted Warsaw, 1969).

Plaza Bores, Angel de la. *Guia del investigador. Archivo General de Simancas.* Valladolid, 1962.

Plon, Eugène. *Leone Leoni et Pompeo Leoni.* Paris, 1887.

Pometti, F. "I Martirano." *Memorie dell'Accademia dei Lincei*, ser. 5, vol. 4 (1898): 58-157.

Ponz, Antonio. *Viaje de España.* Madrid, 1947.

Ponz, José. "Vida de Don Antonio Ponz." In Antonio Ponz, *Viaje de España*, 18 vols. in 1, pp. 5-15. Madrid, 1947.

Porreño, Baltasar. *Dichos y hechos del rey D. Felipe II.* Madrid, 1639.

Portabales Pichel, Amancio. *Maestros mayores, arquitectos y aparejadores de El Escorial.* Madrid, 1952.

———. *Los Verdaderos artífices de El Escorial y el estilo indebidamente llamado Herreriano.* Madrid, 1945.

Prado, Jerónimo, and Villalpando, Juan Bautista. *In Ezechielem Explanationes.* 2 vols. Rome, 1596-1604.

Prieto Cantero, Amalia. "Inventario razonado de los documentos referentes al Monasterio de El Escorial existentes en la sección de casa y sitios reales del Archivo General de Simancas." In RA 71 (1963): 7-127.

Quevedo, José de. *Historia del Real Monasterio de San Lorenzo.* Madrid, 1849.

Quinet, Edgar. *Mes Vacances en Espagne.* Paris, 1844.

Quiñones, Juan de. *Explicación de unas monedas de oro de emperadores romanos que se han hallado en el puerto de Guadarrama.* Madrid, 1620.

Rekers, Bernard. *Benito Arias Montano.* London-Leiden, 1972.

Riba Garcia, Carlos. *Correspondencia privada de Felipe II con su secretario Mateo Vazquez, 1567-1591.* Madrid, 1959.

Rief, Josef. *Der Ordobegriff des jungen Augustinus.* Paderborn, 1962.

Riegl, Alois. *Spätrömische Kunstindustrie.* 2nd ed. Vienna, 1927.

———. *Augustinus.* Paderborn, 1970.

Ringrose, David. "The Impact of a New Capital City. Madrid, Toledo, and New Castile." *Journal of Economic History* 33, no. 4 (1973): 761-791.

Robert-Dumesnil, Alexandre. *Le Peintre-graveur français.* 5 vols. Paris, 1835-1871.

Rocco, G. *Pellegrino Pellegrini.* Milan, 1939.

Rodríguez Gutierrez de Ceballos, Alfonso. "La arquitectura del manierismo." *Revista de ideas estéticas* 20 (1962): 1-29.

———. *Bartolomé de Bustamante y los orígenes de la ar-*

quitectura jesuítica en España. Biblioteca Instituti Historici Societatis Iesu, vol. 27. Rome, 1967.

———. "Juan de Herrera y los jesuitas Villalpando, Valeriani, Ruiz, Tolosa." *Archivum Historicum Societatis Iesu* 35 (1966): 285-321.

Ronchini, A. *Atti e memorie delle RR. Deputazioni di Storia Patria per le Province Modenesi e Parmensi* 3 (1865): 300.

Rosenfeld, Myra Nan. *Sebastiano Serlio on Domestic Architecture: Different Dwellings from the Meanest Hovels to the Most Ornate Palace: The Sixteenth-Century Manuscript of Book VI in the Avery Library of Columbia University.* New York, 1978.

Rotondo, Antonio. *Historia descriptiva, artística y pintoresca del real monasterio de San Lorenzo, vulgarmente llamado del Escorial.* Madrid, 1863.

Rubio, Luciano. "Cronología y topografía de la fundación y construcción del Monasterio de San Lorenzo el Real." In *Monasterio de San Lorenzo el Real*, pp. 11-70. El Escorial, 1964.

———. "Los Historiadores del Real Monasterio de San Lorenzo de El Escorial." CD 172 (1959): 499-521.

———. "El Monasterio de El Escorial, sus arquitectos y artífices. Observaciones a algunos libros recientes." CD 160 (1948): 51-108, 419-474; CD 161 (1949): 157-215; CD 162 (1950): 91-122, 527-553.

———. "La Victoria de San Quintín (1557) y la Fundación del Real Monasterio de San Lorenzo de El Escorial." CD 170 (1957): 401-432.

Ruiz, Hernán, II. "Libro de Arquitectura." MS (described by Manuel Gomez-Moreno, El Libro español de arquitectura, pp. 12-13, 27; 5 unnumbered plates).

Ruiz de Arcaute, Agustín. *Juan de Herrera. Arquitecto de Felipe II.* Madrid, 1936.

Saalman, Howard. "Michelangelo at Saint Peter's: The Arberino Correspondence." *The Art Bulletin* (in press).

Saintenoy, Paul. "Les Arts et les artistes à la cour de Bruxelles." *Académie Royale de Belgique, Mémoires*, ser. 2, vol. 2 (1932): 1-185.

Salazar de Mendoza, Pedro. *Cronica del cardenal Don Juan Tavera.* Toledo, 1603.

Salcedo de Las Heras, Pedro. *Monasterio del Escorial: Planta baja y general del edificio.* [Lithographed Plan of Escorial. 1876?].

Saltillo, Marquis del [Lasso de la Vega y Lopez de Tejada, Miguel]. "El Rey Don Felipe II, Juan de Herrera y otros artífices de El Escorial." *Escorial* 8, no. 45 (1953): 137-170.

San Jerónimo, Juan de. "Libro de memorias deste Monasterio de Sant Lorencio el Real." In CDIHE, vol. 7 (1845).

Santos, Francisco de los. *Descripcion del Real Monasterio de San Lorenzo del Escorial, única maravilla del mundo.* Madrid, 1657.

Schlosser, Julius. *La Letteratura artistica.* Florence, 1956.

Sepúlveda, Jerónimo de. "Historia de varios sucesos . . . 1584-1603." In DHM, vol. 4 (1924).

Serlio, Sebastiano. *Tercero y quarto libro de architectura* [1552]. Trans. F. Villalpando. Valencia, 1977 (facsimile edition).

Serrano, Luciano. *Correspondencia diplomática entre España y la Santa Sede.* 4 vols. Madrid, 1914.

Sigüenza, José de. *Fundación del Monasterio de El Escorial* Madrid, 1963. (Reprint of Books 3-4 of preceding title.)

————. *Historia de la Orden de San Jerónimo* [1605]. Nueva Biblioteca de Autores Españoles. 2 vols. Madrid, 1907-1909.

Simpson, Lesley Byrd. *The Encomienda in New Spain: Forced Native Labor in the Spanish Colonies, 1492-1550.* Berkeley, 1929.

Skelton, Raleigh A., and Summerson, John. *A Description of Maps and Architectural Drawings in the Collection Made by William Cecil First Baron Burghley Now at Hatfield House.* London, 1971.

Spencer, John. *Filarete's Treatise on Architecture.* 2 vols. New Haven, 1965.

Spiriti, Salvatore. *Memorie degli Scrittori Cosentini.* Naples, 1750.

Stirling-Maxwell, William. *The Cloister-Life of the Emperor Charles V.* London, 1891.

Stockholm. National Museum. *Äldre utländska målningar och skulpturer; peintres et sculptures des écoles étrangères antérieures à l'époque moderne.* Stockholm, 1958.

Sumario. See Herrera.

Svoboda, Karel. *L'Esthétique de Saint Augustin et ses sources.* Paris, 1933.

Tafuri, Manfredo. *L'Achitettura del manierismo nel Cinquecento europeo.* Rome, 1966.

Taylor, René. "Architecture and Magic: Considerations on the *Idea* of the Escorial." In *Essays in the History of Architecture Presented to Rudolf Wittkower,* pp. 81-109. New York, 1967.

————. "El Padre Villalpando (1552-1608) y sus ideas estéticas." In *Academia 1952: Anales y Boletín de la Real Academia de San Fernando,* Madrid. Pp. 1-65.

Teeuwen, Norbert. "Bibliographie non espagnole de l'Escorial." In *Monasterio de San Lorenzo el Real,* pp. 777-805. El Escorial, 1964.

Terzaghi, A. *Arte antica e moderna* 4 (1958): 376-377.

Toledo, Fray Juan de. "Relación sumaria del incendio de esta casa y convento de San Lorenzo el Real del Escorial en el año 1671." DHM 8 (1965): 69-81.

Tormo y Monzó, Elias. *Los Jerónimos.* Madrid, 1919.

Tscholl, Josef. "Augustins Interesse für das Körperliche Schöne." *Augustiniana* 14 (1964): 72-104.

————. *Gott und das Schöne beim heiligen Augustin.* Heverle-Louvain, 1965.

————. "Vom Wesen der körperlichen Schönheit zu Gott." *Augustiniana* 15 (1965): 32-53.

Tümpel, C. "Ikonographische Beitráge zu Rembrandt." *Jahrbuch der Hamburger Kunstsammlungen* 16 (1971): 20-50.

Turienzo, Teodoro Alonso. "La Ciudad de Dios, archivo de documentos escurialenses." In *Monasterio de San Lorenzo el Real,* pp. 777-805. El Escorial, 1964.

Ulloa, Modesto. *La Hacienda real de Castilla.* Rome, 1963.

Unamuno, Miguel de. *Andanzas y visiones españolas.* Madrid, 1922.

Valenzuela Rubio, Manuel. "El Escorial. De Real Sitio a nucleo turístico." AIEM 9 (1974): 363-402.

Van der Essen, León. *Alexandre Farnèse.* 5 vols. Brussels, 1933-1937.

Vandernesse, Jean de. "Journal des voyages de Philippe II de 1554 à 1559." In *Collection des voyages des souverains des pays-Bas,* ed. L. Gachard and P. Piot. Vol. 4, pp. 1-453. Brussels, 1882.

Varni, Santo. *Spigolature artistiche nell'archivio della basilica di Carignano.* Genoa, 1877.

Vicuña, Carlos. *Anécdotas de El Escorial.* El Escorial, 1975.

————. "Juan Bautista de Toledo: Arquitecto segundo de la fábrica de San Pedro de Roma." AEA 39 (1966): 1-8.

————. "Juan Bautista de Toledo, principal arquitecto del Monasterio de El Escorial." In *Monasterio de San Lorenzo el Real,* pp. 71-97, 125-193. El Escorial, 1964.

Villalpando, J. B. *In Ezechielem Explanationes.* Vol 2. Rome, 1604.

Vitruvio Pollion, M. *De Architectura.* Trans. Miguel de Urrea [before 1569]; Alcalá de Henares, 1582. Valencia, 1978, (facsimile edition).

Walcher Casotti, Maria. *Il Vignola.* 2 vols. [Trieste] 1960.

Walsh, William Thomas. *Philip II.* New York, 1937.

Walters Art Gallery [Baltimore]. *Catalogue of Paintings.* Baltimore, n.d.

Weise, Georg. "El Escorial como expresión esencial artística del tiempo de Felipe II y del período de la Contrareforma." In EEC 2: 273-295.

Wilkinson, Catherine. "The Career of Juan de Mijares and the Reform of Spanish Architecture under Philip II." *Journal of the Society of Architectural Historians* 33 (1974): 122-132.

————. "The Escorial and the Invention of the Imperial Staircase." *Art Bulletin* 57 (1975): 65-90.

————. *The Hospital of Cardinal Tavera in Toledo.* New York, 1977.

————. "Juan de Mijares and the Reform of Spanish Architecture under Philip II." In *Actas del XXIII Congreso Internacional de Historia del Arte,* 2: 443-447. Granada, 1973.

Ximenez, Andrés. *Descripción del Real Monasterio de San*

Lorenzo del Escorial: Su magnifico Templo, Panteón, y Palacio. Madrid, 1764.

Zarco Cuevas, Julian. "Carta de fundación y dotación de San Lorenzo el Real." DHM 2 (1917): 63-138.

———. *El Monasterio de San Lorenzo el Real de El Escorial*. 5th ed. El Escorial, 1935.

———. *Pintores españoles en San Lorenzo el Real de El Escorial (1566-1613)*. Madrid, 1931.

———. *Pintores italianos en San Lorenzo el Real de El Escorial (1575-1613)*. Madrid, 1932.

———, ed. DHM, vols. 1-4. Madrid, 1916-1924.

Zavarrone, Augusto. *Biblioteca calabra*. Naples, 1753.

Zorzi, Giangiorgio. *I Disegni delle antichità di Andrea Palladio*. Venice, 1958.

———. "Progetti giovanili di Andrea Palladio per palazzi e case in Venezia e in Terrafirma." *Palladio* 4 (1954): 105-121.

Zuazo Ugalde, Secundino. "Antecedentes arquitectónicos del Monasterio de El Escorial." In EEC 2: 105-154.

———. *Los Orígenes arquitectónicos del Real Monasterio de San Lorenzo del Escorial*. Madrid, 1948.

INDEX

Entries without place name refer to the Escorial (italic numbers refer to illustrations)

abbatial lordship, 59
Accademia dell'Arte del Disegno, 51-53
accountant (*contador*), 32
Açiaga, Martin de, 78
aesthetics, early Christian, xv. *See* Augustine
agreements (*conciertos*), 72
airshafts, 85-86, *64*
Alaejos, Fray Miguel de, prior, 31-32
Alba, Duke of, 18, 114
Alberti, Filippo, 51
Alberti, Leone Battista, 54
Alcántara, Diego de, 26, 62, 80
alchemy, 128, 140
Alessi, Galeazzo, 51, 53, 95
Alfonso XII, 119
Almaguer, Andrés, 26, 78
Almela, Juan Alonso de, 4, 100
Alvarez Turienzo, Saturnino, 7
Amadeo I, 119
America, 29, 133
Ammannatti, Bartolomeo, 52
Andrada Pfeiffer, Ramón, xvi, 122-125, *117-123*
Andrés Martinez, Gregorio de, xvi, 4
anonymous satire, 8, 155-157
Antona, Miguel, 64, *35*
Antwerp, 48
appraisals (*tasaciones*), 38
apsidal sanctuary, 67, *26*
Aranjuez, 27
architecture, museum, 122
archival collections, xvi, 171-172
Arias Montano, Benito, 131
artisans (*oficiales*), 39
astrology, 138
attic, 104, *93, 114*
Atuy, Francisco de, 82
Auberson, Luis Manuel, xvi, 4
Augustine, Aurelius, xv, 131-132, 132 n49; aesthetic system of, 125
Augustinian Order, 119

Aulnoy, Madame d', 9
Avila, S. Tomas, 54
Azeiza, Domingo de, 82

Baedeker, Karl, 127
bailiff, 39-40
Ballesteros, Juan de, 82
balsas, see toilets
basement vaults, 69
basilica, 77; contracts, 73, 81-84; interior, 84-86, *5, 26, 54, 62, 63*; as royal chapel, 86; towers, 85, *59-61*
benefits, to laborers, 41
Bermejo, Fray, Damián, 6-7
Bernaldós, slate quarries of, 39
Bertano Gurone, 53
Bertault, François, 9
bidding, on contracts, 37, 72, 81
Bocerraíz, Juan de, 82
Bonaparte, José, 118
bonding (*fianzas*), 82
Bourgoing, Jean-François de, 9
Bronzino, Angelo, 52
Brunel, Antoine de, 8
Brunete, battle at, 119
Brussels, royal palace, 47
Buen Retiro (Madrid), palace, 115
building costs 1562-1598, 141-154
building grade, 110
Burghley, Lord, 79
Bustamante, Bartolomé, 45, 78

Cabrillana, Nicolás, 59
Caesar's pediment, 54. *See also* pediment
Caimo, Norberto, 5-6, 9
camaranchón, see attic
camarín, 117
Camón Aznar, José, 4, 126
Campero, Sebastián, 82
Campiglia, Villa Repeta, 54
Campillo, 59, 118

capialçados, see lintels
Caprarola, palace, 47
Carbonell, Alonso, 115, 116
Carmelite Order, 54-55
Carpio, Pedro del, 82
Carranza, Francisco de, 82
cartage, 34, 40
Casa de Infantes, 102, 117
Casale, G. V., 51
casas de ministros, 102
casas de oficios, 101-102
Casita de Abajo, 117
Casita de Arriba, 117
Castello, Fabricio, 79 n21
Castello, G. B., 25, 52, 72
Castillo, Fray Francisco del, prior, 117
Cateau-Cambrésis, Treaty of, 17
Caturla, M. L., 115
Cellini, Benvenuto, 46
Cervantes, Miguel de, 131
Cervera y Vera, Luis, 4, 10, 70, 114, *33, 106*
Chambord, palace, 16, 44
Charles II, 122
Charles III, 121
Charles IV, 118
Chateaubriand, F.-R. de, 10
chimney stacks, 105
Chinchón, Diego, Conde de, 20, 33
Chueca y Goitia, Fernando, 4, 11, 17, 44
cisterns, 111, *101*
Ciudad Real, Fray Hernando del, prior, 31
Claret, Antonio Maria, Padre, 118
cloister of hospice (*hospederia*), 93, *51*
cloister vaults, estimates, 69
Coimbra, Santa Cruz, 75
Colegio de Estudios Superiores de Maria Cristina, 119
college, 92, 118-119
Colmenar, Fray Juan del, prior, 31
commission on choosing site, 60

Compaña, 41, 99, 121, *85*, *86*
compound, defined, 71 n90
conflagrations, 78, 119-122
Congregación, membership, 19; function supervisory, 30, 32; appoints commission of review, 65; increases employment, 75
contracts, favored by King, 37; numbers fall off, 78; annual listing, 162-168
contractual terms, 72
Cordova, Jeronymite cloister, 75
correspondence, of parts, xv, 77
corridor basements, 111, *103*
Cortés, Martin (Marqués del valle de Oaxaca), 16, 20, 33
cost of Escorial, 36. *See also* building costs
Council of Trent, 119, 126
courtiers' dwellings, 102, *72*, *73*
Covarrubias, Alonso de, 19
cranes, 36, 75, 83, *55*, *66*
Crescenzi, J. B., 111, 116, *108*
criado, 25
Cricoli, Villa Trissino, 54
crossing towers, 107, *80*, *97*
cruciform courts, 45, *1*, *24*, *31*
crypt, basilica, 45, 115, 123, *44*
cuadro (block), 87, 98, *1*, *104*, *117*

Danti, Egnatio, 51
Danti, Vincenzo, 51, 52
dedication, 87
derrick, 27
design, 42; by Toledo, 43
Discurso de la figura cúbica, 130
dome, supports, 80; construction, 83
Doric Order, 74, *42*, *43*
dormers, 105, *97*
drafting rooms, 35
drawings, before 1576, 85-86; for service buildings, 102; by Villanueva, 118; by Andrada, 122-125
Duca, Giacomo del, 46
ducts and drains, 111-112, *105*

eclecticism, 128 n17
Egas, Enrique, 21, 45
El Parral, 131
enclosure of lands, 59
encomienda, defined, 33
entrance portico, 95, *83*
entresols, 105, *110*
Escalante, Lucas de, 24, 36, 38, 74, 78
Escolapios, Padres, 119
Escorial, etymology, 157 n5; admirers, 3; detractors, 7-8; and Gothic taste, 10; purpose of, 12, 14, 133; other names, 13; foundation and endowment, 14-15; financial structure of *fábrica*, 19; place in economy, 33; Ital-

ian projects, 45; drawings lost, 62; religious retreat, 89; site chosen by King, 61; state of building in 1568, 70, *33*, *34*
Escorial, Villa (lower town), 29
exclaustration, 118
exemption, from episcopal rule, 118; from taxes for laborers, 33, 174
expropriation, 118

farm buildings, 100
Farnese, Alessandro, 50
fenestration, 106
Ferdinand VI, 118
fiesta de Fray Antonio, 41, 80. *See also* Villacastín
Filarete, Antonio Averlino, 44-45
firewalls, in attics, 121
First Republic, 118
flooding, in basements, 111
flooring, uniformly level, 109
Florence, Accademia dell'Arte del Disegno, 52-53
Fons Vitae, 75
food prices, 41
forechurch, 55, *57*. *See also sala tetrastila*
forecourt, 43, 84, *82B*, *97*; parallel in Alessi's work, 95 n55
foreman, master, prior appoints, 39
foreman (*sobrestantes*), 32; accompanied by friar-delegate on rounds, 38
Formermüdung, 128
Foucault, Michel, 130
fountains, 65, 111, *49*; in small cloisters, 26, *51*

Galapagar, mayor, 59
garden pool, 101 n18
garrets, 105
Gautier, Théophile, 10
Gil de Hontañón, Rodrigo, 21
Gili Gerónimo, 24
Giordano, Luca, 64
Gombrich, Ernst, 128
Gómez de Mora, Juan, 54, 115, 117
Gonzalez, Francisco, 82
Gonzalez de Lara, Hernando, 21, 78
governance, 68
grain sales, 59
Granvelle, Cardinal, 46
Gregory XIII, 33
Grimaldi, Marquis de, 117
Guadarrama, 61; bridge, 27
Guinard, Paul, 7, 10
Guisando, 61

Hatfield drawing, attribution, 79 n21; dating, 79; as record, entire, *65*; details, *66*, *74*, *78*, *84*, *99*, *100*
Hauser, Arnold, 126

Hempel, Wido, 3, 4
Henermann, Theodor, 4, 10
Hermetism, 128
Herrera, Fray Marcos de, 120
Herrera, Juan de,
　　career, 23; *criado* at court, 25; Brussels, 23; *discipulo* (assistant) to Toledo, 20, 22-23; inscription by, 24; aide to Master of Horse, 25; known as "soldier of the German guard," 23; dwelling in lower town, 26, 78; reorganizes *fábrica*, 26, 78; court chamberlain, 25, 27; rise to power, 27, 75; testaments, 27, 81; medal honoring, 14, *12*; royal architect, 25
　　designs by: basilica, 26; grilles, 26; fountain (main cloister), 75; main cloister supports, 74; roofs, 26, 74; sanctuary, 84
　　drawings by, 102; service buildings, 101-103; main cloister, 24; wall of niches, 24-25
　　relationships: to King, 28; to Lull, 129; to G. B. Castello, 25; to J. B. de Toledo, 21, 28
　　writings: *Discurso de la figura cúbica*, 130; *Sumario*, 84; on managerial economies, 81; on pulleys, 24
Herreran revival (1770s), 102
Hispanidad, 45
hospice, 41
hospitals, in Villa, 41; at monastery, 44; in outbuildings, 98-99; in Toledo, 78
Hoyo, Pedro de, 33
Huete, Fray Juan de, prior, 8, 31; hostile to J. B. de Toledo, 64-65, 66, 67; his plans enlarging monastery, 65
Humboldt, Wilhelm von, 10
hydraulic conditions, 112-113

iglesia de prestado, see provisional church
"imperial" stairway, 109 n61; *48*
income, from New Spain, 138
infirmary-garden building, 67. *See also* sun-corridors
Iñiguez Almech, Francisco, 4, 11, 52, 84
inspector (*veedor*), 32-33
Isabel II, 118

Javarria, Ursula, 21
Jean de Rouen, 75
Jeronymite Order, character, 15, 29; comfortable life, 74; dedication to monarchy, 29; local power absolute, 30; participation in siting and building, 60; plans, 61; royal affection for, 13
Jerusalem, Temple, 107
John III, of Portugal, 127
John V, of Portugal, 127

Jouvin, A., 9
Justi, Carl, 4, 126

keeper of materials (*tenedor*), 34
Kerley, C. P. , xvi
King's house, 5; described by Lhermite,
88; bedroom, 85, *17*, *58*; occupied
first, 89; restored, 122; as retro-sac-
risty, 96; as royal dwelling, 87-89
kitchens, distribution, 100; King's, 101;
roofing, 73
Kubler, E.G.A., xvi; photographs and
drawings, xi-xiii

laborers (*peones*); 39; competition for, 73;
food tax-exempt, 39, fluctuations, 40;
organization under prior, 30
La Fresneda, 73, 89, 158, *41*
La Granjilla, 59, 118
large chambers, fenestration, 108-109, *37*
Las Radas, 118
Lastricati, Zenobio, 52
lead roofs, 16
legal instruments (*escrituras públicas*), 73
Leoni, Pompeo, contracts, 27, *11, 70*
Lerma, Duke of, 114, 115
Lerma, palace at, 114, *106*
Lhermite, Jehan de, 76, 90, 100
library, 44, design, 96-97, frescoes, 129,
98
library portico, lost drawings, 95 n54, *83*
lightning, and conflagrations, 82, 119-
122
lintels (*capialçados*), 106
Lisbon, Jeronymite monastery at Belem,
172; S. Vicente de Fora, 54; King and
Herrera at, 84
Lizargarate, J. B., 111
Llaguno y Amirola, Eugenio, 11
Lomazzo, Gianpaolo, 46
Lombardo, Pietro, 54
Lonedo, Villa Godi, 54
lonjas (paved terraces), 103
Lope de Vega, on Lerma, 115
Lopez Serrano, Matilde, 84
Lorriaga, Mateo de, 97
Louvre, Paris, 16
lower town, 8
Lull, Ramón, 128-129

Madrid, Alcazar, 16; Biblioteca Na-
cional, 62; Biblioteca de Palacio, 62;
Encarnación, 54; S. Jerónimo, 54
"capitalhood," 18; residence of court,
17-18
Madrid, Fray Nicolás de, 111, 116
magic, Renaissance, 130
main cloister, *10*; arcades, *74*; building
history, 74-75; contract, 96; fountain,

75, *49*; Garden of Eden, 75; plans, 24;
principal stairway, 45, 73, 110, *48*
malaria, 59, 90
Mannerism, 125-126
Mantua, S. Sebastiano, 54
Manuel I, of Portugal, 127
Martirano, Bernardino, Barone, 51
Martirano, Gian Tomasso, 51
Mary, Queen of England, 76
Mass, first, 68; commemorative, 76
master builders, 73
master masons, 35-36
Matienzo, Diego de, 82
Matienzo, Juan de, 82
Maza, Juan de la, 82
Mendicant Orders, 34
Menéndez Pelayo, 131
mental image, among builders, 98
Mérida, ruins, Roman, 27
Meunier, Louis, 6 n20, *9, 10*
Michelangelo, offers designs, 46
Mijares, Juan de, 27, 36, 78-79
Milan, Ospedale Maggiore, 44, *24*; S.
Maria Presso S. Celso, 95
Mitelli, Agostino, 116
models, of basilica, 78
Modino de Lucas, Miguel, 31
monastery cloisters, 66, *31, 51, 97*
monastic character of Escorial, 44-45, 71
Monegro, J. B., 42, 96
Montalban, Francisco de, 75, 112-113
Montecchio Precalcino, Villa Cerato, 54
Montepulciano, S. Maria, 54
Mora, Francisco de, 27, 97, 100, 101
n18, 115
moving day (1570), 79

nails, machine for, 26
Naples, 48
narthex, 54, *1, 20, 21*
Nates, Juan de, 114
Navarro, Federico, 118
New Spain, 71
Nice, 47

obelisks, 42, *20*
oecus corinthia, 55. See also *sala tetrastila*
Olabarrieta, Juan de, 82
Olivares, Count-Duke of, 115
Olmo, José del, 117
open chapel, 86, *21*
ornament, xv
outbuildings, 44, *91*
outside corbelled passage, 69, *36*
oxen, enclosure, 63; prior responsible
for service, 40; friar in charge, 64

Paciotto, Francesco, criticisms by, 48-50;
drawings by, 20, 52; mission, 47;
sober style, 50; and Vignola, 50

painting, museum of, 121, 122
palace, building, 89-91, *74, 75*; court,
91, 104, *77*; plans, 91-92, *72, 73*; re-
built, 122; services, *76, 77*
Palladio, lost project, 51; *Quattro libri,*
53; roman-bath windows, 107-108
Panteón, 116 n11. See also crypt
Pardo palace, 16
Párraces, Jeronymite monastery, 131;
college at, 93
Passarge, Ludwig, 10
Patio de los Evangelistas, see main clois-
ter
Patio de los Mascarones, see King's
house
Patio de los Reyes, see forecourt
Patrimonio Nacional, 119, 122
paymaster (*pagador*), 32
payroll, 38
pediment, as *fastigium,* 54; arched, 107,
20, 21
pedimented narthex, 54, *82*
Peña, Gaspar de la, 120
perpetual commemoration, 71
Perret, Pedro, 24, 104, *1-7, 11, 18*
Pevsner, N., 125
Peyron, Jean-François, 9
pharmacy (*botica*), 99
Philip II, autograph comments, xvi, 12;
aversion to astrology, alchemy, 129,
140; Black Legend, 14; early interests,
14; testament, 14-15; travels in Eu-
rope, 18; warning on economy, 19; at
Yuste, 20
Escorial, his idea of, 3; instructions
on governance, 29; Burgundian court,
18; his plan (lost) for cloisters, 66;
move to monastery, 66; agendas, 68,
70; letter of foundation and endow-
ment, 70; pleasure in landscape, 70;
rejects designs by Michelangelo, 47;
low opinion of Toledo's church, 63;
taste in architecture, 17;
Portugal and, 17; inherits and rules
Portugal, 27, 127
Philip III, horoscope, 129
Philip IV, redecoration, King's house,
122
Piacenza, Cittadella, 47
piecework (*a jornal*), 36
Pius VI, 118
plateresque stonecutting, 109
plumbing, 111-112
Pompeii, House of the Silver Wedding,
55
Ponz, Antonio, 5, 117
Ponz, José, 5-6
Ponzio, Flaminio, 54
Porreño, Baltasar, 129
Portabales Pichel, Amancio, 11, 19

Portici (Naples), 52
Portugal, under Spanish rule, 84
Praves, Diego de, 114
Praves, Francisco de, 114
preparators (*aparejadores*), authority of, 29; functions, 35; dwell at site, 69
prior, authority of, 30; reverses architect's decision, 69; King appoints, 30; feudal privileges, 30
professors, housing of, 101
promenade (*público passeadero*), of college, 94, *81*
proportions, 107
provisional church, 64, 70, 71, *1, 40*

quarry-dressing, 26-27; -finishing, 53; -shaping, 80-81
Queen's apartments, 83; building, 90, *74. See also* palace
Quesada, Diego de, 137
Quevedo, José de, 41
Quinet, Edgar, 10

Ramirez, Gonzalo, treasurer, 26, 78
ramps, 109
reburial, royal bodies, 76
Regla, Fray Jean de, 29
relics, 76 n133; altars of, *71*
retainers, 90 n19
Ribeo, Nicolás del, 82
Ribera, Andrés de, 21
Rief, J., 132
Riegl, Alois, 132
Rio, Francisco del, 82
riot, of masons, 36, 82, 83
risers, on stairs, 109
ritual, supported by relics, 76
Rodriguez Gutierrez de Ceballos, Alfonso, 126
Roman-bath, fenestration, 53, 55, 107-108, *62, 63*
Rome, S. Maria Dell'Orto, 95; S. Sebastiano, 54; Spanish Academy, 117; theater of Marcellus, 74, *43*; Villa Madama, 54
roofs, lead, slate, 16; replacement in steel, 122, *114*; Sigüenza on, 105
Roriczer, Mathäus, 104
Rossi, Vincenzo de, 52
rough-dressing, at quarry, 26-27; -finishing, 53; -shaping, 80-81
royal bodies, 87; reburial, 76, *40, 108*
royal residences, 89
Rubio, Fray Luciano, xvi, 4, 10, 72
Ruiz de Berriz, Martin, 82

St. Germain-en-Laye, 16
sala tetrastila and *sotacoro*, 53, 7, *57*
Salcedo de las Heras, Pedro, 111, 112

Sanchez, Coello, Claudio, 117, 173, *frontispiece*
Sanchez, Simón, 82
sanctuary, drawings for, 15, 84, *47*
Sangallo, Francisco da, 52
San Jerónimo, Fray Juan de, 4, 29, 64
San Lorencio el real, 8
San Lorenzo (martyr), 60
San Lorenzo de la Victoria, 9, 13
San Lorenzo (upper town), 102
San Quintín (St. Quentin), 7, 13, 60, 119
Santa Forma, altarpiece, 5. *See also* Sanchez, Coello
Santos, Fray Francisco de los, 5, 116, *112* (attrib.)
Scalza, Ippolito, 54
Schiller, Friedrich von, 10
Second Republic, 119
Segovia, S. Cruz, 54
seminary, function, 44; new foundation, 118
Sepúlveda, Fray Jerónime de, 105
Serlio, Sebastiano, 14, 45-46, 96, 106, *95*, 107
servants' quarters, 101, *1-69*, 87
Sesniega, Diego de, 82
Sevilla, Exchange (*Lonja*), 27
sheep of monastery, 59
shortages, materials, cartage, 75
Sigüenza, Fray José de, civil name, 131 n38; life, 131; *Historia*, 131; and Inquisition, 131 n38; as chronicler, 4
 on architecture, 128; on Paciotto, 47, 50; on J. B. de Toledo, 22; on Diego de Siloe, 127; credibility, 129; his plain style, 127; his iconographic programs, 75, 129, *49, 98*; on proportions, 107
 in Spanish literature, 131; Augustine's aesthetic system, xv, 125, 127, 133-134
similitude, in medieval thought, 130
Sinot, Oliver, 80 n22, 105
Sixtus V, 118
slate roofs, 16, 96, 103-104
slaters, from Flanders, 75
Sobieski, Jacob, 7
Soria, Juan de, 82
Soria, Martin, 117
sotacoro, see forechurch, *sala tetrastila*
sotacoro narthex, 53
Spalato, 43, *23*
specifications (*condiciones*), 37, 69, 72
Spinola, Lorenzo, 138
spires, 104, 122, *3, 79, 97, 100*
stables, 43
stairways, "imperial," 109, *48*; garden, 99, 109-110, *99*

stone, 98, 103-104; cutting, 35; dressing, 27; shaping, 27-38; lift (*cabrilla*), 38
styles of, architecture, 17; François I, 17; Plateresque, 17; plain (*chão, desornamentado*), 5, 10, 17, 78, 126-127
Sumario, 25, 84
sun-corridors, 69, 99, *38*
Svoboda, Karel, 132

Tafuri, Manfredo, 125-126
talus wall, 110, *36*
Taylor, René, 4, 128
Temple of Solomon, 43, *22*
temples of victory, 13, *13, 14, 15*
termites, 122
thermal windows, *see* Roman-bath
thirty-foot cornice, contract, 69, *2, 120*
Tibaldi, Pellegrino, 51, 97 n65, 129, *98*
toilets, 111, *101, 104*
Toledo, Alcazar, 19; Hospital de Tavera (or Afuera), 45, 78; S. Juan de los Reyes, 54
Toledo de Alfonsis, Juan Bautista de, preparator (*aparejador*) in youth, 22; appointment as architect, 20, 22, 60, 71; blamed, 8; decline, 63; defends work, 67; designs, early, 63, 65, 67, *39*; documentation, 72.
 drawings by, 61-62, *26, 31, 32*; lost, 62; attributed to, 62
 indolent, 21; King's orders, 69; military background, 109; on piecework, 74; praised, 20-21; quarrels, 21; refuses King's order, 68; reputation in Italy, 21; restricted activity, 68; Serlio's influence on 46; work accelerates after death of, 74
Tolosa, Pedro de, chief mason, 26; quarrel with Toledo, 21; fired 36; assists prior, 65; demoted to Uclés, 78
tomb groups, 27; *70*; 84n 59, 7
torus molding, 64; *36*
towers, basilica, 85 *59, 60, 61*; corners, 64, 67, 94, 104, 122, *19, 35, 39*; crossings, 65, 93, *1, 78, 79, 80, 97, 113*; south façade, 70, *33, 34*
trasparente (altar), sacristy, 117
traza universal (master-drawings), 62
Trezzo, Jacome da, contract, 27; main altar, 84, *11*; medals, 27, *12, 14*
Tricio, Fray Julián de, prior, 31
turbine drive, 100 n17, *86*
Turienzo, Fray Teodoro Alonso, xvi, 4
Turriano, Juanelo de, 23, 112
Tuscan Order, 46

Uclés, 78
Unamuno, Miguel de, 3, 127

Valdés, Juan de, 131
Valencia, Juan de, 20, 22, 24
Valero, Fray Juan, 121
Valladolid, 27, 114
Valsain, 16
Vandelvira, 106
van Veen, Otto, 24
vault, forechurch, 69
vaulted basement, 110
Vega, Gaspar de, 15-16, 20, 21, 63
Venice, S. Maria dei Miracoli, 54; and
 Spalato, 43
Vicenza, Villa Thiene, 54
Vicuña, 61
Vignola, 47, 48, 52, 95
Villacastín, Fray Antonio de, 4, 31, 33-
 34, 36, 40-41, 63, 72, 81, 113

Villa del Escorial, 8
Villalpando, Francisco do, 15, 16
Villa Mocenigo (Palladio), 55
Villanueva, Juan de, remodeled north
 façade, 105-106, *110*, *112*; rebuilt up-
 per town (villa), 102; drawings cata-
 logued, 159-161, *111*
Vitruvius, 17, 55

"warped" apertures (asymmetrical
 jambs), 74, 104, *79*, 108-109, *2, R,O,
 98*; military, 109
Weise, Georg, 10
west façade, division, 106, *7, 50*
windows, frames, 106; lintels, 106, *95,
 96 A*; sizes, 107; north façade, 106, *94*;
 south façade, 106, *6*

windstorm, 82
working hours, 40

Ximenez, Fray Andrés, 117 n14

Yermo, Pedro del, 27
Yuste, 13, 29, 34, *17*

Zarco Cuevas, Julián, 4, 173
Zeiller, 43, *73*
Zuazo Ugalde, Secundino, 4, 11, *30B,
 38*
Zúmbigo, Bartolomé, 116, 120, 122
Zuñiga, Juan de, 17

Library of Congress Cataloging in Publication Data

Kubler, George, 1912–
 Building the Escorial.

 Bibliography: p.
 Includes index.
 1. Escorial. I. Title.
NA5811.E84K8 720′.946′41 81-47140
ISBN 0-691-03975-5 AACR2

GEORGE KUBLER is Sterling Professor of the History of
Art at Yale University

ILLUSTRATIONS

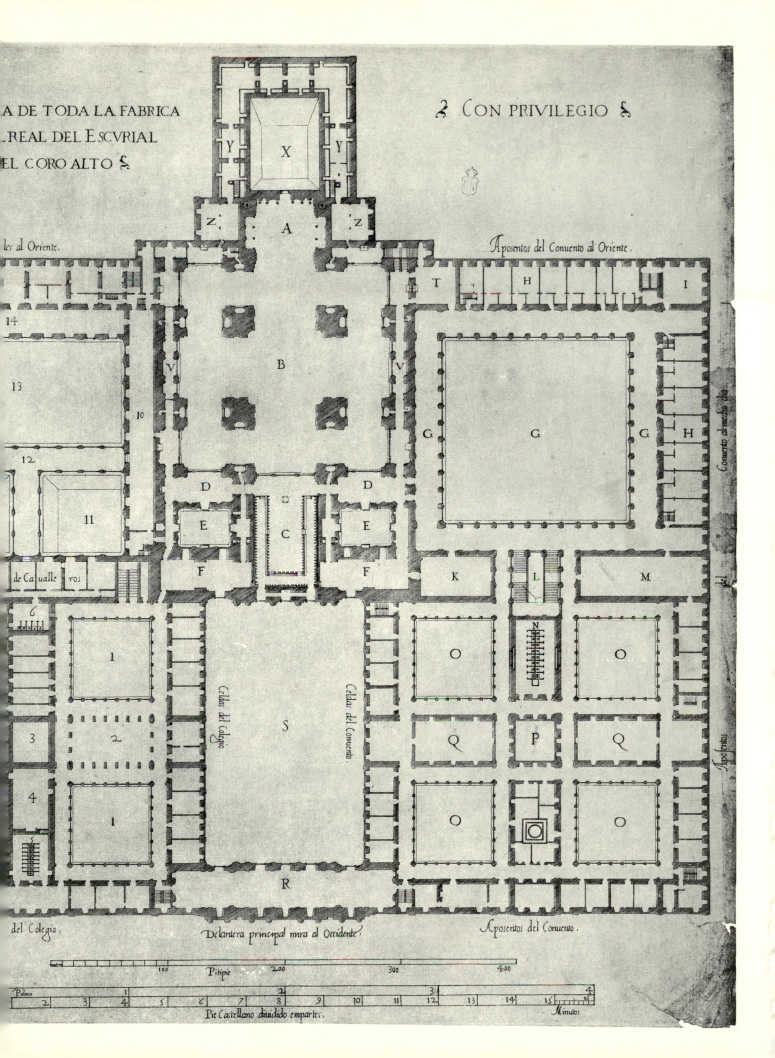

A DE TODA LA FABRICA

.REAL DEL ESCVRIAL

EL CORO ALTO

CON PRIVILEGIO

les al Oriente.

Aposentos del Conuento al Oriente.

Y X Y

Z A Z

T H I

14

13

10

V B V

G G G H

D D

11

E C E

G

F F

K L M

de Caualleros

N

6

1

O O

3 2

Celda del Colegio Celda del Conuento S

Q P Q

4 1

O O

R

del Colegio.

Delantera principal mira al Occidente.

Aposentos del Conuento.

Conuento al medio dia

del

Aposentos

100 Pitipie 200 300 400

Palmo 1 2 3 4

2 3 4 5 6 7 8 9 10 11 12 13 14 15

Pie Castellano diuidido en partes.

Minutos

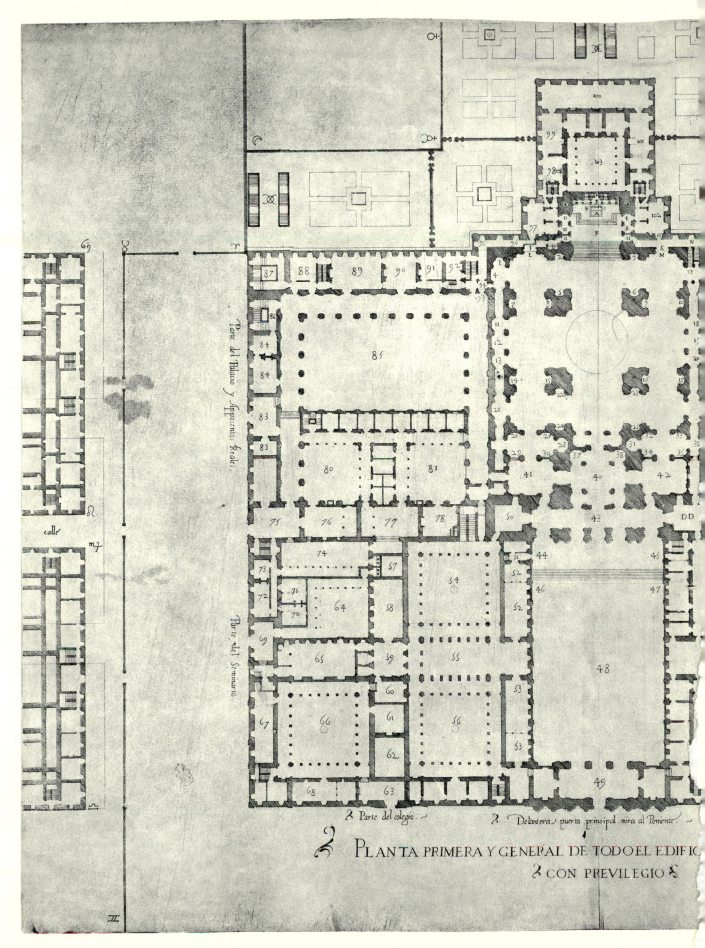

Parte del Palacio y Apposento Reales.

Parte del Seminario.

calle

Parte del colegio. — Delantera puerta principal mira al Poniente.

PLANTA PRIMERA Y GENERAL DE TODO EL EDIFIC

CON PREVILEGIO

1. Ground plan between 5- and 15-foot levels (from HS, text pp. 7-16).

A–Main altar.
B,C–Doorways to sacramental chapel (*sagrario*) behind A.
DD, EE–Royal oratories at level of F.
F–Main altar floor level, 9 feet above nave.
G–Doorway to reliquary chapel I.
H,N–Passage from sacristy (R) with stairway at N,O to main altar level at F.
I–Reliquary chapel, north.
K–Reliquary chapel, south.
L,M–Altars beneath reliquary chapels at east aisle ends.
N,O–Stairway rising from sacristy to altar and to choir balcony level (30 feet above sacristy floor).
P–Doorway to sacristy vestibule (Q).
Q–Sacristy vestibule.
R–Sacristy.
S,T–Upper and lower chambers for sacristy service. (Later rebuilt for *Sagrada Forma* altarpiece and chapel.)

Monastery (*convento*)

V–Entrance and services for upper and lower levels of prior's cell.
X,Y–Stairway descending to basement and rising to upper prior's cell and roofs.
Z–Prior's vaulted reception room.
&–Chapter room, northern half.
&l–Vestibule to the two chapter rooms.
Þ–Chapter room, southern half.

AA–Main cloisters (*Evangelistas*).
BB–Cloister fountain center.
CC–Fountain basins.
DD–Vestibule and entry way to monastery in ground floor of south tower.
EE–Parlor (*locutorio*) for visitors.
FF–Main stairway.
GG–Provisional church (*capilla de prestado*) built for use during construction.
HH–Archive.
II–Monastery court.
KK–Toilet tank (*caxa de necesarias*).
MM–Wardrobe (*roperia*).
NN–Vestibule to refectory, rising to roof-level and giving light to adjacent passages and rooms.
OO–Refectory, over basement chambers

passing also under vestibule and wardrobe.
PP–Court of administrative offices (*procuracion*) and guest house (*hospederia*).
QQ–Kitchen with hot and cold water service.
RR–Infirmary court with two cisterns.
TT–Refectory for patients.
VVV–Pharmacy, extending into XX, and new pharmacy court beyond (not shown here).
XX–Sun-corridor for convalescents (*corredor del sol*).

1-38–Lesser altars in the basilica (*templo*).
39–Doorway for processions from church to main cloister.
40–Under-church (*sotacoro, cuerpo de la yglesia*).
41,42–Air-shaft courts (*patinejos*), lighting the *sotacoro*.
43–Narthex (*portico*) with entrances to basilica, monastery, and college.
44,45–Terrace (*paseadero lonja y peaña*) above stairs (46,47) from atrium (48).
46,47–Stairs to terrace.
48–Atrium (*patio descubierto*) dividing college and monastery.
49–Main portico at entrance shared by monastery and college.

College

50–Entrance in south tower of basilica.
51–Seminary doorway.
52,53–Lecture rooms for Theology and Arts.
54–College court.
55–Covered promenade for collegians (*publico paseadero*).
56–College court.
57–Toilet tank (*caxa de necesarias*).
58–Refectory for collegians.
59–Vestibule of refectory.
60–Serving pantry.
61–Warming room (*chimenea*) for seminary.
62–Toilet tank (*caxa de necesarias*).
63–Vestibule entrance for college and seminary.
64–Court for kitchen, animal yard, and services for college and seminary.

65–Kitchen of college.
66–Seminary court.
67–Seminary refectory.
68–Seminary lecture room for Grammar.
69–Vestibule for entrance and service at college kitchen. (Unnumbered chambers in monastery, college, and seminary serve as friars' cells.)

Palace (*casa real*)

70,71,72,73–Service quarters for the offices of the table.
74–Courtyard and services for kitchens.
75–Vestibule and entrance to the services of the royal palace.
76,77,78–Kitchens for different services.
[79]–Room of state for the meals of gentlemen of the chamber, major domos and other gentlemen (number not shown; probably between 75 and 83).
80,81–Courtyards with dwellings for services of the table and officers, with rooms on lower and upper floors.
[82]–Doorway from palace to church, monastery, and college (number not shown; probably between 81 and 41).
83–Vestibule for royal persons to dismount where the guard stands watch.
84–Lodgings for ambassadors.
85–Royal courtyard over two cisterns for rainwater.
86–Main stairway in palace.
87–Toilet tank (*caxa de necesarias*).
88,89,90,91,92–Royal chambers at ground level.
93–Doorway to the King's house behind the sanctuary.
94–Doorway from King's house and other parts to services in the basilica.
95,96–Passage to enter His Majesty's private quarters.
97,98,99,100,101,102–His Majesty's private quarters.
103–Court of the King's House.
⚬–Door for His Majesty to enter the monastery.
☙,&l,𝔪,≈–Outbuildings for royal services of the table and dwellings for their officers on 6 courts.

2. Upper plan between 15- and 30-feet levels (from HS, text pp. 16-19).

A. Sanctuary.
B. Basilica.
C. Choir balcony.
DD. Anterooms to choir for choir books.
EE. Air-shaft courts (*patinejos*).
FF. Rooms for choir books and their maintenance (*servicio*). On the college side (north) is the chapel of the collegians.
GG. Main cloister, upper walks.
HH. Friars' cells.
I. Prior's cell.
K. Upper sacristy and service of the choir.
L. Main stairway.
M. Novices' dormitory.
N. Toilets.
O. Courts and walks of monastery.
P. Vestibule of monastic refectory.

QQ. Dormitory.
R. Library (185 × 32 feet) under another chamber of similar size for its service.
S. Entrance court.
T. Square chamber, serving upper cloister and sacristy, where scripture is read to the friars.
VV. Passage surrounding the church at level of organs and upper altars.
X. Court of King's house.
YY. Attic chambers of King's house.
ZZ. Square chambers at attic level giving access to passages VV. Four steps down and attics YY. Higher up at cornice level in the basilica, another such continuous passage surrounds the inner walls and gives access to the roofs and dome.

1. Courts and corridors of the college.
2. Upper walks overlooking promenade for collegians.
3. Vestibule of college refectory.
4. Upper warming room for collegians.
5,6. Toilets.
7. Dwellings for seminary.
8. Courtyard of college services.
9. Dormitory of seminary.
10. Royal gallery of murals.
11. Courts of royal services.
12. Roof terraces of lead sheets above two stories of dwellings.
13. Court of royal palace.
14. Vaulted walks for service of royal dwellings on east and north.
15. Royal dwellings in east range.

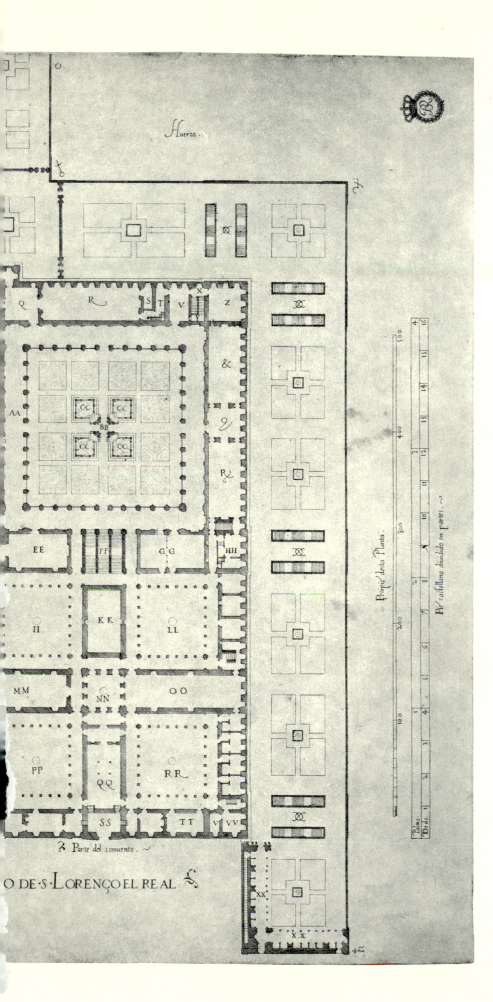

Huerta.

Perpié' desta Planta.

Br castellano diuidido en partes.

Parte del conuento.

O DE S LORENÇO EL REAL

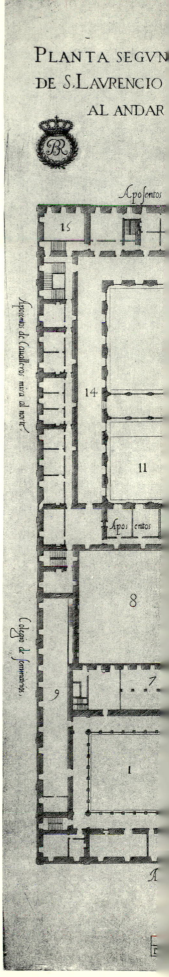

PLANTA SEGVN
DE S. LAVRENCIO
AL ANDAR

Aposentos

Aposentos de Cauallers mira al norte.

Colegio de Seminaros.

2

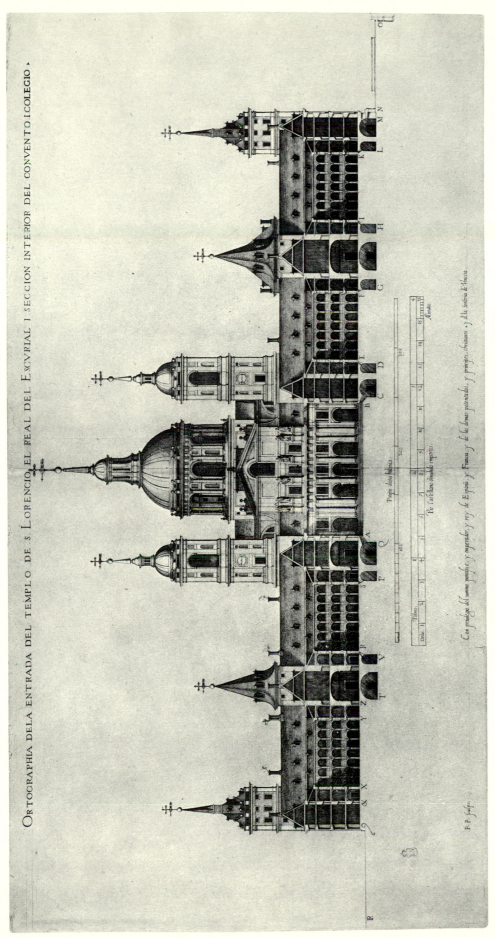

3. Section through westernmost cloisters (from HS, text pp. 19ᵛ–21ᵛ).

AB. Façade of basilica.
CD. Basements under north range of monastery.
EF. East elevation of northwest monastery court.
GH. Basements under ranges from west façade to main cloister.

IK. East elevation of southwest monastery court.
LM. Basements under south façade building (*quarto*).
NO. Section of garden terrace surrounding south and east façades.
PQ. Basements under lecture rooms of Theology and Arts.

RS. East elevation of southwest college court.
TV. Basements under central range of college.
℣&X. Section of north range of Seminary.
℞℥. North terrace.

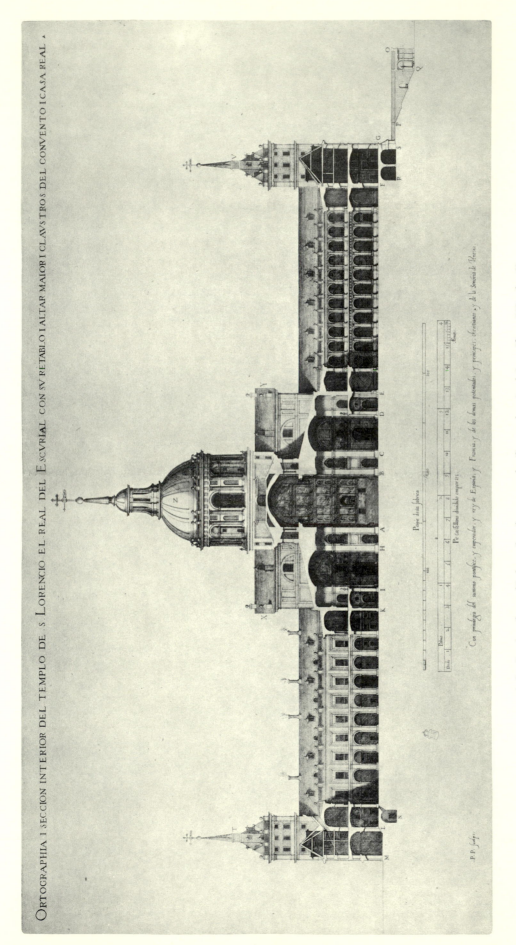

4. Section (north-south) through palace court, basilica, and main cloister (from HS, plan 3).

AB. Sanctuary and altarpiece.
BC. Elevation of southeast crossing support.
CD. South aisle, toward reliquary chapel.
DE. Passage at outer south wall, lined with altars for friars' masses.
EF. Main cloister.
FG. South range, at east chapter-room.
GO. South garden terrace with section of stair and grotto.

QP. Section of stair to lower garden.
RS. South-range basements repeated on east range.
AH. Elevation of northeast crossing support.
HI. North aisle, toward reliquary chapel.
IK. Passage at outer north wall, lined with altars for collegians' masses.
KL. Main court of royal block (*quarto*).

LM. North range and gentlemen's rooms above ground level.
N. Basement passage to royal block.
T. Tower rising at northeast corner.
V. Tower rising at southeast corner.
XY. Transept-crossing exterior showing lead-sheet roofing.
Z. Dome exterior.

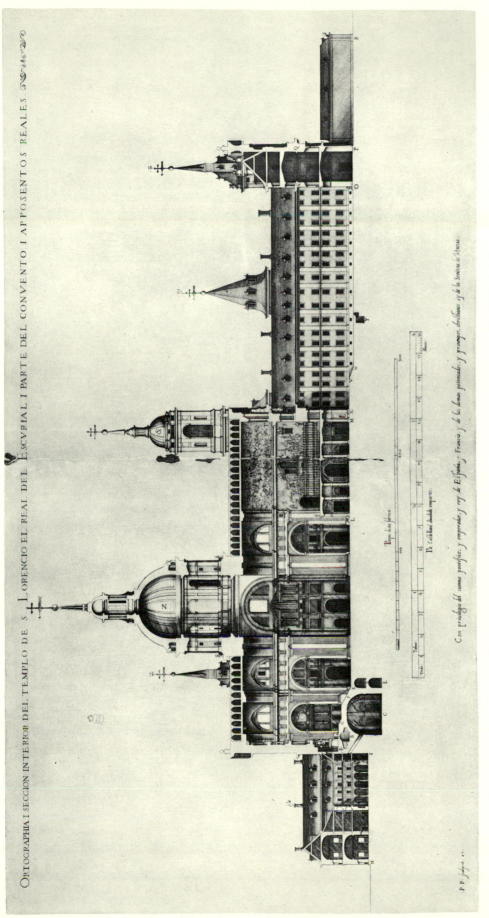

ORTOGRAPHIA I SECCION INTERIOR DEL TEMPLO DE S. LORENCIO EL REAL DEL ESCVRIAL I PARTE DEL CONVENTO I APPOSENTOS REALES

5. Section (east-west) through King's house, basilica, forecourt, and portico (HS, plan 5).

+. Sacramental chapel (*sagrario*).
A. Main altar.
B. Burial chamber for royal bodies.
C. Chapel beneath sanctuary.
DE. Upper and lower choirs of chapel C.
AK. Sanctuary (*capilla mayor*) showing royal oratories.
FG. Stairs approaching altar.
HI. Royal dwellings.

KL. Basilica (*cuerpo del templo*) with organ in transept.
LM. Under-church and entrance portico to monastery and college.
XV. Atrium terrace (*lonja*).
XVNO. Monastery façade and atrium.
OP. Main entrance portico.
RR. Pharmacy and services.
QQ. Cross section of main façade.

SS. Choir-balcony.
T. Barrel vault over choir.
Y. Underground passage from monastery to college crossing atrium.
Z. Dome.
&. South tower.
ᛪ. Monastery crossing tower.
♃. Corner towers

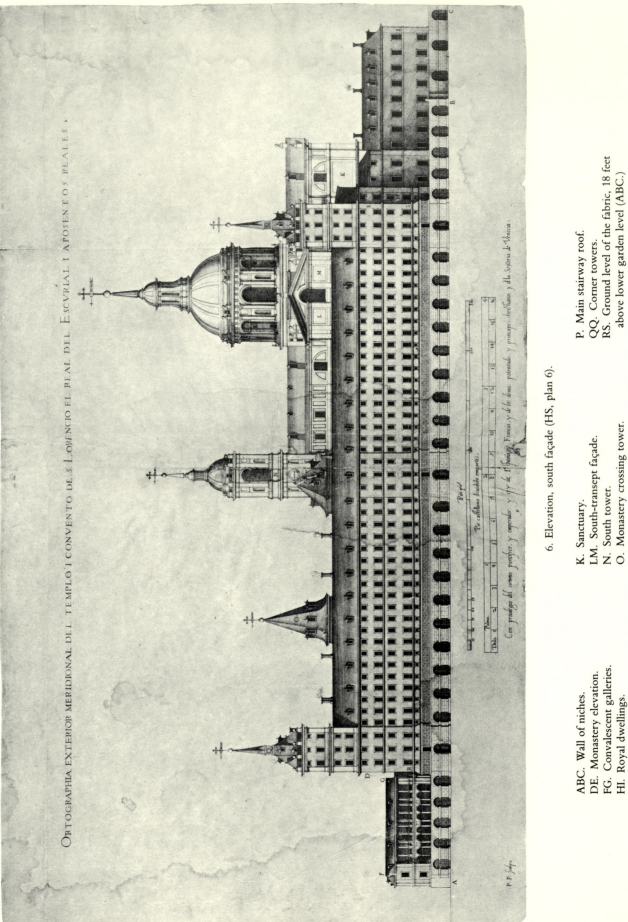

ORTOGRAPHIA EXTERIOR MERIDIONAL DEL TEMPLO I CONVENTO DE S LORENCIO EL REAL DEL ESCVRIAL I APOSENTOS REALES ▪

6. Elevation, south façade (HS, plan 6).

ABC. Wall of niches.
DE. Monastery elevation.
FG. Convalescent galleries.
HI. Royal dwellings.

K. Sanctuary.
LM. South-transept façade.
N. South tower.
O. Monastery crossing tower.

P. Main stairway roof.
QQ. Corner towers.
RS. Ground level of the fabric, 18 feet
 above lower garden level (ABC.)

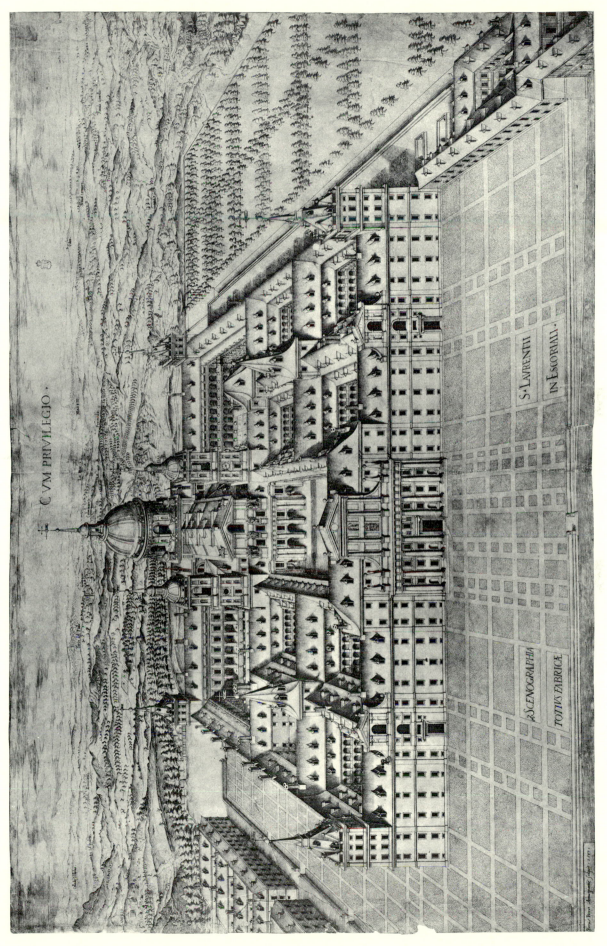

7. Perspective rendering from west by north (HS, plan 7).

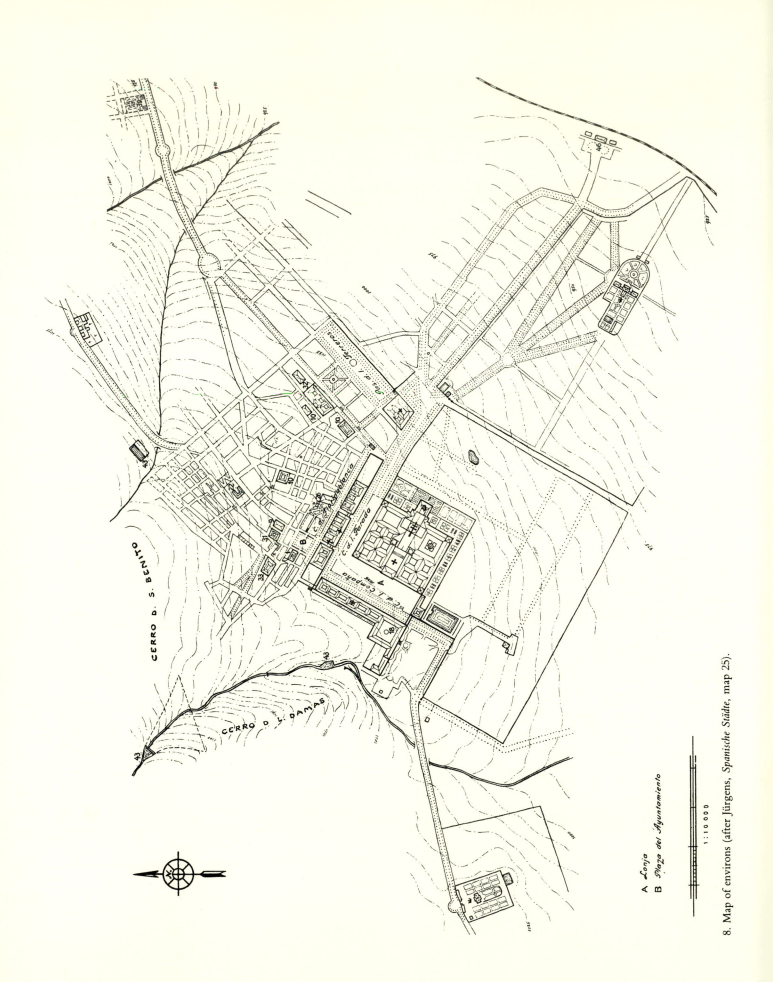

CERRO D. S. BENITO

CERRO D. L. DAMAS

A *Lonja*
B *Plaza del Ayuntamiento*

1 : 10 000

8. Map of environs (after Jürgens, *Spanische Städte*, map 25).

9. View from southeast (Meunier, ca. 1665, in EEC, 1:666).

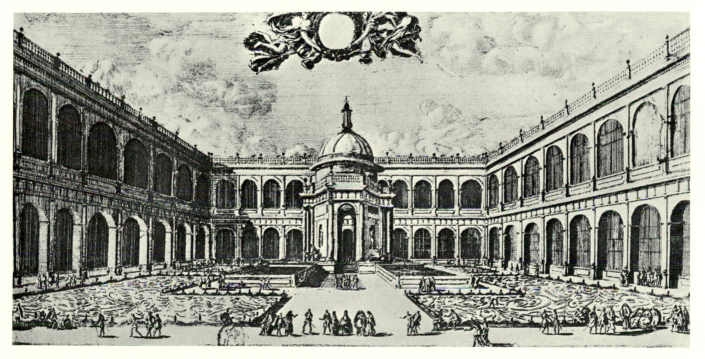

10. Main cloister, from west (Meunier, ca. 1665, in EEC, 1:670).

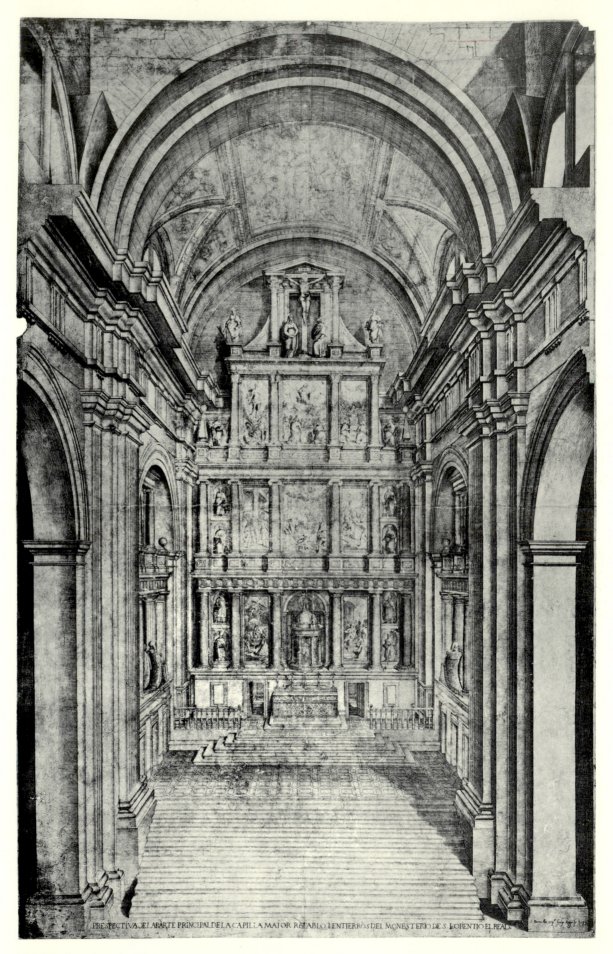

PRESPECTIVA DE LA PARTE PRINCIPAL DE LA CAPILLA MAIOR RETABLO I ENTIERROS DEL MONESTERIO DE S. LORENTIO EL REAL

11. Main altar, from choir balcony (HS, *perspectiva*).

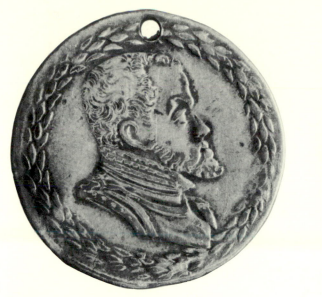
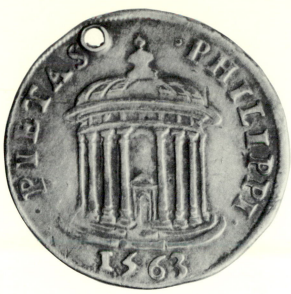

12

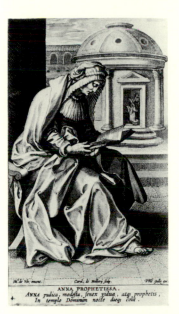

12. Jacome da Trezzo, commemorative medal (MAN).

13. Karel de Mallery, *Hannah* (courtesy Colin Campbell).

14. Jacome da Trezzo, medal commemorating Herrera, the basilica, and the birth of Philip III, 1578 (MAN).

13

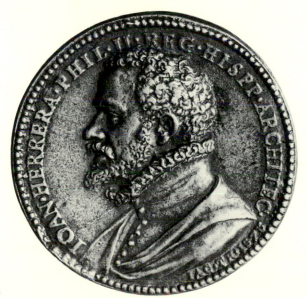
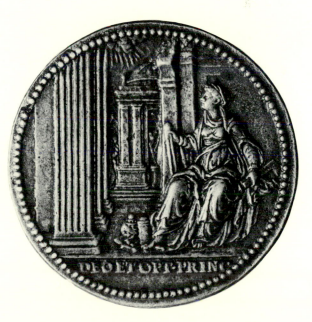

14

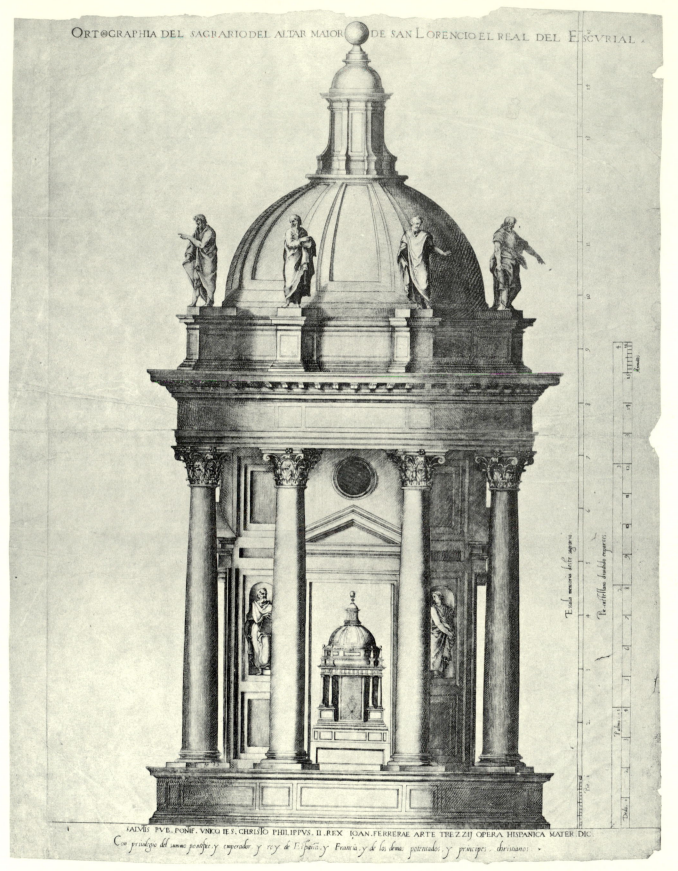

SALVIS PVB. PONIF. VNICO IE.S. CHRISTO PHILIPPVS. II. REX IOAN. FERRERAE ARTE TREZZIJ OPERA HISPANICA MATER. DIC.

Con priuilegio del summo pontifice, y emperador, y rey de España, y Francia, y de los demas potentados, y principes. christianos.

15. Tabernacle in main altar (HS, plan 9).

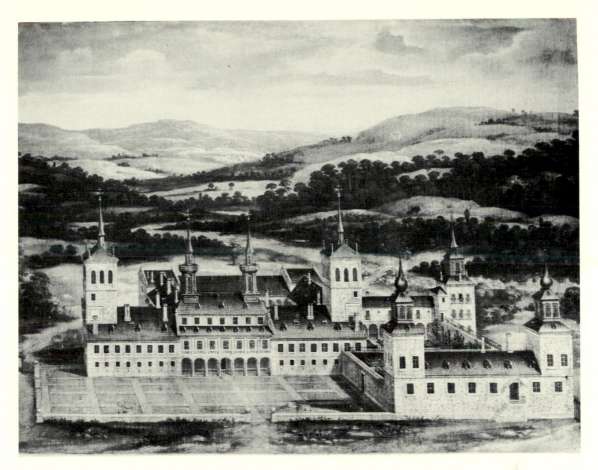

16. Valsain, oil painting (photo EK, 1979, by permission of IVDJ).

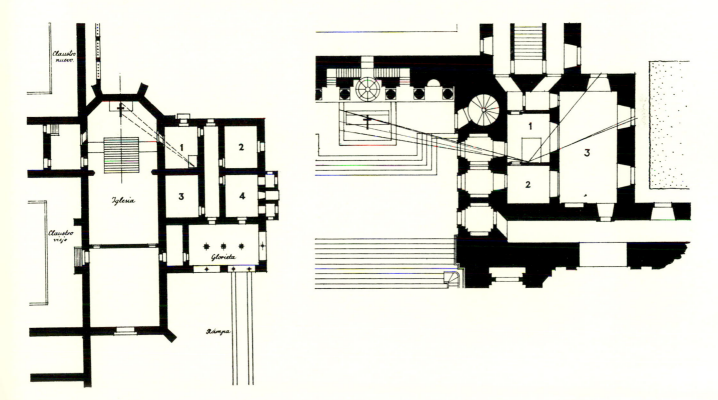

17. Yuste and Escorial, royal bedroom in relation to altar (after Zuazo, in EEC, 2:141).

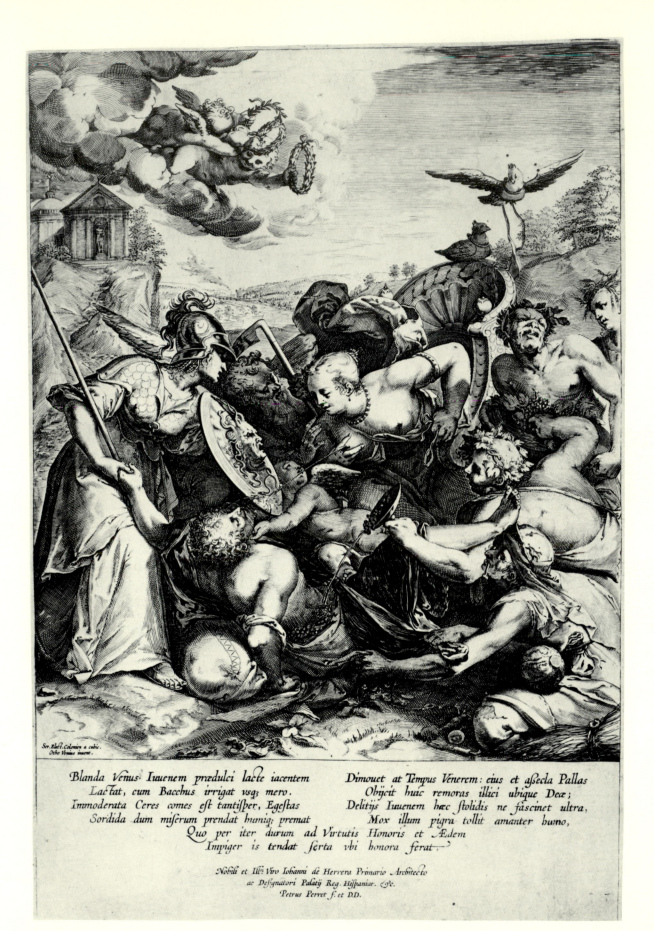

Ser. Elef. Colonien a cubic.
Otho Venus inuent.

Blanda Venus Iuuenem prædulci lacte iacentem
 Lactat, cum Bacchus irrigat usq; mero.
Immoderata Ceres comes est tantisper, Egestas
 Sordida dum miserum prendat huniq; premat
 Quo per iter durum ad Virtutis Honoris et Ædem
 Impiger is tendat serta vbi honora ferat.

Dimouet at Tempus Venerem: eius et assecla Pallas
 Obijcit huic remoras illici ubique Deæ;
Delitijs Iuuenem hæc stolidis ne fascinet ultra,
 Mox illum pigra tollit amanter humo,

Nobili et Illr̄i Viro Iohanni de Herrera Primario Architecto
 ac Designatori Palatij Reg. Hispaniar. &c.
 Petrus Perret f. et D.D.

18. Pedro Perret, *Allegory* (after Cervera, in EEC, 2:94).

19. Drawings of spires (lower left) and details of main cloister (LS, pl. 19).

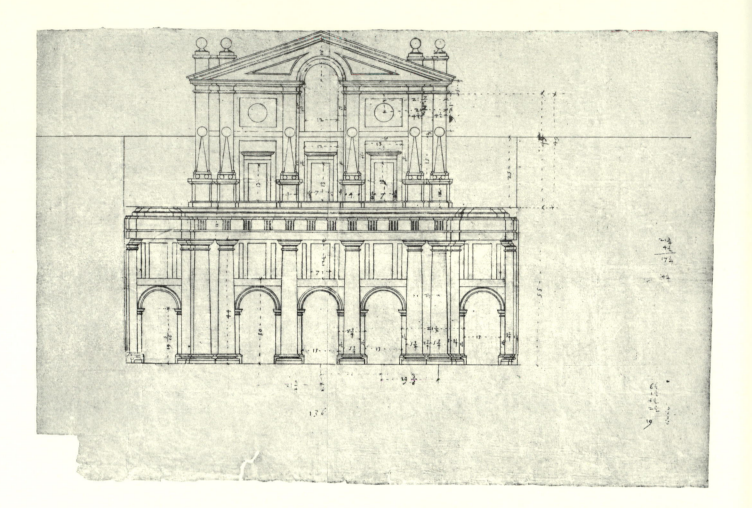

20. (*above*) Entrance façade of basilica (LS, pl. 1).

21. (*right*) Entrance façade of basilica with statues

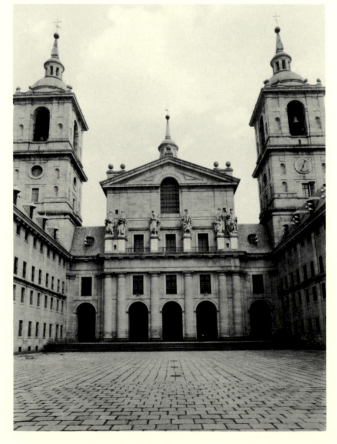

ORIENTALIS FACIES SVBSTRVCTIONIS AB IMIS VALLIBVS CVBITOS TRECENTOS ERECTAE AD SVSTINENDOS SERIES CVIBVS ATRIORVM TEMPLI AREAM SALOMON LAXANDAM CVRAVIT NECNON PERIBOLI ATQVE PORTICVVMQVE AD HIERAON QVAQVE AD GENTILES PERTINEBANT
SVB MINIMA CVBITORVM MENSVRA VA ETIAM VNIVERSALIA VESTIGIA DIMETIVNTVR

22. Temple of Solomon (after Prado and Villalpando, *Ezechieleni*, 2: pl.12, courtesy Columbia University Libraries).

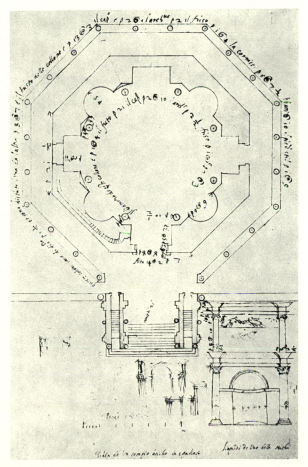

23. Drawings of Spalato (after Zorzi, *Disegni*, figs. 266, 267).

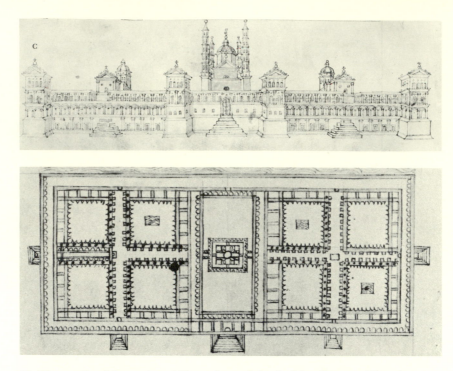

24. Filarete, *Ospedale maggiore*, Milan, plan and façade (after Spencer, *Filarete's Treatise*, 2:ff. 82ᵛ, 84ᵛ).

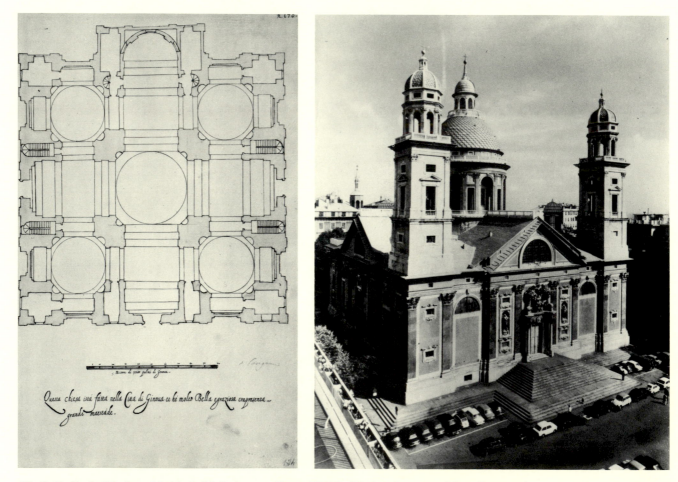

25. G. V. Casale (A) plan of S. Maria del Carignano, Genoa (BNM); (B) view from west (photo Sagep spa).

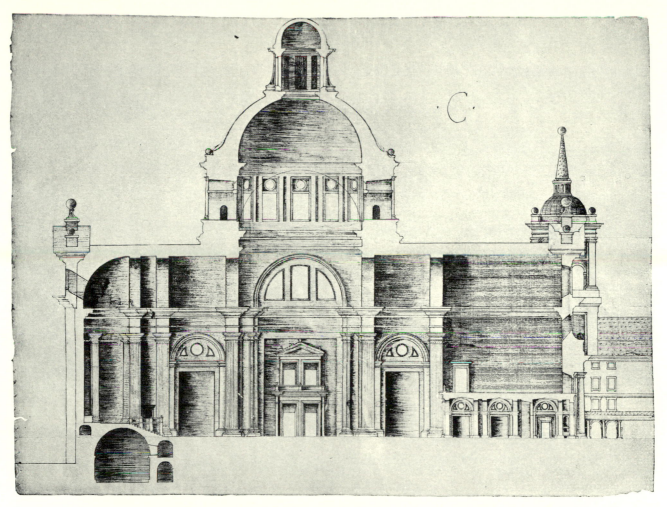

26. Section of basilica, preliminary design (LS, pl. 2).

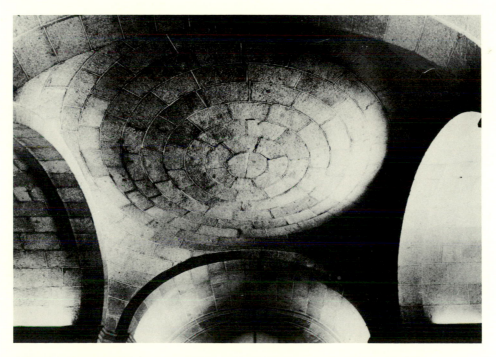

27. Flat vault in forechurch (photo EK).

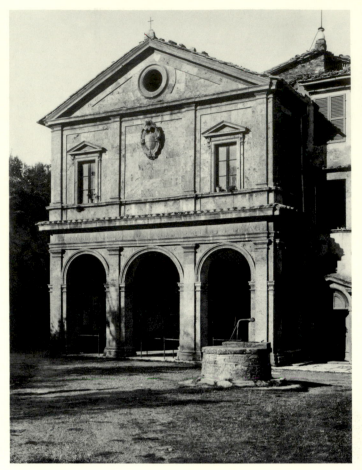

28

29

28. S. Sebastiano, Mantua (after Mancini, *Vita di Alberti*, p. 396).

29. S. Maria, Montepulciano (photo Alinari).

30. Escorial, reconstructions of early design (A) Zuazo, in EEC, 2:110; (B) L. Perez Bes, 1970 (after copy in AME).

30 A

B

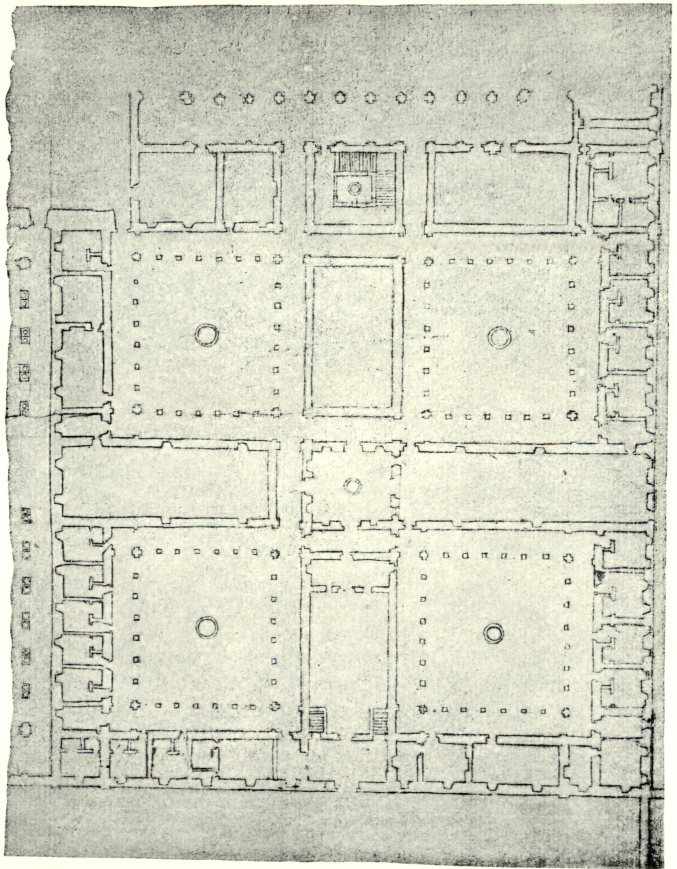

31. Monastery cloisters, plan before 1567 (LS, pl. 21).

32. Elevation (rejected) adding fourth story to monastery cloisters (LS, pl. 20).

33. Sketch plan of the state of construction in 1568 (based on Rubio, in CD 161 [1949]: opp. p. 182).

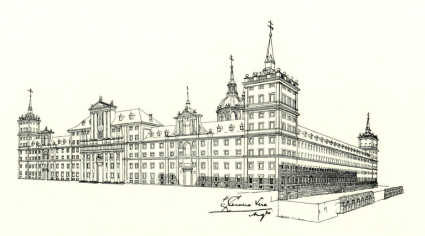

34. Perspective view of construction in 1568 (Rubio, in CD 161 [1949]: opp. p. 182).

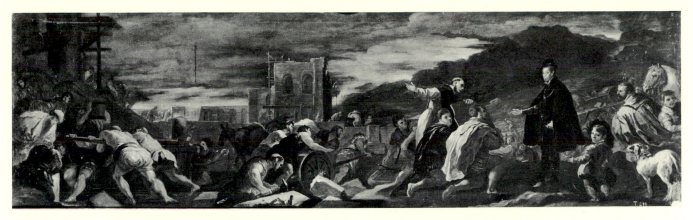

35. Luca Giordano, mural in main stairway (before 1702), at right the King, Toledo, Herrera, and Villacastín (photo Mas).

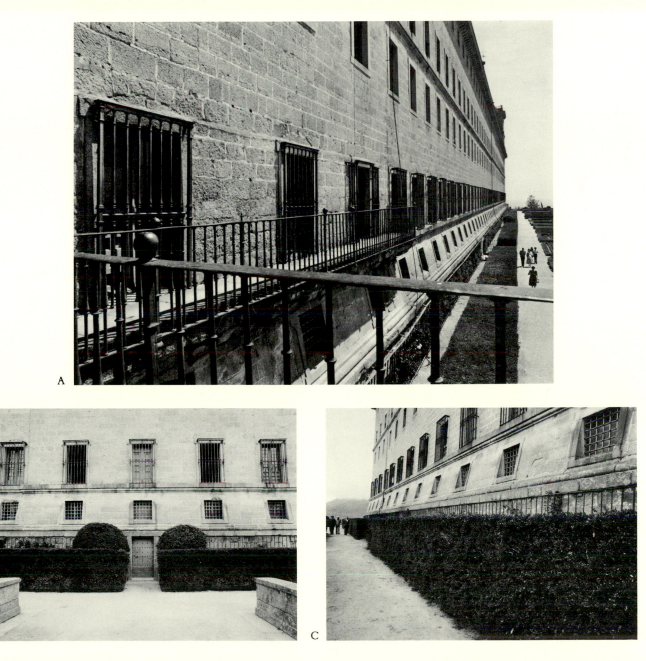

A

B

C

36. Views of basement talus (A) southwest tower; (B) adjoining central "tower"; (C) southeast corner at prior's tower (photos author, 1952).

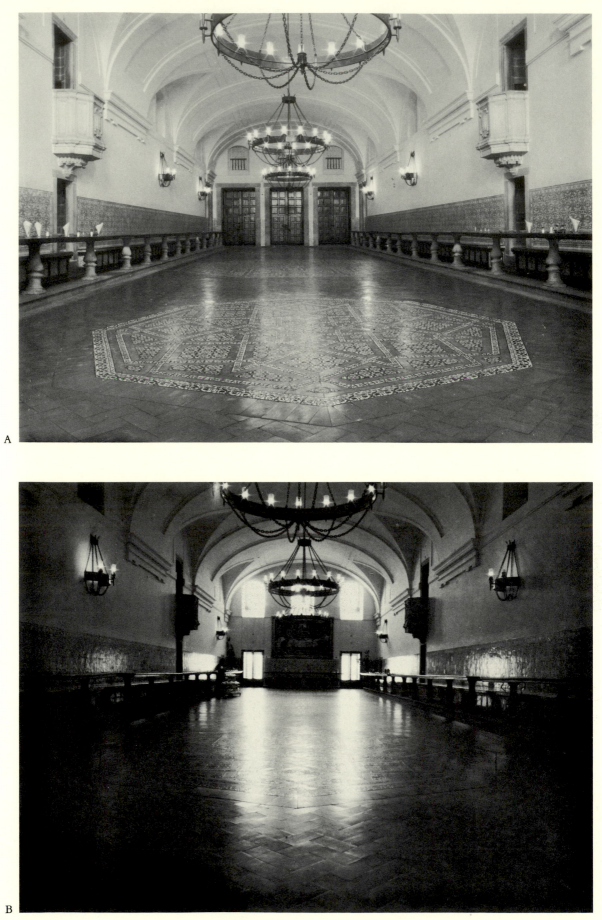

37. Refectory (A) to north (photo EK); (B) to south (photo EK).

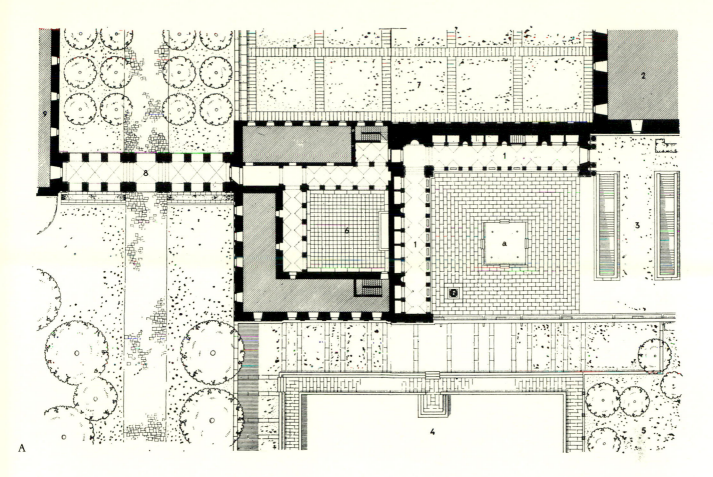

A

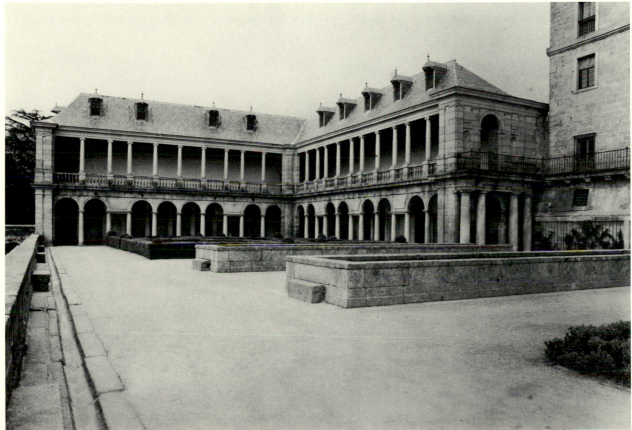

B

38. (A) Plan (after Zuazo, in EEC, 2:147); and (B) view of "sun-corridors" (photo EK).

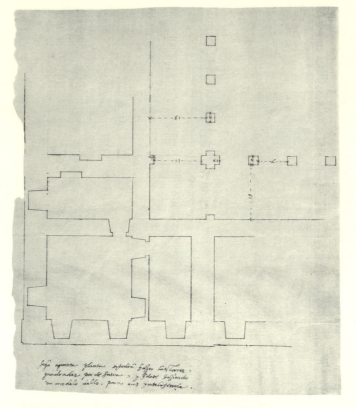

39. Plan at ground level of southwest tower and cloister supports with comments in handwriting of Juan Bautista de Toledo (LS, pl. 18).

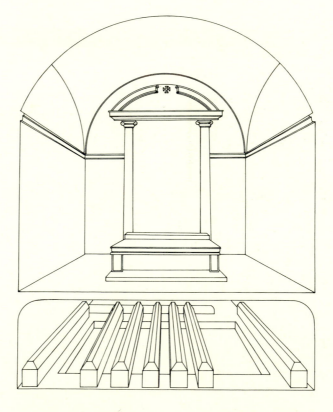

40. Provisional church (A) showing crypt beneath altar (AME); (B) looking north (photo author, 1964); (C) to south (photo EK).

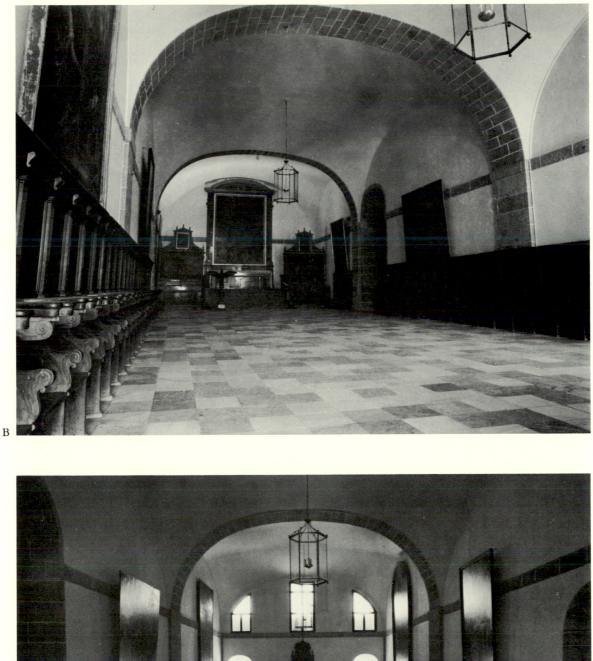

B

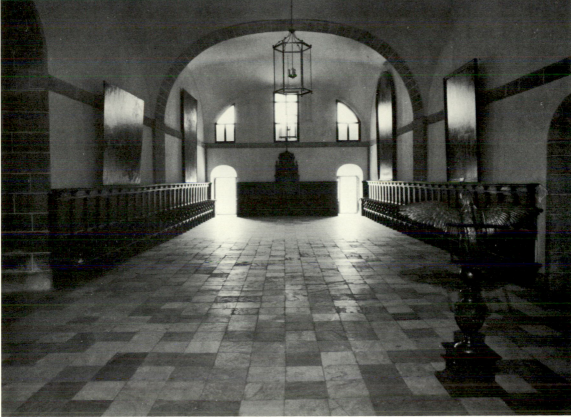

C

41. View of the King's dwelling at La Fresneda (A) façade; (B) monastery cloister; (C) monastery façade (photos EK).

42. Elevation of ground floor, main cloister, northeast corner (LS, pl. 22).

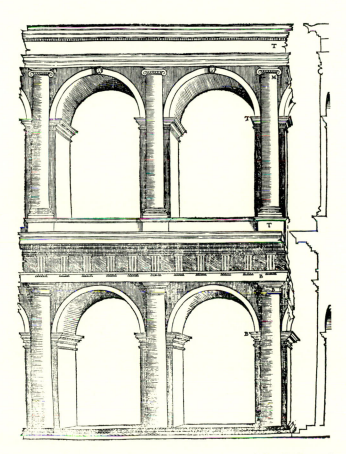

43. Serlio, façade, theater of Marcellus, Rome (after Serlio, *Libro Tercero*, 1552, fol. 27).

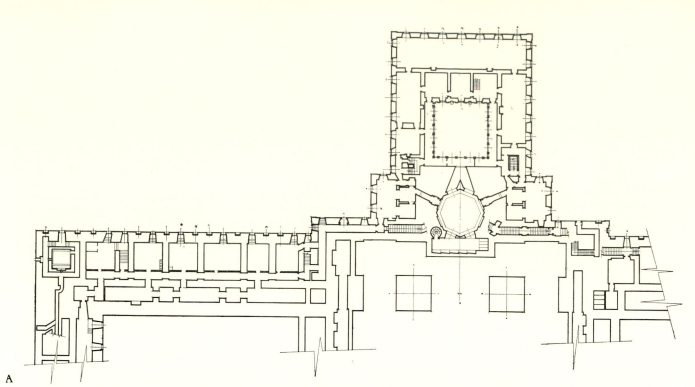

A

44. Plan of crypt (A) after Andrada, in EEC, 2:339; (B) after LS, pl. 24; (C) after LS, pl. 23.

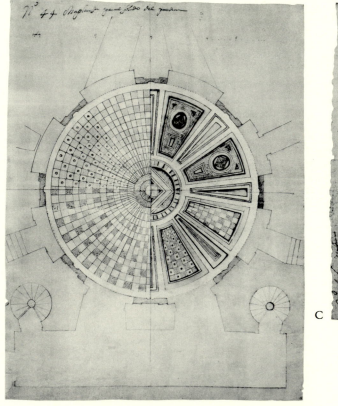

B

C

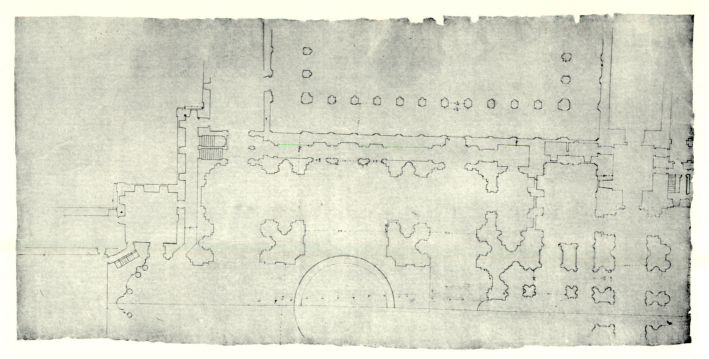

45. Plan of basilica, with discarded sanctuary, before 1575 (LS, pl. 5).

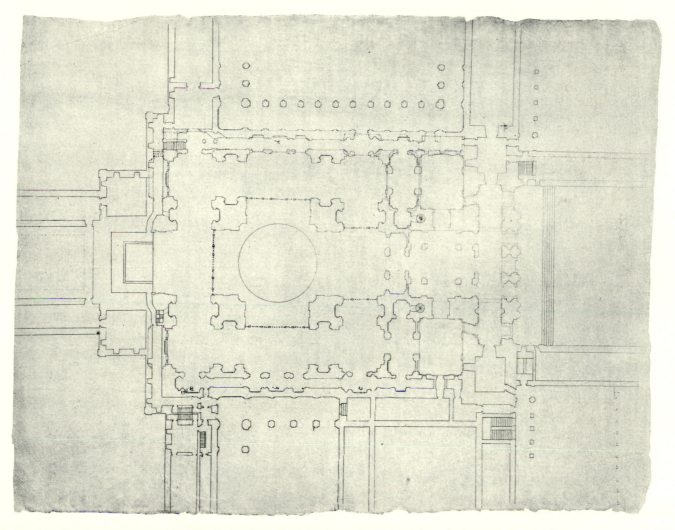

46. Plan of basilica at sanctuary foundation level, changed after 1575 in palace court and spiral stairs to choir (LS, pl. 7).

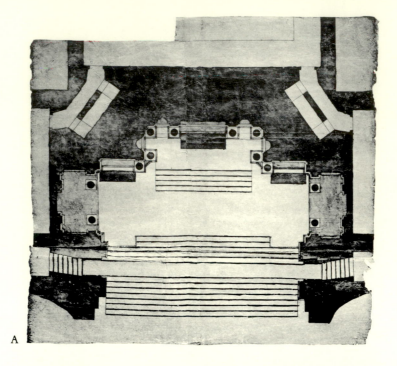

A

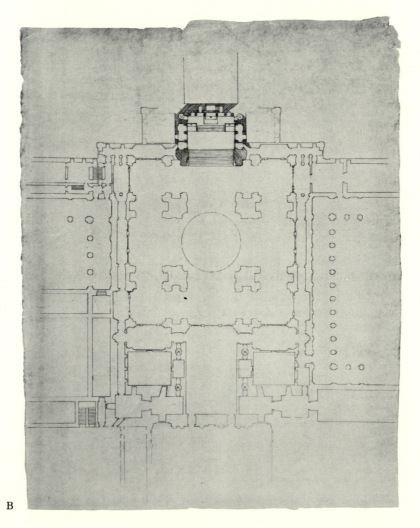

B

47. (A) Rejected plan for sanctuary at level of royal tombs flanking main altar
(LS, pl. 6); (B) nearly final plan of basilica, with quadrate sanctuary, *camarín*,
lateral tombs. Palace court and spiral stairs to choir altered in final design 1576
(LS, pl. 8).

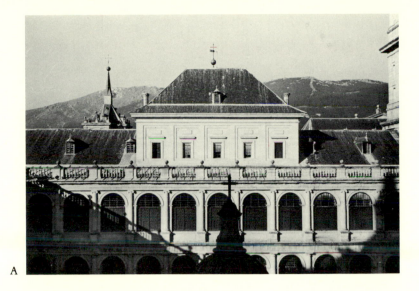

A

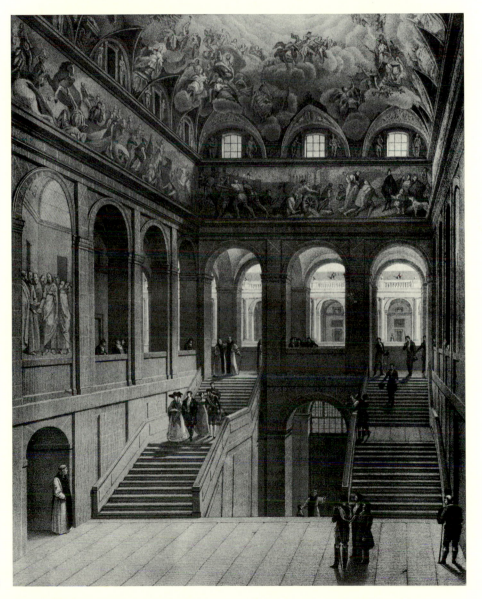

B

48. Main cloister, "imperial" stairway (A) stair tower, from east (photo author, 1964); (B) view looking east (after Brambilla, *Colección*, 1832, p. 7).

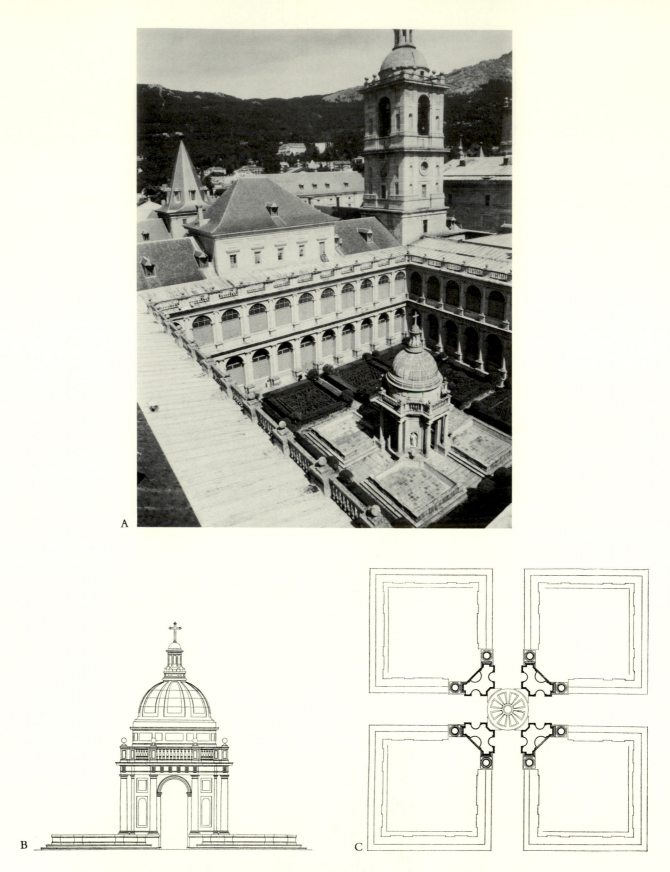

49. (A) Main cloister, fountain of the Evangelists (photo EK); (B) elevation of fountain edicule; and (C) plan of basins (after Ruiz de Arcaute, *Juan de Herrera*, pp. 121, 122).

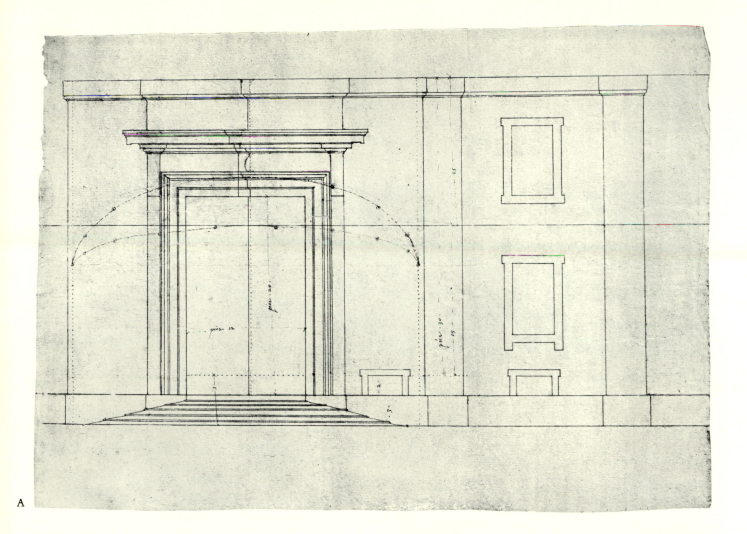

A

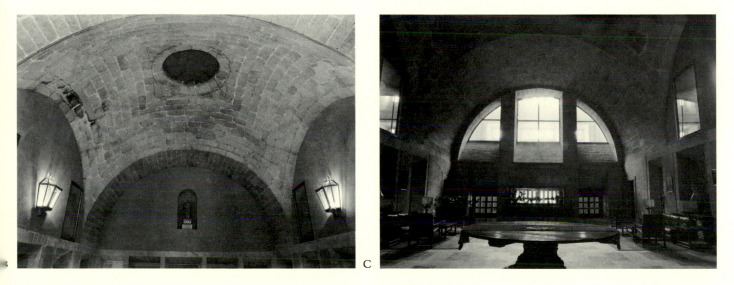

C

50. (A) Elevation of kitchen portico, west front, built after 1568 (LS, pl. 25); (B) kitchen vault (photo EK); (C) kitchen to west (photo EK).

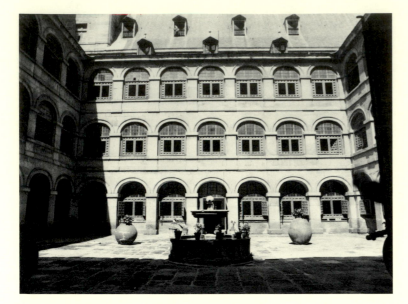

51. Monastery cloister, southwest court (photo EK).

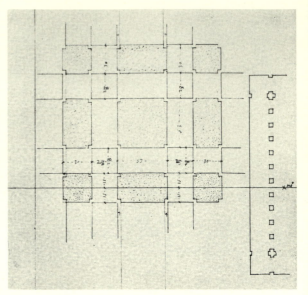

52. Plan of foundations under dome supports to basilica, begun 1573 (LS, pl. 9.1).

53. Variant designs for dome supports: the smallest corresponds to pillars as built (LS, pl. 10).

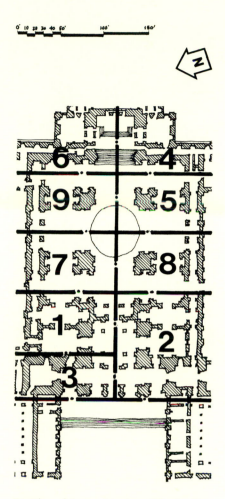

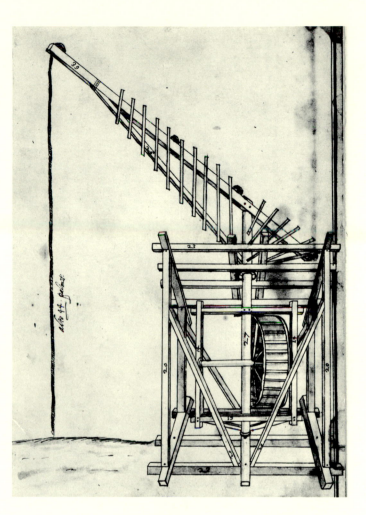

54. Plan of the partitioning of the basilica in contracts.

55. G. V. Casale, drawing on site of crane used at Escorial (BNM).

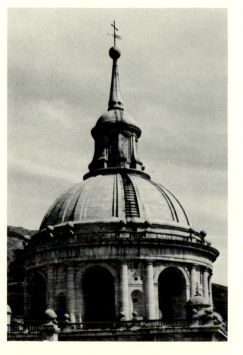

56. Dome of basilica (photo EK).

57. Preliminary plan (rejected) of forechurch beneath choir balcony (LS, pl. 9.2).

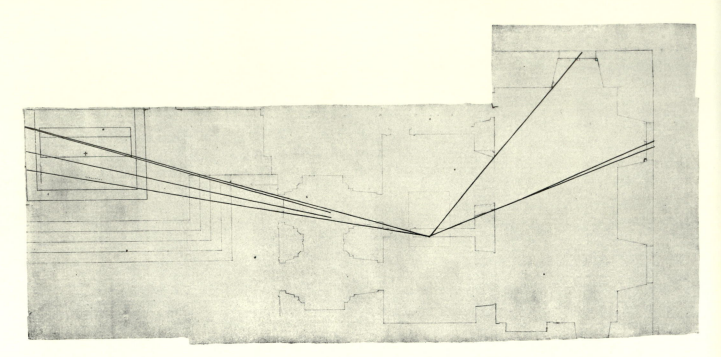

58. Plan of sanctuary and King's apartment marked with sightlines from bed to windows and altar (LS, pl. 14).

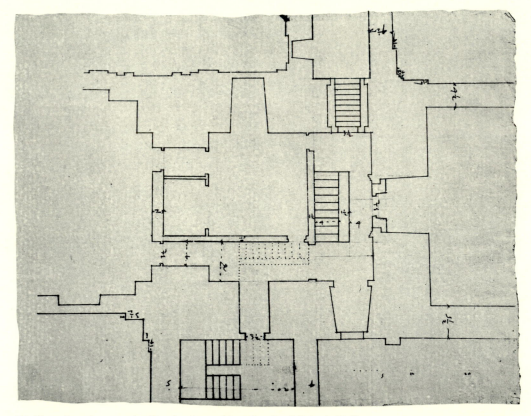

59. Plan of south tower, basilica façade, at thirty-foot level (LS, pl. 15.2).

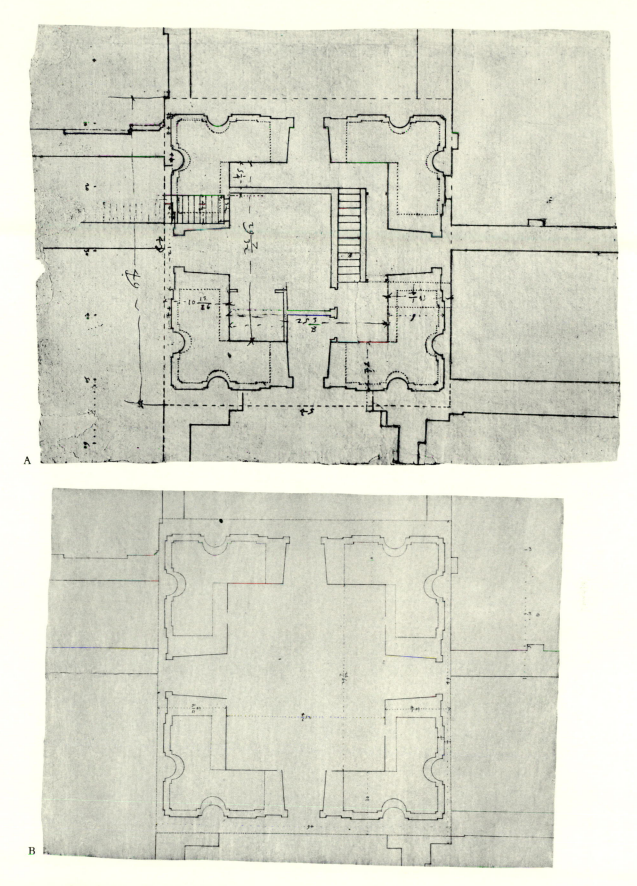

60. Plans of south tower showing lower and upper shaft above monastery roof (A) working draft with corrections; (B) finished tracing (LS, pl. 16).

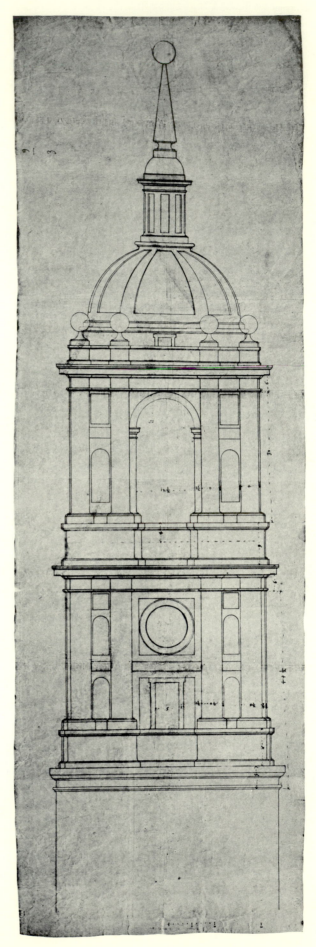

61. Tower face, suitable for any of the eight identical faces of both towers (LS, pl. 17).

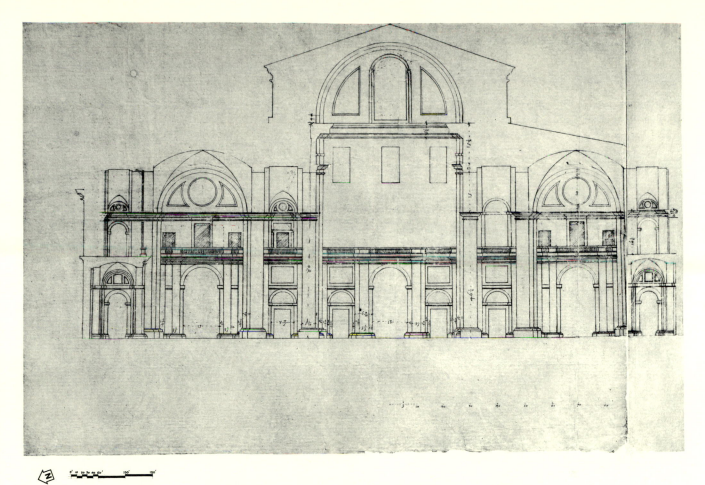

62. Working interior elevation looking west at north-south cross section (LS, pl. 3).

63. Working elevation in basilica, looking south, from tower at right to entrance to sacristy at left (LS, pl. 4).

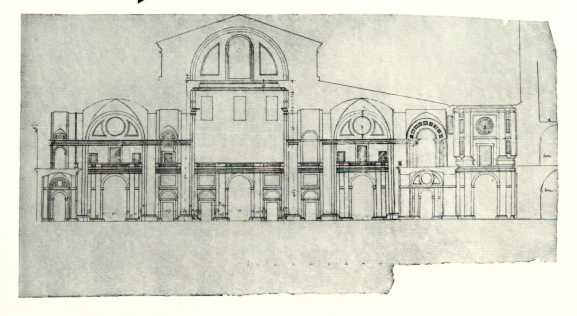

B

C

A

64. Airshafts flanking forechurch, behind basilica towers (A) north airshaft (photo author, 1964); (B) detail of fig. 63 showing south face of south airshaft as designed before changes (LS, pl. 4, detail); (C) south airshaft as built (photo author, 1964).

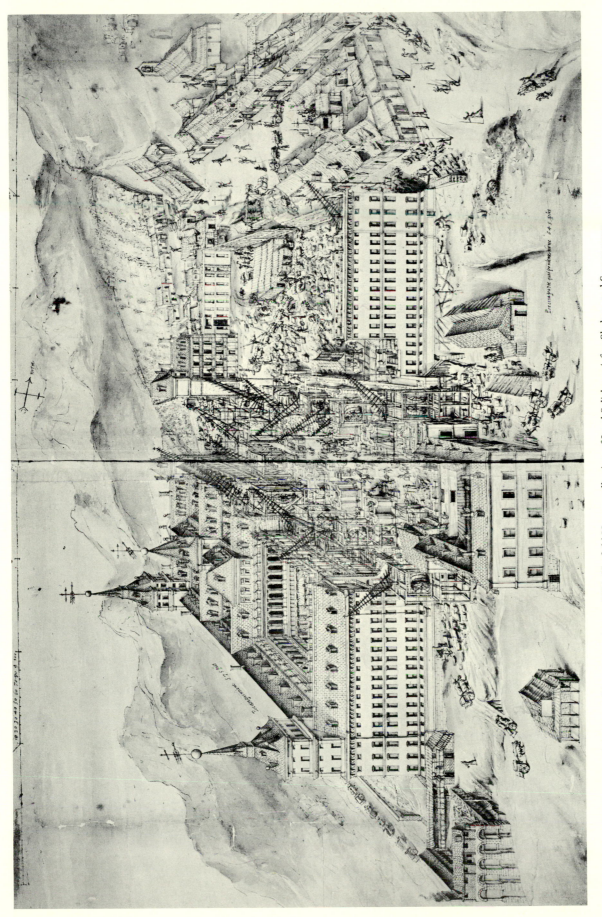

65. Fabricio Castello? Drawing of the Escorial in construction, c. 1576. Hatfield House, collection of Lord Salisbury (after Skelton and Summerson, *Description of Maps*, permission of Lord Salisbury).

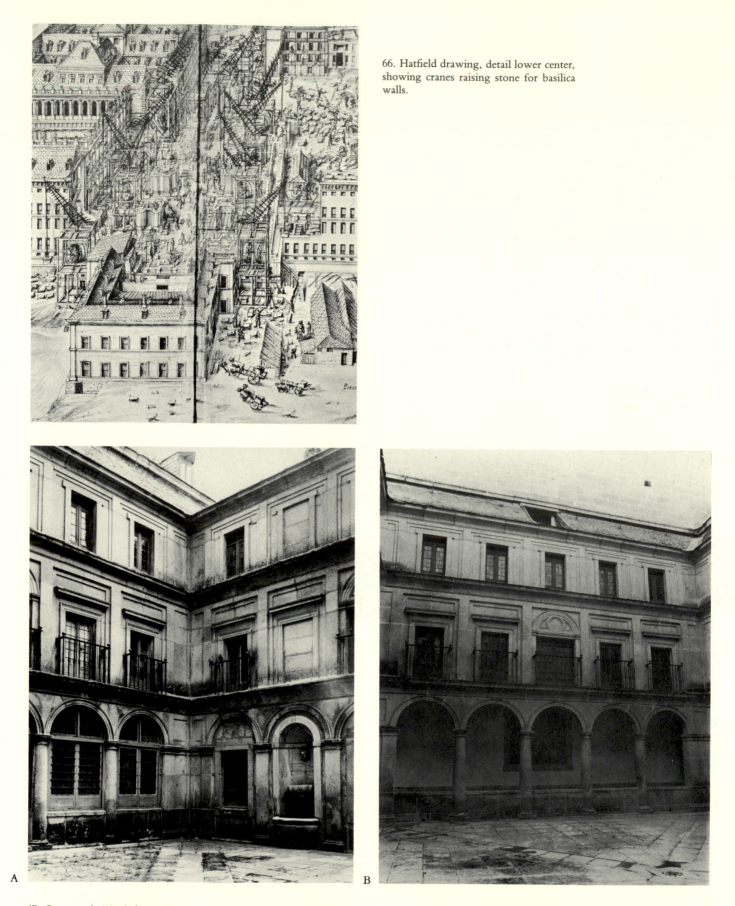

66. Hatfield drawing, detail lower center, showing cranes raising stone for basilica walls.

A

B

67. Courtyard, King's house (A) east range corner before removal of ground-floor windows (photo Eloy, 1963); (B) west range (photo EK); (C) west range fenestration (photo EK); (D) upper sanctuary wall (photo EK); (E) east range (photo EK).

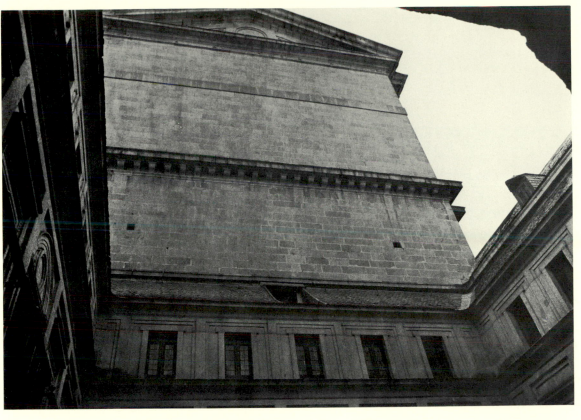

D

C

E

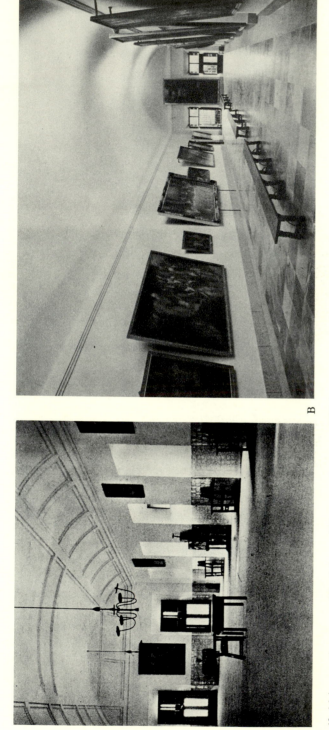

68. Main reception rooms, King's house (A) upper winter room; (B) lower summer room (after Zuazo, in EEC, 2:348).

69. King's apartment: dining room and bedroom (PAN).

A

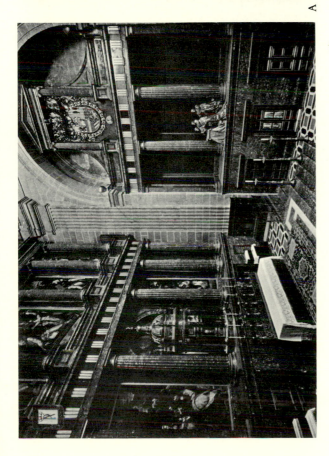

70. Sanctuary, altar, and tomb of Philip II above doorways to King's bedroom, left and center (PAN).

71. Window illuminating north reliquary chapel (A) exterior position (PAN); (B) detail, south side, exterior (photo author, 1964); (C) interior position relative to chapel of relics (photo author, 1964).

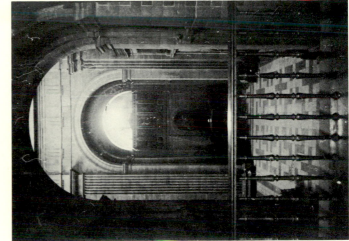

C

B

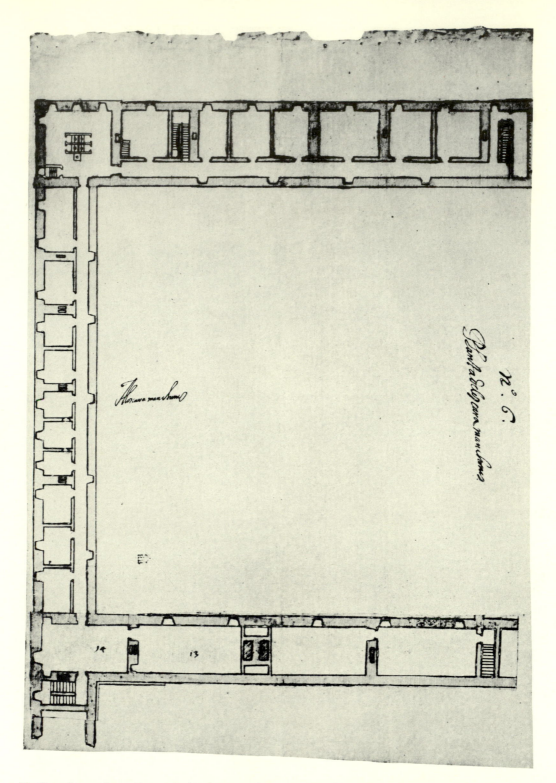

72. Plan of upper floor palace attic chambers on palace court (LS, pl. 31).

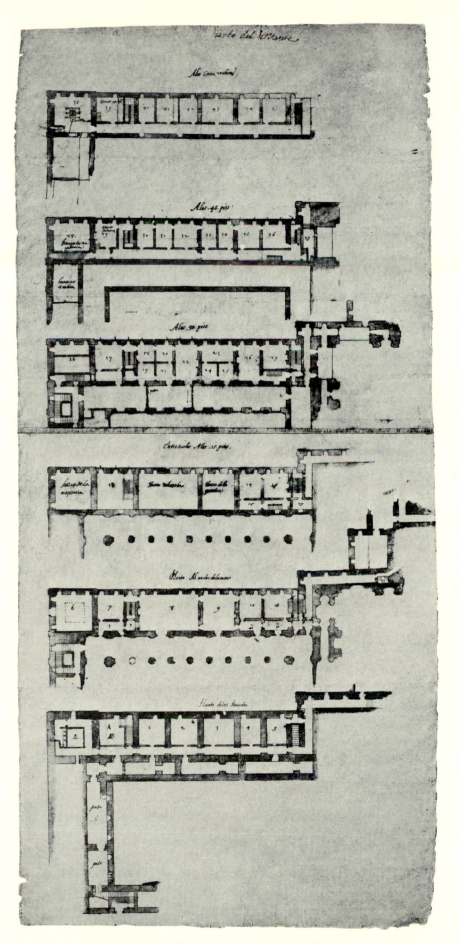

73. Plans of six levels in east building of palace court (LS, pl. 30).

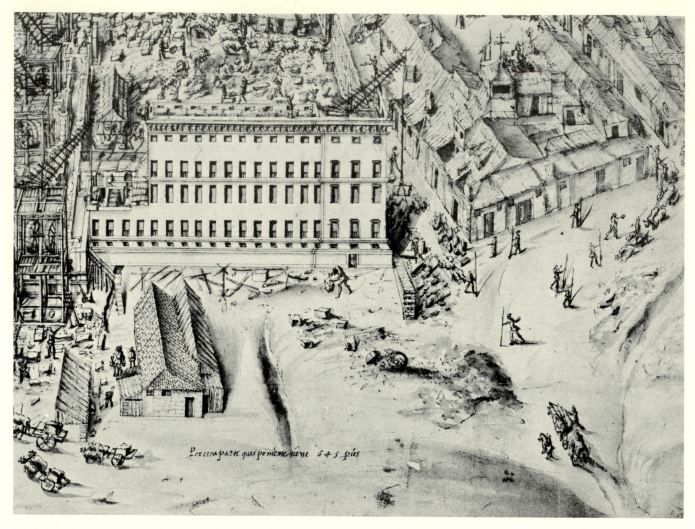

74. Hatfield drawing, lower right, east building of palace during construction, 1576.

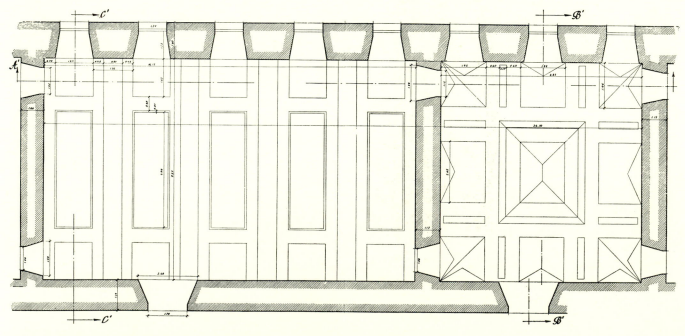

75. Plan of hall and reception room in east building of palace (after Andrada, in EEC, 2:345).

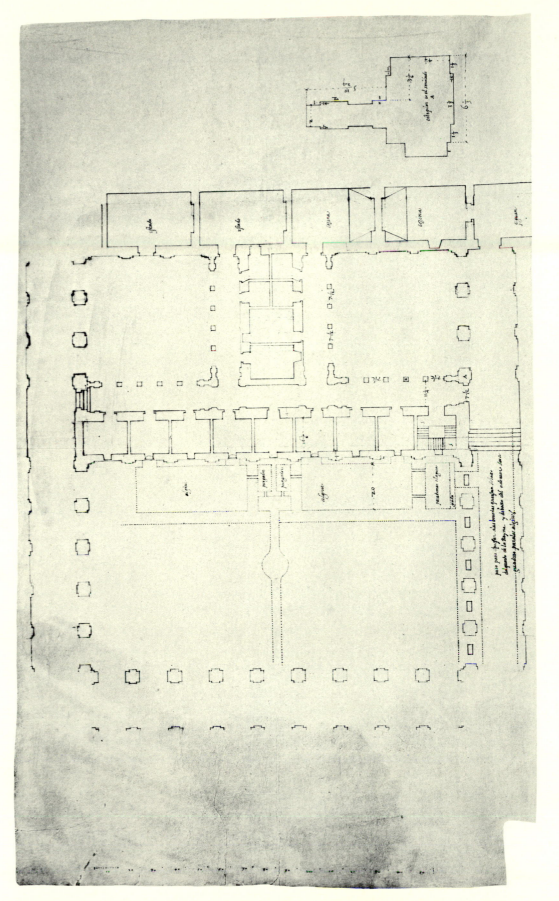

76. Plan of service buildings at ground level in palace court, working drawings (LS, pl. 26).

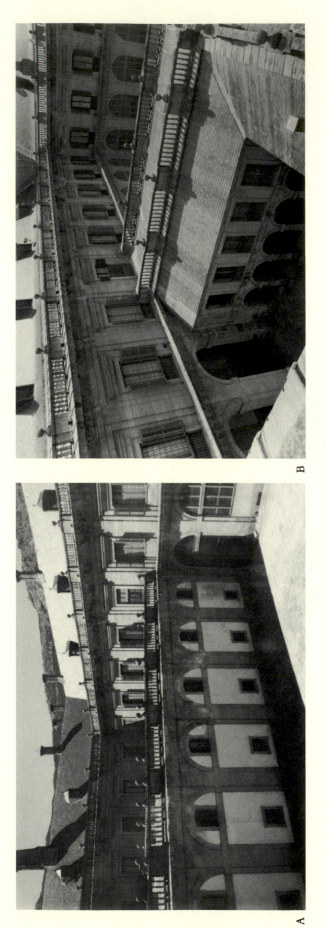

B

A

77. Views of service buildings from palace (A) looking southwest (photo author, 1978); (B) looking northeast (photo EK).

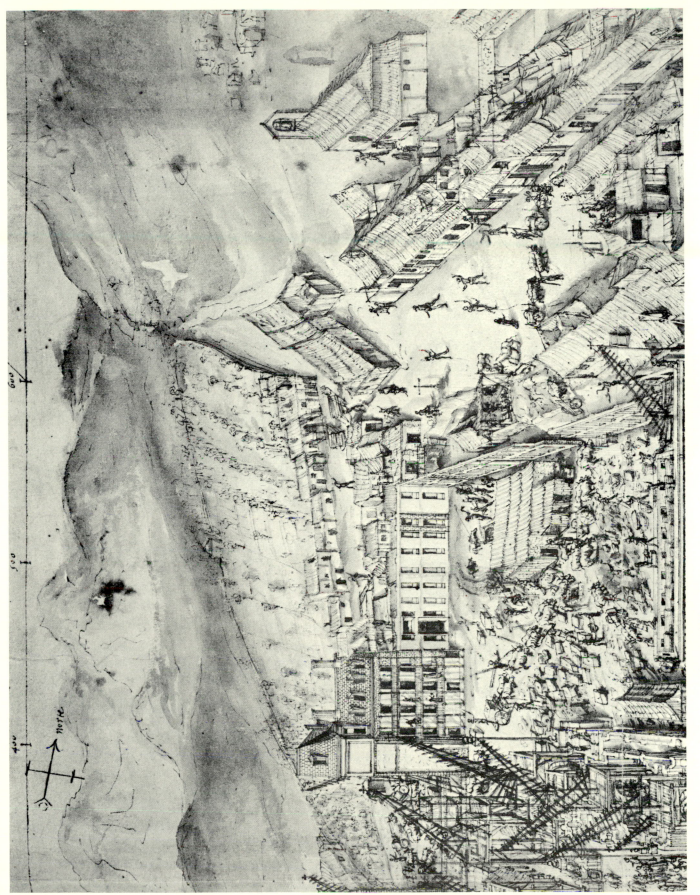

78. Hatfield drawing, upper right, college quadrant in 1576.

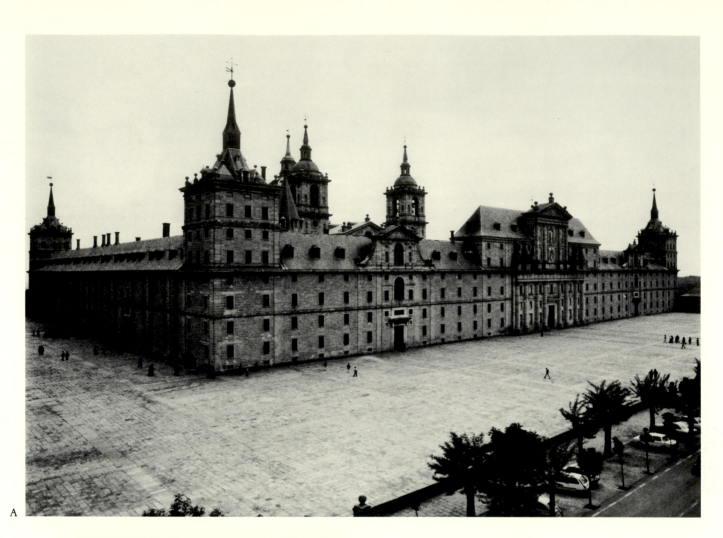

A

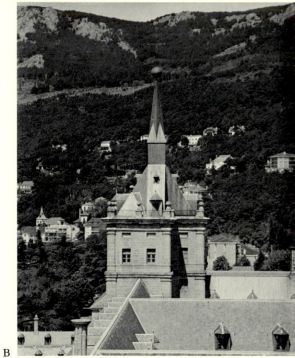

B

79. North façade and college tower (A) north and west façades; (B) northwest tower from south (photos EK).

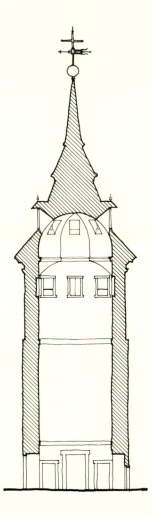

80. Plans and section of college crossing tower (drawing EK).

81. View of college assembly room (after Zuazo, in EEC, 2:119).

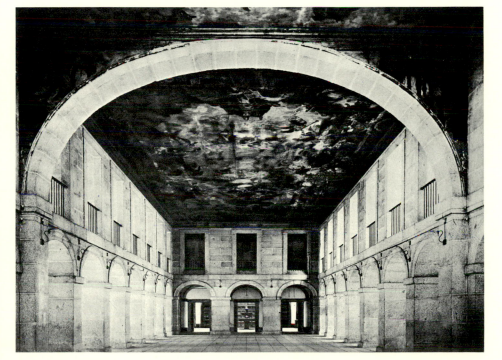

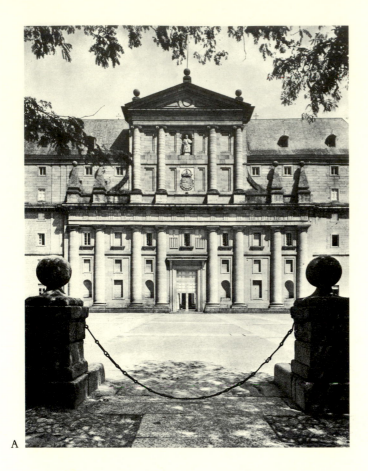

A

82. Main entrance façade (A) from
west (after Cervera, in EEC, 2:54);
(B) from forecourt (photo EK).

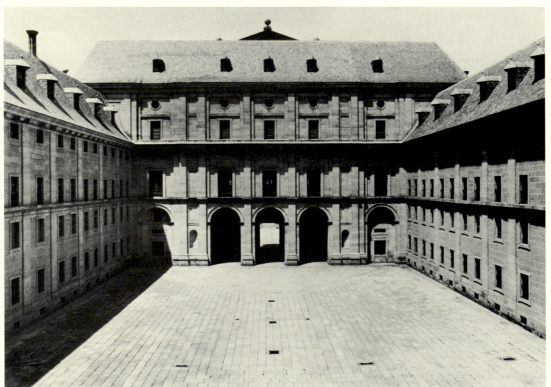

B

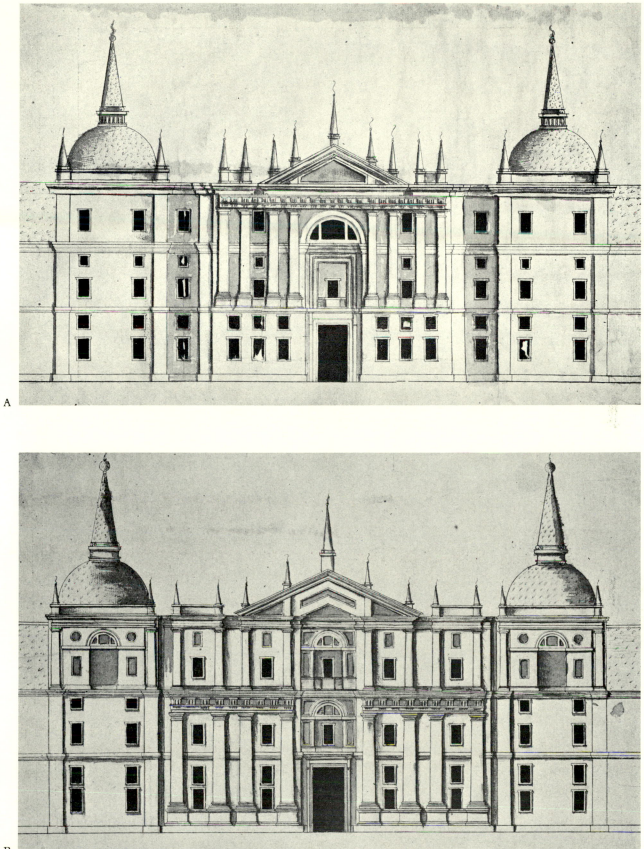

83. Projects attributed to Juan Bautista de Toledo for main entrance (A) "Palladian"; (B) "Alessian" (after Ruiz de Arcaute, *Juan de Herrera*, opp. pp. 17, 32).

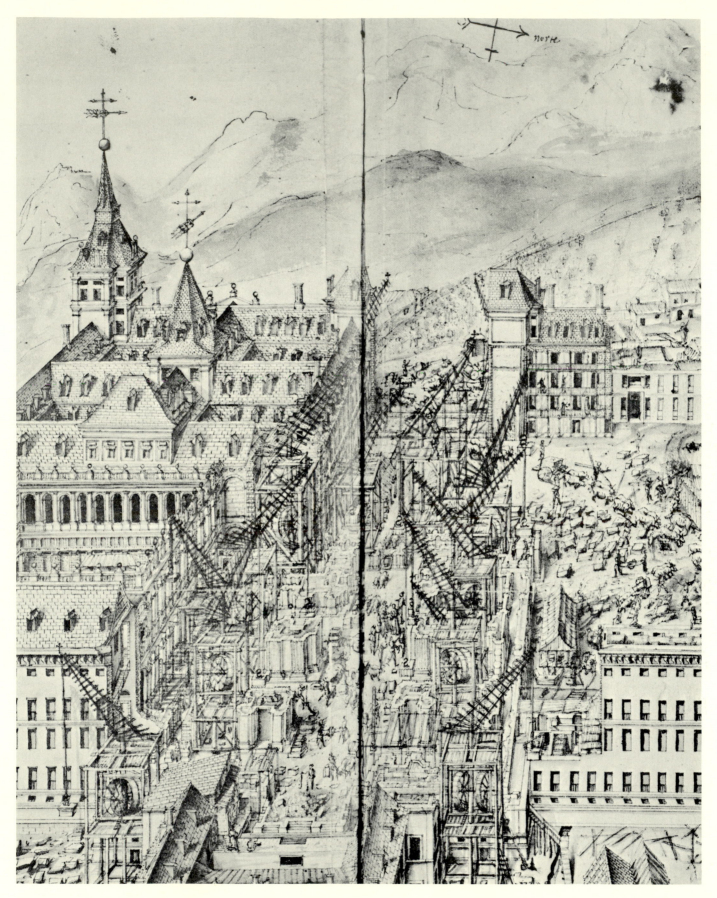

84. Hatfield drawing, top center, showing entrance area and forecourt.

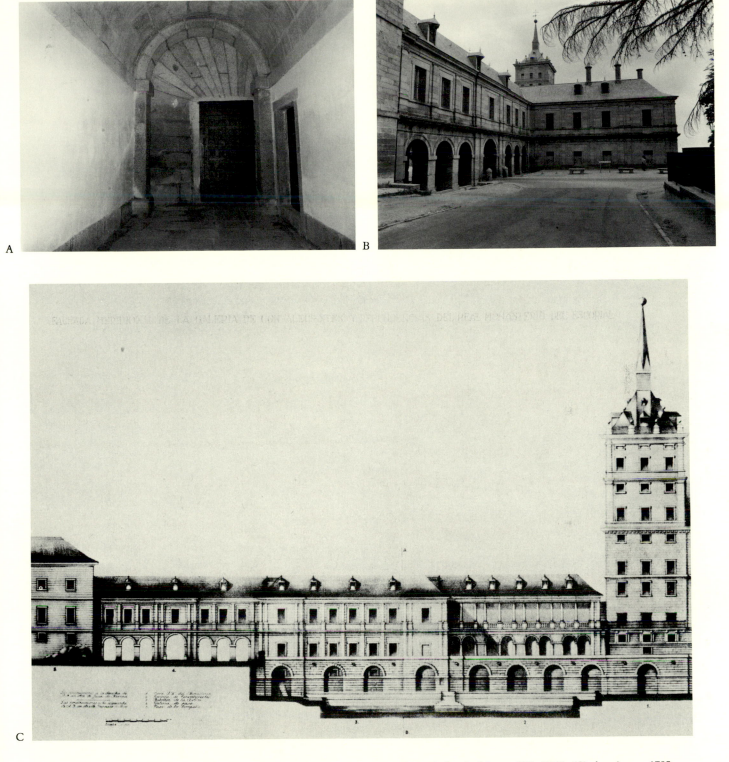

85. Passage between infirmary and Compaña (A) "warped" door to street; (B) south façade (photos EK, 1979); (C) drawing c. 1785, south elevation (after Caturla, *Pinturas*, opp. p. 20).

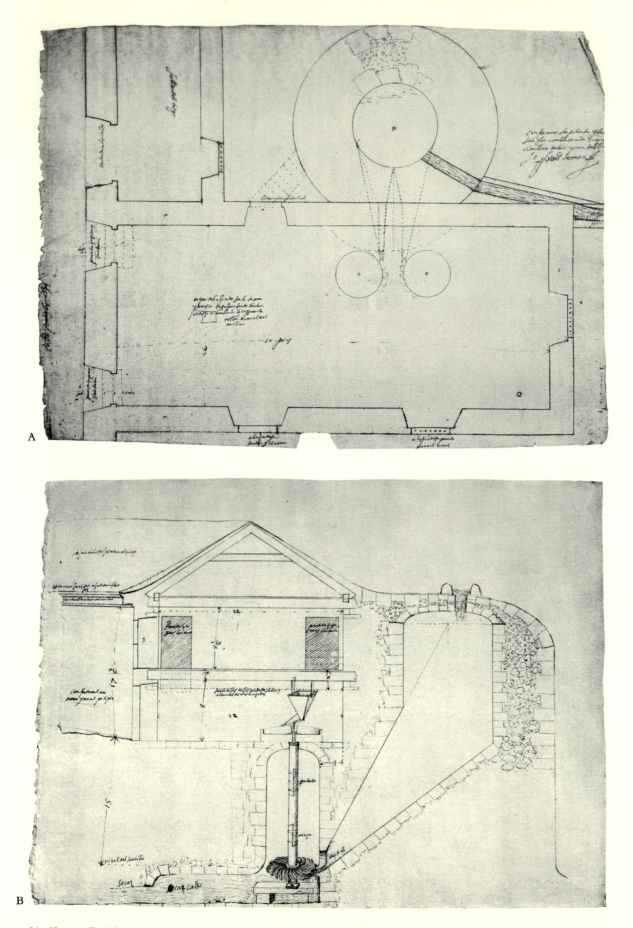

86. Flour mill with water-driven turbine in Compaña outbuildings (A) plan; (B) section (LS, pls. 38, 37).

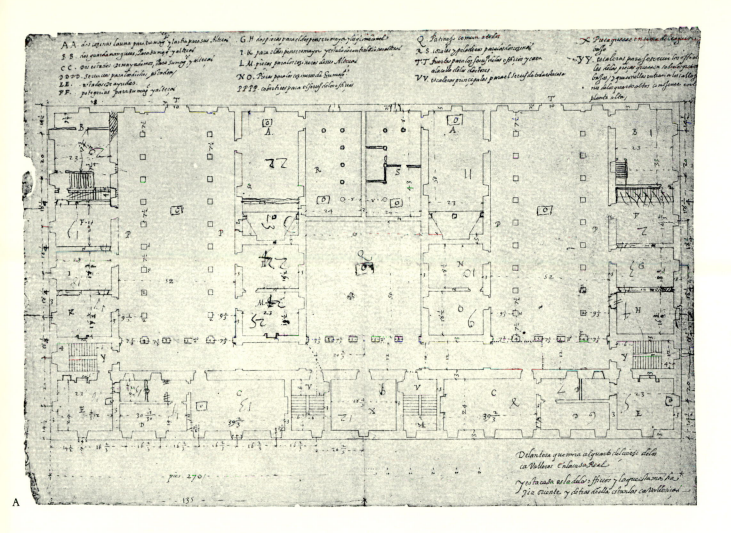

A

B

87. Plans of upper floor, "second" *casa de oficios* (A) indexed as to use; (B) plan of chapel at northwest corner as built (LS, pls. 46, 45); (C) view of both *casa de oficios* from southwest (photo author, 1978); (D) court of present post office (photo EK).

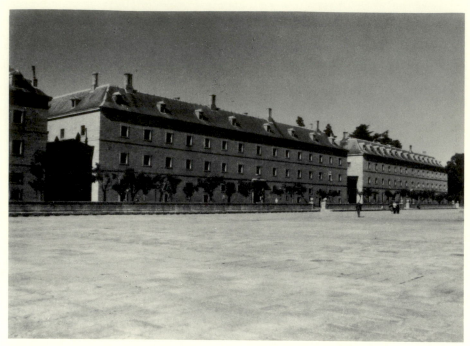

87 C

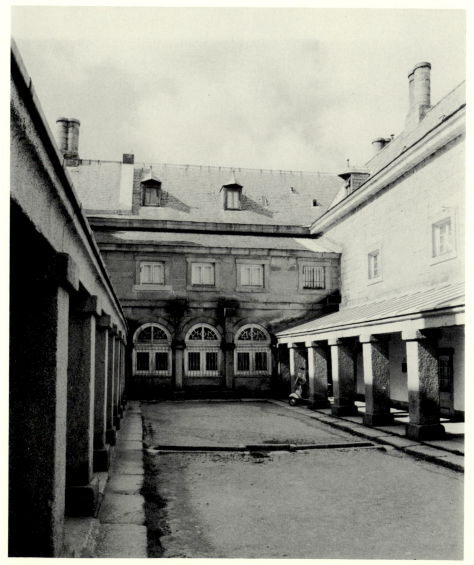

87 D

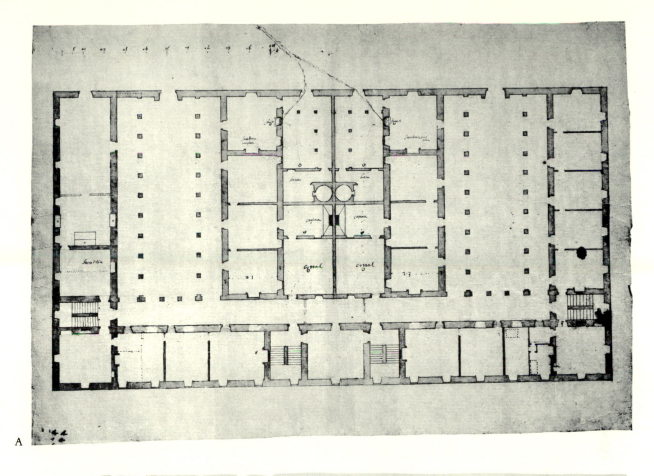

A

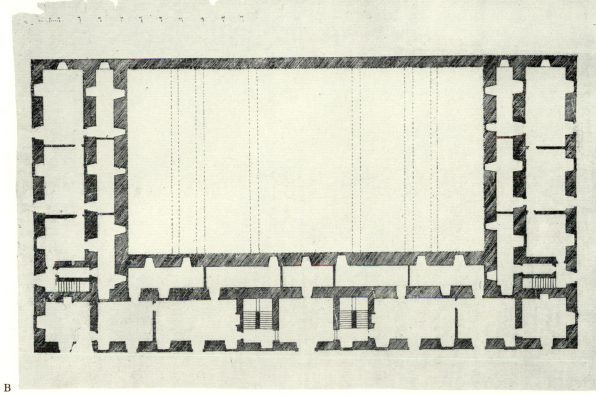

B

88. Plans, elevations, and sections of "second" *casa de oficios* (A) final working plan, including chapel (LS, pl. 47); (B) plan at lower level (LS, pl. 48); (C) east elevation and section of north building in palace (LS, pl. 40); (D) north elevation, upper street (LS, pl. 39); (E) section through court and south rooms (LS, p. 41).

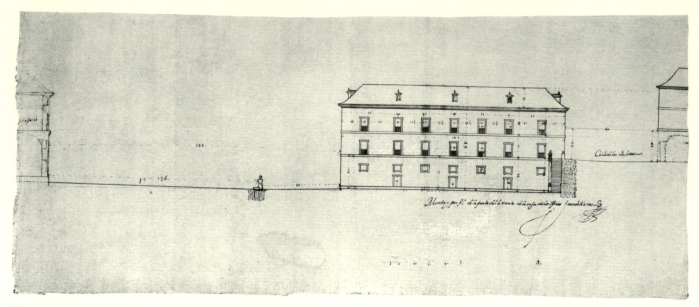

88 C

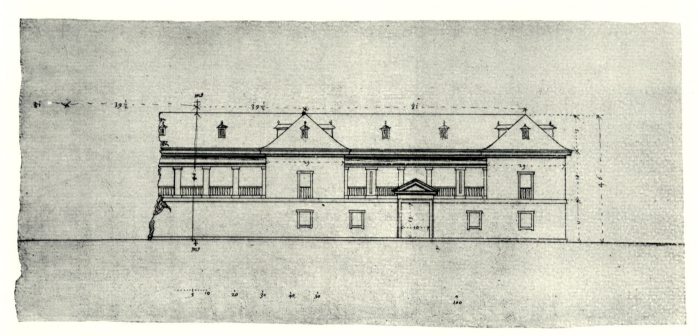

88 D

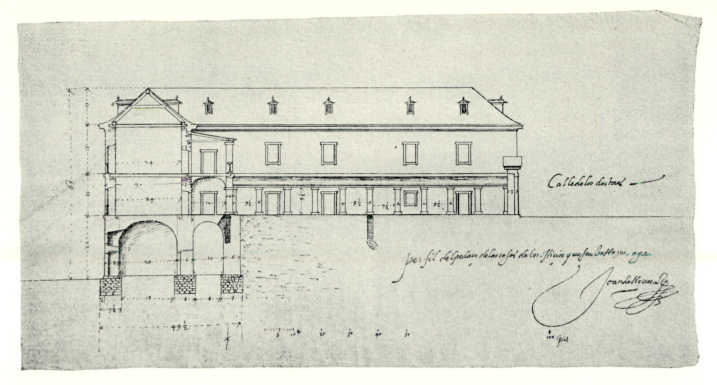

Calle de los doctores

perfil del pedaço de las casas de los officios y que son botterias, agua

Joan de Herrera

88 E

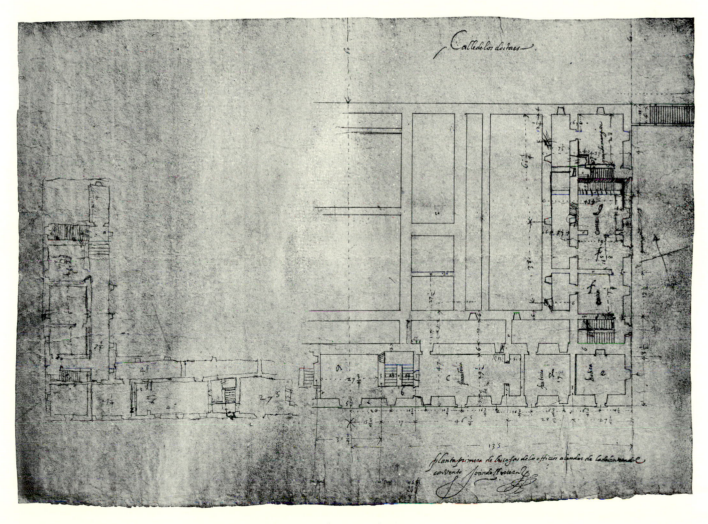

Calle de los doctores

Planta primera de las casas de los officios a la parte de la enfermeria del convento Joan de Herrera

89. Working sketch and plan for ground floor, "second" *casa de oficios* (LS, pl. 42).

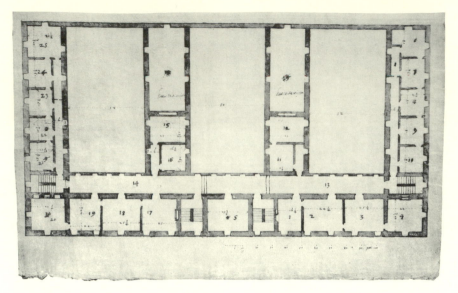

90. Final plan, upper floor, "second" *casa de oficios* (LS, pl. 49).

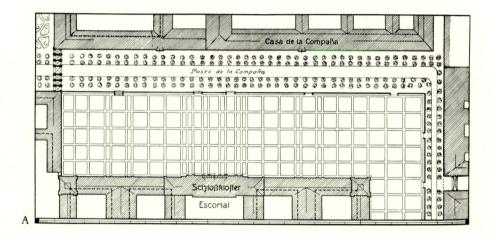

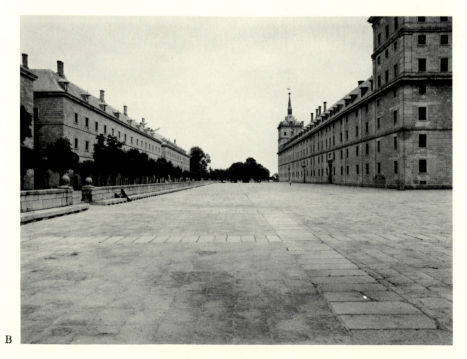

91. (A) Plan of paving on west and north plazas (the "compaña" should be the "in-fantes") (after Jürgens, *Spanische Städte*, pl. 12); (B) view of north plaza (photo EK).

92. Meeting of low palace lead roof and steep monastery slate roof between basilica and monastery (photo author, 1964).

93. Lower attic chamber (*camaranchón*) between main stair tower and south basilica-façade tower (photo author, 1964).

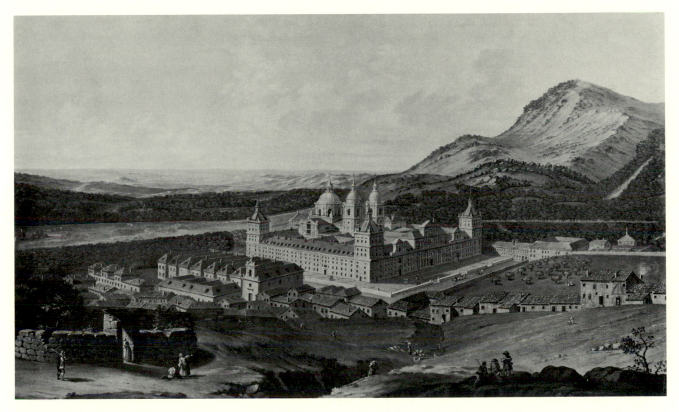

94. Gabriel Joli (1700-1777), oil painting before 1771 (photo M. Soria collection, Yale University).

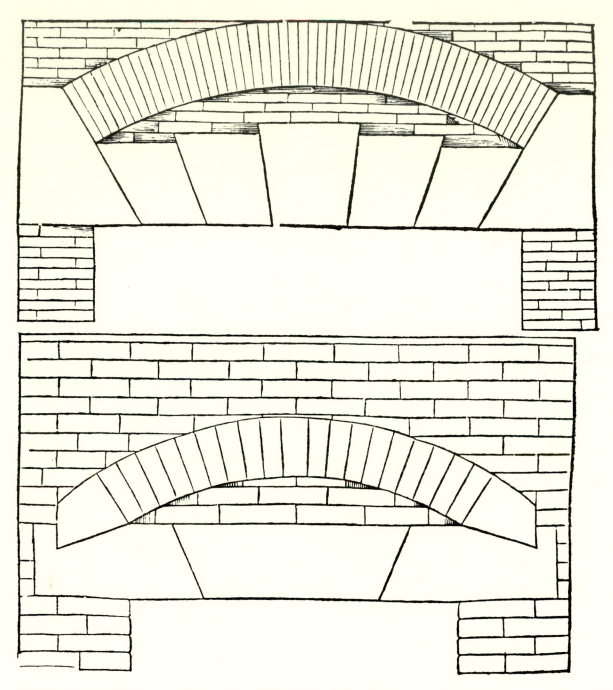

95. Serlio, diagrams of relieving arches over flat-arch lintels (after Serlio, *Libro Quarto*, 1552, fol. 17ᵛ).

A

B

96. (A) Interior, southwest-tower stair (photo EK, 1979); (B) iron bands in ceiling reinforcing archive stairway (photo author, 1964).

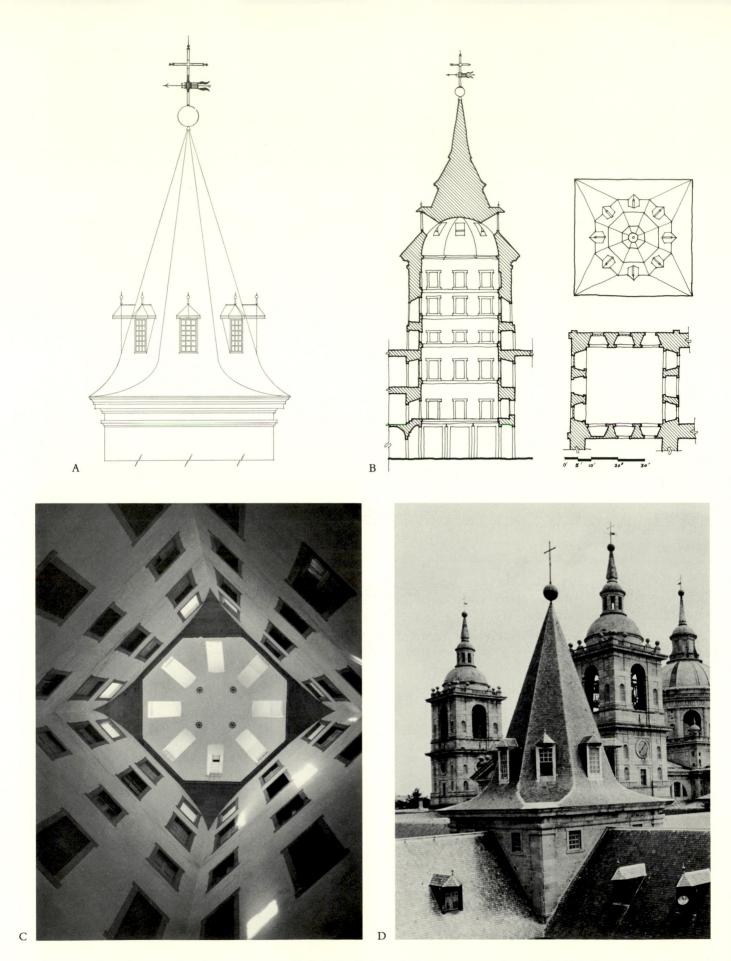

97. Monastery-crossing tower (A) elevation, as originally built (Andrada, in EEC, 2:333); (B) as restored after 1671 (drawing EK); (C) view of interior (photo EK); (D) view from southwest (photo EK).

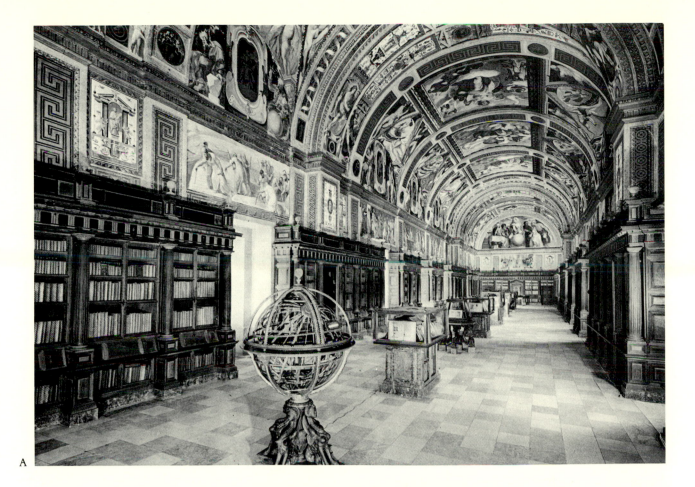

A

B

98. Library (A) from south (PAN); (B) northern window on east side, drawing by P. Tibaldi with comments by Herrera (BM).

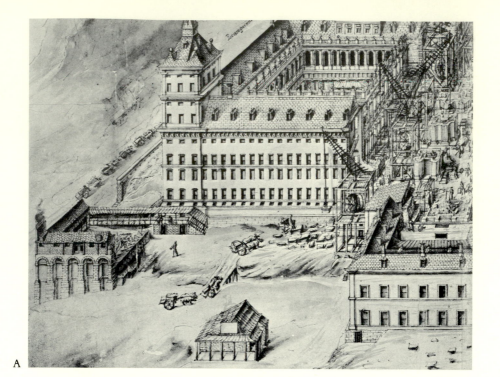

A

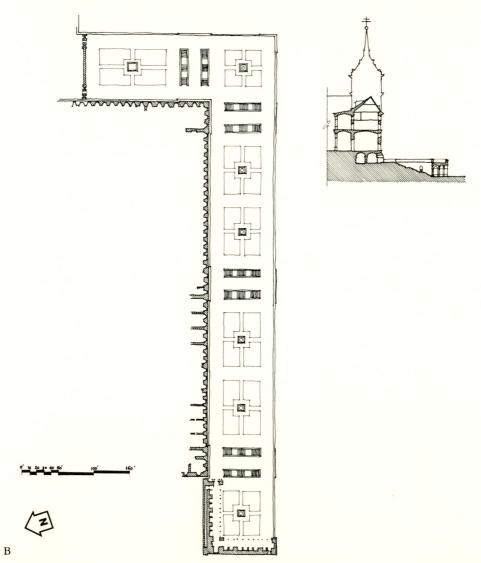

B

99. Garden stairs (A) Hatfield drawing, lower left building the prior's garden stairs; (B) section and elevation (HS, plans 1, 4); (C) plan and section; (D) view of grotto and its entrance at southwest corner, lower garden level (photo EK, 1979).

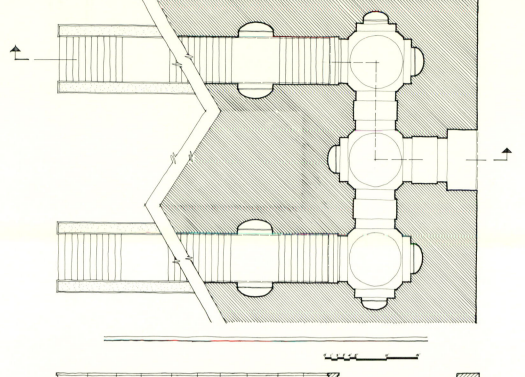

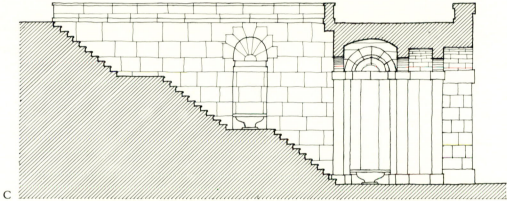

C

D

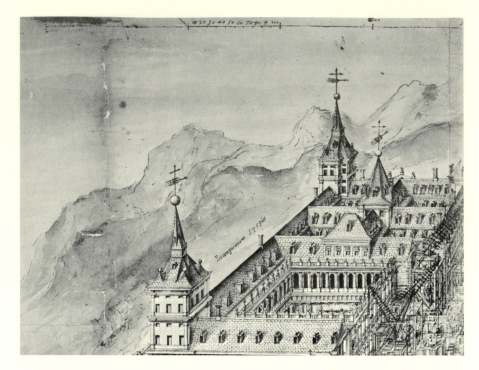

100. Hatfield drawing, upper left, showing curved spire profiles and main-stair roof, 1576.

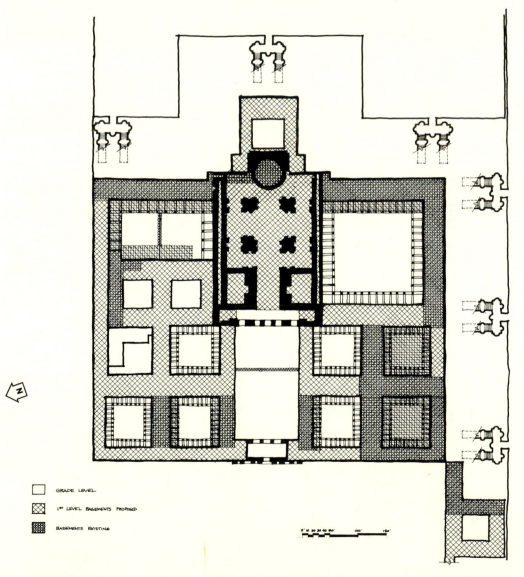

GRADE LEVEL

1ˢᵀ LEVEL BASEMENTS PROPOSED

BASEMENTS EXISTING

101. Basements, cisterns, and toilet tanks as indicated by Herrera in HS, LS, Salcedo, and archival sources (drawing EK).

102. North façade in summer (photo EK, 1979).

103. East building, palace, basements (now Museum of Architecture) (photo Eloy).

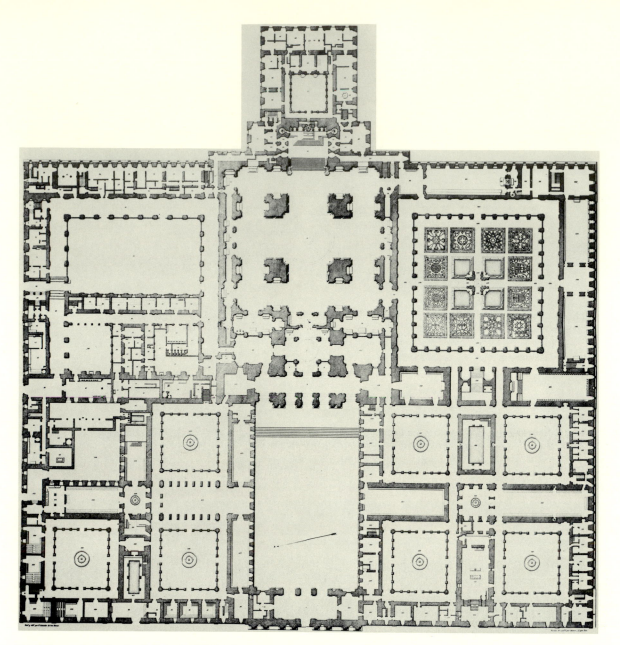

104. Lithographed plan by F. Salcedo (1876) (photo courtesy BNM).

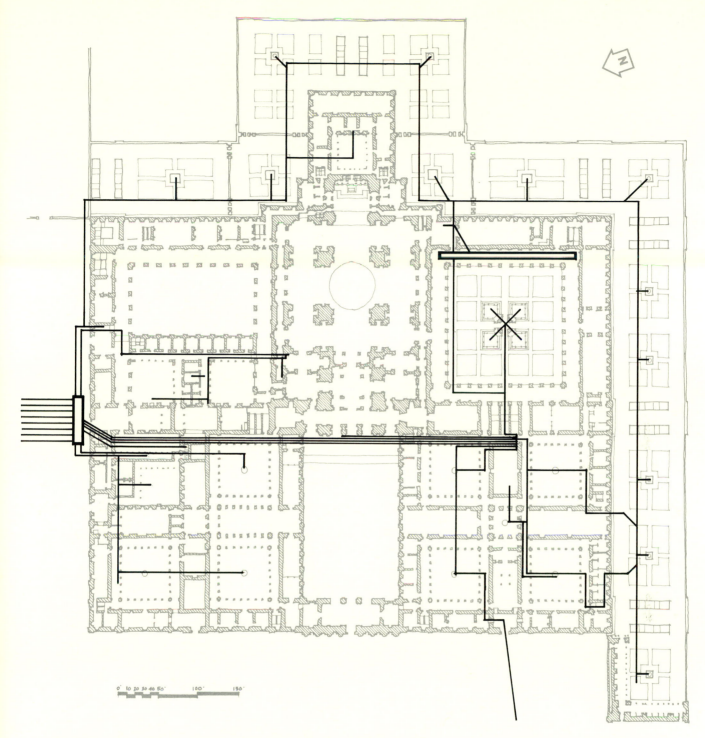

105. Water ducts and drains, shown without vertical pipe-runs, diagram based on manual of maintenance written in 1645 (after G. de Andrés, "Relaciónes").

106. Lerma, ducal palace, river façade (after Cervera, *El Conjunto palacial*, fig. 45).

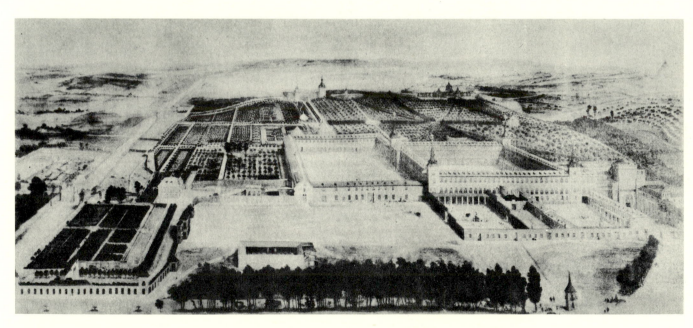

107. Madrid, Buen Retiro palace (after Caturla, *Pinturas*, opp. 34).

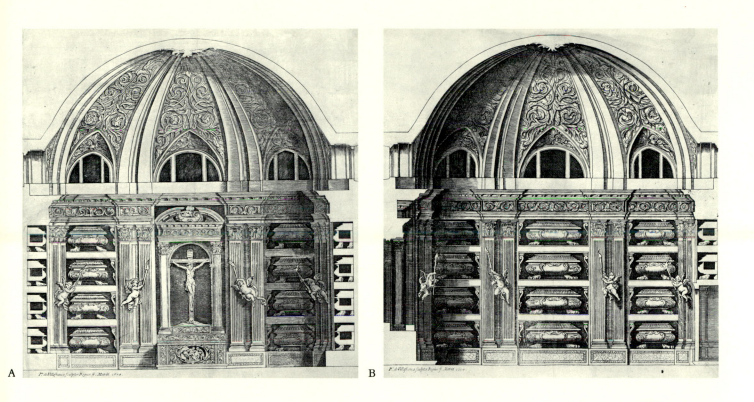

108. Crypt under basilica, remodeled as Panteón engraved by Pedro de Villafranca, 1654, after Ximenez
(A) entrance axis (southwest to northeast); (B) cross-axis (southeast to northwest); (C) plan; (D) stair-
way.

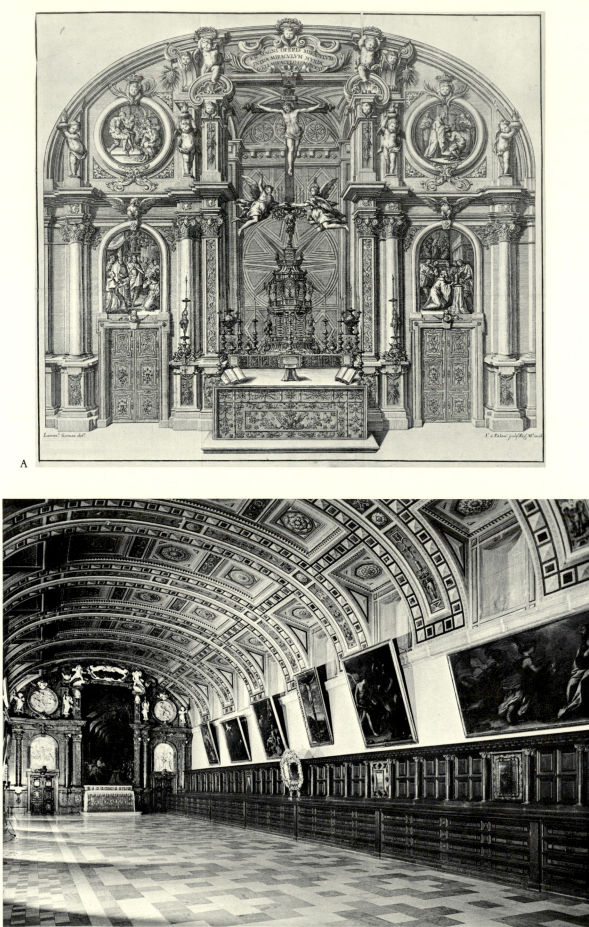

109. Sacristy (A) altar and *camarín* of the *Sagrada Forma* (after Ximenez): (B) view of sacristy from south (PAN).

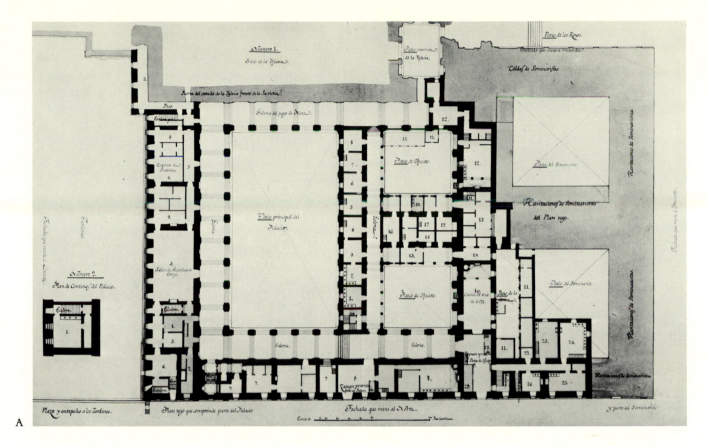

A

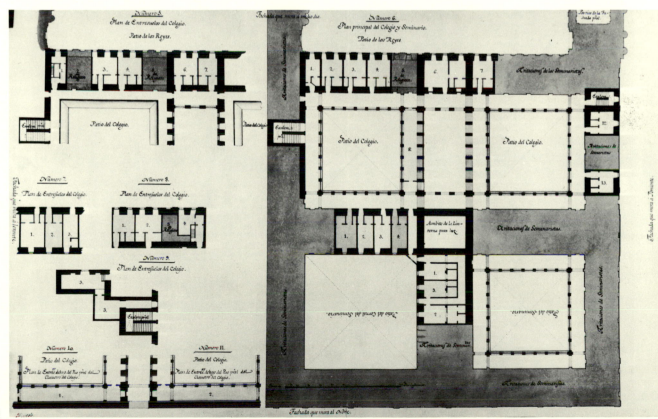

B

110. Juan de Villanueva, plans of palace quadrant in 1785 before remodeling palace entrance and north façade (A) ground plan and basement under northeast tower; (B) plans of college apartments on entresol, upper floor and cloisters at north forecourt façade, including part of college assembly room (AGP, photos permission PAN).

A

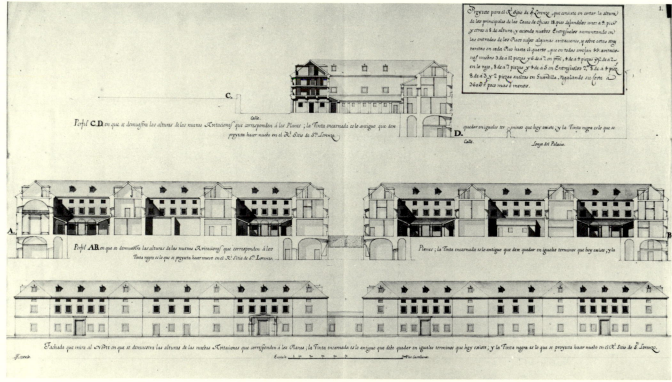

B

111. Juan de Villanueva (A) plans; (B) elevations of the Herreran *casas de oficios* showing crowded additions in 1785, and Villanueva's designs for further enlargement (AGP, photos permission PAN).

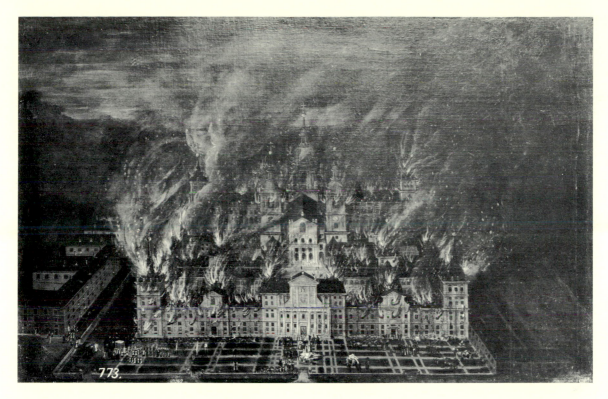

112. Oil painting attributed to fray Francisco de los Santos of the conflagration of 1671 (in Facultad de Arquitectura, Madrid, courtesy G. de Andrés).

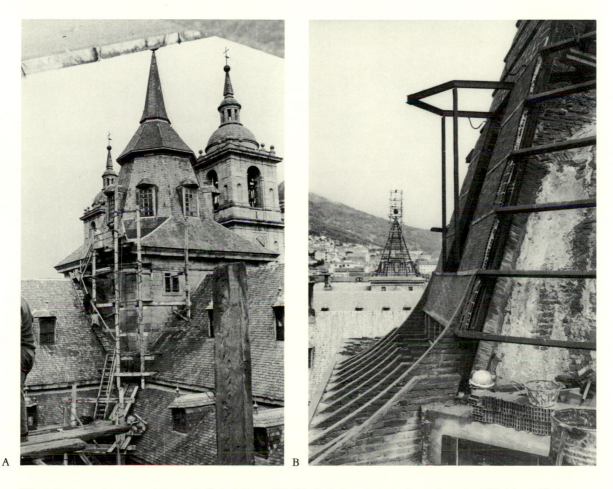

A
B

113. College-crossing tower (A) as rebuilt in 1673 on Zúmbigo's design, about to come down in 1963 (photo Eloy, courtesy Ramón Andrada); (B) college-crossing steel spire, seen from cloister-crossing spire being rebuilt in 1963 to Herrera's design (photo Eloy, courtesy Ramón Andrada).

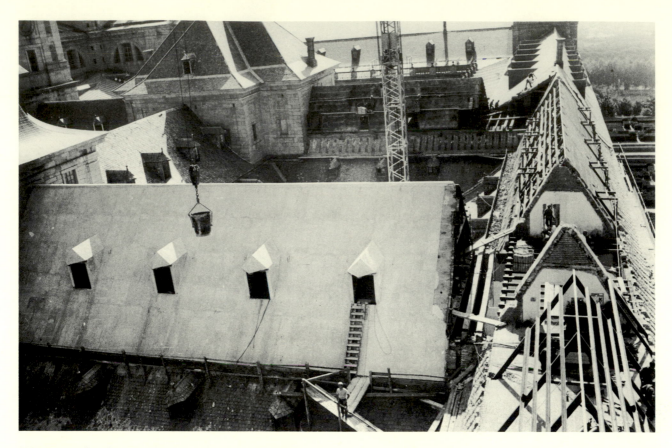

114. New roofs and attics, at the southern cloisters, looking east to main-stairway housing, 1967 (photo Eloy, courtesy Ramón Andrada).

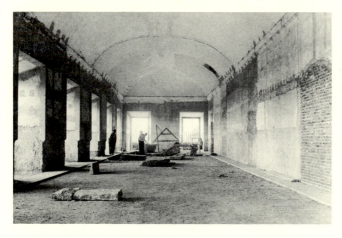

115. King's house, eastern gallery, lower floor at terrace level, after removal of nineteenth-century partitioning in 1962 (photo Eloy, courtesy Ramón Andrada).

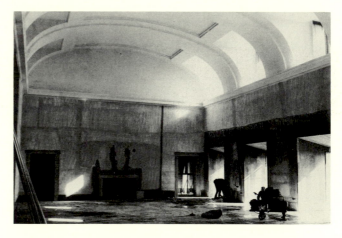

116. Reception room, ground floor, east range of palace, during restoration in 1963 (photo Eloy, courtesy Ramón Andrada).

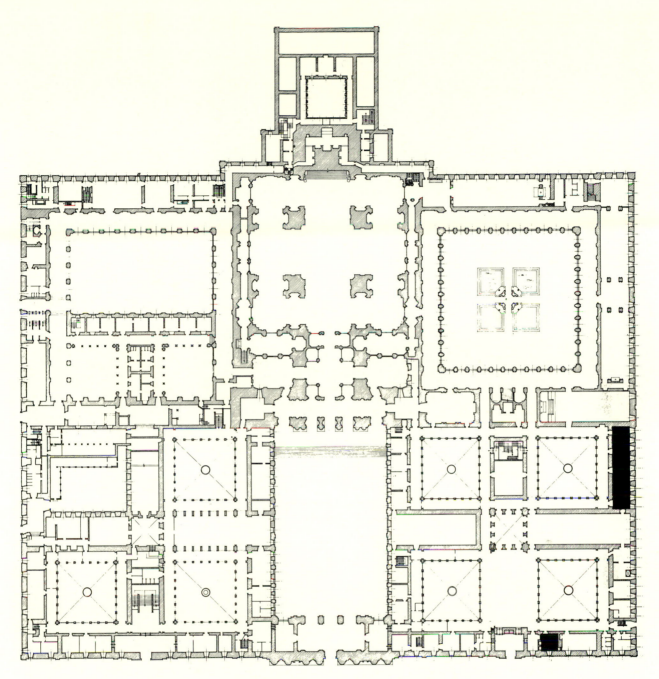

117. Ground plan at level of basilica floor and *pudridero*, 1972 (courtesy Ramón Andrada).

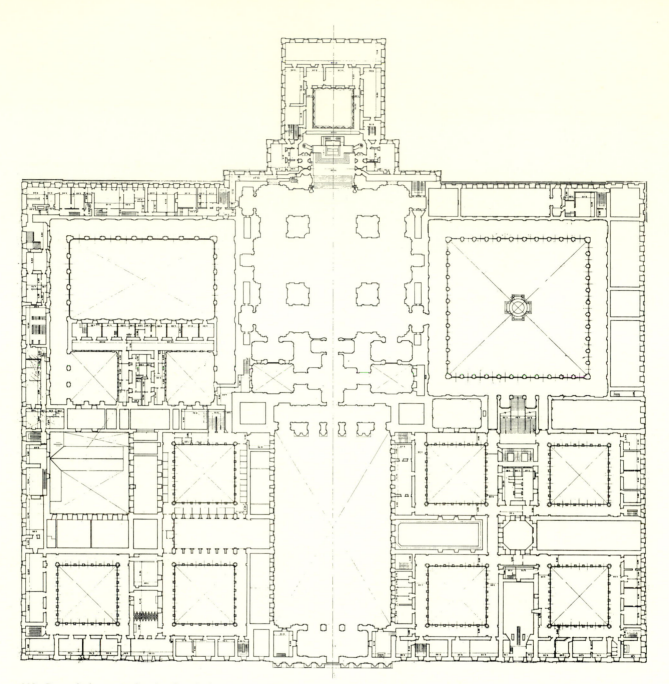

118. Ground plan at 15-foot level with dimensions, 1964 (courtesy Ramón Andrada).

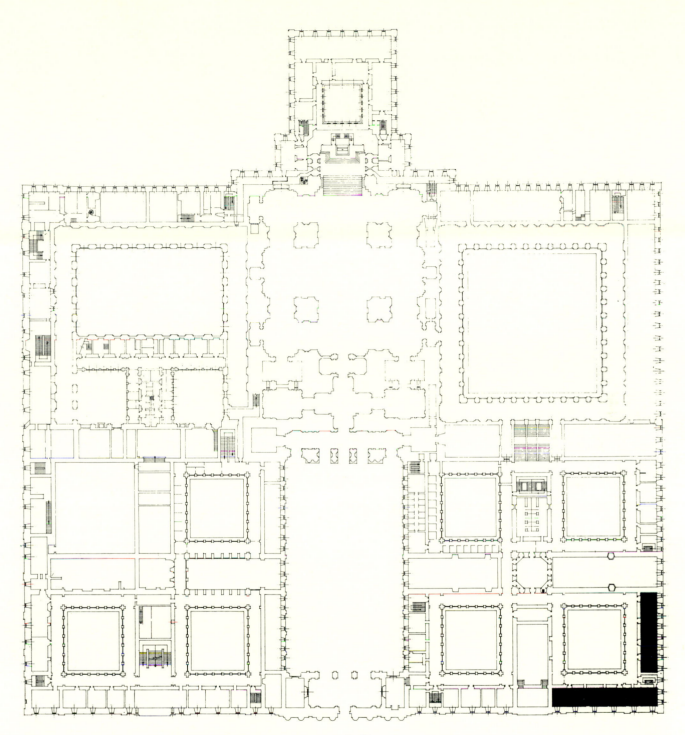

119. Plan with partitions at 15-foot level, 1972 (courtesy Ramón Andrada).

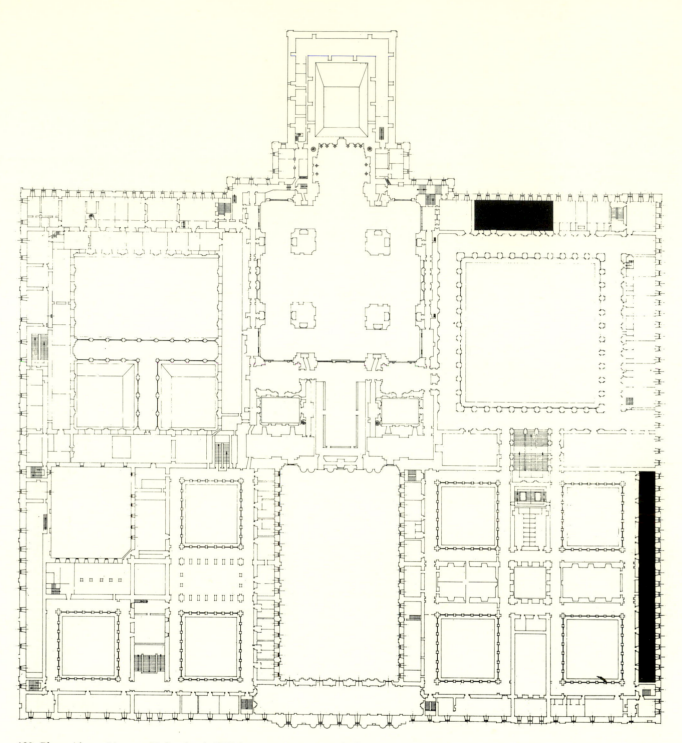

120. Plan with partitions at 30-foot level, 1972 (courtesy Ramón Andrada).

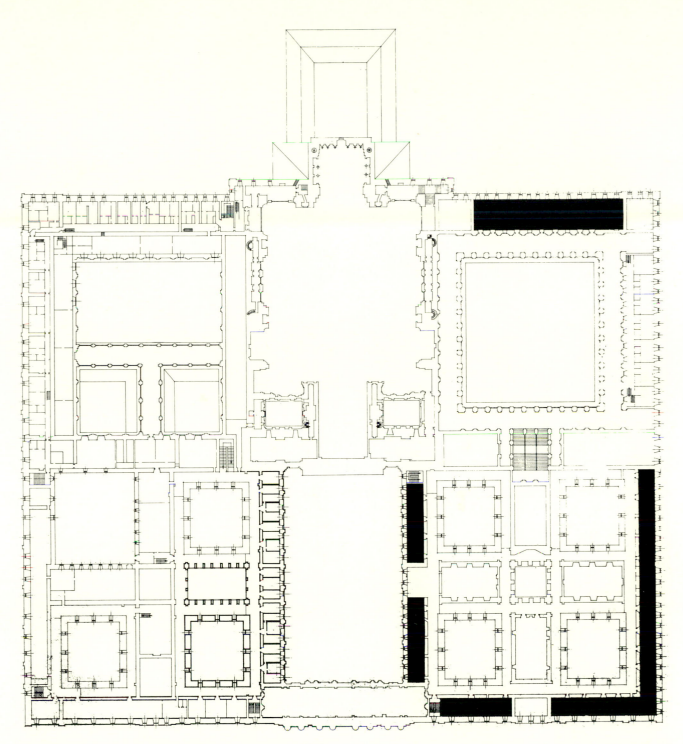

121. Plan below 55-foot cornice, 1972 (courtesy Ramón Andrada).

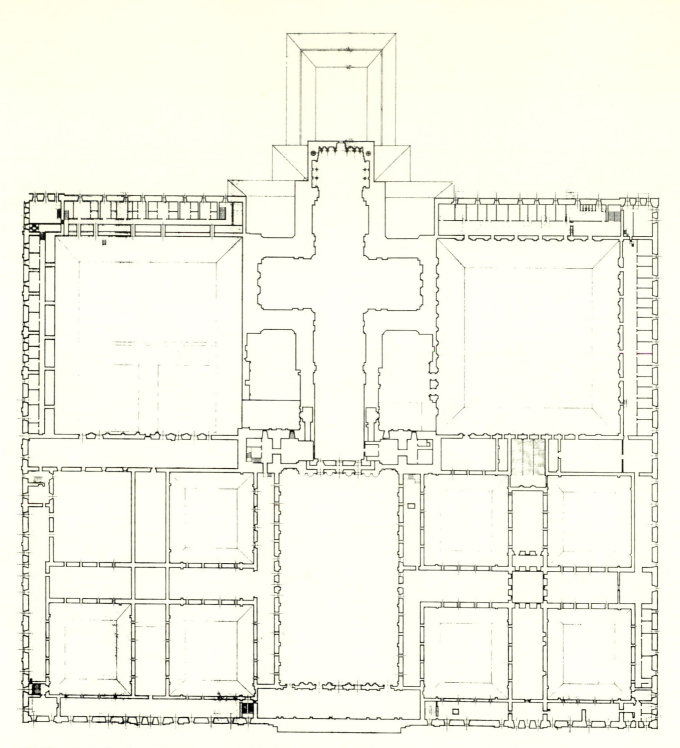

122. Plan of attic chambers and dormitories, 1972 (courtesy Ramón Andrada).

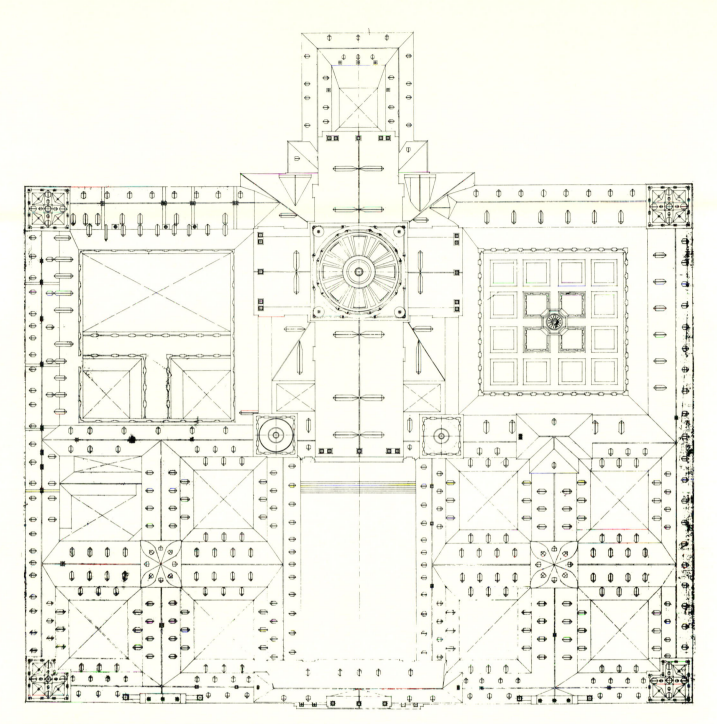

123. Plan of the roofs and vaults, 1967 (courtesy Ramón Andrada).